A
CELEBRATION
of ANIMATION

THE 100 GREATEST CARTOON CHARACTERS IN TELEVISION HISTORY

Marty Gitlin
and Joe Wos

Foreword by Tom Kenny, voice of SpongeBob SquarePants

LP

Guilford, Connecticut

An imprint of Globe Pequot

Distributed by NATIONAL BOOK NETWORK

British Library Cataloguing in Publication Information available

Library of Congress Cataloging-in-Publication Data

Names: Gitlin, Marty, author. | Wos, Joe, author.
Title: A celebration of animation : the 100 greatest cartoon characters in
 television history / Marty Gitlin and Joe Wos.
Description: Guilford, Connecticut : Lyons Press, 2017.
Identifiers: LCCN 2017026371 (print) | LCCN 2017025749 (ebook) | ISBN
 9781630762797 (ebook) | ISBN 9781630762780 (hardcover)
Subjects: LCSH: Cartoon characters—Miscellanea. | Animated television
 programs—Miscellanea.
Classification: LCC NC1765 (print) | LCC NC1765 .G53 2017 (ebook) | DDC
 741.5/8—dc23
LC record available at https://lccn.loc.gov/2017026371

♾™ The paper used in this publication meets the minimum requirements of American National Standard for Information Sciences—Permanence of Paper for Printed Library Materials, ANSI/ NISO Z39.48-1992.

Printed in the United States of America

A
CELEBRATION
of ANIMATION

FROM JOE:

Special thanks to—
Andrew Farago
Van Eaton Galleries
Mark Levy
Comic-Mint.com
Gary Long
Nikki Romero
Zack Kaplan
Tom Kenny
Marilyn Allen
and
Ava Wos

FROM MARTY:

To my now-grown children—Emily, Andrew, and Melanie—whose love for watching cartoons with me helped keep my perpetual childhood alive.

PHOTO CREDITS

32. Mighty Mouse (Mighty Mouse) © CBS. CBS/Photofest

33. Mr. Magoo (The Mr. Magoo Show) © DreamWorks Classics. Publicity image, Movie Stills Database

34. Korra (Legend of Korra) © Nickelodeon. Publicity image, Movie Stills Database

35. Crusader Rabbit (Crusader Rabbit) © 20th Century Fox. Publicity image, Movie Still Database

36. Underdog © Universal Television. CBS/Photofest

37. Harley Quinn (Batman: The Animated Series) © Fox. Fox/Warner Bros./Photofest

38. Wile E. Coyote and Road Runner (Looney Tunes) © Warner Bros. Entertainment, Inc. Publicity image, Movie Stills Database

40. Alvin (The Alvin Show) © NBC. NBC/Photofest

41. Twilight Sparkle (My Little Pony) © Lionsgate. Lionsgate/Photofest

42. Mr. Peabody (Peabody and Sherman) © ABC. ABC/Photofest

43. Bobby Hill (King of the Hill) © 20th Century Fox Television. Fox Broadcasting/Photofest

44. Angelica Pickles (The Rugrats) © Nickelodeon. Nickleodeon/Photofest

45. Finn and Jake (Adventure Time) © Cartoon Network. Cartoon Network/Photofest

56. Charlie Brown (Peanuts) © ABC. ABC/Photofest

60. Mr. Burns (The Simpsons) © 20th Century Fox Television. Fox/Photofest

61. Space Ghost (Space Ghost) © CBS, CBS/Photofest

62. Patrick (SpongeBob SquarePants) © Paramount Pictures. Paramount/Photofest

65. The Tick (The Tick) © Fox. Fox/Photofest

66. Wanda and Cosmo (Fairly Odd Parents) © Nickelodeon. Nickelodeon Network/Photofest

68. George of the Jungle (George of the Jungle) © ABC. ABC/Photofest

69. Goliath (Gargoyles) © Walt Disney Television Animation. Disney/Photofest

70. Garfield (Garfield & Friends) © 2008-10 Dargaud Media. CBS/Photofest

71. Roger Ramjet (Roger Ramjet) © Hero Entertainment. Hero Entertainment/Photofest

72. Jokey Smurf (The Smurfs) © NBC. NBC/Photofest

73. Miss Frizzle (Magic School Bus) © Public Broadcasting Service. PBS/Photofest

74. Uncle Scrooge (DuckTales) © Walt Disney Television Animation. Walt Disney/Photofest

75. Dudley Do-Right (Dudley Do-Right of the Mounties) © ABC. ABC/Photofest

77. Sylvester & Tweety (Looney Tunes) © Warner Bros. Entertainment, Inc. Warner Bros./Photofest

78. Penny (Inspector Gadget) © LBS Communications. LBS Communications/Photofest

79. Bender (Futurama) © 20th Century Fox Television. Publicity image, Movie Still Database

80. Gonzo (Muppet Babies) © CBS. CBS/Photofest

81. Boris and Natasha (Rocky and Bullwinkle) © ABC. ABC/Photofest

82. Beast Boy (Teen Titans) © Warner Home Video/ Warner Home Video/Photofest

83. Sterling Archer (Archer) © 20th Century Fox Television. Publicity image, Movie Stills Database

91. Secret Squirrel (The Atom Ant/Secret Squirrel Show) © Hanna-Barbera. Artist's sketch

98. Snagglepuss (The Yogi Bear Show) © Hanna-Barbera. Working sketch

CONTENTS

CONTENTS

CONTENTS

FOREWORD

Just why do cartoons and cartoon characters have such a grip on us? If you're reading this book, it's a good bet that at some point during your formative years, some animated character "hit" you, worked their way into your consciousness, and acted as a kind of "gateway drug." Now all these years later that monkey (or some other anthropomorphized critter) is still on your back.

That's MY story. Cartoons ate my brain! You too, huh?

Be it Popeye or Pikachu, Skeletor or Stewie, Bullwinkle or Butt-Head, cartoons are mind-worms that take hold and don't let loose. Our favorite animated characters retain a near-mystical power over us that lasts a lifetime . . . and often much longer!

Think about it: Mickey Mouse was "born" in 1928. A kid who fell for "America's Favorite Rodent of 1929" would now be looking down the barrel of their hundredth birthday! Yet, wave a picture of Mickey Mouse in front of just about any four year old in 2017, and that kid will yell out Mickey's name! Now try doing that with any other 1920's or 1930's box office titans. How many Wallace Beery backpacks are stuffed into those kindergarten cubbies? "Hey, twenty-first-century kid: Whaddya MEAN you never heard of Greta freakin' Garbo?"

To my child self, cartoons weren't something you watched INSTEAD of "educational television" . . . Cartoons WERE my "educational television"!

That heady "cartoon brew" that seeped into my DNA when I was a little kid is still very much there. Rocky and Bullwinkle's linguistic lunacy taught me to love wordplay. Chuck Jones's version of Daffy Duck taught me all I needed to know about feelings of insecurity. Bugs Bunny taught me that unexpected comedy is a useful weapon to turn the tables on one's aggressors (Bugs was paralyzing the rifle-toting Elmer Fudd by smooching him full on the lips decades before Vietnam-era hippies were sticking flowers into the gun barrels of gob-smacked soldiers!) Max & Dave Fleischer's doodle daughter Betty Boop provided my first exposure to the music of Louis Armstrong & Cab Calloway, and Popeye showed me that good people stick up for the "little guy." Tex Avery's paradoxically hyperactive films about the low-energy Droopy made me fall in love with amped-up, surreal, slapstick absurdity.

Little Tommy Kenny started asking questions like: "Who makes these voices? And is that an actual job that a grown-up can have?" Lucky for me, I was able to suss out the answers to both of those queries! It's been twenty-five years since my first cartoon voiceover gig. Back then, I felt like I had stumbled into the best job in the world. I still do. The art of animation can produce one-of-a-kind characters, yet it is arguably the most collaborative of art forms. When children ask me about it, I compare it to one of those giant Japanese robots with a whole bunch of people controlling the different extremities (I guess I would be the larynx guy). Regardless of the technology used (what it was, is, or will be), to pull off that magic trick—the illusion that a series of drawings lives, breathes, feels, and becomes somehow "real" to the viewer—is lightning in a bottle. It doesn't happen very often. To even attempt the trick, everybody has to be "working the robot" in perfect sync: character designers, prop designers, writers, storyboard artists, recording engineers, voice actors, editors, musicians, and many many more.

Being the voice of SpongeBob is a very rewarding thing. Being a part of the team that makes SpongeBob come to life is even better. When it really works, that character resonates in a way

that no actor made of mere meat ever could. A great animated character will ultimately have more staying power and connect on a deeper, more lasting level than any Hollywood beefcake in a cape and leotard fighting pixilated, exploding junk in front of a green screen.

I don't know about you, but for me it's empowering to know that long after dopey dreck like *Duck Dynasty* recedes permanently into the pop cultural rearview mirror, the ducks that TRULY matter (Donald, Daffy, Darkwing, and all their beaked bufflehead brethren) will still be quacking wise. It's comforting to consider that when this week's mind-numbing, soul-killing reality television is a teeny faded blip on the radar screen, good ol' Charlie Brown and his anemic Christmas tree will endure.

It's those times where I feel like maybe—just maybe—this oddball job of jumping around behind a microphone and giving voice to the drawings of people vastly more talented than me actually may have an indefinable deeper worth. Like maybe by putting something peculiar and fun and kindhearted out into the universe, we may actually be providing something that kinda . . . matters?

Then I shake it off and just keep on making my weird sounds and acting like a goofball. Because once you start taking comedy seriously, you're a dead duck.

I don't want to be a dead duck. I want to be a duck amuck!

Enjoy the book.

—Tom Kenny, voice of SpongeBob SquarePants

INTRODUCTION

To mangle a line from *Star Trek*, the authors of this book have gone where no authors have gone before. They have ranked the greatest cartoon characters ever to grace the small screen.

Given that most characters who appeared in theatrical shorts also eventually starred on television and were therefore eligible for inclusion in this book, swelling the number of possibilities to those representing Warner Bros., Disney, and many other studios, the candidate pool was virtually endless. In other words, this was no easy task.

But somebody had to do it. Debates both friendly and heated have raged for generations about which animated legends were the best of the best. Some perceive it as comparing apples to green beans to pork chops. After all, some were humorous, others serious. They emerged from markedly different eras, resulting in tremendous imbalances. Can one judge, for instance, the bawdy material emanating from the lips of Peter Griffin (*Family Guy*) or Eric Cartman (*South Park*) against the lines delivered by Mr. Magoo?

The answer? Yes.

But any list must be formed not only through subjectivity, but an objective set of criteria that provides a rationale both for placement in the Top 100 and particular spots in the rankings. The authors considered many factors, including legacy, interaction with fellow characters (such as Daffy Duck and his jealousy of Bugs Bunny), longevity (think Homer Simpson), popularity of the shows in which they appeared, visual appeal, and uniqueness of voice. Only within that framework did the authors' expertise and personal feelings come into play.

Each entry begins with a "Toon-Up Facts" section that provides some basic information about the character (creator, studio, debut, voice artist, catchphrase, defining role, antagonists, and more). The section that follows varies from character to character, often focusing on trivia but also sometimes including tidbits essential to understanding the animated subject. The "About" segments detail the history of the character from conception to final appearance (though some remain active). The final section explains both objectively and subjectively the reasoning behind the character's inclusion in the book and rank.

This book invites debate. No reader will agree with every entry or ranking; it is mathematically impossible. Disagreements are not only welcome, but embraced.

Most of all, though, it's fun. Older readers may begin to wax nostalgic as they recall watching the characters from earlier generations on Saturday mornings with a bowl of cereal on their laps. Younger readers may fondly remember seeing the characters from a more recent era as anytime fare on cable networks such as Cartoon Network, Nickelodeon, and the Disney Channel.

Indeed, if this book puts smiles on faces, its creators too will smile. If it brings joy to those with lives beset by far more pressing and serious matters than the placement of Woody Woodpecker or Johnny Bravo on a list of all-time animated greats, the authors will be thrilled. And when it generates friendly debate over inclusion and ranking, everyone will be well armed with a grin and their own opinions.

After all, this book is designed to take minds off the grave issues of the day. So, sit back, relax, and enjoy *A Celebration of Animation: The 100 Greatest Cartoon Characters in Television History.*

1
BUGS BUNNY

TOON-UP FACTS

Creator: Tex Avery
Studio: Leon Schlesinger Productions (later Warner Bros.)
Voice: Mel Blanc
Debut: 1938 (*Porky's Hare Hunt*); fully developed 1940 (*A Wild Hare*)
Catchphrase: "Eh . . . What's up, Doc?"
Antagonists: Elmer Fudd, Daffy Duck, Yosemite Sam
Passion: Carrots
Defining role: Theatrical shorts
Top TV venue: *The Bugs Bunny Show* (1960–1975)

Bugs Bits

- The wascally wabbit has his own star on the Hollywood Walk of Fame.

- Bugs speaks with a Brooklyn accent.

- The US Postal Service honored Bugs by placing him on a stamp in 1997.

- The only short in which Bugs was portrayed as a villain was *Buckaroo Bugs* (1948), his introduction to Looney Tunes after serving as a character in Merrie Melodies cartoons.

- Bugs won an Academy Award for *Knighty Knight, Bugs* in 1958.

- A 1976 poll of Americans regarding their favorite real or imaginary character resulted in Bugs finishing second to Abraham Lincoln.

- Bugs's mannerisms have been compared to those of famed comedian Groucho Marx, particularly how the former holds his carrot and the latter his trademark cigar.

- The Utah Celery Company of Salt Lake City offered to provide staff members at Warner Bros. with plenty of their product if Bugs would switch his favorite vegetable from carrots to celery. The Broccoli Institute of America later urged the famed rabbit to sample their vegetable on occasion.

- Bugs was voted the most popular short-subject character in both the United States and Canada in 1945—and remained #1 over the next sixteen years.

- The word *bugs* is defined as slang for "crazy" or "insane" by dictionary.com.

About Bugs Bunny

One who watches his debut as a trickster and tormenter in *Porky's Hare Hunt* (1938) might be surprised to learn that they are actually watching Bugs Bunny. His voice sounds more like that of Woody Woodpecker, his ears are back rather than upright, his buck-teeth are far less prominent, and his face is thinner. And nary a "What's up, doc?" is uttered.

But if not for the positive reaction of viewers to that early incarnation, the Bugs Bunny cherished by millions might never have been developed. The transformation was complete by July 27, 1940, the date of release for *A Wild Hare*, which not only featured what is now considered a modern Bugs in looks and voice as the most sought-after prey for Elmer Fudd, but proved so critically acclaimed that it earned an Academy Award nomination for Best Cartoon Short Subject. He had adopted a thick New York accent, the roots of which have been described as a cross between Bronx and Brooklyn. And he was far more in control in his role as a trickster than the giggling, bouncing rabbit seen in *Porky's Hare Hunt*.

His popularity grew to the point that he became the star of the Merrie Melodies clan by 1942, despite and because of the birth and growth of several animated characters off of whom he played. Though Bugs was often outwitting characters created for one particular short, his relationships with such enemies as Elmer Fudd, Daffy Duck, and Yosemite Sam gave the writers a wide range of opportunities to utilize him as a protagonist.

His popularity motivated Warner Bros., which bought out Schlesinger in 1944, to utilize him in what amounted to propaganda cartoons during World War II. The short *Bugs Bunny Nips the Nips* (1944) stereotyped Japanese to the point that it has since been yanked from distribution, but the anti-Nazi *Herr Meets Hare* (1945) that features Bugs outwitting Adolf Hitler and Hermann Goering can still be seen today.

The advent of television proved an ideal vehicle for Looney Tunes and began turning the baby boomer generation on to the greatness of Bugs. He continued to appear in new cartoons through 1964, four years after ABC launched *The Bugs Bunny Show* in primetime. By that time, Bugs had earned his first Academy Award for Best Cartoon Short Subject with his appearance in the medieval *Knighty Knight Bugs* (1958), and he had established his rivalry with Daffy Duck and starred in another short with Elmer Fudd (*What's Opera, Doc*) that parodied a Richard Wagner classic, was deemed "culturally significant" by the US Library of Congress, and eventually became the first cartoon to be preserved by the National Film Registry.

Bugs appeared in several animated network television specials and compilation films in the 1970s and 1980s. A year before Mel Blanc died in 1989, he voiced Bugs in the hit film *Who Framed Roger Rabbit?* His appearances lost much of their luster in more recent fare, such as *Box Office Bunny* (1990) and *Space Jam* (1996), not only because he was no longer voiced by Blanc, but because of the more complex plots and modernized productions. Bugs was in his element and at his best when he was confronted by and attempting to foil solely the likes of Elmer Fudd, Daffy Duck, Yosemite Sam, or any other antagonist seeking to throw a wrench into the contented and simple life in his rabbit hole that he so cherished.

Why Bugs Bunny Is No. 1

Though one might consider Bugs an antagonist, it must be remembered, as Warner Bros. animator and director Chuck Jones stressed, that Bugs reacted only when provoked. Otherwise he could have been considered a bully. This fact increases his likeability and allows his humor to be enjoyed to the fullest.

That belief successfully rebuts the claim that Bugs was a ripoff of big, boastful bunny Max Hare, who was featured in the 1935 Disney short *The Tortoise and the Hare*. Max was careless in losing to the tortoise—and carelessness (not to mention defeat) could never be associated with Bugs. The former was outwardly conceited and antagonistic without provocation in that Disney short. Again, that's not Bugs, who was also far wackier than the predecessor with whom he was compared.

Other cartoon characters—such as Mickey Mouse—can be considered equally legendary. But none who have gained that status through three-quarters of a century of movie screen and television prominence have elicited more laughter through a keen wit and a sense of fun-lovingness, even in the face of danger. His creativity in extricating himself from jams is unmatched.

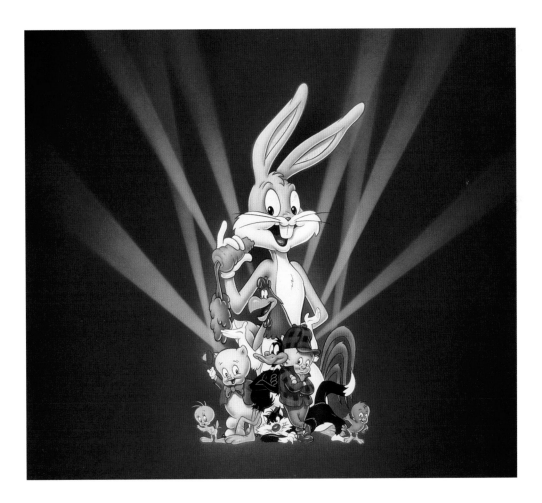

One must look no further than the short *Rabbit Hood* (1949). Bugs gets himself in trouble for eating carrots meant for the sheriff of Nottingham. Bugs eventually pops up in front of the sheriff, rolling in on a one-hundred-foot-long red carpet wearing the outfit of a king. He proceeds to "knight" the sheriff by striking him on the head repeatedly with a scepter and proclaiming him with each smack such silly titles as "Sir Loin of Beef," "Baron of Munchausen," "Essence of Myrrh," "Milk of Magnesia," and "Quarter of Ten." As the dazed sheriff is about to fall, Bugs rushes into the woods, slides in a stove, stirs up a mix, bakes a cake, pulls it out of the oven, frosts it, and places it on the ground just in time for the sheriff to fall face first into it.

Then there is the pace and timing of the *Rabbit of Seville* (1950), a brilliant short featuring only Bugs and Elmer Fudd that is in my view the funniest of all the "Wascally Wabbit" performances. It is unique in that Bugs and Elmer sing their way through the entire episode.

It begins with a rifle-wielding Elmer chasing Bugs through the back of a theater in which patrons are filing in to witness a production of the legendary opera, *The Barber of Seville*. It ends with Elmer dressed in a wedding gown and the music switching to *The Wedding March* by Mendelssohn. Bugs carries his bride over the threshold, a door located at the top of a long flight of stairs, and drops him several stories into a wedding cake.

Only Bugs Bunny could pull that off.

—MG

2
HOMER SIMPSON

TOON-UP FACTS

Creator: Matt Groening
Studios: Gracie Films (1987–1989); Klasky Csupo (1989–1992); Film Roman (1992–present)
Voice: Dan Castellaneta
Debut: 1987 (*Good Night*)
Series debut: 1989 ("Simpsons Roasting on an Open Fire")
Birthdate: May 12, 1956
Wife: Marge
Son: Bart
Daughters: Lisa, Maggie
Mother: Mona
Father: Abraham
Catchphrase: "D'oh!"
Hometown: Springfield
Employer: Springfield Nuclear Power Plant
Boss: Charles Montgomery Burns
Defining role: *The Simpsons* (1989–present)
Traits: Lazy, clumsy, ignorant, faithful, inept, crude, slovenly

Simpleton Stuff

- Groening named Homer after his father, who was a cartoonist in his own right, as well as a filmmaker. The elder Groening was named after the poet Homer. Groening thought Simpson was a funny name because its first syllable is "simp."

- Pop superstar Michael Jackson loved *The Simpsons* and asked Groening if he could make an appearance. Groening obliged and allowed him to voice a character named Leon Kompowsky, who shared a room with Homer in a mental institution.

- Homer's hometown was deemed to be Springfield because Groening recalled it was the same name of the city in which the family lived in the 1950s sitcom *Father Knows Best*. Groening had always imagined Springfield resting near his own hometown of Portland, Oregon.

- Duff beer—the favorite of Homer—was placed on the market in several countries without the permission of Groening, resulting in legal battles. *Time* magazine listed Duff as one of the most influential fictional companies of all time in 2016.

- The only similarity Groening claims between his father and Homer Simpson is the love for ice cream.

- A surprise inspection at the Springfield Nuclear Plant revealed 342 violations, greatly due to Homer's incompetence, resulting in $56 million in fines that the miserly Mr. Burns refused to pay. Among the violations was the disposal of waste in a children's playground and cracked cooling towers that were later "fixed" using chewing gum.

- Homer's wife Marge is voiced by Julie Kavner, who first gained fame as the title character's little sister in the 1970s sitcom and *Mary Tyler Moore Show* spinoff *Rhoda*.

- As did most of the characters on the show, Homer had just four fingers on each hand.

- Homer and his family were awarded a star on the Hollywood Walk of Fame in 2000.

- Though Homer loves basic foods such as hamburgers and hot dogs, it can be argued that his favorite edible creation is the doughnut.

- The first name of Homer's buddy Barney Gumble is a small tribute to the first primetime animated cartoon, *The Flintstones*. Fred Flintstone's best friend was Barney Rubble.

- Homer met his wife at a summer camp. They fell in love in 1974.

- Among the inspirations for the loopy humor of *The Simpsons* was surreal 1960s sitcom *Green Acres*, a childhood favorite of Groening. He attended a *Green Acres* reunion with cast members as a student at USC.

- Homer was raised on a farm by parents Mona and Abraham.

- One reason for Homer's epic stupidity is that there is a crayon lodged in the frontal lobe of his brain.

- Homer's middle name is Jay. The middle initial "J" was provided by Groening as a tribute to animated stars and buddies Rocky and Bullwinkle, both of whom boasted the same middle initial.

About Homer Simpson

Little could one have imagined that arguably the greatest cartoon character in television history—and one generally considered the best of all animated human figures—was given birth as a bumper feature on a program he outlasted for thirty years and counting. Homer Simpson and his cohorts first appeared as a series on the critically acclaimed, but short-lived *Tracy Ullman Show* in 1987.

Matt Groening created Homer as the ultimate everyman, only significantly dumber. He sits on his couch with his Duff beer, eats Krusty burgers and doughnuts, soaks in television fare such as the mindless *Krusty the Clown Show* with far too much seriousness, and is in over his head as a father, husband, and employee at—and this is delicious—the Springfield Nuclear Power Plant. What better possibilities for comedic and satirical commentary than to have half-wit Homer

responsible for preventing radiation from leaking out to the good people of Springfield, who are lucky to remain alive.

Homer is among the most recognized figures—animated or otherwise—in the world. He is paunchy and bald—save a few strings of hair on the top and side of his scalp—with bulging eyes. His fashion of choice is a white, collared shirt and sweatpants.

In the original cartoon shorts, the focus was on the relationship between an irritated Homer and a clueless, unappreciative, troublemaking Bart. Groening has confirmed that he targeted Homer as the star when it was decided to transform *The Simpsons* into a half-hour animated sit-com. It was then he turned Homer into a dumbbell. That simply had more comedic possibilities.

Homer's is a case of arrested development, which prevents him from best carrying out his familial duties. But one should not mistake his inabilities for a lack of caring for his loved ones. His occasional harebrained, money-making schemes that always fall flat smack of Ralph Kramden, but both he and his fellow *Honeymooners* slob were motivated by devotion to their families. Homer is a lousy father not because he doesn't care, but due to intellectual incapacity that prevents him from doling out advice that will allow his kids to grow. Lisa, in particular, thrives despite her father.

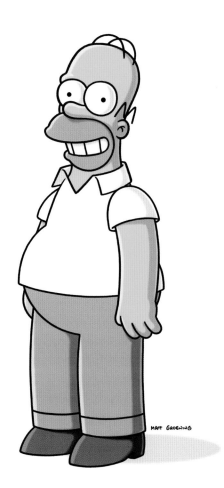

Though the focus of his character is on his relationship with family members and his own battles with emotional consistency (he can be transformed from calm to raging at any moment), his connections to those in the outside world are also noteworthy. He boasts a love-hate relationship with moralistic, religious neighbor Ned Flanders, from whom he has spitefully stolen such items as a weather vane, diploma, and air conditioner. Homer both embraces and despises Flanders, who irritates him by maintaining a consistent tolerance for him. Another is Barney Gumble, his beer-swilling buddy at favorite hangout Moe's Tavern with whom Homer feels most comfortable. Yet another is evil, power-hungry boss Mr. Burns, who often cannot even remember Homer's name.

But nobody—neither friends nor relations—can change Homer. In the parlance of the twenty-first century, he is what he is. In other words, that ship has sailed.

Why Homer Simpson Is No. 2

Is it any wonder that the *Sunday Times* of London deemed Homer Simpson the "greatest comic creation" of [modern] time? That not only speaks of his significance in the history of animation, but his global reach as well.

Groening succeeded wildly in creating a character with negative traits that can be positively embraced, not unlike George Costanza of *Seinfeld* fame. But Homer is far more complex than one might think. There is a yin-and-yang quality to him, which adds to his depth. He is inept, yet he at times succeeds. He is lazy, yet devoted to his family. He is haphazard in his job at a nuclear power plant, yet he and his fellow townspeople survive. He is happily mindless, yet can be overcome by bouts of temper.

Homer is the central character in easily the most successful primetime cartoon ever, one that has remained a staple on Sunday nights for nearly three decades (though it was moved to Thursday nights for four seasons in the early 1990s) and spawned a highly successful full-length film in 2007. He is more responsible than any character for *The Simpsons* having won thirty-two Emmy Awards, including ten for Outstanding Animated Program.

—MG

3
SPONGEBOB SQUAREPANTS

TOON-UP FACTS

Creator: Stephen Hillenburg
Studio: United Plankton Pictures
Voice: Tom Kenny
Debut: 1999 ("Help Wanted")
Hometown: Bikini Bottom
Best buddy: Patrick
Antagonist: Plankton
Employer: The Krusty Krab
Boss: Eugene H. Krabs
Hobby: Jellyfishing
Defining role: *SpongeBob SquarePants* (1999–present)
Traits: Friendly, trusting, childlike, naïve, well-intentioned, innocent, happy

Soaking Up SpongeBob

- The show went old school in its casting of Mermaid Man and sidekick Barnacle Boy.

- They were voiced by aging actors Ernest Borgnine and Tim Conway, respectively.

- Hillenburg toiled as an animator, then creative director for *Rocko's Modern Life* before emerging with a concept for SpongeBob SquarePants that Nickelodeon accepted.

- The infantility of SpongeBob has been compared to that of man-child comedian and actor Jerry Lewis.

- Kenny is best known for voicing SpongeBob, but he served as the voice of the narrator in *The Powerpuff Girls* and Dog in *CatDog* as well. Kenny also did voice work for *Rocko's Modern Life*, which led Hillenburg to approach him about voicing SpongeBob.

- Hillenburg has stated that his concept of SpongeBob SquarePants and his friendship with Patrick was born out of his love for Laurel and Hardy shorts.

- SpongeBob was originally named Sponge Boy, but that name was already being copyrighted for a mop.

- Controversy swirled around SpongeBob in 2005 when conservative Christian groups claimed he was promoting homosexuality to kids. They stated that SpongeBob was included in a pro-gay video that was mailed to thousands of elementary school children. Though the video existed, there were no references to sexual orientation. Hillenburg was still motivated to state his view that he always considered SpongeBob to be asexual.

- Among the projects Hillenburg worked on as a student at the California Institute of the Arts was a cartoon short about a physically challenged Girl Scout with oversized hands destroying all that gets in her way.

- In 2009 SpongeBob became the first fictional character to be honored with a wax sculpture at the famed Madame Tussauds museum in New York City.

- Former president Barack Obama stated that *SpongeBob SquarePants* was his favorite TV character of all time because he watched the show with his daughters.

- Hillenburg distanced himself from his hands-on work with the show in 2004, but it went on without a hitch under the auspices of his production company, United Plankton Pictures.

- The *SpongeBob SquarePants* theme song not only cites that he lives in a pineapple under the sea, but states that "absorbent and yellow and porous is he."

- The humor in *SpongeBob SquarePants* quickly gained comparisons with *Ren & Stimpy* upon its release because of its popularity with college students and other young adults.

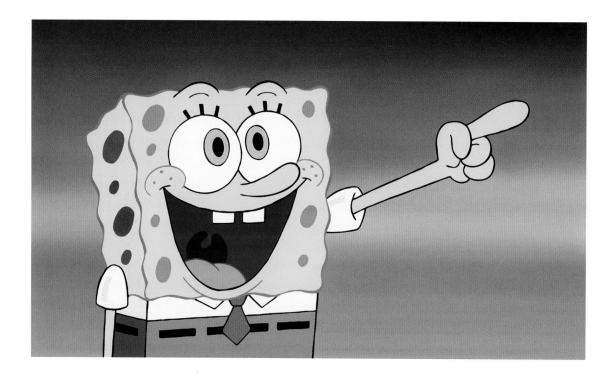

About SpongeBob SquarePants

If not for the love of one Oklahoman native for sea life, there would be no SpongeBob SquarePants. That Okie is Hillenburg, who spent much of his youth watching documentaries featuring French oceanographer Jacques Cousteau. Hillenburg also enjoyed snorkeling, so it was no wonder that he decided to study marine life in college.

So where does SpongeBob come in? Patience.

Hillenburg spent his post-graduate years teaching marine biology. But another passion from his youth motivated him to enroll at the California Institute of the Arts, from which he earned his master's. He then landed his first gig with Nickelodeon as an animator on *Rocko's Modern Life* alongside show creator Joe Murray. But Hillenburg yearned to combine his two loves. He recalled the interest his students developed in such sea creatures as crabs and starfish. He conceived of a sweet, childlike animated character that lived in the sea. Nickelodeon embraced the concept and SpongeBob was born.

SpongeBob SquarePants is a yellow, hairless sponge with tiny, thin arms and legs, big, blue eyes, a perpetual smile, and two slightly separated upper teeth. He boasts a vivacious personality, trusting nature, and strong sense of responsibility, particularly in regard to his job as a fry cook at the Krusty Krab, a greasy spoon in his hometown of Bikini Bottom in an underwater world. He maintains his innocence, happiness, and zest for life despite the obstacles thrown in his way by others, including the numbing stupidity and carelessness of starfish friend Patrick, the pressure from greedy crustacean boss Eugene Krabs, the depressing pessimism of Squidward, and the jealousies of Plankton as he seeks to use SpongeBob to destroy the Krusty Krab.

The show was a hit from the start as Saturday morning fare in 1999 and on weeknights two years later. The humor attracted both kids and adults, including many celebrities. It came as little surprise when *SpongeBob SquarePants* won the 2002 Television Critics Association award for Best Children's Program and was nominated for Emmy Awards for Outstanding Animated Program in each of the next two years. It also came as no surprise when *The SpongeBob SquarePants Movie* hit it big in 2004.

The television show has a long way to go to match *The Simpsons* in terms of longevity, but new episodes were still being created in 2016, strengthening a legacy that will last for generations.

Why SpongeBob SquarePants Is No. 3

A sponge that lives in a pineapple under the sea? Come on—what's not to like. Granted, some folks consider him annoying. But most believe he is the cutest and funniest cartoon character of the new millennium. He is certainly the most successful.

SpongeBob is downright lovable. And he boasts a joy for living that cannot be diminished by any event or any of his dysfunctional fellow citizens of Bikini Bottom. His unshakeable optimism and determination cannot be broken by failure. Just ask Mrs. Puff, his flustered driving instructor.

He is the title character on a show that does not try to make a social or political statement. He is a funny sponge on a funny show. As the theme song points out, the show is for those who crave nautical nonsense. SpongeBob is the star of that show. And that is more than enough.

—MG

4
DAFFY DUCK

TOON-UP FACTS

Creators: Tex Avery and Bob Clampett
Studio: Leon Schlesinger Productions (later Warner Bros. Cartoons)
Voice: Mel Blanc
Debut: 1937 (*Porky's Duck Hunt*)
Antagonists: Bugs Bunny, Elmer Fudd
Catchphrases: "Woo-Hoo!" . . . "You're dethpicable!"
Defining role: Theatrical shorts
Top TV venue: *The Bugs Bunny Show* (1960–1975)
Traits: Frenetic, vengeful, jealous, frustrated, devious

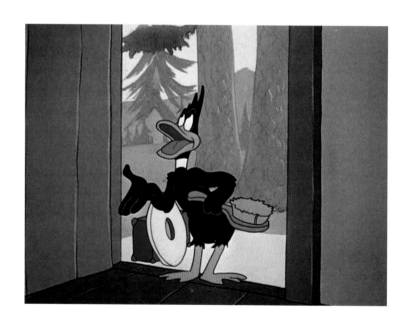

Duck Droppings

- Daffy debuted a year before co-star Bugs Bunny in the almost identically titled short *Porky's Hare Hunt*.

- The pronounced lisp came courtesy of the brilliant Blanc.

- Daffy claimed himself to be a mere ten pounds in the short *Muscle Tussle* (1953).

- The duck played second fiddle to Bugs again—actually fourth fiddle behind Sylvester and Tweety as well—when he followed those characters onto a US Postal Service stamp in 1999. But he received the honor of April 16 being proclaimed Daffy Duck Day in Hollywood.

- In the supremely creative black-and-white short titled *You Ought to Be in Pictures* (1940), which uses live-action film and features Leon Schlesinger Productions staff members (including Schlesinger himself), a framed drawing of Daffy comes alive and claims to a just-drawn-and-suddenly-animated Porky Pig that starring in features is preferable to being in cartoons and that a leading man for Bette Davis can make "three grand a week."

- He is not known as Daffy Duck until his second short, titled *Daffy Duck and Egghead* (1938). He does not appear in *Porky's Duck Hunt* until more than halfway through the short and is unnamed. Egghead eventually evolved into Elmer Fudd.

- Daffy does not exactly yearn to join the battle in *Drafter Daffy* (1945). He displays striking cowardice by working feverishly to avoid a bespectacled little man from the draft board. At one point he launches himself in a rocket reserved "in case of induction only" that crashes him through the Earth's surface straight to hell, but still can't shake the draft board rep determined to sign him up.

- In a rare pairing with Foghorn Leghorn titled *The High and the Flighty* (1956), Daffy toils as an unscrupulous salesman. He plays off the rivalry between Foghorn and a barnyard dog by selling both an elaborate series of practical jokes they use on each other. The final joke is on Daffy, however, when the two finally wise up. He winds up stuffed into a tiny bottle, the victim of his own novelty device.

About Daffy Duck

Warner Bros. was seeking more stars to align alongside Porky Pig in the late 1930s. They came up with a personality in Daffy unlike any that had been previously produced. His frenetic, frantic energy that bounces him all over the screen proved new, exciting, and hilarious to audiences, which quickly embraced him. After first appearing as Daffy Duck alongside Egghead, he was dropped as a featured character by Avery in favor of his bald tormentor. But Avery soon realized the error of his ways and promoted Daffy as a star. By the mid-1940s he had become the studio's second-biggest draw to archrival Bugs—a fact that Warner Bros. writers took full advantage of in various shorts in which Daffy displayed his blinding jealousy.

Such was certainly the scenario in the memorable *Show Biz Bugs* (1957), in which Daffy receives second billing to Bugs in a talent show in front of an audience that expresses great appreciation for the latter and none for the former. Bugs receives tremendous applause for a short and lackadaisical effort, then crickets can be heard after Daffy embarks on a tap dance performance

that makes Fred Astaire look like an amateur. Daffy grows increasingly frustrated by the minute, sabotaging the acts of his hated rivalry to no avail. The crazed craving to extract a positive reaction from the audience motivates Daffy to blow himself up. That finally earns him the applause for which he so desperately yearns.

Daffy starred in dozens of memorable shorts, including the incomparable *Duck Amuck* (1953) in which he is at the mercy of the animator. In this brilliant effort, Daffy and the scenery continue to change, much to his bewilderment and irritation as he demands an explanation from the animator. He is eventually placed in a plane, but the animator draws a mountain into which Daffy crashes. He begins falling softly to Earth, only to have the animator replace his parachute with a huge anvil. After Daffy slams to the ground, he asks in no uncertain terms for the responsible party to show himself. The animator does just that—and it turns out to be none other than Bugs Bunny, who completes the short by eyeing the audience and stating, "Ain't I a stinker?"

Daffy's penchant for bouncing crazily and easily from one spot to the next allowed animators to maximize their spatial creativity and place Daffy in most unusual settings and circumstances. By the time Warner Bros. had jumped on the growing fascination with outer space in 1953 with *Duck Dodgers of the 24 1/2th Century* (1953), Daffy had established himself as one of the most legendary cartoon characters in history.

Why Daffy Duck Is No. 4

Daffy was simply one of the most entertaining and downright zany cartoon characters of all time. He also represented a breakthrough as the first animated character to boast the capacity to bounce crazily around the screen, which in turn provided animators with greater ammunition and versatility in performing their craft and entertaining audiences.

His ability to play off Bugs Bunny as a jealous antagonist strengthened his appeal. Their rivalry, for which Daffy hopelessly and hilariously played second fiddle, peaked in *Rabbit Fire* (1951) as the two seek to convince Elmer Fudd that the other was in-season for hunters. As Bugs and Daffy trade pronouncements ("Rabbit season!" . . . "Duck season!" . . . "Rabbit season!" . . . "Duck season!"), the latter is consistently outsmarted with unfortunate results. Daffy and Bugs played off each other brilliantly, giving both greater depth and humor.

Bugs has earned his place as the greatest cartoon character ever, but Daffy was arguably more versatile. He could be placed more easily in different roles, such as a slick-talking salesman or space explorer. The daffiness that earned his moniker made Daffy Duck one of the most funny and endearing characters ever to appear on the large or small screen.

—MG

5
STEWIE GRIFFIN

TOON-UP FACTS

Creator: Seth MacFarlane
Studio: Fuzzy Door Productions
Voice: Seth MacFarlane
Debut: 1999 ("Death Has a Shadow")
Age: One
Father: Peter
Mother: Lois
Sister: Meg
Brother: Chris
Dog: Brian
Hometown: Quahog, Rhode Island
Address: 31 Spooner Street
Security blankets: Teddy bear Rupert, laser gun
Defining role: *Family Guy* (1999–2003, 2005–2016)
Traits: Homicidal, erudite, insecure, snobbish, flamboyant, plotting, megalomaniacal, violent, bitter, brilliant

Fodder of the Baby

- Nonsensically, his middle name is Gilligan. The personalities and motivations of Stewie Griffin and the harmless (unless one is trying to be rescued), goofy title character from *Gilligan's Island* cannot be less of a match.

- Stewie reached his first birthday in the Season 1 episode "Chitty Chitty Death Bang" and his age was never updated. He has, however, been seen attending preschool.

- One of many oddities regarding Stewie is that he speaks with a British accent despite being born into an American family.

- The voice of Stewie is based on that of British actor Rex Harrison as he spoke in the legendary musical *My Fair Lady*. MacFarlane practiced his Harrison impression in college, then put it to good use.

- Stewie was praised by none other than *Psychology Today* for the method in which he spoke with a suicidal Brian in a stunningly dark episode titled "Brian & Stewie" (2010). The magazine gave kudos to Stewie in an online article for asking Brian open-ended questions in a nonjudgmental manner and expressing his love and caring for the dog.

- MacFarlane spoke at one point about the perception of some that Stewie is gay because he is sophisticated and speaks with a British accent. The show creator finally outed Stewie in an interview with *Playboy* in 2009. He stated that he sought to keep the character's sexual identity vague, but that he would either be "gay or a very unhappy repressed homosexual."

- Stewie appeared prophetic in the Season 7 episode titled "We Love You, Conrad" when he offered to Brian his belief that Bruce Jenner was a woman. The sex-change operation that transformed Bruce into Caitlin did not occur until about five years later.

- Among his idiosyncrasies is the inability to correctly pronounce "Cool Whip." Stewie pronounces the letter "w" to start words correctly in every other case, even when asked to pronounce the word "whip," but pronounces the name of the product "Cool Hwip," much to the annoyance of Brian, in an episode titled "Barely Legal" (2006).

- The masochistic side of Stewie was revealed in "Peter's Two Dads" (2007), when he confided to teddy bear Rupert that he enjoyed the pain he had received in a spanking from Lois. Stewie worked unsuccessfully to provoke Lois into another beating on several occasions in the episode. He even dreamt of being tortured by a dominatrix version of his mom.

- The unusual, rectangular football shape of Stewie's head forced him to dig a hole so he could sleep sideways outdoors during an episode titled "Extra Large Medium" (2010). The scene was praised as showing an awareness of the difficulties those with disabilities face on a daily basis and how there can be ingenious solutions to their problems.

About Stewie Griffin

MacFarlane originally created Stewie as just another baby, with the idea that he would be an unimportant side character in *Family Guy*. But he later decided to provide him with a unique look and personality that would allow his character to shine through. The millions of fans of Stewie and the show in which he stars are thankful that MacFarlane gave it some more thought.

Stewie is arguably the most unusual cartoon character to ever appear on the small screen. A baby that plots to murder his mother? Who can pull weapons out of hammerspace? Who speaks like an adult sophisticate? Who is both homicidal and masochistic? Who is a master of physics? This is not your parents' cartoon character anymore. Stewie might have tested the censors more than any other *Family Guy* character—and that's saying something.

The youngest Griffin does not look unlike a baby aside from his horizontally shaped, all-but-bald head that is as wide as the rest of his body. He wears red pants with suspenders over a yellow shirt. His eyes have both lower and upper lids that cannot hide evil intent.

Stewie is bent on power and control, particularly in earlier episodes, when he regularly dreamed of killing his mother. His madness is supplemented by a genius that allows him to reach his malevolent goals. He also acts violently, for instance punching out Brian to a bloody pulp in scenes that could be described as comical only to the most twisted of viewers.

The character has evolved over the years, growing mentally and emotionally. He began to care more about his family, particularly Brian.

The other Griffin family members are unusual in their own ways, but Stewie is out of this world in his departure from all that a baby is supposed to be—gentle, innocent, and dependent. Though Stewie craves the attention and physical love of his mother, he is otherwise independent. He is also quite the opposite of gentle and innocent.

Stewie is arguably the character most responsible for the longevity and legacy of *Family Guy*, which remains a television staple nearly two decades after its launch.

Why Stewie Griffin Is No. 5

The creativity and boldness alone that it took to formulate the personality and motivations of Stewie Griffin make him an exceptional character. MacFarlane could have taken the easy way and made this baby just a baby. But he created a monster.

Granted, Stewie is one disturbing and disturbed monster. He is not every viewer's cup of tea, and the violence can be over the top. But to many who can turn off their sensibilities, he is one hilarious toddler with a depth unlike any other baby.

—MG

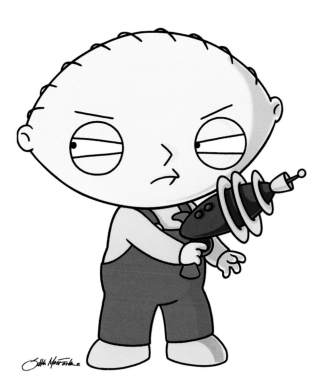

6
SNOOPY

Creator: Charles M. Schulz
Studio: Bill Melendez Productions
Voices: Bill Melendez, Robert Towers (*You're a Good Man, Charlie Brown*) and Cameron Clarke (*Snoopy: The Musical!*)
Animated debut: 1959 (The Ford Show starring Tennessee Ernie Ford)
Print debut: October 4, 1950 (*Peanuts*)
Owner: "The Round-headed Kid" (Charlie Brown)
Antagonists: "The Red Baron," "The Stupid Cat Next Door" (neither is seen on screen)
Main love interest: Fifi
AKA: The Flying Ace, Joe Cool, The Easter Beagle, The April Fool, Joe Motocross, Flashbeagle, and over one hundred other aliases and identities
Sidekick: Woodstock
Birthplace: The Daisy Hill Puppy Farm
Siblings: Andy, Marbles, Spike, Olaf, Molly, Rover, and Belle
Prized possession: His dog dish
Defining role: *It's the Great Pumpkin, Charlie Brown* (1966)
Traits: Imaginative, athletic, creative, comical, and confident

Beagle Bites

- Snoopy was based on *Peanuts* creator Charles M. Schulz's childhood pet beagle Spike. A sketch of Spike as drawn by a young Schulz appeared in the newspaper feature *Ripley's Believe It or Not!*

- Snoopy's unique laugh and sound were voiced by producer and animator Bill Melendez.

- In 1969 NASA's Apollo mission's lunar module was christened Snoopy. Snoopy has had a long relationship with NASA. One of the highest honors NASA bestows is the Silver Snoopy for Space Flight Awareness.

- Snoopy sleeps on the roof of his doghouse despite it having a spacious interior housing a recreation room, his Van Gogh, and much more. The interior of the house is only seen once—in the animated special *It's Magic, Charlie Brown*.

- When in character as "The Flying Ace," Snoopy's doghouse is referred to as "The *Sopwith Camel*," a reference to the British biplanes introduced in 1917.
- Snoopy is the star player on Charlie Brown's baseball team. He plays shortstop.
- In the holiday special, *A Charlie Brown Christmas*, Snoopy's iconic red doghouse is blue!
- Though Snoopy speaks in an odd series of grunts and guffaws, we only hear him speak/sing in a "human" voice in two specials: *You're a Good Man, Charlie Brown* and *Snoopy: The Musical!*
- In 2016 the Snoopy Museum opened in Tokyo, making Snoopy one of only a handful of characters with an entire museum dedicated in his honor.
- Snoopy and Woodstock are the only two characters whose voices are not supplied by a child actor.

About Snoopy

He's the world's most famous beagle, but the beloved pet of Charlie Brown is so much more than just an average ordinary dog. As an anthropomorphic character, Snoopy possesses many of the traits of his human counterparts. He leads an active and cultured lifestyle. He participates in sports and is also a skilled writer, cook, artist, puppeteer, tennis player, pilot . . . the list goes on and on.

Snoopy is a generally happy-go-lucky character with few worries beyond an empty dinner dish. Though he is acknowledged as Charlie Brown's dog by the neighborhood children, they also interact with Snoopy's fantastical anthropomorphic characterizations. Whether he is the World War I flying ace trapped behind enemy lines or a world famous ice skater, his Walter Mitty–like

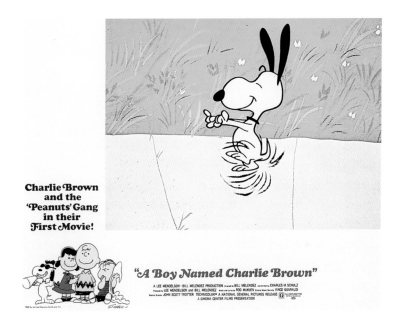

imaginings become reality. One character, Peppermint Patty, seems unaware that he is a dog, viewing him instead as a "big-nosed kid." Snoopy is a boundless and unbridled bundle of energy and imagination.

The character's translation from the printed page of newspaper funnies to animation is a testament to the strength of the character. In making the choice to deny Snoopy a human voice through much of the animated series and specials, the animators were forced to explore and create new elements of the character's persona. Finding the physical design of the other characters to have limited animation possibilities, they found Snoopy was the most pliable, with the widest range of motion and abilities. In that range of motion, Snoopy became a master of pantomime able to interact with objects in the tradition of silent film stars. His battle with a folding chair in *A Charlie Brown Thanksgiving* is a prime example as the simple act of unfolding a chair escalates into a wrestling match.

Snoopy's adventures allowed the animators to break out of the "real world" rules imposed by the human characters. He can don costumes, transform into a helicopter, impersonate other animals, and more. He is limited only by his imagination and his imagination has no limit.

Snoopy also changes the very tone of a scene with his lighthearted personality. As the *Peanuts* characters such as Charlie Brown deal with the weight of the world, Snoopy literally glides past without a care in the world, lifting our spirits.

Through the annual specials and more recent big-screen adaptations, Snoopy continues to bring joy to his countless fans worldwide.

Why Snoopy Is No. 6

Snoopy is recognized in more parts of the world than the Mona Lisa. The character has appeared in film, television, comic strips, comic books, video games, museums, and even stage musicals. It is Snoopy's role in the "Charlie Brown" holiday specials that secures his place in the TV animated Top 10. In the United States the beloved character is welcomed into our households every Halloween, Thanksgiving, and Christmas in an annual tradition as much a part of the holiday as pumpkins, turkeys, and mistletoe.

While Charlie Brown is the central character, it is Snoopy that provides the much-appreciated comic relief. He is the balance to the shows' sometimes heavy pathos.

In the world of *Peanuts,* Charlie Brown is who we all are, but Snoopy is who we wish to be!

—JW

7
BULLWINKLE

TOON-UP FACTS

Creators: Jay Ward, Bill Scott (writer)
Studio: Jay Ward Productions
Voice: Bill Scott
Debut: 1959 (*Rocky and His Friends*)
Sidekick: Rocket J. Squirrel
Catchphrase: "Hey, Rocky, watch me pull a rabbit outta my hat."
Antagonists: Boris Badenov and Natasha Fatale
Hometown: Frostbite Falls, Minnesota
Defining role: *Rocky and His Friends* (1959–1961); The Bullwinkle Show (1961–1964)
Traits: Scatterbrained, dimwitted, good-natured, oblivious, self-deprecating

Moosilliness: Bullwinkle Banter

Rocky: Well, they don't call him Wrongway Peachfuzz for nothing.
Bullwinkle: You mean they gotta pay?

Rocky: Do you know what an A-bomb is?
Bullwinkle: Certainly. A bomb is what some people call our show.

Bullwinkle: Humble, that's me . . . Mr. Modesty. When it comes to humility, I'm the greatest.

Rocky: Hey, Bullwinkle, we're in real trouble now!
Bullwinkle: Oh good, Rocky! I hate that artificial kind!

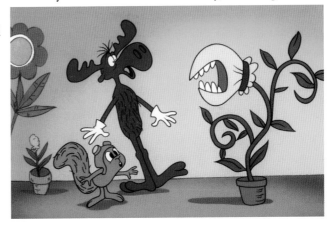

Rocky: Bullwinkle, I'm worried.
Bullwinkle: Ratings down in the show again?
Rocky: No.
Bullwinkle: That's odd.

Rocky: I'm worried because there have already been two attempts on your life.
Bullwinkle: Oh, don't worry. We will be renewed.
Rocky: I'm not talking about *The Bullwinkle Show*.
Bullwinkle: You had better; we could use the publicity.

Rocky: Bullwinkle, it says here that for you to inherit the fortune, you have to spend the weekend in the ancestral home, Abominable Manor.
Bullwinkle: That's no problem. I've been living in an abominable manner all my life."

Bullwinkle [pointing to Florida on a map]: Here it is: Frostbite Falls, Minnesota.
Rocky: Bullwinkle, that's Florida!
Bullwinkle: Well, if they keep adding new states all the time how can you expect me to keep up?

About Bullwinkle

What began in Mom's garage (not *Bullwinkle*'s mom) blossomed into what many believe is the downright funniest character in the history of made-for-television animation.

It all started in the earliest days of the newfangled medium, before college buddies Jay Ward and Alex Anderson constructed a makeshift studio in the latter's mother's garage in Berkeley, California. Anderson boasted some experience working briefly with his uncle, Paul Terry, owner of Terrytown Studios. Ward, however, was merely an interested novice.

The two launched Television Arts Productions and proposed three cartoon ideas to NBC: Crusader Rabbit, Dudley Do-Right, and private eye Hamhock Jones. Only the former was accepted (though Dudley later emerged as a star). Crusader Rabbit premiered in 1950, but legal issues forced Ward and Anderson to sell their company while maintaining control of other characters they had been developing.

Among their projects was *The Frostbite Falls Review*, which featured among many animated animals Rocky the Flying Squirrel and a French-Canadian moose named Bullwinkle (taken from local Chevy dealer Clarence Bullwinkel, whose name Ward perceived as humorous). Though Anderson left the business to pursue a career in advertising, Ward eventually returned to animation, teaming up with successful storyman Bill Scott, who had thrived at Warner Bros. and United Productions of America (UPA). They soon launched *Rocky and His Friends*, with Scott unexpectedly landing the voice of Bullwinkle. The side characters—particularly Russian spies Boris Badenov and Natasha Fatale—were hilarious, "straight man" Rocky was lovable, and the program also featured clever segments such as Peabody's Improbable History and Fractured Fairy Tales. However, it became obvious from the start that Bullwinkle was the shining star of the show, which debuted on ABC in November 1959.

Bullwinkle was a tall, two-legged, good-natured brown moose with antlers. He spent virtually all his time with inseparable and loyal friend Rocky. Though they most often roamed the confines of Frostbite Falls, they were also world travelers as they toiled as do-gooders to foil evil plots hatched by the scheming Mr. Big. He relayed his directives to Fearless Leader, the boss of Boris and Natasha, who carried out the dirty work. Bullwinkle was scatterbrained and ignorant (despite

having attended Wossamotta U.). He was also lucky as he escaped death time and again through remarkable fortune. He occasionally became angry, but never physically threatened others—not even the Russian spies. Bullwinkle boasted a silly sense of humor that served to denigrate himself and even, hilariously and surrealistically, the show in which he starred.

Bullwinkle was not limited to his adventures with Rocky. He was also an inept magician ("Hey Rocky, watch me pull a rabbit outta my hat . . . no doubt about it, I gotta get another hat"), poetry reader ("Bullwinkle's Corner") and failed do-it-yourselfer ("Mr. Know-It-All"). Storylines with which Bullwinkle was involved lasted many installments. Among these was one that began in the first episode of *Rocky and His Friends* in which the pair accidentally stumble upon the power of "mooseberries" through a rocket fuel in Grandma Moose's cake recipe. It is powerful enough to send a stove to the moon. The government urges Bullwinkle to duplicate the formula, but he is met with great resistance from Boris and Natasha. The evil pair receive help from moon men Gidney and Cloyd, who are motivated by a desire to prevent tourism on the moon.

Many other clever storylines followed. It was those storylines that brought critical acclaim in an era in which the labor-intensive art of animation was suffering greatly due to the prolific amount of production deemed necessary in the television era.

Several factors brought change. One was the popularity of Bullwinkle, whose personality was quickly embraced by millions. In one of many publicity stunts Ward cooked up to promote the primetime show, he invited just five hundred people to hear the "Bullwinkle Philharmonic" on Sunset Boulevard. About five thousand fans showed up. Another motivation for change was the notion of attracting adult viewers as well as kids, a difficult endeavor Ward and Scott had succeeded in achieving through the humor in the show. Yet another was the realization that prime-time cartoons could bring in high ratings, as did *The Flintstones*. The result of all those influences was that the program moved to NBC in the fall of 1961 and was shown at 7:00 p.m. under the title *The Bullwinkle Show*.

Though it lasted only through 1964, the legend of Bullwinkle grew to the point that the show remained continuously on TV in syndication through 1973. So legendary had Bullwinkle and his cohorts become that a half-live, half-animated film titled *The Adventures of Rocky and Bullwinkle* attracted such acting luminaries as Robert De Niro, Rene Russo, and Jason Alexander before hitting the theaters in 2000. The humor in the movie stayed true to the original show and proved so surprisingly funny that no less an expert than Roger Ebert gave it three stars.

Why Bullwinkle Is No. 7

One need not delve deeply into the psyche or motivation of Bullwinkle to grasp his greatness as a cartoon character. There is no complexity here, just one hugely entertaining and funny moose. His personality and humor spawned tremendous popularity and a cult following that has remained strong to this day.

Full-length movies more than a half-century after a character's animation creation are not produced for just any ordinary moose. Bullwinkle was the undisputed standout in a cartoon peppered with standouts, not only in his segments, but beyond in Dudley Do-Right, Snidely Whiplash, and Mr. Peabody.

—MG

8
ERIC CARTMAN

TOON-UP FACTS

Creators: Trey Parker, Matt Stone
Voice: Trey Parker
Debut: 1997 ("Cartman Gets an Anal Probe")
Hometown: South Park, Colorado
Address: 21208 E. Bonanza Circle School: South Park Elementary
Grade: Fourth
Catchphrases: "Screw you guys . . . I'm going home." . . . "Respect My Authoritah!"
Aliases: The Coon, Time Child, Bad Irene, The Rad Russian
Friends: None, really
Antagonists: Stan Marsh, Kyle Broflovski, Kenny McCormick
Hatreds: Foreigners, hippies, Jews, gays, redheads, Justin Bieber, anyone who gets in his way
Defining role: *South Park* (1997–present)
Traits: Hateful, angry, scheming, racist, resourceful, vengeful

Most Heinous Cartman Acts

- Dresses up like a teenage girl, appears on *The Maury Povich Show*, and competes for attention with another fat, slutty teen. Cartman claims he has slaughtered five baby seals with his own hands and that he is currently in twelve gangs that commit only hate crimes.

- Creates a school presentation in an attempt to foster hatred toward redheads. He offers to his classmates that those he refers to as gingers "creep us out and make us feel sick to our stomachs." He adds that "ginger kids have no souls" and that "this disease is called 'gingervitis.'"

- Poops on his teacher's desk to earn a detention and avoid an after-school fight with Wendy, whom, he confesses to himself, will "kick my ass."

- Convinces the wife of the doctor, who was trying to help the boy as the leader of his anger management group, to commit suicide through a series of text messages.

- Accidentally bashes in Kenny's skull with a frying pan while trying to kill a bug on the boy's face.

- Kidnaps sixty-three hippies and traps them in his basement.

- Sneaks into Kyle's room, draws HIV-contaminated blood from himself and squirts it into his mouth as an act of revenge for laughing at him.
- Creates a meth lab in his backyard to frame his mother and allow him to live in a foster home after learning that his family is the second-poorest in South Park.
- Kidnaps fellow student Billy Turner, poisoning his milk, handcuffing him to a flagpole, and forcing him to cut off his own leg to procure the antidote.
- Hijacks a race car and runs over several spectators and pit crew members, killing eleven.
- Gives crack cocaine to babies diagnosed with fetal cocaine syndrome, then videotapes them playing with the bag of crack and places it on the Internet.
- Pretends he has Asperger's syndrome and autism by placing hamburgers in his butt. Begins selling said hamburgers.
- Seeks revenge on Scott through a series of acts and achieves his ultimate goal by chopping up Scott's mother with a hacksaw and cooking her body parts into Scott's chili. The horrified boy realizes she's dead when he pulls her finger out of his food.

About Eric Cartman

The character of Cartman is based on Archie Bunker, the intolerant, bigoted lead character from medium-altering 1970s sitcom *All in the Family*. Parker described a conversation with *South Park* co-creator Matt Stone in the 1990s during which they conceded that the Bunker character could not be accepted in the current era of political correctness, but would be tolerated as an eight-year-old. The result was the creation of Eric Cartman. George Costanza, the lying, cheating

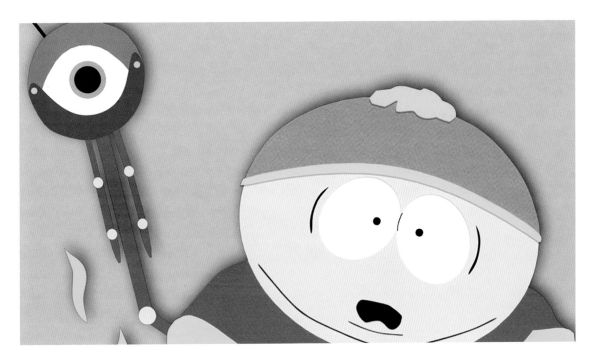

loser on tremendously successful 1990s sitcom *Seinfeld*, proved that a fictional character must not necessarily be likeable to be loved. Cartman takes that premise to the next level. He is an insensitive, conniving, hateful, immature (even for a kid) bigot whose extremism makes Archie Bunker look tolerant and is only made acceptable by the wonders of animation, which allows for exaggeration in personality and action.

The rotund eight-year-old somehow maintains strained friendships—if one can call them that—with fellow South Park Elementary School students Stan, Kyle, and Kenny. His home life is unsatisfying, partly because he has no father figure; his family is one of the poorest in South Park and his mother Laine has been described as a "dirty slut." One wonders, though, if even an ideal home life would change the ultimately self-centered Cartman, who never appears satisfied at anything unless he is bringing misery to others.

Not that Cartman only dishes it out. He is ultrasensitive, particularly about his weight (ninety pounds), and is teased unmercifully by others. But his overreactions in plotting and carrying out revenge against those he perceives as having wronged him create the most outrageous and humorous moments in the episodes focusing on him. The villainous Cartman is a completely unsympathetic character.

Why Eric Cartman Is No. 8

Bottom line: Eric Cartman is funny as hell. Granted, viewers must strip themselves of every instinct toward morality to fully appreciate the humor from such a racist, homophobic, insensitive bastard of a child, but once that is achieved, one can feel free to laugh at his outrageousness.

The preposterous plotlines and other funny, notable personalities in *South Park* preclude any notion that the show would lack humor without Cartman. But he is easily its most outlandish, laughable character. He is unbound by scruples or any sense of decency.

Indeed, his seemingly boundless wickedness and willingness to act out in the most heinous and vengeful way make Cartman one of the most outrageous and humorous character in the history of animation.

—MG

9
DONALD DUCK

TOON-UP FACTS

Creator: Walt Disney
Studio: Walt Disney Studios
Voices: Clarence "Ducky" Nash, Tony Anselmo
Screen debut: *The Wise Little Hen* (June 9, 1934)
Television debut: *Disneyland: The Donald Duck Story* (1954)
Catchphrase: "Aw, phooey!"
Middle name: Fauntleroy
Love interest: Daisy Duck
Best friends: Mickey Mouse and Goofy
Antagonists: Chip 'n' Dale, Humphrey the Bear, Spike the Bee, Mickey Mouse, Adolf Hitler
Nephews: Huey, Dewey, and Louie
Uncle: Scrooge McDuck
Rivals: Mickey Mouse, Gladstone Gander
Hometown: Duckburg
Home: *The Miss Daisy*, Houseboat
Defining role: *Disneyland: The Donald Duck Story* (1954)
Traits: Irascible, temperamental, selfish, vindictive, sheepish and egocentric

Tales of the Duck:

- Donald Duck won an Oscar for taking on Nutzi (Nazi) Germany in the 1942 animated short *Der Fuehrer's Face*.

- In 1947 Oregon University and Walt Disney personally made a deal for Donald Duck to be the mascot of the university, making Donald the only animated TV or film character to appear as an official university mascot in the United States.

- Asteroid 12410 is named after Donald Duck. It was discovered on September 26, 1995.

- Donald's sister, Della, is an astronaut and frequently leaves her children, Huey, Dewey, and Louie in Donald's care. Much to his dismay!

- Donald is frequently jealous of Mickey's fame and success as witnessed in the opening credits of the *Mickey Mouse Club*; as the others cheer "Mickey Mouse!", Donald interjects with his own name.

- Donald need not worry about his popularity. He has starred in seven feature films, hundreds of animated shorts, and eight television series, more than any other Disney character.
- Donald Duck is also the most published comic book character of all time. Take that Mickey Mouse!
- Walt Disney referred to Donald as the Disney family's "problem child."
- In the series *DuckTales*, Donald serves in the US Navy. In "real life" Donald was formally discharged from the US Army in 1983. He was retired as Buck Sergeant Duck at a special ceremony for his fiftieth birthday in Torrance, California.
- Clarence "Ducky" Nash voiced Donald Duck for over fifty years. He then trained his replacement Tony Anselmo to take over the role.

About Donald Duck

"Who's the leader of the club that's made for you and me?" If you shouted Mickey Mouse and then interrupted yourself with the name Donald Duck, you no doubt grew up with the original *Mickey Mouse Club*. The irascible duck, who never got his due, was forever in the shadow of the beloved mouse.

Donald Duck began his career on the silver screen as a supporting character in 1934's *Wise Little Hen*, but it wouldn't be until later that year with the release of *Orphan's Benefit* that Donald would take his place alongside Mickey as one of Disney's most bankable and lovable characters. He would get his first top billing in 1937 with *Donald's Ostrich*. From that point on Donald was a star worthy of his own ego.

Donald's lovability is in direct contrast or perhaps correlation to his temperament. He is prone to hilarious incoherent outbursts of anger. His negativity, frustration, and aggressive persona were a welcome relief from good guy Mickey Mouse. Walt Disney had become frustrated himself, after Mickey had become a role model to young children. Walt bestowed on Donald all the negative attributes Mickey could no longer display including Donald's defining short temper.

In his sailor suit and hat, Donald looks the part of a happy-go-lucky ducky. In many regards he is. He has a positive outlook on life and generally begins his daily situations in a happy mood and with a smile on his bill. However it's only a matter of time before tragedy befuddles and fouls up his fowl life.

Donald begins each of his daily tasks with content resolve and determination only to have unexpected competition with antagonists slowly get under his skin. A prime example is his interaction with frequent foils Chip 'n' Dale in the 1949 animated short *Toy Tinkers*. A quiet holiday at home rapidly escalates into an all-out war over walnuts. In the end Donald's explosive temper is done in by a slightly more explosive piece of dynamite.

Donald has had frequent supporting roles on Disney television series from the *Mickey Mouse Club* to *DuckTales*, but his best moments are in the series that collect his classic animated shorts from the silver screen. It is in those shorts, unfettered by the rules of children's television, that Donald shines and gets the well-deserved top "bill."

Why Donald Duck Is No. 9

Donald is a feathered ticking time bomb just waiting to explode, and every dynamic moment he is on the screen is a joy to watch. The world heaps misery upon him, and rather than quietly plodding along or falling into lucky happenstance, he lets loose with a burst of anger and frustration that is to be envied and admired! He puts into incoherent words and actions the frustrations we have all had. Watching Donald Duck is a cathartic experience. In the unrealistic cartoon Disney universe of fairy tales, happy endings, and "whistling while you work," Donald is the lone voice of frustration shouting in the wilderness, saying "Aw, phooey!" For our list Donald finally takes a rightful spot above Mickey Mouse as one of the top toons!

—JW

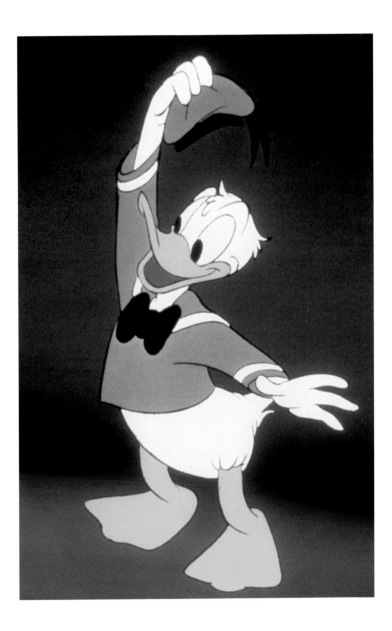

10
YOGI BEAR

TOON-UP FACTS

Creators: William Hanna, Joseph Barbera
Studio: Hanna-Barbera
Voice: Daws Butler
Debut: 1958 (*Yogi Bear's Big Break*)
Sidekick: Boo-Boo
Antagonist: Ranger Smith
Love interest: Cindy Bear
Catchphrase: "I'm smarter than the average bear!"
Defining role: *The Yogi Bear Show* (1961–1962)
Traits: Self-serving, happy, outgoing, mischievous, daring, persistent

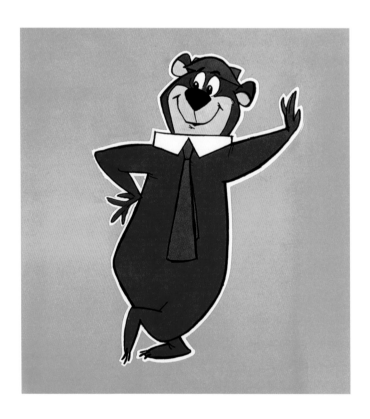

The Bear Facts

- Comparisons have been made between Yogi and the two legendary main male characters in *The Honeymooners*—Ralph and Norton. The upturned brim on his hat and his speaking patterns were mindful of the latter. But his body type and personality—particularly his scheming—had more in common with the former.

- The fame of Yogi has resulted in a chain of campground-resorts throughout the United States and Canada called Yogi Bear's Jellystone Park. They can be found in thirty states and three provinces.

- Debuted in an episode of *The Huckleberry Hound Show*. The short, titled *Yogi Bear's Big Break*, was literally Yogi Bear's big break as it launched him to stardom. It featured Yogi devising various escape plans from Jellystone Park, then learning like Dorothy that there was no place like home.

- In an era in which cartoon characters were affiliated strongly with breakfast fare, Yogi was placed on the box cover of Kellogg's OKs cereal in the early 1960s. He was shown flexing his muscles.

- Though Hanna-Barbera claims it was a coincidence, most believe he was named after New York Yankees superstar catcher Yogi Berra. Berra, who had been a baseball star for a decade by the time Yogi Bear was introduced, took legal action against the studio for defamation of character, but eventually dropped his lawsuit. Yogi looks stunningly like the Hall of Famer and one might find the similarity in names more than a fluke.

- The studio promoted Yogi and Magilla Gorilla by creating presidential campaigns for both. Huckleberry Hound served as the "campaign manager" for Yogi (and Top Cat for Magilla). The company released a record touting Yogi for president (based on the election results, many might have believed him to be a more palatable option than Barry Goldwater) that featured the slogan, "Yay! All the Way with Yogi! Yogi Bear for '64!"

- Among the most creative shorts was *A Bear Pair* (1960), in which Boo-Boo wins a trip with Yogi to Paris and the two are mistaken by the French for ambassadors. On the flight, Boo-Boo asks Yogi the location of Paris. The reply? Rhode Island. The two get the red carpet treatment in Paris until Yogi asks for ketchup to glop on his filet mignon at a fancy restaurant. The enraged chef slams the ketchup bottle over Yogi's head. Yogi threatens war on France, but he and Boo-Boo are placed on a plane and forced to parachute back to Jellystone.

About Yogi Bear

A year after establishing their own studio, William Hanna and Joe Barbera found their first superstar in Yogi Bear. He quickly bypassed Huckleberry Hound in popularity with his personality.

Yogi could never be termed dull. His distinctive appearance included a green tie and green hat upturned in the front, both of which gave him a human quality. So did the fact that he walked strictly on two legs. And so did his lifestyle, which included a nice bed for hibernation in a cave decorated like a real home. His unique sing-song speaking style—often in rhymes—added to the unique and charming characterization.

The resident of Jellystone Park and buddy of little Boo-Boo, who attempted in vain to talk him out of causing trouble for both of them, Yogi was indeed a schemer, most often to secure the contents of "pic-a-nic baskets" brought to the park by visitors. He meant no harm, but his appetite for "goodies" provided more motivation than any sense of right and wrong or fear of the consequences. Despite complaints from parental groups that his antics promoted stealing, his fame continued to skyrocket.

Yogi sometimes spread his wings outside the confines of Jellystone. In one notable short titled *Rah Rah Bear* (1959), his confusion and pride in his species motivates him to join the Bears—the Chicago Bears that is—in a gridiron battle against the New York Giants.

His popularity prompted Hanna-Barbera to launch *The Yogi Bear Show* in January 1961. The studio continued to churn out entertaining shorts, including one titled *Touch and Go-Go-Go* (1961) in which "the bear's fairy godmother" provides him the power to turn anything he touches into a picnic basket. The clearly fattened bear was at first thrilled, of course, but it got out of hand when he transformed Boo-Boo and Ranger Smith into talking picnic baskets with legs.

His relationship with "Mr. Ranger, Sir" displayed the two sides of Yogi Bear. He respected, even feared Ranger Smith and viewed him as a father figure. But his negative motivations proved too powerful to keep himself in check. Though angered and frustrated by the antics of his most famous bear, the Jellystone Park official genuinely liked Yogi and was particularly fond of Boo-Boo.

So popular was Yogi that Hanna-Barbera starred him in a full-length motion picture titled *Hey There, It's Yogi Bear* in 1964, a year after production of the TV show had ended. The more complex plot than would have been made possible in a short featured Cindy Bear seeking to make Yogi her own, but he proves far more motivated by securing picnic baskets than becoming a target of Cupid's arrow.

Yogi Bear would never be quite the same, though his shorts remained immensely popular in syndication. New efforts to promote him in specials such as *Yogi's Ark Lark* (1973), which led to *Yogi's Gang* (1973), featured the bear as just one of many Hanna-Barbera characters. Yogi became the star of many holiday specials, then returned to his roots in 1988 with *The Yogi Bear Show* in newly animated shorts. He was then voiced, however, by Greg Burson rather than the just-departed and distinctive Daws Butler.

Why Yogi Bear Is No. 10

Yogi Bear is among the first and best animated characters developed strictly for television. Though the level of animation had been lowered by the need for more prolific production, thereby weakening expressiveness in characters on the small screen, viewers embraced Yogi for his devil-may-care personality.

Arguably the most popular cartoon character ever produced by Hanna-Barbera—with apologies to Tom, Jerry, and Fred Flintstone, Yogi gained tremendous identification with viewers through his utterances ("I'm smarter than the average bear") and motivation for picnic baskets. His distinctive voice, jolly disposition, and perseverance have also attracted kids and adults alike for generations.

—MG

11
POPEYE

TOON-UP FACTS

Creators: Elzie Segar (comic strip), Dave Fleischer (animator)
Studio: Fleischer Studios
Voices: Billy Costello (1933–1935), Jack Mercer (1935–1984)
Debut: 1933 (*Popeye the Sailor*)
Antagonist: Bluto
Love interest: Olive Oyl
Catchphrases: "Well blow me down!" . . . "I'm strong to the finish, 'cause I eats me spinach, I'm Popeye the Sailor Man!"
Defining role: Theatrical shorts
Top TV venue: *Popeye the Sailor* (1960–1962)
Traits: Gruff, pugnacious, scrappy, chivalrous, moralistic

The Poop on Popeye

- Popeye had already been established as a fictional sailor in a classic comic strip titled *Thimble Theatre* four years before Max Fleischer negotiated with King Features Syndicate to bring him to life.

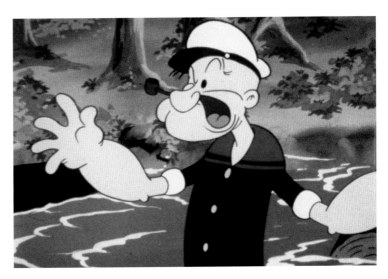

- He ate his spinach raw, right out of the can. He needed the provided power with no time to spare.

- Thimble Theatre was launched in 1919, but Popeye did not appear until ten years later.

- Popeye boasts an anchor tattoo on both forearms.

- His forthcoming screen debut was announced to movie audiences by his singing the "Popeye the Sailor Man" theme and showing his strength by punching a large fish mounted on a plaque so hard that it split into a cascade of miniature sardine cans.

- Original voice William Costello, who had been known as Red Pepper Sam in vaudeville, was fired after a short period because (according to early Olive Oyl voice Mae Questel) he got a big head.

- Longtime Popeye voice Jack Mercer was hired on the spot after Dave Fleischer heard his voice as Mercer purchased a newspaper.

- Popeye friend J. Wellington Wimpy was prominent in the comic strip, but a minor character on screen. He did, however, utter one of the cartoon's most legendary lines: "I'll gladly pay you Tuesday for a hamburger today."

- Wimpy restaurants never flourished in the United States, but became highly popular in Europe and South Africa, where in 2011 there were more than five hundred locations.

About Popeye

Max Fleischer was not blindly predicting success when he launched Popeye onto the silver screen. The super sailor had already become a comic strip hit. But Fleischer likely could not have predicted that Popeye would blossom into one of the greatest animated characters in history.

It all began with the simply titled *Popeye the Sailor* in 1933, which featured a brief appearance by the legendary Betty Boop as a hula dancer. His first official cartoon, released two months later, was *I Yam What I Yam* (1933). Soon the pattern was established. Popeye, often motivated by chivalry and an infatuation with Olive Oyl, would find himself in a fine fix perpetrated by burly villain and ultimate masher Bluto. Popeye would appear doomed before somehow extracting spinach from a can into his mouth, then gain the superhuman strength to power his way to freedom, destroy his enemy, and save his girl.

Mercer brought depth and humor to the character when he took over as the voice of Popeye in 1935. Most memorable and engaging were the under-his-breath mutterings of the sailor as he worked his way in and out of jams. But the fledgling character had already reached stardom as a featured attraction for Paramount Pictures that had begun to rival Mickey Mouse before the arrival of Mercer.

Among the early successes was *A Dream Walking* (1934), during which Popeye and Bluto seek to be the hero that saves a sleepwalking Olive Oyl through a dizzying urban journey that includes houses, telephone pole wires, skyscraper construction beams, and flagpoles (night watchman Wimpy is of no help as Olive Oyl walks perilously hundreds of feet in the air—he hilariously offers that Olive Oyl will awaken when she falls). The battle continues until Popeye consumes his spinach, punches Bluto into oblivion, and continues to follow the slumbering Olive Oyl back

into her home and bed. She awakens, notices Popeye in her window, calls him a "Peeping Tom" and fires at him everything she can find in her room, including his framed picture. But Popeye is content in the knowledge that he had fulfilled his chivalrous duty.

The inclusion of Bluto as a permanent foil and spinach as his power (neither were prominent in the comic strip) strengthened the Popeye character by providing consistent personal motivation and a food audiences could identify with him. His growing popularity and a desire to prevent his character from falling into a rut motivated Fleischer and Paramount Pictures to produce two technicolor reels that were promoted in theaters as featured attractions, the first titled *Popeye the Sailor Meets Sinbad the Sailor* (1936) and the second titled *Popeye Meets Ali Baba and the 40 Thieves* (1937). Both featured Bluto as the villain and proved to be hits, but the former (a seventeen-minute feature) gained greater critical acclaim. So emboldened was Paramount at the success of the films that it had Popeye proclaiming in a newspaper ad that Clark Gable and Robert Taylor were merely "amachures" compared to him in "movin' pictures."

That was not far from the truth. Popeye remained the top draw for Fleischer even after the studio weakened the detailing of the animation to produce monthly shorts. The brilliance of Mercer, who was now receiving frequent story credits, continued to result in highly entertaining releases. It's no wonder that Popeye remained popular among kids and adults for decades on television decades after the last short was produced in 1957. The motivation to re-create Popeye as a film entity in 1980 bespeaks of his legendary status.

Why Popeye Is No. 11

No cartoon figure in American history boasts a longer-lasting legacy than this pipe-tooting sailor. Popeye was the star of every show in which he appeared, despite the strength of fellow characters Bluto and Olive Oyl. Such side characters as Wimpy, Sea Hag, and nephews Peep-eye, Pip-eye, Pup-eye and Poop-eye (all of whom took turns uttering the words of every sentence and whose existences were inspired by Donald Duck nephews Huey, Dewey, and Louie) could never steal the spotlight from this star.

Popeye never strayed from the moral righteousness and (in the case of his beloved Olive Oyl, who never fully appreciated him if her repeated forgiveness of Bluto is any indication) chivalry that provided his motivation in life. The endearment he earned from the viewing public grew greatly due to Mercer, whose mumblings resulted in more humor and gave Popeye's personality greater depth.

Many of the most memorable moments in Popeye shorts and, indeed in cartoon history, were his battles with Bluto, which never got old or stale. The studio for decades continued to produce new and fresh ideas despite the continuation of the basic premise that Popeye and Bluto were fighting for the affection of Olive Oyl and that a good dose of spinach would be required for a happy ending.

With his humor, voice, and strong visual identification (pipe, anchor tattoos, sailor hat, spinach), Popeye has earned a spot high on the list of greatest cartoon characters of all time.

—MG

12
THE PINK PANTHER

TOON-UP FACTS

Creators: Friz Freleng, David DePatie, Hawley Pratt
Studios: United Artists, DePatie Freleng Enterprises
Rare utterances: Voiced by Rich Little in *Sink Pink* (1965) and *Pink Ice* (1965); Matt Frewer in *The Pink Panther* (1993–1996)
Film debut: 1963 (*The Pink Panther*)
Cartoon short debut: 1964 (*The Pink Phink*)
Antagonist: The Little Man (Big Nose)
Defining roles: *The Pink Panther Show* (1969–1970); *The New Pink Panther Show* (1971–1976)
Traits: Unflappable, erudite, confident

Thinking Pink

- Spoke one line in *Sink Pink*: "Why can't man be more like animals?" Proved a bit more talkative in *Pink Ice*. His distinct and sophisticated British accent made him sound a bit like urbane movie actors Rex Harrison and David Niven.

- Every Pink Panther short title featured the word "pink" in it. Some of the most creative included *Pickled Pink* (1965), *Pink-A-Boo* (1966), *Pink of the Litter* (1967), and *The Scarlet Pinkernel* (1975).

- Legendary Pink Panther Theme composer Henry Mancini appeared as a live-action figure alongside the famous feline at the end of *Pink, Plunk, Plink* (1966). He was shown alone in the stands applauding The Pink Panther's performance at the Hollywood Bowl.

- Though placed in such historical times as the prehistoric era in *Extinct Pink* (1969) and medieval Europe in *The Pink Piper* (1975), he generally didn't stray from the modern world.

- Producers at DePatie-Freleng decided that if The Pink Panther didn't talk, neither should anyone else in his shorts. Otherwise it would appear the star was mute.

- Became so iconic that Post created Pink Panther Flakes cereal in 1974. They were basically pink frosted flakes.

- Displayed his sophistication in some early shorts by gripping a cigarette holder between his fingertips or lips.

- Shortly after *The New Pink Panther Show* debuted in 1971, sponsor General Foods created a compilation of his shorts for a cartoon festival that was shown in theaters nationwide.
- Became a father to Pinky and Panky for the Saturday morning show *Pink Panther and Sons*, which launched in 1984 and lasted just one season. They talked—he still didn't.

About The Pink Panther

It all began when producer/director Blake Edwards decided his movie comedy *The Pink Panther* (1964), which launched a series of films, required an animated sequence and contacted his buddy DePatie. The flick, starring Peter Sellers as the bumbling inspector Clouseau, revolves around his tracking of a jewel thief, played by David Niven. The priceless gem in question is actually the "title character" and had gained its name due to a flaw in it that creates an image of a tiny pink panther.

Edwards selected a pink panther design created by Pratt among the approximately eighty drawn. The Pink Panther appears in the film inside the gem sitting on his haunches and grasping a cigarette in a holder. He scurries and slinks through the credits and the rest is history.

The overwhelmingly positive reaction to his appearance motivated United Artists to commission DePatie-Freleng to produce shorts based on the character. The result was *The Pink Phink*, which earned an Academy Award for Best Animated Short. The team went on to produce about ten more theatrical shorts per year, peaking at seventeen.

The Pink Panther was placed in a myriad of situations, not all of which matched his elegant and sophisticated identity. He plays a phony hero in *Super Pink* (1966), during which he causes a little old lady to be run over by a car, hit by a falling piano (the umbrella he holds overhead does

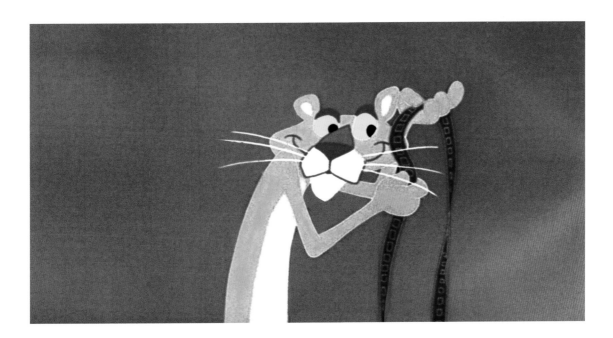

not exactly offer adequate protection), and crushed by a rock. He plays a homeless character sleeping on a park bench in the snow in *Slink Pink* (1969).

Soon—as one might expect—television came calling. *The Pink Panther Show* debuted in 1969. *The New Pink Panther Show* followed from 1971 to 1976, but the fabulous feline was not done with the silver screen. He was featured hilariously in *The Return of the Pink Panther* (1975), transforming himself into such stars of the entertainment industry as Groucho Marx and Boris Karloff during the title sequence. He upped the ante in *The Pink Panther Strikes Again* (1976) by morphing from Julie Andrews on a hilltop in a scene from *The Sound of Music*. Featured in a series of new cartoons when ABC launched *The All-New Pink Panther Show* in 1978, which lasted just one season, he continued to be embraced by new generations of fans. Meanwhile, he gained greater fame on TV specials such as *A Pink Christmas* (1978), *Pink Panther in Olym-Pinks* (1980), and the Valentine's Day special *Pink at First Sight* (1981). He returned to TV in 1984 with *Pink Panther and Sons*. He was also featured in over eighty issues of Gold Key comic books from 1971 to 1984.

Why The Pink Panther Is No. 12

One might scoff at the notion of a cartoon character that rarely uttered a word earning such a prominent spot on this list. But The Pink Panther actually gained popularity the less he spoke. His style and mannerisms spoke for themselves and made him among the most embraced and legendary characters in the history of animation.

He fit into any persona, scenario, or even transformation. He played a soldier. He played a construction worker. He played a secret agent. He played a toreador. He played a genie in a lamp. He played a lumberjack. He flew, then *became* a kite. His silence made his versatility easier to accomplish because the realism that accompanies any voice would have made it impossible to place him in such a variety of roles, including those in *The Pink Panther* film series in which he transformed into various giants of the entertainment world.

The Pink Panther was far more cool than cute and lovable, which made him one of the most marketable animated characters ever. His ability to remain unflustered in the most chaotic circumstances and emerge victorious did not diminish the intrigue of his shorts—viewers remained glued to the screen to see how he would extract himself from the various messes in which he found himself.

The Pink Panther was a superstar, not just in television shorts, but in commercials, comic books, print ads, and film. His arrival on the scene accompanied by the legendary Mancini-created theme is among the most iconic moments in entertainment.

—MG

13
SCOOBY-DOO AND SHAGGY

TOON-UP FACTS

Creators: Ken Spears, Joe Ruby, Iwao Takamoto
Studio: Hanna-Barbera
Voices: Scooby-Doo: Don Messick (1969–1994); Shaggy: Casey Kasem (1969–1997)
Debut: 1969, *Scooby-Doo, Where Are You!* (Episode: "What a Night for a Knight")
Defining role: *Scooby-Doo, Where Are You!* (1969–1970)
Friends: Fred Jones, Daphne Blake, Velma Dinkley
Scooby-Doo's breed: Great Dane
Scooby's age: Seven years old
Hometown: Coolsville
Fears: G-g-g-ghosts!
Scooby's catchphrase: "Ruh-Roh Raggy!"
Shaggy's catchphrase: "Zoinks!"
Treat of choice: Scooby Snacks
Vehicle: The Mystery Machine
Traits: Loyal, fearful, brave (with the right encouragement), resourceful, insatiable appetite

Scooby Dooby Data

- Scooby-Doo's name derived from a nonsense bit of scat by Frank Sinatra in the song "Strangers in the Night" in which he improvised the phrase, "Scoobie dooby doo. . . ."

- Casey Kasem briefly quit voicing Shaggy when he was asked to voice a Burger King commercial. Kasem, a vegan, refused. He returned to the show after Shaggy became a vegetarian as well.

- Scooby's full name is Scoobert. Shaggy's is Norville Rogers.

- Scooby-Doo is one of several animated dogs voiced by legendary voiceover artist Don Messick. A few others include: Mutley (*The Wacky Races*), Ruff (*Ruff and Reddy*), Toto (*Journey Back to Oz*), Bandit (*Jonny Quest*), Droopy (*Droopy*), Precious Pup (*The Atom Ant Show*), Spike (*The Tom and Jerry Show*), Mumbly (*The Mumbly Cartoon Show*) and Astro (*The Jetsons*).

- Scooby is one of a set of triplets. The other two are Skippy-Doo and Dooby-Doo.

- Scooby-Doo and Shaggy are the only two characters to appear in all of the show's many incarnations.

- Scooby-Doo was the first Saturday morning cartoon to feature a laugh track like most sitcoms.

- On the TV series *Buffy the Vampire Slayer*, the group of characters who battle the forces of evil are called "The Scooby Gang," named in honor of Scooby-Doo!

- Famed astronomer Carl Sagan was a fan of Scooby-Doo. He felt the show encouraged a healthy skepticism of the supernatural.

- According to a speech pathologist, Scooby's distinct "Ruh-roh!" and replacing beginning vowels with an "R" can be diagnosed as a speech disorder known as "Rhotic Replacement."

About Scooby and Shaggy

Under one of its original titles, *W-Who's S-S-Scared*, the show was initially rejected for being too scary for children. After toning down some of the scary themes, the show refocused by making the dog, named "Too Much," the star of the show. Renaming him Scooby-Doo, they paired him up with his pal Shaggy and amped up the humor taking a cue from the "Abbott and Costello Meet the Monsters" series of films. The characters' personas were largely pulled from the TV series *The Many Loves of Dobie Gillis*. Most noticeably, Shaggy strongly emulates the character of Maynard G. Krebs.

Scooby-Doo, *Where Are You!* follows the misadventures of a group of supernatural sleuths. Traveling around the country in "The Mystery Machine," the crew dispels ghost and monster myths by revealing the true often-criminal culprits literally behind the masks.

When danger arises the team quickly splits up into teams of Fred and Daphne, Scooby and Shaggy, and Velma on her own. The team-ups were the direct result of the writing teams finding it easier to write bits for the humorous tandem of Shaggy and Scoob.

While Scooby and Shaggy are frequently hesitant to split up, they can always be coaxed into bravery with a "Scooby Snack." Once they split up, the real adventure begins and the comical duo dodge and befuddle the episode's "villain." The short skits of the two interacting with the villain are the highlight of the show. Whether disguising themselves as belly dancers or Italian chefs, they provide comic relief in what is otherwise a kid-friendly horror show. Despite their bumbling Scooby and Shaggy frequently solve the case, whether inadvertently or as the result of Shaggy being used as live bait to draw out the g-g-g-ghosts!

Though it is an ensemble cast, Scooby and Shaggy shine as the true stars of the show.

Why Scooby and Shaggy Are No. 13

Through dozens of incarnations Scooby and Shaggy have survived ghosts, goblins, monsters, myths, and perhaps their greatest challenge . . . Scrappy-Doo! Their camaraderie stands as one of cartoondom's greatest friendships, and while other members of the cast have come and gone over the years, the core relationship of Scooby and Shaggy has remained steadfast. Underneath

their comical shenanigans lies a deeper truth addressing our own human weakness of fear and our ability to overcome it. Unlike many cartoon characters, they are reluctant heroes. They are heroes born of the situation and not of an innate ability and will. When faced with a terrifying situation and frightening foe, they overcome their fears and face them with humor and a weak-kneed bravery. For a show that started out "too scary" for kids, it evolved into a show teaching kids that it's okay to be afraid and that strength of character can arise from within any of us at the right moment.

The two characters remain among the most beloved in animation history, and Scooby-Doo went on to become the longest-running franchise of the bygone Saturday morning cartoon era.

Shaggy and Scooby might consider it a jinx to be placed at #13 on the list, but a couple Scooby Snacks will quickly help them overcome any hesitation and bravely stand their ground.

—JW

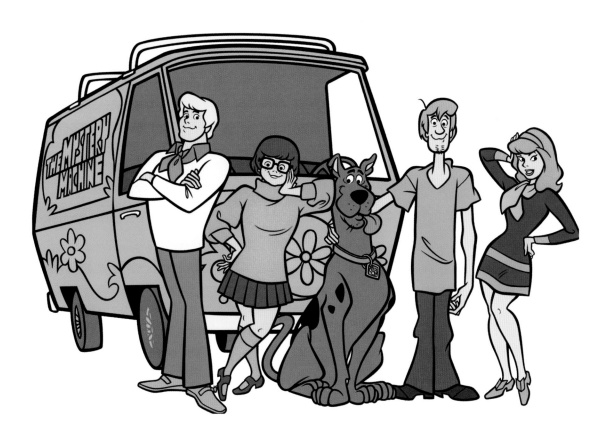

14
FRED FLINTSTONE

TOON-UP FACTS

Creators: Don Gordon, Ed Benedict, William Hanna, Joseph Barbera
Studio: Hanna-Barbera
Voice: Alan Reed
Debut: 1960 (*The Flintstone Flyer*)
Catchphrase: "Yabba-Dabba-Doo!"
Bosom buddy and lifelong pal: Barney Rubble
Wife: Wilma
Daughter: Pebbles
Pet: Dino
Favorite sports: Bowling, billiards
Employer: Rockhead and Quarry Construction Company
Boss: Mr. Slate
Defining role: *The Flintstones* (1960–1966)
Traits: Grouchy, dimwitted, scheming, loyal, loving, jealous

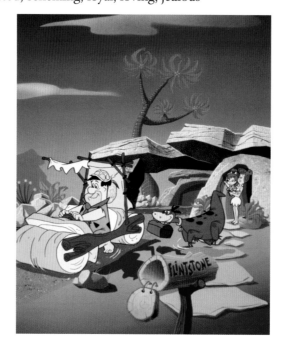

Fred Facts

- A survey of grade school students in the 1980s revealed that 30 percent could identify a photo of the current president while 90 percent could recognize Fred Flintstone.

- Cartoon voice giant Daws Butler voiced Fred in the 1959 pilot in which the family name was Flagstone. They were also nearly named the Gladstones.

- Fred and Barney could be seen puffing on Winston cigarettes in commercials during the show. Winston was among the sponsors, as were One-a-Day vitamins.

- Among the ideas considered by Hanna-Barbera for a cartoon family were pilgrims, Romans, cowboys, and Eskimos. But all were rejected.

- It has been suggested that Fred and his pals were inspired by the (Max) Fleischer Studios Stone Age Cartoons, a series of just twelve shorts produced in 1940.

- Fred and Barney used the following password to enter the Loyal Order of Water Buffaloes Lodge: "Ack Ack a Dack . . . Dack Dack a Ack." Wilma and Betty learned that before sneaking into a meeting in "Ladies Night at the Lodge" (1964).

- Among the celebrities that entertained viewers in an episode was the San Francisco–based Beau Brummels (introduced as the Beau Brummelstones on the show), who sang their 1964 hit "Laugh, Laugh" as animated characters in "Shinrock a Go-Go" (1965).

- Among the most humorous moments in the series occurred in "Divided We Sail" (1962) after Barney wins a boat on the game show *The Prize is Priced*. Barney wants to name it "Nautical Lady" while Fred yearns to call it "Queen of the Sea." So they compromise and call it "Nau-Sea," leading Betty to exclaim, "That's 'Nausea' and it's a sickening name for a boat."

- Fred finds Dino in the mountains in "The Snorkasaurus Hunt" (1961) and brings him home as a pet. It is a bit confusing both because Dino actually talks in the episode, then does odd jobs around the house. But he had already appeared in previous episodes as a pet with only dog-like qualities. And that returns to be his role thereafter.

About Fred Flintstone

The success of Hanna-Barbera in the late 1950s motivated Screen Gems to approach the pair about developing the first primetime animated series. There was one stipulation. The spotlight on animals that had become a Hanna-Barbera fixture would be removed. Screen Gems wanted it to star cartoon humans. The result was *The Flintstones*. And though it centered on the lives of two families, Fred was the star.

Not that the idea was completely original. Fred was an obvious takeoff on Ralph Kramden, the standout character on the short-lived, but brilliant 1950s sitcom *The Honeymooners*. The other Flintstones mainstays were also based not so subtly on the primary characters from that show.

Fred was overweight, but nimble. He did not exactly own an expansive wardrobe—he generally donned his usual orange leopard skin and tie. He toiled rather unhappily as a brontosaurus crane operator who despised and feared boss Mr. Slate, but spent much of his time at work and at home dreaming up get-rich-quick schemes that ultimately failed. He was quick-tempered and at

times jealous, but a loving husband to wife Wilma and father to daughter Pebbles. His recreational life revolved around bowling and, on occasion, billiards and attending baseball games.

He also found himself accidentally in alternate roles, such as a sophisticate named Frederick after taking a blow to the head, an ape after taking "Scram" pills, and a singer named Rock Roll whose inhibitions in front of an audience requires a pin-to-the-butt from Barney to get him flying onto the stage and lip-synching "The Twitch."

Fred developed distinctive relationships with Barney, Wilma, and Pebbles. His love-hate relationship with Barney generally resulted in them emerging as "bosom buddies and lifelong pals" at the end of episodes in which they quarrel and fight like enemies. Among the cleverest was "No Help Wanted" (1960), when Fred helps Barney land a job as a furniture repossesser—and his first task is to take away Fred's television set. Fred's love for his wife and daughter, who arrived with great fanfare late in Season 3, remains unquestioned. But that love often leads him to act jealously or haphazardly.

The simple relationships and humorous plot twists made *The Flintstones* a hit and Fred one of the most recognizable and beloved cartoon characters in history. But in the view of many, the show "jumped the shark" by adding alien The Great Gazoo to the cast and creating episodes such as the one in which the newcomer arranges to send Fred and his friends and family into the future. Fred was at his best when he was spatting with Barney, deceiving Wilma, and finding ways to get out of work or home obligations so he could go bowling.

The Flintstones finally ran out of steam in 1966, but syndication turned new generations on to Fred, though much of the attention landed on Pebbles and the Rubbles' Herculean son Bamm Bamm. Dozens of new Flintstones shows, specials, and films followed, including one that used live actors in which John Goodman played Fred.

Why Fred Is No. 14

Fred remains the most recognizable and beloved character from the first primetime animated series in television history, one that was nominated for an Emmy in 1961 and soared to No. 18 in the Nielsen ratings in its first season.

His distinctive personality and simple motivation, though certainly similar to that of Ralph Kramden, was not identical (after all, he never threatened to send Wilma to the moon with one punch). Fred was at his best as simply a disgruntled worker in a middle-class family with unfulfilled dreams, loyal friends, and loving family. When writers brought in outside forces to complicate his life, it weakened his appeal.

Wilma and Betty had their moments (such as when they yelled "CHARGE it!" before embarking on a shopping expedition). Barney added humor as a fine sidekick. Pebbles was cute. So was Dino. But Fred Flintstone was the funniest and most captivating character on the show named after his family.

—MG

15
PINKY AND THE BRAIN

TOON-UP FACTS

Creators: Tom Ruegger
Studio: Warner Bros. Television Animation, Amblin Entertainment
Pinky Voice: Rob Paulsen
The Brain Voice: Brian LaMarche
Debut: September 3, 1993, *Win Big (Animaniacs)*
Protagonists: Snowball the Hamster
Starring TV roles: *Animaniacs* (1993–1998); *Pinky and the Brain* (1995–1996); Pinky, Elmyra, and the Brain (1998–1999)
Place of containment: Acme Labs
Pinky's traits: Hyperactive, curious, kind, gentle, scatterbrained, childlike
Brain's traits: Intelligent, egocentric, abusive
Brain's catchphrase: "Are you pondering what I'm pondering?"
Pinky's catchphrase: "Narf!"
Goal: To take over the world
Brain's top ten plans to take over the world:

- Shrink all the world's fedoras with steam thereby trapping the wearers inside them!

- Replace Steven Spielberg's with an android.

- Become country music star Bubba Bo Bob Brain, and use subliminal messages to gain fans' loyalties.

- Broadcast an infinite loop of Rush Limbaugh singing an acapella version of *Dream Weaver*, driving the whole world insane.

- Market wooden furniture with assembly destructions ordering people to obey him.

- Make the Sunday crossword puzzle unsolvable sending the world's most intelligent people into a frenzy.

- Change the directions on the world's shampoo bottles to read "repeat endlessly," sending the world into a literal lather.

- Print "property of Brain" discreetly on the Earth and claim ownership.

- Replace the *Cosmopolitan* quiz with a "Who Is Your Perfect World Leader" quiz, with "Brain" as the only resulting answer.

- Racer X was a complex hero that portrayed the very real emotions of sibling rivalry.

About Pinky and the Brain

When *Animaniacs* debuted in 1993 it was a new concept in television animation, sharing more in common with *Saturday Night Live* than "Saturday mornings." Under the guidance of executive producer and head writer Steven Spielberg, *Animaniacs* created a slew of new characters in the style and spirit of the Warner Bros. tradition. The show was a loose and freestyle mishmash of vignettes, blackout bits, movie parodies, and original shorts all tied together by the show's host/stars, the Warner siblings: Yakko, Wakko, and Dot. Pulling inspiration from such diverse elements as *A Hard Day's Night*, the *The Marx Brothers*, and *Goodfellas*, the show appealed to adults and children, with much of the more "adult" humor soaring over children's heads.

Each episode of *Animaniacs* featured multiple rotating segments from the crotchety cartoon veteran Slappy the Squirrel to the deft *Goodfellas* parody, "The Goodfeathers." Over 100 feature and supporting characters populated *Animaniacs* satirizing everything from musicals to the show's own producer Steven Spielberg's films.

Of all the brilliant segments and characters that appeared on the show, without question the two breakout characters were Pinky and the Brain.

Pinky and the Brain are two genetically enhanced laboratory mice contained in a cage at Acme Labs. Their "intelligence" is the result of a gene splicing experiment, called the Biological Recombinant Algorithmic Intelligence Nexus (B.R.A.I.N). The show revolves around their misguided efforts at taking over the world.

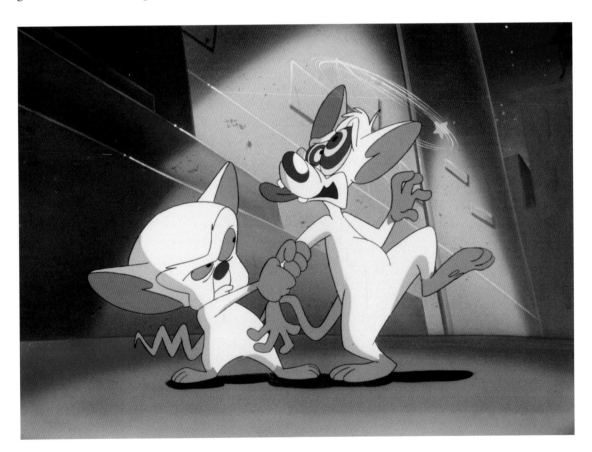

Pinky and the Brain creator, Tom Ruegger, drew inspiration from two real life characters: Eddie Fitzgerald and Tom Minton. They were both writers of Tiny Toon Adventurers. Both their personalities and physical appearance led Ruegger to ask the question, "What would happen if the two of them tried to take over the world?"

Their role in inspiring the characters was acknowledged in the "The Pinky and the Brain Reunion Special," when the two of them appeared caricatured as writers on the show.

Brain's persona would be further shaped by voice actor Maurice LaMarche; upon seeing the character for the first time he immediately saw a resemblance to actor/director Orson Welles. The voice helped define the character, and even inspired multiple storylines that would pull from the Orson Welles connection, including a verbatim re-creation of Orson Welles's infamously irate "frozen peas" commercial.

Pinky, voiced by Rob Paulsen, took his signature "Narf!" and "Egad!" catchphrases directly from Eddie Fitzgerald, who would frequently use the exclamations in the Tiny Toons production studios.

Every episode's adventures would begin with a simple query from Pinky: "Gee Brain, what do you want to do tonight?" Brain's response, "Same thing we do every night Pinky; try to take over the world!" would then set into motion their latest mousebrained scheme.

Though driven by his ego, Brain's motives for wanting to rule the world were actually magnanimous; he truly believed his leadership to be in the best interest of the planet Earth.

Brain's brilliant plans often begin with a flash of brilliance, leading him to ask his compatriot, Pinky, "Are you pondering what I'm pondering?" Only once has Pinky responded affirmatively. More often he responds with a non sequitur such as, "I think so Brain, but where do you stick the feather and call it macaroni?" Despite the frequent miscommunications, the two of them always manage to pull together an inspired plan for world domination.

Unfortunately for Brain, even the best laid plans of mice and men often go awry. His brilliant schemes always failed, frequently as the result of Pinky's involvement.

In the end the two of them returned to their home at Acme Labs and planned the following day's agenda . . . "to take over the world!"

The popularity of Pinky and the Brain led to their own series in 1995. Although it was envisioned as a prime-time competitor to the Simpsons, with the humor skewed more adult, it struggled to compete in the ratings. The show was then relegated to the Kids' WB! programming block and reworked with the addition of former Tiny Toon's character Elmyra. The show's writers resisted the new format as unnecessary tampering with the show's formula. Despite the changes being made, the writers managed to get in the last word in the theme song by adding the lyric, "It's what the network wants, why bother to complain?" Only thirteen episodes were produced. Pinky and the Brain came to an end in 1999, but they remain popular characters . . . perhaps just biding their time until they can take over the world!

Why Pinky and the Brain are #15

World domination has been a goal of cartoon villains since the first maniacal strains of laughter lifted up from an evil lair. But Pinky and the Brain are no villains. They are heroes. Brain's motives are purely for the betterment of humanity. As he sees it, he is the only mouse for the job!

Unlike traditional world domination storylines, there is no hero in tights attempting to foil the plans in *Pinky and the Brain*. Their failings are their own, and they accept them with dignified resignation yet renewed ambitions to try again.

They are lovable failures in the great tradition of Wile E. Coyote and Charlie Brown. They are hopeful characters who never lose sight of their goals and will try again and again undeterred.

Despite their failings and miscommunications, their friendship too remains intact. Their mismatched personalities perfectly complement each other, creating a balance of brilliance and incompetence, ego and modesty, complexity and simplicity. They are a modern maniacal animated incarnation of Laurel and Hardy.

Their mismatched relationship is what makes the show so entertaining. The show's plot may revolve around world domination, but it would be equally compelling to watch the two of them collaborate on even the most mundane tasks.

The world might just be a better place if it were ruled by Pinky and the Brain.

—JW

16
REN AND STIMPY

TOON-UP FACTS

Creator: John Kricfalusi **Studio:** Spumco
Ren voices: Kricfalusi, Bob Camp, Billy West
Stimpy voice: West
Debut: 1991 ("Stimpy's Big Day")
Ren's full name: Ren Hoek
Ren's dog breed: Chihuahua
Stimpy's full name: Stimpson J. Cat
Stimpy's cat breed: Manx
Ren catchphrase: "You eeediot!"
Stimpy catchphrase: "Oh, joy!"
Defining role: *The Ren & Stimpy Show* (1991–1996)
Ren traits: Violent, psychotic, intelligent, sadistic, angry, vengeful
Stimpy traits: Dimwitted, cheerful, emotional, encouraged

Ren and Stimpy Stuff

- The voices of Ren and Stimpy based their inflections on old-school actors—one serious and one comedic. Ren sounded quite like Peter Lorre, while Stimpy's voice resembled that of *Three Stooges* nitwit Larry Fine. Billy West performed his impressions of Fine on *The Howard Stern Show*.

- Kricfalusi studied animation and writing under Bob Clampett, who was certainly someone to emulate after he had worked with Warner Bros. and created Beany and Cecil.

- *The Ren & Stimpy Show* was the first series underwritten by Nickelodeon. The network had previously been known first and foremost as Nick at Nite, which aired decades-old sitcoms for those seeking nostalgic entertainment.

- In several episodes, it is mentioned that Ren and Stimpy live in Hollywood. That is, Hollywood, Yugoslavia.

- Before hitting it big with the band Nirvana, lead singer Kurt Cobain wrote a theme song for *The Ren & Stimpy Show* that Nickelodeon rejected. What became the theme was written by a group of Spumco employees and is called "Dog Pound Hop."

- Kricfalusi used his animation talents on unsuccessful revivals of *The Jetsons* and Mighty Mouse before founding Spumco and hitting his stride with Ren and Stimpy.

- The censors were displeased in some instances about references to bodily functions, about which Ren and Stimpy seemed to have a fascination. A few episodes were rejected.

- An eight-minute pilot episode titled "Big House Blues" played in film festivals beginning in December 1990 before *The Ren & Stimpy Show* was launched on television eight months later.

- Powdered Toast Man, a superhero with powdered toast for a head (complete with a mouth, nose, and ears) appeared in commercials within *The Ren & Stimpy Show*. Powdered Toast is a breakfast treat that does not taste right unless farted upon before consuming. Powdered Toast Man was created by none other than bizarre musician Frank Zappa.

- The last two episodes of *The Ren & Stimpy Show* aired on MTV rather than Nickelodeon. The final one was "The Last Temptation," during which Ren chokes to death after eating Stimpy's oatmeal and is sent to purgatory, where he is instructed to be nice to Stimpy. Ren returns to treat Stimpy well, giving him a million bucks after admitting he'd been stealing from his piggy bank.

- Among the recurring characters on the show is Mr. Horse. He is neither an antagonist nor protagonist to either starring character, but does receive his share of action. He was utilized as a judge in a dog show, victimized by a fall from a skyscraper, and even portrayed as a psychiatrist.

About Ren and Stimpy

The rather contentious relationship between Nickelodeon and Kricfalusi began after the latter launched Spumco and created the characters of Ren and Stimpy. His failure to land a home for them eventually ended when Nickelodeon agreed to take on the series. Kricfalusi would be fired in 1993 and replaced by Bob Camp due to tension between the two parties, but not before Ren and Stimpy had become the network's greatest success, particularly among college students and young adults, none of whom seemed to mind the characters' preoccupation with gas expulsion and other bodily functions. *The Ren & Stimpy Show* was a ratings and merchandising bonanza.

Ren is a scrawny, hunched-over, pale orange Chihuahua with large, bulging pink eyes and long ears that lie horizontally behind his head. He is a sadist with a violent temper who has no patience for the mindlessness of his dimwitted friend and often flies into an uncontrollable rage. Stimpy is the ideal counterpart. He is a chubby brownish tailless Manx with a big blue nose, perpetual smile, and an optimism about life that Ren neither understands nor tolerates. He is fixated on his litterbox, which is described as his first material possession, and enjoys the simple pleasures of life as he sees it—eating, watching television, and farting.

The characters featured a variety of exaggerated poses and expressions as well as jokes about bodily functions, while straddling the line between crudity and obscenity. Ren and Stimpy withstood tremendous physical damage, such as having their tails cut off or teeth rot out, only to have their conditions revert to normal by the next episode.

Artistic and financial differences between Kricfalusi and Nickelodeon led to a parting of the ways in 1993, which caused flagging ratings. Kricfalusi emerged in 2003 with *The Ren & Stimpy Adult Party Cartoon*, even taking on the voice of the former once again, but the show was cancelled after a brief run on Spike.

Why Ren and Stimpy Are No. 16

There was no secret formula for the ratings and merchandising success of Ren and Stimpy, not only with college students and young adults, but with kids and their parents as well. Their clashing personalities and motivations meshed to create what viewers believed to be one heck of a funny cartoon show. Granted, much of it was based on bathroom humor, but they made people laugh and that was the bottom line.

The program received critical acclaim as well. Though it failed to win, it was nominated for an Emmy for Outstanding Animated Program in 1992, 1993, and 1994.

Exaggeration is a wonderful tool. Animation allows for exaggeration in character and action that cannot be achieved in real life. Ren and Stimpy were marvelously exaggerated characters who reacted in exaggerated and funny ways to whatever fate tossed in their directions. That is why they are one of the greatest comedy teams in the history of television cartooning.

—MG

17
TOM AND JERRY

TOON-UP FACTS

Creators: William Hanna, Joseph Barbera
Studio: MGM
Debut: 1940 (*Puss Gets the Boot*)
Tom's signature scream: "Yeow-Owwww!"
Defining role: Theatrical shorts
Top TV venue: *Tom and Jerry* (1965–1972)
Tom traits: Mischievous, intimidating, reckless, persistent
Jerry traits: Intelligent, resourceful, prideful, energetic, determined

Stuff to Say about T & J

- The high level of violence in their shorts inspired the fictional "cartoon within a cartoon" *Itchy and Scratchy Show*, the ultra-destructive cat-and-mouse team often watched by kids Bart and Lisa in *The Simpsons*.

- Their debut in *Puss Gets the Boot* represented the first combined directorial effort by William Hanna and Joseph Barbera. It was nominated for an Academy Award in 1940 but lost to *Milky Way*, another MGM production.

- Tom was originally known as Jasper. He did not assume his famous name until MGM's *Puss Gets the Boot* gained success at the box office and began receiving critical praise.

- Hanna and Barbera concentrated solely on *Tom and Jerry* until the mid-1950s. They then expanded into commercial animation and created Hanna-Barbera Productions in 1957.

- Tom and Jerry inspired several other cat-and-mouse cartoons, the most famous of which was Hanna-Barbera's own *Pixie and Dixie and Mr. Jinks*. Pixie and Dixie (who had a southern accent) were rodents often chased by Mr. Jinks. It was among the only cat-and-mouse cartoons in which the feline occasionally emerged victorious. Another was also produced by Hanna-Barbera— hillbilly rivals Punkin' Puss and Mushmouse. Ultimate triumphs by Tom over Jerry were rare.

- Both spoke rarely. But in *Solid Serenade* (1946), Tom could be heard in four different voices, including a French accent.

- Their first Academy Award nomination was earned for *The Night Before* (1941), a mere one year after their launch. Their first Oscar victory was achieved for *Yankee Doodle Mouse* (1943) just two years later.

- Racist characterizations in 1940s and 1950s cartoon shorts drew sharp criticism during the civil rights movement and beyond. Among the negative stereotypes was Mammy Two Shoes, a black maid in the home in which Tom lived. Shown most often from the knees down, she shuffled about the house in fear and anger while carrying such items as dice and switchblades in her many bloomers. Greater sensitivity eventually motivated MGM to animate white legs over her black ones and give her an Irish accent.

- Mammy Two Shoes was originally voiced by African-American character actor Lillian Randolph, whose career extended through the 1970s and included performances in such TV hits as *Sanford and Son* and *The Jeffersons*, as well as the blockbuster mini-series *Roots*.

- MGM considering using a dog and fox as cartoon combatants before emerging with Tom and Jerry in 1940.

- The origins of future Hanna-Barbera standout duck Yakky Doodle can be found in a 1950 Tom and Jerry short titled *Little Quacker*. Yakky, who sounded similar to Daffy Duck, soon teamed up with dog and protective best friend Chopper in many Hanna-Barbera shorts.

- The legendary folk rock singing duo Simon and Garfunkel originally performed under the moniker Tom and Jerry.

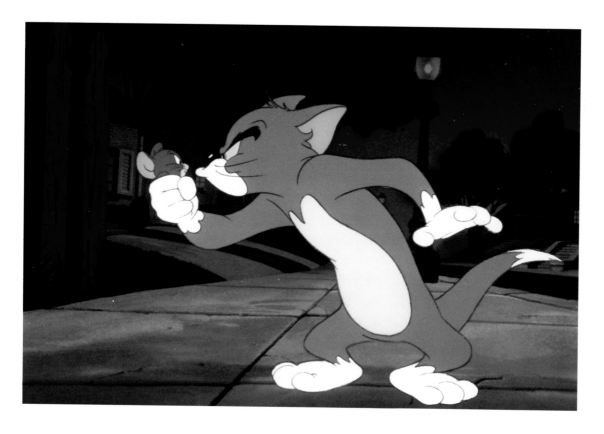

About Tom and Jerry

Most associate William Hanna and Joe Barbera with TV classics such as *Yogi Bear* and *The Flintstones*. But by that time the art and depth of animation had taken a hit due to the demands of television, requiring prolific production that necessitated cutting corners. The two created its finest work when they launched another duo—Tom and Jerry—in 1940.

The theatrical short *Puss Gets the Boot*, which featured rounder main characters compared to what audiences later became accustomed, established a cat vs. mouse scenario that became standard in American cartooning. But there would always be something special about Tom and Jerry beyond the artistic brilliance that resulted in their creation and maintained their standing as two of the greatest animated characters ever. And that was their relationship. Though adversarial and violent, to be sure, there was an underlying caring and respect.

The chase that leads to violent confrontation remains at the core of their features, but neither character is one-dimensional. Indeed, Tom yearns to get his paws on Jerry, but he also establishes a rivalry with bulldog Spike and alley cat Butch, and embarks on several love interests over the years. And Jerry is not a cowering rodent at the mercy of his pursuer. His cleverness, energy, determination, and resourcefulness allow him to escape Tom's clutches time and again. The heart of the *Tom and Jerry* cartoons, however, is the chase and the violent confrontations that result in them being hit by sharp and heavy objects, including forks, knives, bricks, hammers, frying pans, mallets, shovels, bats, golf clubs, plates, books, violins, pool cues, and even guillotines, many of which caused Tom to unleash his signature cry: "Yeow-wwww!"

The critical acclaim and positive public reaction to Tom and Jerry motivated MGM to become quite prolific. By the end of World War II and into the 1950s, it was cranking out four or five *Tom and Jerry* shorts per year, quite a feat considering the time and effort that went into each individual project. Hanna and Barbera continued to concentrate solely on their cat-and-mouse creation until the studio intentionally lessened its animation work and released the pair in 1957. The duo soon turned their focus to television.

The departure from theatrical shorts did not last long. MGM created new *Tom and Jerry* cartoons overseas starting in 1961 that expanded their personalities to show their more thoughtful and caring side. Perhaps the most poignant example was *Mouse Into Space* (1962), in which Tom feels so guilty and miserable after Jerry leaves that he turns to drinking.

MGM returned to creating *Tom and Jerry* shorts in the United States that year. The studio hired former Warner Bros. standout director Chuck Jones, who was in the unfamiliar position of inheriting an already established character and struggled in the process. He admitted that he could not draw Tom particularly well. The violence directed at the cat disappeared, and the shorts were given more of a Coyote vs. Road Runner plot.

The baby boomer generation certainly remembers *Tom and Jerry* as a television cartoon. It became a Saturday morning staple in 1965 and remained so for a generation. The first run, however, lasted only until 1972 as parents lambasted the networks for the violent content. New cartoons produced in the mid-70s and shown on *The New Tom and Jerry/Grape Ape Show* were far less violent. Soon there would be very little resemblance to the Tom and Jerry that gained so much popularity in theaters and earned such critical acclaim.

Why Tom and Jerry Are No. 17

Any doubters should look no further than those who select Academy Award winners in the category of Best Animated Short Subject (or Film). *Tom and Jerry* cartoons won seven Oscars, by far the most in the history of the competition.

The quality and detail of the animation, expressiveness of the cat and mouse, depth of characterization, and entertainment value of the albeit violent action all combine to make *Tom and Jerry* one of the greatest cartoons ever produced, particularly in their Hanna-Barbera heyday. So expressive are Tom and Jerry in their faces and actions that no dialogue has ever been necessary, though a bit was occasionally delivered.

Not only did Tom and Jerry gain tremendous popularity, but they launched an entire genre of one-on-one animated battles that later included not just other cat-and-mouse cartoons such as *Pixie and Dixie and Mr. Jinks*, but also such legendary Warner Bros. efforts as Wile E. Coyote vs. Road Runner and Sylvester vs. Tweety.

—MG

18
PIKACHU

TOON-UP FACTS

Creators: Atsuko Nishida and Ken Sugimori

Studios: OLM Inc., Team OTA (1997–2006), Team Iguchi (2006–2009), Team Kato (2010—present)

Voices: (English) Ikue Otani

Animated debut: April 1, 1997 (Japan), September 8, 1998 (United States): *Pokémon* (Episode: "I Choose You")

Game debut: February 27, 1996

Best friend/trainer: Ash Ketchum

Powers: Thunder Shock, Thunderbolt, Volt Tackle, and Electro Ball

Height: One foot four inches tall

Weight: Thirteen pounds

Antagonists: Team Rocket, Meowth

Starring TV roles: *Pokémon* Catchphrase: "Pika!"

Favorite food: Ketchup

Personality traits: Loyal, smart, friendly, determined, confident, charming

Pikachu Trivia

- Pikachu was selected as the "second best person of the year" of 1999 by *Time* magazine.

- Pikachu will attack anything that pulls on its tail.

- In the Manga version of Pokémon, Ash's Pikachu is named Jean Luc Pikachu.

- The Pokémon episode "Electric Soldier Porygon" was banned from television after causing over seven hundred Japanese children to suffer seizures.

- The rare "Illustrator" Pokémon card featuring Pikachu sold for twenty thousand dollars. Only six copies of the card exist.

- Pokémon is not a Japanese word but an English contraction of the words Pocket Monster.

- Ash, the TV show's main protagonist, has captured roughly eighty of the over seven hundred Pokémon available.

- Pokémon uses a classic cartoon trope—cat and mouse! Pikachu is based on a mouse, while his nemesis, Meowth, is based on a cat from Japanese folklore named Maneki-Neko.
- The Pokémon franchise stretches into comics, toys, and video games. The series of video games is the second most popular in the world, ranking second behind Super Mario Bros.
- The inspiration for Pokémon was the popular Japanese pastime of collecting insects.

About Pikachu

When Pokémon was first launched in 1995 as a series of video games, a character named Clefairy was intended to be the face of the franchise. When the time came to make the leap to television, the producers didn't feel the character was "cute" enough to appeal to audiences and Pikachu was elevated in its place. The rest is Pokémon history!

The name Pikachu is a broader breed of Pokémon but frequently refers more specifically to the character owned by Ash in the Pokémon animated series. Pikachu's animated origin tale begins when he is gifted to Ash for his 10th birthday by Professor Oak. At first Pikachu is deviant and refuses to follow Ash's orders. When Ash risks his own safety to defend Pikachu from a flock of Spearow, he earns the respect and gratitude of Pikachu and the two of them become fast friends from that day forward.

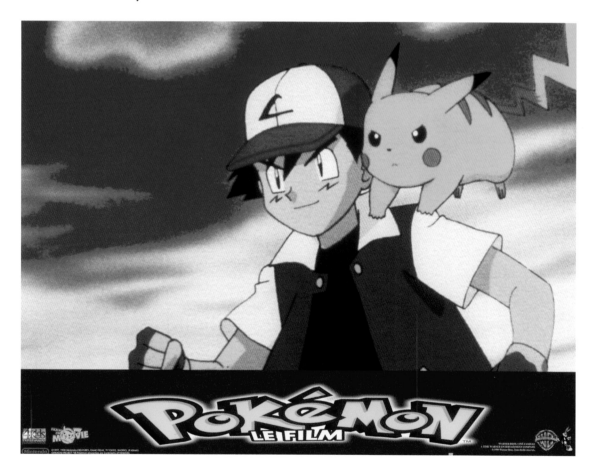

"Pika" is the Japanese word for the sound of electricity and "Chu" is how the Japanese describe the sound a mouse makes; thus Pikachu is an "Electric Mouse." Its distinctive bolt-shaped tail is meant to evoke a visualization of electricity, and most of its powers revolve around its ability to induce an electrical shock. Unlike most Pokémon, Ash's Pikachu does not like to be transported in a Pokeball and is generally seen walking alongside his trainer.

While the goal of most Pokémon is to evolve to the next "level," Pikachu has been content to remain in his current state just as his owner has managed to remain forever ten years old. This has remained a consistent trait of the two throughout multiple incarnations of the animated series and films.

Why Pikachu Is No. 18

He's been called Japan's answer to Mickey Mouse. Like Mickey, Pikachu has an international following and is the face of a media empire spanning film, television, manga, books, and video games. In the 1990s the export of Pokémon to the United States became a phenomenon akin to the Beatles' British invasion. Its impact on America's youth was widespread. Early critics were quick to dismiss Pikachu and his friend's popularity as a fad, but the trend has remained evergreen and seen reinvigorating resurgences such as the popularity of the mobile app "Pokémon Go."

In the card and video games the character is considered very basic and not especially powerful, and yet it remains the most popular character.

Pikachu's popularity is largely due to its adorability factor. With a rotund build and almost teddy bear–like facial features, Pikachu was literally designed to embody cute and cuddly.

Pikachu has remained an icon for an entire generation and shows no signs of waning. We chose you, Pikachu, for the #18 spot on our list.

—JW

19
DARIA MORGENDORFFER

TOON-UP FACTS

Creators: Glenn Eichler, Bill Peckman, and Susie Lewis

Studio: MTV Production Development, Tenth Annual Industries

Voice: Tracy Grandstaff

Debut: March 19, 1993, *Beavis and Butt-Head* (Episode: "Sign Here")

Unfortunate nickname: Diarrhea

Parents: Helen and Jake Morgendorffer

Best friend: Jane Lane

Sister: Quinn

Love interest: Trent Lane

Hometown: Highland

Moved to: Lawndale

Defining role: *Daria* (1997–2002)

Traits: Intelligent, patient, snarky, sarcastic, cynical, depressive, caustic, acerbic, misanthropic, jaded

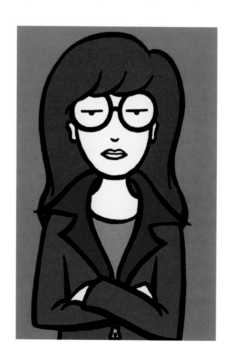

Daria Data

- Daria is a Greek word, meaning upholder of truth.

- Daria's astrological sign is Scorpio.

- Daria meets her best friend Jane in a self-esteem class they were both forced to attend. Jane helps them both get out of the class early, having memorized all the answers from her multiple times attending the class.

- The word *la* is repeated 109 times in the show's theme song, "You're Standing On My Neck."

- Throughout the series Daria is seen reading several classic works of literature including *One Flew Over the Cuckoo's Nest*, *Heart of Darkness*, *Catch-22*, *Howl and Other Poems*, and *The Bell Jar*.

- The characters of Daria and Jane are both left-handed.

- The episode "Boxing Daria" was intended to be a finale. However the show proved so popular the creators were given an option for six more episodes. They instead opted to produce a ninety-minute TV movie *Is It College Yet?*. This is considered the official finale. A montage at the end of the movie reveals Daria's future co-hosting a morning talk show with Jane.

- Tracy Grandstaff, the voice of Daria, was a cast member on the unaired pilot for the MTV show *The Real World*.

- Despite being a spinoff of the show *Beavis and Butt-Head*, the two characters never appeared on *Daria* and are mentioned only once in the entire run of the show.

About Daria

Daria began her animated existence as supporting character on Mike Judge's *Beavis and Butt-Head*. As that show had become more successful, they wanted to introduce a female character that could act as both a foil and intelligent balance to the two boys' hopeless stupidity.

As MTV began its search for more animated shows, it plucked Daria away from *Beavis and Butt-Head* to star in her own vehicle. This was done with the blessing of B and B creator Mike Judge. All connections to *Beavis and Butt-Head* ended at that moment, and the show was built to stand on its own with an entirely different sensibility, humor, and intelligence.

Daria and her family left their homes in Highland due to the high levels of uranium in the water, and moved to the new locale of Lawndale. Daria lives with her parents Helen and Jake Morgendorffer and her superficial younger sister Quinn.

Daria is the quintessential angst-ridden teen. Unlike many cartoon characters, Daria aged with the show, forcing her to go through the painful stages of progression from childhood to young adulthood. Her dark and moody demeanor is a direct contrast to the exaggerated American suburbia that surrounds her. Her self-deprecating humor was often more an acknowledgement of her "failure" to live up to the expectations of parents and society than a true self-disdain.

Her appearance befits her persona; a drab green jacket, black skirt, combat boots, and the large wide-rim round glasses through which she sees the town of Highland for the shallow materialistic self-centered world that it is. She is unable or unwilling to assimilate and is forced to therefore act as a caustic monotone commentator on what she views as a plastic planet.

Why Daria Is No. 19

Daria is a strong-willed realist in a cartoon world. Her obstinate stance helps her maintain an intellectual integrity despite her low self-esteem.

Her character became a hero to many young girls who refused to embrace "traditional" gender roles of school society and shunned pom-poms and taffeta in favor of philosophy and nihilism. Ironically, Daria helped make antisocial behavior socially acceptable.

She is a unique character in the realm of cartoons and would no doubt strongly object to being placed so highly on our list of such colorful, joyful characters.

—JW

20
FAT ALBERT

TOON-UP FACTS

Creator: Bill Cosby Studio: Filmation Voice: Bill Cosby
Debut: 1969 (Hey, Hey, Hey, It's Fat Albert!)
Series debut: 1972, *Fat Albert and the Cosby Kids* (Episode: "Lying")
Catchphrase: "Hey, Hey, Hey!"
Hometown: Philadelphia
Friends: Bill, Russell, Rudy, Mush Mouth, Dumb Donald, Weird Harold, Tito
Advisor: Mudfoot Brown
Instruments: Makeshift bagpipe/accordion, bedspring
Defining role: Fat Albert and the Cosby Kids (1972–1985)
Traits: Influential, moralistic, athletic, civic-minded, mature, conscientious

AlberTrivia

- The character was based on Cosby childhood friend Albert Robertson.

- Cosby voiced several other characters in the show, including Mush Mouth, Bill, Mudfoot, and The Brown Hornet.

- The theme music leading up to *Fat Albert and the Cosby Kids* episodes was followed by Cosby introducing himself and informing the viewers that "if you're not careful, you may learn something before it's done."

- A television character within a television character on the show was The Brown Hornet, a superhero takeoff on The Green Hornet who was idolized by the kids. His adventures often paralleled what the kids were experiencing in their own neighborhood.

- *Fat Albert and the Cosby Kids* received four Emmy nominations for Outstanding Entertainment: Children's Series or Outstanding Animated Program.

- The cartoon was retitled *The New Fat Albert Show* in 1979. Later episodes featured the kids expanding their horizons by attending a mostly white school.

- The insistence of Cosby that his cartoon focus on education motivated him to hire a panel of advisors headed by Dr. Gordon Berry of UCLA. Berry and his group ensured that each episode lived up to the standards set forth by the show's creator.

- The makeshift bagpipe and accordion played by Fat Albert on the show consisted of a funnel, radiator, and airbag. He also played a bedspring on occasion.

- Brilliant jazz pianist and keyboardist Herbie Hancock wrote and performed the music for the 1969 hybrid animation and live-action special that brought Fat Albert to life.

- When the characters yearned to give a makeshift concert for the viewers, they gathered in a junkyard in North Philadelphia, where the series was set.

- Fat Albert was in existence before his animation. He was the subject of a Cosby stand-up routine in 1967 titled *Buck Buck*, which was recorded for the album *Revenge*.

- *Hey! Hey! Hey! It's Fat Albert* was broadcast on NBC. Its producers wanted the network to transform it into a cartoon series, but were turned down because the show was considered too educational to thrive in the ratings. It was not until three years later that CBS picked it up.

- It comes as no surprise that the Bill Cosby character is based on Bill Cosby himself. He spends much of his time on the show keeping younger brother Russell out of trouble, just as the real Bill did as a child.

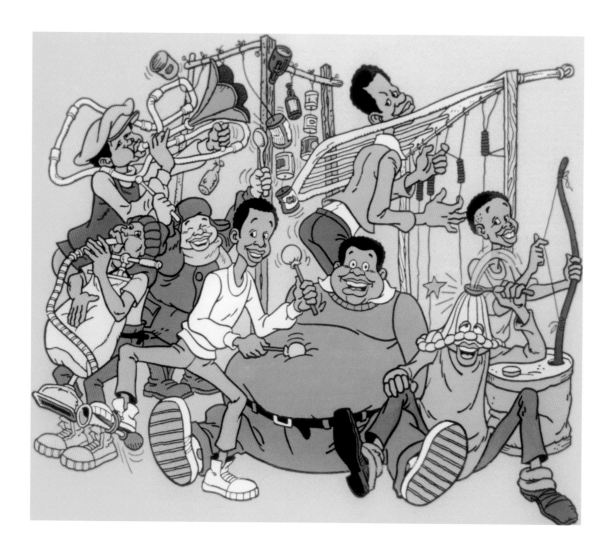

About Fat Albert

Fat Albert is the lead character on a groundbreaking show that proved influential not just to what skeptics believed to be the target audience of African-American youth, but young viewers of all races. The cartoon revolutionized popular television animation outside the realm of PBS by providing education along with entertainment.

The leader of the group was aptly named. Fat Albert was downright obese, but far more active and athletic than his girth would indicate. He competed quite well in football games with his friends. Fat Albert could generally be seen wearing blue pants with a black belt.

Though Fat Albert was the unquestionable head and moral compass of the Cosby Kids, he was team-oriented. He yearned to create a sense of togetherness and singular purpose for the group while leading the charge to help the community and the cause of diversity as a whole. He embraced his friendships with intriguing and entertaining characters based on Cosby's own childhood experiences (including himself, in the case of Bill).

Fat Albert and his friends faced a number of issues previously considered verboten for fictional television, particularly children's programming, such as drugs, poverty, gangs, and crime. Even homicide was touched upon in an episode titled "Talk, Don't Fight" in which Cosby Kid Tito is killed by a stray bullet intended for his older brother, who had joined a gang.

The lessons the Cosby Kids learn about such subjects are also learned by the viewers and helped create a legacy for the show that would have remained as strong today as ever had revelations about alleged sexual misconduct not ruined Cosby's reputation nearly a half-century after the cartoon was launched.

Why Fat Albert Is No. 20

Fat Albert is a positive role model for his friends in his North Philadelphia neighborhood. He does not merely talk a good game about morals and civic duty. He leads the way in instilling those virtues in the Cosby Kids.

Fat Albert is an important character, particularly for the era in which his character was launched. He not only brought a sense of pride to African-American children, but opened their eyes and those of millions of others to the need for the integration of education and moral teachings into youth entertainment.

—MG

21
GUMBY

Creators: Art and Ruth Clokey
Studio: Clokey Studios
Voices: Ruth Eggleston (1955–1956), Dallas Mckennon (1957–1988)
TV debut: 1955, *The Howdy Doody Show*
Parents: Gumbo and Gumba
Best friend: Pokey
Preferred vehicle: Scooter
Antagonists: The Blockheads
Defining role: *The Gumby Show* (1957–1968)
Traits: Creative, energetic, optimistic, kind

Gumby Trivia

- Gumby's name derived from a clay and mud mixture Art Clokey played with as a child.

- He dubbed it gumbo.

- Gumby saw a resurgence in the 1980s when comedian Eddie Murphy began a parody portrayal of the character on *Saturday Night Live*.

- Gumby creator Art Clokey was also the creative force behind the Lutheran Church in America–produced *Davey and Goliath*.

- Gumby's pliable and bendable physicality has made his name synonymous with flexibility.

- Gumby was "green" long before other characters. The 1956 Gumby episode "The Fantastic Farmer" made a bold statement about chemical usage on farms getting out of control.

- Art Clokey's first animated film was a short three-minute student film called *Gumbasia*, a satirical reference to Disney's *Fantasia*.

- Gumby voice artist Dallas Mckennon can be heard in several Disneyland and Disney World attractions. He is the voice of Andrew Jackson in the Hall of Presidents, the old deaf man in the Haunted Mansion, and provides the safety dialogue for Big Thunder Mountain.

- A formation of fault-bounded troughs on the planet Venus was dubbed Gumby by NASA because of their visual similarity to the character.
- Gumby's horse pal Pokey was voiced by his creator Art Clokey.

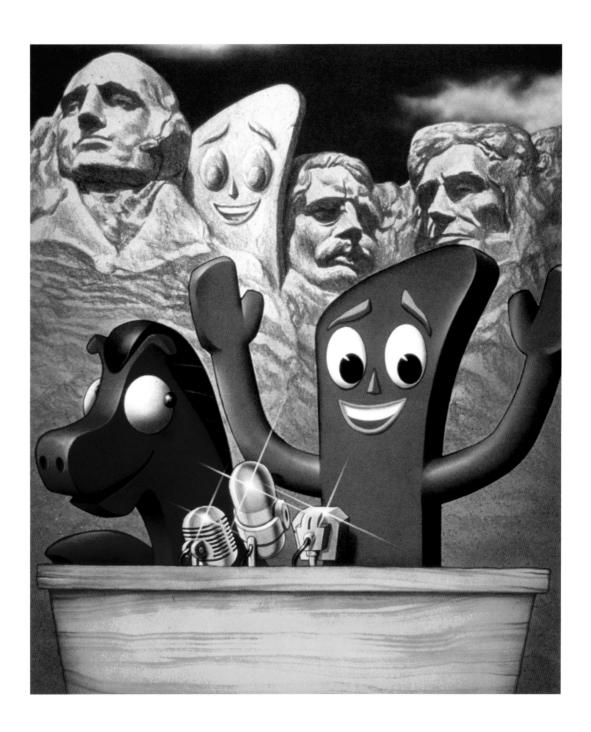

About Gumby

Gumby is the world's favorite boy made of clay. He began his life on *The Howdy Doody Show* in 1955 and soon became a star in his own right.

Gumby's distinctive physical appearance was grounded in practicality. Because the hot lights melted the clay, the form and shape had to be one that could be quickly and easily recreated. Ruth Clokey suggested a gingerbread boy, to which Art added the trademark "bump." That "bump" was inspired by Art Clokey's father's hairstyle. Gumby's wide feet and base made the character much easier to prop up when animating. His eyes, eyebrows, and mouth used simple geometric shapes, again to keep animation as simple as possible.

Perhaps one of the few things about Gumby inspired not by practical use, but by a personal value was his color: green. Clokey chose the green shade because it represented no specific race and Gumby could therefore be universal in his appeal.

Gumby's personality was easygoing, trusting, kind, and generous. His traits and qualities were molded in the shape of his creator Art Clokey, who was a man deeply rooted in his faith. He considered Gumby to be grounded by his unconditional love and faith in following his heart.

Why Gumby Is No. 21

Gumby is a groundbreaking character, which literally broke out of the ground! Using Claymation as opposed to traditional ink and paint, Gumby possessed a tangible quality that made him all the more real to his fans. His "realness" was contrasted by the surreal quality of his abilities to jump in and out of books and interact with life-size objects, effectively changing the setting and course of stories in an instant. Gumby is a character culled from the clay of the 1950s in his values and style but remains a timeless character worthy of the twenty-first spot on our list.

—JW

22
WOODY WOODPECKER

TOON-UP FACTS

Creators: Walter Lantz, Ben "Bugs" Hardaway
Studio: Universal
Voices: Mel Blanc, Ben Hardaway, Kent Rogers, Grace Stafford, Billy West
Debut: 1940 (*Knock Knock*)
Trademark laugh: "Ha-ha-ha-HA-ha!"
Cloned from: Bugs Bunny, Daffy Duck
Targets: Wally Walrus, Buzz Buzzard, Gabby Gator
Defining role: Theatrical shorts
Top TV venue: *The Woody Woodpecker Show* (1957–1958, 1970–1972)
Traits: Mischievous, maniacal, self-centered, nutty, obstinate, energetic

Wood Chips

- Grace Stafford was Lantz's wife. She voiced Woody the longest—from 1950 to 1972.

- The only voice heard in the Woody Woodpecker theme music was often that of the star, who in later shorts pecks out his name. But there was a "Woody Woodpecker Song" sung by the lead singer of the Kay Kyser Orchestra, ironically named Gloria Wood. The tune was used in the theme for the Woody short *Wet Blanket Policy* (1948) and was nominated for an Academy Award.

- Woody Woodpecker had no name in the Andy Panda short in which he debuted as a side character. He went unnamed until starring in *The Cracked Nut* (1941).

- The signature Woody laugh was first used by Mel Blanc in voicing Bugs Bunny. Bugs laughs similarly in early shorts. Blanc only voiced Woody for three shorts.

- Ben Hardaway directed Bugs Bunny and Daffy Duck cartoons for Warner Bros. before creating Woody.

- After his retirement in 1976, Walter Lantz created oil paintings of Woody posing as such legendary subjects as Blue Boy (Thomas Gainsborough) and Mona Lisa (Leonardo da Vinci).

- Woody did not just debut in theatrical shorts with Andy Panda. He also appeared with Andy and Oswald the Rabbit, an original Walt Disney creation, in Dell Comics' *New Funnies* in 1942.

- One unique aspect of the original *Woody Woodpecker Show* was a segment in which Lantz, who hosted the program, gave lessons to young viewers on the art of animation.
- Billy West voiced Woody in *The New Woody Woodpecker Show*. West was among the most prolific voice actors of his generation. Among his most significant cartoon characters were Ren and Stimpy.
- Lantz embraced alliteration in the names of his cartoon characters. The first and last names of Woody Woodpecker, as well as such foils as Gabby Gator, Wally Walrus, and Buzz Buzzard, all began with the same last letter.
- Grace Stafford remained uncredited until 1958. She felt that audiences would be disenchanted upon learning that Woody was voiced by a woman.

About Woody Woodpecker

The story has been refuted by some—but it's one heck of a story. Lantz claimed he was honeymooning with Grace in a cabin when they were visited by a pesky woodpecker that played "knock knock" on the roof. Thus inspired, Lantz decided to create a woodpecker cartoon character. And, of course, Woody debuted in *Knock Knock* that same year, an Andy Panda cartoon that would ironically serve to shove the star behind the secondary character in the studio pecking order.

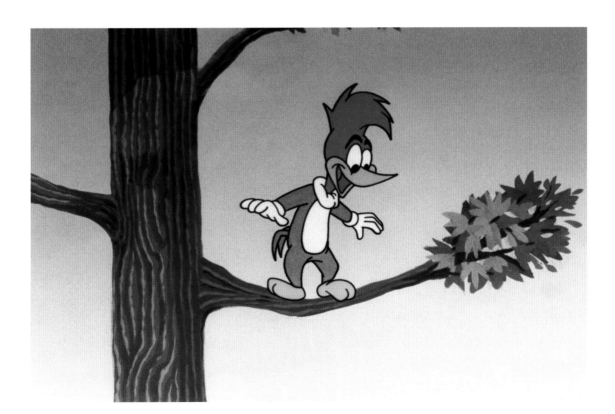

Though it has been claimed that the honeymoon took place after that cartoon hit the theaters, the fact that *Knock Knock* featured the red-breasted Woody (who was later established as white-breasted) pecking through Andy's roof seems to confirm the Lantz version of the story.

Woody Woodpecker is an animated maniac. He is part Bugs Bunny in his wisecracking nature and demented laugh and part Daffy Duck in his wild energy. But some perceive him as downright evil, which could not be claimed about the other Warner Bros. superstars. Woody is an instigator who torments others simply for the fun of it, then ends his escapades with the laugh that made him famous.

It seemed every short was hold-onto-your-seat hijinks. Among them was *Convict Concerto* (1954), during which he plays a piano tuner held at gunpoint by a fleeing bank robber named Mugsy. The gun-wielding crook crawls into a piano and tells Woody to keep playing "or else" while a clueless cop (voiced by the prolific Daws Butler) is on the trail. Mugsy calls on his accomplices to load the piano into a truck, which speeds away. Woody continues to pound away at *Hungarian Rhapsody No. 2* by Franz Liszt while the piano flies out of the truck onto a train, off a cliff, and into a jail courtyard, where Mugsy finds his new home. Woody proves to be the hero.

The greatness of Woody Woodpecker was supported by two Academy Award nominations, one for *The Dizzy Acrobat* (1943) and another for a reuniting with Andy Panda in *Musical Moments from Chopin* (1947). And though no Woody cartoon ever again received such an honor, they continued to be produced until 1972.

Baby boomers were the first to be exposed to a character that had entertained their parents. But Woody Woodpecker would eventually be exposed to future generations as well. Fox Kids Network placed *The New Woody Woodpecker Show* into its Saturday morning fare from 1999 to 2002.

Why Woody Woodpecker Is No. 22

In searching for a unique and colorful personality to head the studio lineup, Lantz hit the jackpot with Woody Woodpecker despite the fact that the annoying creature could hardly be considered a sympathetic figure. The laugh alone made him a star and even motivated a hit song in the late 1940s.

But it was his manic, wisecracking style that was embraced by audiences and made Woody one of the most memorable cartoon characters ever. His similarities to Bugs and Daffy are undeniable, but he also developed his own traits that set him apart, particularly as a troublemaker. Bugs reacted to threats and to being treated unjustly. Daffy was driven greatly by jealousy and dreams of greatness. But Woody fell into neither category. He is an instigator who, like the woodpecker that annoyed Lantz on his honeymoon, irritated others because he enjoyed it. Just ask Andy Panda. Woody not only annoyed Andy in *Knock Knock*, but he pushed him right out as the studio star in the process.

—MG

23
SPIDER-MAN

Creators: Stan Lee, Steve Ditko
Studios: Grantray-Lawrence Animation (1967–1968), Krantz Films (1968–1970), Marvel Comics Groups
Voice: Paul Soles
Debut: September 9, 1967, *Spider-Man* (Episode: "The Power of Doctor Octopus")
Comic book debut: August 1962, *Amazing Fantasy #15*
True identity: Peter Parker
Powers: Spider sense, web slinging, super strength, wall climbing, agility, intelligence
Antagonists: Doctor Octopus, Electro, Mysterio, The Green Goblin, The Vulture
Starring TV roles: *Spider-Man* (1967–1970)
Hometown: New York City
Place of employment: *The Daily Bugle*
Boss: J. Jonah Jameson
Catchphrase: "Your friendly neighborhood Spider-Man."

Spider Sense Tingling Trivia

• Ralph Bakshi, best known for his more adult-oriented films such as *Fritz the Cat*, directed the second and third seasons of the original animated *Spider-Man* series.

• In the first season the spider logo on Spider-Man's chest was occasionally shown with only six legs.

• The original theme song has gone on to be one of the most recognized superhero themes.

• Three-time Academy Award winner Paul Francis Webster wrote the lyrics.

• The theme song has been covered by a wide variety of performers including Aerosmith, Michael Bublé, and The Ramones.

• The animation on the show was notoriously bad and relied heavily on close-ups and reusing scenes. Episodes late in the series even lifted scenes from other shows such as *Rocket Robin Hood*.

• When Stan Lee and Steve Ditko submitted the idea of Spider-Man to Martin Goodman, then head of Marvel, he thought it was a poor idea due to the fact that most people hate spiders.

- Spider-Man's name is always hyphenated. This was done purposefully to differentiate him from the popular DC character Superman.

- The stage musical *Spider-Man: Turn Off the Dark* featured music and lyrics by U2's Bono and the Edge. The show had the longest preview period in Broadway history with over 180 performances.

- Stills from the 1960s animated series took on new life as a popular series of memes beginning in 2009.

- Paul Soles, the voice of Spider-Man/Peter Parker, is also the voice behind Hermey the misfit elf in the 1964 holiday classic *Rudolph the Red-Nosed Reindeer*.

About Spider-Man

Your "friendly neighborhood Spider-Man" first started web crawling on the pages of comic books in August of 1962. The creation of Stan Lee and Steve Ditko, Spidey was an instant hit and quickly rose to the top of Marvel Comics' sales.

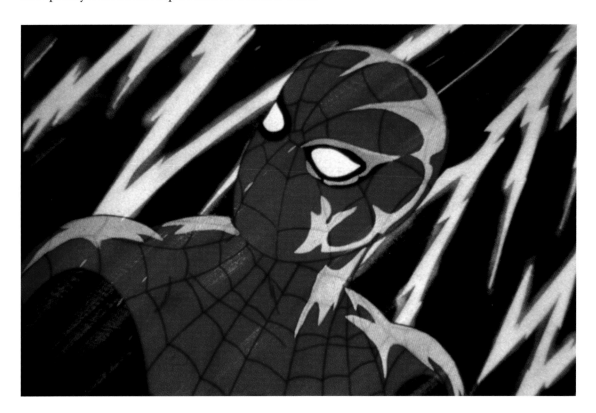

Despite the character's popularity, it would take five years for an animated incarnation of Spider-Man to appear.

Staying true to the comic's origin backstory, the teenage Peter Parker derived his powers from the accidental bite of a radioactive spider. At first he uses his powers purely for self-gain and ignores the responsibilities that come with "great power." However, he goes through an emotional transformation after a thief whose actions earlier Peter chose to ignore as "not his problem" murders his beloved Uncle Ben.

Endowed with extraordinary superpowers including, strength, agility, and the ability to climb walls, Peter took on the role of a crime fighter under the super moniker of "Spider-Man."

He was witty and intermittently confident and insecure. He was very much a teenager.

Much like the comic books, early episodes of the cartoons dealt not just with being a superhero but everyday issues faced by the average person. These included interoffice relationships, family issues, and the foibles of adolescence. The show struck a balance between Peter Parker's real-life high school drama such as trying out for a spot on the baseball team and superhuman battles between Spider-Man and a rogues' gallery of villains.

Many of the villains were culled from the popular comic books including King Pin, The Vulture, The Rhino, The Green Goblin, and Dr. Octopus.

As the show progressed into its second and third seasons, the producers began to cut corners to save money. They began by introducing non-canon villains such as The Snowman and Desperado, in an effort to avoid licensing issues. To reduce costs even further, they often patched together storylines through repurposed footage. This added a level of campiness to the show that has been embraced by nostalgic audiences and provided fodder for the popular satirical "Spider-Man Meme," which in turn created a renewed interest in the original series.

Why Spider-Man Is No. 23

The superhero animation genre was one filled with primarily adult heroes. Tacked on safety tips for kids added to the feeling that the superheroes were just more adults talking down to kids and telling them what they could and couldn't do. Spider-Man was different; he spoke, thought, and acted like a kid.

Peter Parker and his alter ego, Spider-Man, explored his newly found powers with the curiosity and ambitions of any teenager. He didn't just use his powers to catch bad guys; he considered using his powers in trying out for the football team. He did the things any of us would do when given superpowers. The character spoke to his audience with sincerity, wit, and genuine respect. He was one of them. Despite frequently saving the city from peril, he still had the personal perils of homework and impressing girls. He was just one of the kids.

He was and is our friendly neighborhood Spider-Man.

—JW

24
BART SIMPSON

TOON-UP FACTS

Creator: Matt Groening
Studios: Gracie Films (1987–1989); Klasky Csupo (1989–1992); Film Roman (1992–present)
Voice: Nancy Cartwright
Debut: 1987 (*Good Night*)
Series debut: 1989 ("Simpsons Roasting on an Open Fire")
Father: Homer
Mother: Marge
Sisters: Lisa, Maggie
Catchphrases: "Eat my shorts!" . . . "Don't have a cow, man!" . . . "Ay Caramba!" . . . "D'oh!" . . .
"Get bent!"
Hometown: Springfield
School: Springfield Elementary
Teacher: Edna Krabappel Grade: Fourth
Defining role: *The Simpsons* (1989–present)
Traits: Rebellious, mischievous, disrespectful, energetic, underachieving, cool

Bart's Best Phony Phone Calls to Moe's

Bart: Hello, is Al there?
Moe: Al?
Bart: Yes, Al. Last name: Coholic.
Moe: Let me check . . . [*calls*] Phone call for Al. Al Coholic. Is there an Al Coholic here?
[*bar patrons laugh*]
Moe: Wait a minute. [*to phone*] Listen, you little yellow-bellied rat jackass. If I ever find out
who you are, I'll kill you! [*hangs up*]

Bart: Is Oliver there?
Moe: Who?
Bart: Oliver Klozoff.
Moe: Hold on, I'll check. [*calls*] Oliver Klozoff! Call for Oliver Klozoff!
Bart & Lisa: [*laugh*] [*Marge picks up the phone*]
Moe: Listen, you lousy bum. If I ever get a hold of you, I swear I'll cut your belly open!

Bart: Is Mr. Freely there?
Moe: Who?
Bart: Freely, first initials I. P.
Moe: Hold on, I'll check. Uh, is I. P. Freely here? Hey, everybody! I. P. Freely! [*the customers laugh*] Wait a minute . . . Listen to me, you lousy bum. When I get a hold of you, you're dead. I swear I'm gonna slice your heart in half!

Bart: Is Seymour there? Last name Butz.
Moe: Just a sec. Hey, is there a Butz here? Seymour Butz? Hey, everybody! I want a Seymour Butz! [*the entire bar laughs; realizes*] Wait a minute . . . Listen, you little scum-sucking pus-bucket! When I get my hands on you, I'm gonna pull out your eyeballs with a corkscrew!

Bart: Uh, yeah, hello. Is Mike there? Last name, Rotch.
Moe: Hold on, I'll check. [*calls*] Mike Rotch! Mike Rotch! Hey, has anybody seen Mike Rotch lately?! [*snickers from the patrons*] [*to phone*] Listen to me, you little puke. One of these days, I'm going to catch you, and I'm going to carve my name on your back with an ice pick!

Bart Bits

- Bart voice Nancy Cartwright learned from one of the best when she trained under the tutelage of Daws Butler, who had become a legend years earlier as the voices of such Hanna-Barbera standouts as Yogi Bear and Snagglepuss.

- Bart became so well known for his skateboarding on the show that Playstation 2 produced a video game that featured Bart doing just that, among other Simpsons-related games.

- Groening has compared Bart to legendary *Leave It to Beaver* character Eddie Haskell, who spoke glowingly and politely to adults such as the Cleaver parents before nastily bad-mouthing them and their kids when they weren't around.

- Bart is the only member of the Simpsons family not named after a member of the Groening family. It has been claimed that Groening was inspired to name him Bart because it is an anagram of the word "brat." But Groening has stated that he used it because it sounded like the word "bark," such as in a barking dog. Groening added that Bart is loosely based on himself and his brother Mark.

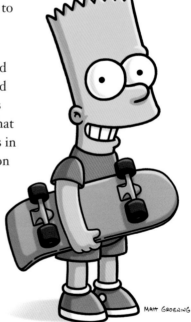

- Tom Metzger, leader of the neo-Nazi group The White Aryan Resistance, was sued by 20th Century Fox in 1991 for placing an image of Bart in a Gestapo uniform giving the Nazi salute on T-shirts. Metzger agreed to stop selling the shirts.

About Bart Simpson

The birth of Bart was actually in print. He was a background character in the Groening comic strip *Life Is Hell*. Little was taken from that strip to create the bumper on *The Tracey Ullman Show* that mushroomed into the most successful animated series in history, but there was a character in *Life Is Hell* that uttered the eventually legendary words, "Don't have a cow, man!" Bart was born.

Early *Simpsons* episodes featured Bart—particularly his contentious relationship with Homer. He was little more than a disrespectful troublemaker. Groening decided Homer would be the star of the show when *The Simpsons* was transformed from a short to a series. But early returns were quite different. It was Bart that became a star.

The year 1990 has been called The Summer of Bart. His image was everywhere. T-shirts with his picture on it screamed out his catchphrases or philosophies on life, such as "Underachiever and Proud of It" or "Ay, Caramba" or "Don't Have a Cow, Man!" or "I'm Bart Simpson. Who the Hell Are You?" He was the spokesperson for nonconformists. And greatly because of Bart, *The Simpsons* became a phenomenon.

Bart Simpson is a jagged-headed ball of unending energy. He cares not one iota about the impression he makes on others—and that includes his family. He simply wants to have fun. That means embarking on activities such as skateboarding that do not test his intelligence. Let Lisa sit around her room and study. Bart is smarter than one might think, but there is no fun in school-work. It is more fun making mischief, like phony phone calls to Moe's and writing satirical and cryptic messages on the school chalkboard. It is no wonder that his favorite cartoon characters are the ultraviolent Itchy and Scratchy.

But Bart is not evil. And his character softened over the years. His relationship with Homer became less combative, he grew more remorseful on occasion after committing minor offenses or hurting the feelings of others, and showed a genuine caring and even sense of protectiveness for sister Lisa.

It would have been impossible for Bart to maintain the level of popularity he gained in the early run of a show that had aired more than six hundred episodes by the fall of 2016. But his legacy will live on forever.

Why Bart Simpson Is No. 24

Bart eventually settled into a role as just one humorous member of a family that is dysfunctional more so because of Homer than himself. But his immense popularity in the early 1990s launched *The Simpsons* into greatness and propelled the program to longevity that nobody could have imagined.

It can be argued that no cartoon character in history made a greater short-term impact than Bart Simpson. Others simply entertained. Bart stirred up emotions. It is no easy feat to capture the imagination of a nation and beyond. His words and actions expressed a sort of "rebel without a cause" feeling among those who embraced him.

—MG

25
THE POWERPUFF GIRLS

TOON-UP FACTS

Creator: Craig McCracken
Studio: Hanna-Barbera
Names: Blossom, Bubbles, and Buttercup
Blossom voice: Cathy Cavadini
Bubbles voice: Tara Strong
Buttercup voice: Elizabeth Daily
Debut: 1995 (*Crime 101*)
Inventor: Professor Utonium
Special seasoning: Chemical X
Hometown: Townsville
School: Pokey Oaks Kindergarten
Teacher: Ms. Keane
Antagonist: Mojo Jojo
Motivation: To save the world
Defining role: *The Powerpuff Girls* (1998–2005)
Blossom traits: Quick-thinking, frank, bold, decisive
Bubbles traits: Charming, happy-go-lucky, sympathetic, fearless
Buttercup traits: Explosive, combative, tomboyish

Powerpuff Points

- McCracken planted the seeds for The Powerpuff Girls as an animation project while at the California Institute of the Art in the early 90s.

- The Powerpuff Girls were originally known as The Whoopass Girls. The chemical used by Professor Utonium was called "whoopass." Their voices were provided by Jennifer Fried, who has no other acting credits.

- The success of The Powerpuff Girls in *What a Cartoon!* led to a series on Cartoon Network that was launched in November 1998.

- McCracken was also instrumental in the art direction for popular Hanna-Barbera cartoon *2 Stupid Dogs*. The large dog in that show was voiced by versatile Brad Garrett, who provided

many cartoon voices before and during his time as an Emmy-winning actor in *Everybody Loves Raymond*.

- One character for which McCracken first gained notoriety was No Neck Joe, who appeared as part of Spike and Mike's Twisted Festival of Animation, an event featuring independently produced short films.
- The voice of Mojo Jojo is Roger L. Jackson, who also supplied the voice of Ghostface in the *Scream* films.
- *The Powerpuff Girls* episode titled "Meet the Beat Alls" (2001) featured dozens of Beatles references including nods to classic songs such as "Eight Days a Week," "Ticket to Ride," "A Day in the Life," "Tomorrow Never Knows," "Lucy in the Sky with Diamonds," and "Hello, Goodbye."
- McCracken felt that *The Powerpuff Girls* attracted two different types of viewers in much the same way that the live-action *Batman* series of the 1960s did. He envisioned kids watching it for the action and adults for the campy absurdity.
- So kind and giving were The Powerpuff Girls that they actually gave lessons on how to be bad to a gang of inept evil wannabes called the Amoeba Boys.
- *The Powerpuff Girls* was the first of the Hanna-Barbera shows to be structured in a two-segment half-hour format rather than the familiar three.
- The 2002 feature-length film starring the girls was considered a far greater technological and artistic success than financial one. It flopped at the box office.

About The Powerpuff Girls

Ms. Keane did not want her kindergarten kids to leave class, but she was understanding when it came to little Blossom, Bubbles, and Buttercup. When they made it known that they were needed to save the world, she let them go.

The Powerpuff Girls were singular of purpose, but boasted distinctly different personalities. They were led by Blossom, who prevented disaster for mankind and her two comrades with her quick thinking. Bubbles was the most caring and joyful of the trio. And Buttercup was the most fiery and resistant. But all three worked together to combat crime.

Their appearances were as dissimilar as their personalities, though they all wore short dresses. Blossom boasted light brown hair with a large bow and featured a short cape tied behind her pink dress and black belt. The pigtailed Bubbles had blonde hair and a blue outfit, while Buttercup wore her black hair in a short flip and was dressed in green.

McCracken created the characters that morphed into The Powerpuff Girls as an entry into the Spike & Mike Animation Festival, which was released in the late summer of 1992. The Whoo-pass Girls—as they were first called—defeated The Vile Gangreen Gang in their debut titled *Whoopass Stew: A Sticky Situation*.

The opening to *The Powerpuff Girls* explains that the three ingredients Professor Utonium used to create the trio were sugar, spice, and everything nice. The addition of Chemical X was an accident, but gave them their power.

The girls themselves played a huge role in popularizing the cartoon. But equally important was the inclusion of many evil-doers, the most prominent of which was a supervillain chimpanzee named Mojo Jojo, whose ambition was no less than to rule the world.

Viewers first embraced the girls on *What a Cartoon!* That motivated the Cartoon Network to launch *The Powerpuff Girls* as regular TV fare divided into two segments in 1998. It was thrice nominated for an Emmy in the category of Outstanding Animated Program before leaving the air in 2005.

Its legacy resulted in a return to Cartoon Network in 2016. The Powerpuff Girls had different voices, but they were still soaring through the sky and saving the world.

Why The Powerpuff Girls Are No. 25

Flying kindergarteners that save the world from destruction? What's not to love? The notion itself makes the Powerpuff Girls unique. Individually, so do their distinctive personalities. And malevolent creatures such as Mojo Jojo give the show a wonderful good vs. evil flavor that elevates the strength of the girls' characters to a higher level.

Those that played roles in the production of *The Powerpuff Girls* earned many nominations and triumphs in awards targeting cartoons. Their popularity motivated a full-length animated film in 2002; a boatload of videos, comic books, and toys; an adaptation by Japanese animators (*Demishita! Powerpuff Girls Z*); and a reboot series in 2016. Their personalities and popularity continue to grow their legacy.

—MG

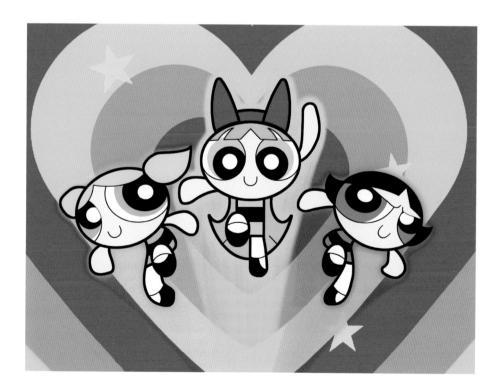

26
YOSEMITE SAM

TOON-UP FACTS

Creator: Michael Maltese
Studio: Warner Bros.
Voice: Mel Blanc
Debut: 1944 (*Hare Trigger*)
Antagonist: Bugs Bunny
Aliases: Sam von Schmamm the Hessian, Shanghai Sam, Chilikoot Sam, Riff-Raff Sam, Sea-Goin' Sam, Square-Deal Sam, Sam Schultz
Defining role: Theatrical shorts
Top TV venue: *The Bugs Bunny Show* (1960–1975)
Traits: Bombastic, persistent, short-tempered, foolhardy, arrogant, volatile

Silly Stuff Said by Sam

- "Say yer prayers, ya long-eared galoot!"
- "Blast your scuppers ya barnacle-bitten land lubber."
- "Missed again, ya hammerhead halibut!"
- "10 dollars! Why it's gettin' so a man can't earn a dishonest livin' no more."
- "Be you the mean hombre that's a-hankerin' for a heap a trouble, stranga? . . . well, be ya?"
- "I'm a sailin' with the tide . . . or my name ain't Shanghai Sam . . . and it is."
- "Ooooh . . . that gastronomic, epicure, culinary crepe suzette . . . I hate him!"
- "Doc? I ain't no Doc. I'm a pirate, Sea-Goin' Sam . . . the blood-thirstiest, shoot 'em firstiest, dawg gone worstiest buccaneer that's ever sailed the Spanish Maine."
- "All right, all right, don't rush me, I'm a thinkin' . . . and my head hurts."
- "Ya doggone idgit galoot . . . you'll blow the ship to smithereenies!"
- "I'm the hootinist, tootinist, shootinist bobtail wildcat in the west!"
- "I'm Yosemite Sam . . . the meanest, toughest, rip-roarinest, Edward Everett Hortonest hombre whatever packed a six-shooter!"
- "Great horny toads . . . a trespasser getting' footie prints all over my desert."
- "Ya double-crossers! I'm a comin' back . . . and I ain't comin' back to play marbles!"

- "No good bush whackin' barracuda."
- "Yeah, Yosemite Sam. The roughest, toughest, he-man scuffest that's ever crossed the Rio Grand-e . . . and I ain't no namby-pamby."
- "Surrender, rabbit. I've got you outnumbered, one-to-one."
- "Stranger, you just yupped yourself into a hole in the head!"

About Yosemite Sam

Elmer Fudd was the first Bugs Bunny antagonist. But Yosemite Sam was the best. Theirs was a match made in cartoon heaven.

The pint-sized wrangler with a gallon-sized ego simply boasted greater depth of personality than the albeit adorable Elmer. Sam was inspired unwittingly by Warner Bros. director Friz Freleng, whom Maltese thought boasted similar personality traits, including most notably the volatility. The quick-tempered, foolhardy new animated character proved to be the ideal counterpart to the cool, quick-witted bunny. He was the ultimate adversary for Bugs.

When the seeds of Sam were planted is up for debate. Some believe his first incarnation was as Red Hot Ryder, a cowboy who was outsmarted by the famous rabbit in *Buckaroo Bugs* (1944). There were vast differences between Sam and Hot Rod both visually and audibly. One, however, can understand why the two have been linked.

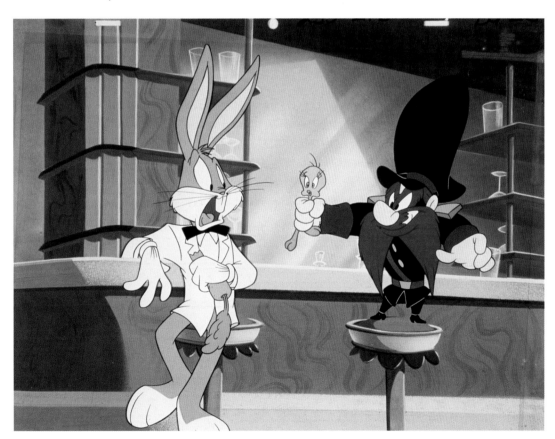

Yosemite Sam boasts arguably the most distinctive look among all Warner Bros. creations. His small stature belied his big personality. He was seen at first as a diminutive cowboy carrying twin six-shooters and sporting a red moustache almost as long as his entire body, huge eyebrows, and a hat the size of which actually did exceed his own height.

Sam, however, proved far more versatile than perhaps first expected. He was an equally effective and bombastic alias as a medieval knight, pirate sea captain, desert sheik, and Roman gladiator. In fact, it was in the first of those roles that he earned his lone Academy Award as the Bugs antagonist in *Knighty Knight Bugs* (1958).

Perhaps the most memorable scene, one that typifies the relationship between Sam and Bugs, highlighted *Buccaneer Bunny* (1948). The short reaches its crescendo when Bugs calmly lights matches and tosses them downstairs twice into a room filled with gunpowder. A panicked Sam races down to pick them up and put them out. But his pride will not allow him to submit to what is tantamount to blackmail. So when Bugs flips another lit match downstairs, he makes an attempt at indifference, tapping his foot, flipping a yo-yo while sweating profusely, and playing jacks. His impatience, however, forces him to rush downstairs just as the explosives blow up the ship and send both he and Bugs flying to the shore.

Yosemite Sam never emerged as a main character. In fact, he only appeared in two cartoons that did not feature Bugs Bunny—*Along Came Daffy* (1947) and *Honey's Money* (1962). He was also never written into more than three shorts in any one year. But his personality was distinctive enough to earn him co-star status in the hearts and minds of viewers. In fact, it has been noted that since Bugs was invulnerable, viewers were most interested in the travails of Yosemite Sam when the two shared the screen.

Why Yosemite Sam Is No. 26

Because he's just damn funny. Perhaps subjectivity has played an uncommonly large role in this particular ranking given Sam's side-character status. But Sam ranks right up there with Daffy Duck among the quirkiest, looniest, most humorous characters in Warner Bros. history and certainly the funniest that never earned center stage (Daffy, of course, was the featured character in many shorts).

Need proof? Just watch Sam and Bugs do their thing in *Bugs Bunny Rides Again* (1948), during which Sam shoots his guns at the feet of Bugs and orders him to "dance," leading the latter to break into a lively vaudeville tap routine, complete with hat and cane. Bugs then screams out, "Take it, Sam!" and claps to the beat while the mustachioed cowboy picks up the number where Bugs left off and dances his way down a mine shaft. Those who don't laugh at that simply have no sense of slapstick humor.

—MG

27
BEAVIS AND BUTT-HEAD

TOON-UP FACTS

Creator: Mike Judge
Studio: MTV Productions
Voice: Mike Judge
Debut: 1992, Liquid Television—Frog Baseball
Catchphrases: "Cool." . . . "This sucks."
Hometown: Albuquerque, New Mexico
High school: Highland High School
High school grade level: Ninth
Antagonists: Stewart Stevenson, Mr. Van Driessen, Coach Buzzcut
Place of employment: Burger World
Beavis alter ego: Cornholio
Defining role: *Beavis and Butt-Head* (1993–2011)
Beavis traits: Low intelligence, clueless, high pain tolerance, witty, reckless
Butt-Head traits: Sadistic, low intelligence, lazy, abusive

Cool Facts:

- Beavis and Butt-Head appeared on the cover of *Rolling Stone* magazine three times.

- Beavis wears a Metallica T-shirt; however in merchandising he wears a "Death Rock" shirt to avoid licensing complications.

- The character of Beavis was inspired by Bobby Beavis, a college friend of *Beavis and Butt-Head* creator Mike Judge.

- *Simpsons* creator Matt Groening claimed to be a fan of the duo because they "took the heat off Bart Simpson for being responsible for the downfall of western civilization."

- Butt-Head's father is seen only once, in the film *Beavis and Butt-Head Do America*. His father, a former roadie for Motley Crue, is voiced by David Letterman.

- Beavis and Butt-Head appeared in a music video singing "I've Got You Babe" alongside Cher.

- References to Beavis being a pyromaniac were edited out of the show after a young boy emulating the character set fire to his home. It also promoted MTV to move the show to a later time slot.

- Beavis and Butt-Head creator Mike Judge provided a single line of dialogue as Kenny in the *South Park* film.

- During government hearings on violence in television, Senator Ernest "Fritz" Hollings of South Carolina famously forgot the names of the iconic characters, calling them "Buffcoat and Beavo, Beaver something." The mispronunciation was later used as a gag on the show.

- Guitarist Reb Beach of Winger blamed Beavis and Butt-Head for ruining his career. The band was a frequent target of ridicule on the show.

About Beavis and Butt-Head

Offensive, disgusting, vile, immature, and repulsive are some of the praises heaped upon the groundbreaking animated MTV show *Beavis and Butt-Head*. The show debuted in an era of doltish duos—Bill and Ted, Wayne and Garth—but *Beavis and Butt-Head* soared far below the others in their effort to satirize the dullness and pointlessness of daily life.

The show focused on the apathetic and oft pathetic lives of the two titular characters: Beavis and Butt-Head. The two dullards spend most of their time sitting in front of the TV hurling insulting commentary at music videos.

Beavis and Butthead were the voice of a generation that had little to say. They could summarize a video with a simple judgment of "This sucks" or "cool."

The characters' frequent snickering at scatological, sexual, and sophomoric humor was derided by social conservatives but widely regarded by humorists and comedians like David Letterman as inspired and subversive.

The characters were anti-role models. Stupidity incarnate, they embodied the dumbest aspects of an apathetic and at times sadistic society.

They reflected society and some, such as the watchdog group Morality in Media, say influenced it. When teenagers began imitating foolish and occasionally criminal acts seen on the show, MTV responded by adding a disclaimer: "Beavis and Butt-Head are not role models. They're not even human. They're cartoons. Some of the things they do would cause a person to get hurt, expelled, arrested, possibly deported. To put it another way: Don't try this at home."

Despite all this, the characters managed to be likeable. They brought out empathy in us, a feeling of befuddlement and sympathy toward two "delinquents" who seemed unable to better their situation. They possessed a self-destructive spirit and yet managed to survive in spite of themselves.

Perhaps it was because we all knew kids growing up just like them. Or maybe, on some level we wish we could be more like them, blissfully unaware and uncaring of the world around us with a complete disregard for social norms, safety, and decency.

Why Beavis and Butt-Head Are No. 27

The two characters encapsulated and satirized an era of indifference. As surely as the Archies represent an idealized version of the 50s teenager, B and B are the embodiment of the 90s. They ushered in a new era of shocking animation that pulled the carpet out from the children of Saturday Mornings and transformed cartoons into a late night snack for hungry teens.

—JW

28
MICKEY MOUSE

TOON-UP FACTS

Creators: Ub Iwerks, Walt Disney

Studio: Walt Disney Studios

Voices: Walt Disney (1928–1947; 1955–1959), Carl Stalling (1929), Jimmy MacDonald (1947–1977), Wayne Allwine (1977–2009), Les Perkins (1986–1987), Bret Iwan (2009–2013), Chris Dimantopoulos (2013–present)

Television debut: March 29, 1954, *Walt Disney's Disneyland*

Theatrical debut: November 18, 1928, *Steamboat Willie*

Catchphrases: "Gosh!" . . . "Hot Dog!"

Protagonists: Pete

Rival: Mortimer Mouse

Love interest: Minnie Mouse

Best friends: Donald, Goofy

Pet: Pluto

Series: *The Mickey Mouse Club* (1955–1959, 1977–1979, 1989–1996), *Mickey Mouse Works* (1999–2000), *Disney's House of Mouse* (2001–2003), *Mickey Mouse Clubhouse* (2006–2016), *Mickey Mouse* (2013–present)

Mickey Mouse Trivia

- "Hidden Mickeys" have become a phenomenon of their own. Animators, artists, and theme park designers have taken to hiding the iconic Mickey Mouse symbol throughout their work as an inside joke.

- Walt Disney did the initial voice of Mickey in the 1920s; he would fill the role through the 1940s before stepping down. He returned to voicing Mickey when the mouse began appearing on television in the 1950s.

- Mickey's big yellow shoes and red short pants with white buttons are as iconic as the character himself. But his most recognizable costume feature didn't come along until a year after his debut. He began wearing white gloves in the 1929 animated short *The Opry House*, and has worn them ever since.

- Mickey Mouse and Bugs Bunny appear on screen together in the 1988 film *Who Framed Roger Rabbit?* They had to be given the exact same amount of screen time as part of the arrangement.

- On November 18, 1978. Mickey Mouse became the first fictional character to get a star on the Hollywood Walk of Fame.

- *Steamboat Willie* was one of the first animated cartoons with sound. But Mickey didn't speak! He wouldn't deliver his first words until the 1929 animated short, *The Karnival Kid*. His first words were "Hot Dogs!" The phrase "Hot Dog!" went on to become one of his catchphrases.

- Mickey Mouse's first spoken words were not uttered by Walt. They were delivered by the legendary Warner Bros. musical composer, Carl Stalling, who was working for Disney at the time.

- Mickey did not appear in movie theaters between the years 1952 and 1983! During that time the character was on a hiatus focusing his efforts on television and theme parks.

- Mickey's voiceover artist from the 80s and 90s, Wayne Allwine, was married to Minnie's voice artist, Russi Taylor.

- Mickey is the only member of the "Sensational Six" (Mickey, Minnie, Donald, Daisy, Goofy, Pluto) whose parents have never been seen on screen.

About Mickey Mouse

Walt Disney once said, "I only hope we don't lose sight of one thing—that it was all started by a mouse." That mouse got his start in 1928.

Mickey had a rocky beginning in show business. He was created after Walt Disney lost the production rights to his most popular character, Oswald the Lucky Rabbit. Distraught over the loss and with his company in peril, he turned to his reliable animation partner Ub Iwerks and asked him to sketch up some ideas. Ub tried cats, dogs, cows, horses, and frogs before settling on a mouse at Walt's suggestion. Walt dubbed this mouse Mortimer, but Walt's wife Lillian immediately redubbed him Mickey, and a legend was born.

Mickey Mouse had a few false starts. His first completed short, *Plane Crazy*, did poorly in test screenings. When the film *The Jazz Singer* introduced sound to film, Walt Disney shelved *Plane*

Crazy and instead began working on the first fully synchronized sound cartoon and Mickey's theatrical debut, *Steamboat Willie*. The short took its name from the Buster Keaton feature-length silent film *Steamboat Bill Jr.*, released the same year. Mickey Mouse was a hit, and for the eight decades that have followed he has remained the central star in an animation empire.

Mickey's central persona in the beginning was that of the downtrodden everyman. He was a direct descendant of Charlie Chaplin's Tramp character. As time went and Mickey became a role model, his temper and frustrations were toned down and his character was given a bit more "dignity." As his silver screen reign was coming to an end, Mickey made the leap to television. His 1954 TV debut was with *Walt Disney's Disneyland* in a short segment that shared his brief life story and an animated theater short. A year later in 1955 new animation would be produced for the opening sequence of *The Mickey Mouse Club*, securing Mickey's place as a television icon. New animated segments were produced with Walt Disney himself returning to voice the iconic character. The show would keep Mickey in the public consciousness for decades in both reruns and reboots of the series.

Mickey's long-established role as the everyman gave way to a new role as a celebrity much to the chagrin of his friendly rival Donald Duck, who viewed himself as the central character in the Disney empire. During this time Mickey had become an ambassador for both the Disney Company and Disneyland. His "mouse ears" had become a costume for the cast members of the club and a top seller at the Disneyland theme park.

As the decades passed it become clear that more kids knew Mickey as a mascot than as a true cartoon character. With reintroductions in shows like *House of Mouse* (2001–2003) and *Mickey Mouse Clubhouse* (2006–2013), Mickey found a renewed following among children and his popularity continues with each new generation.

Why Mickey Mouse Is No. 28

Mickey is undeniably one of the Top 5 animated icons in world history. So the greater question might be, why does he rank so low on our list? When Mickey had his screen debut he became a worldwide phenomenon. As the popularity of big-screen animated shorts began to wane, he made the transition to television via Walt Disney's television anthologies such as *Walt Disney's Disneyland*. While this continued the visibility of Mickey, he was forced to share time with live-action segments. The same was true with *The Mickey Mouse Club*. During this same time his counterparts at Warner Bros. were being packaged into animation-centered showcases that took Saturday mornings by storm. While characters like Bugs Bunny were running amuck on Saturday morning, Mickey Mouse was transitioning into a greater role as a trademark representing a much larger enterprise. While it increased his marketability, it decreased the character's roles in animated shows, and he coasted on his legacy for many decades. It would not be until the 1990s that he would have his own dedicated show focused on him as the central character. Mickey is a true legend and an icon representing a multimedia empire encompassing film, television, comics, theme parks, video games, cruise lines, and much more. Thankfully they have never lost sight that it all began with a mouse.

—JW

29
BATMAN

TOON-UP FACTS

Creators: Bill Finger, Bob Kane
Designer: Bruce Timm
Studios: Filmation (1968–1969 and 1977–1978), Hanna-Barbera (1973–1986), Warner Bros. Animation (1992–2006)
Voices: Olan Soule (1973–1981), Adam West (1977–1985), Kevin Conroy (1992–present), Rino Romano (2004–2008), Diedrich Bader (2008–2011), Bruce Greenwood (2010–2013), Anthony Ruivivar (2013)
Animated debut: September 14, 1968, *Batman Superman Hour*
Comic book debut: May 1939, *Detective Comics #27*
True identity: Bruce Wayne
Parents: Thomas and Martha Wayne, deceased
Sidekick: Robin the Boy Wonder
Hometown: Gotham
Secret lair: The Batcave
Powers/gadgetry: Batarang, utility belt, bat signal
Vehicles: Batmobile, Batcopter, Batboat, Batcycle
Chief protagonists: The Joker, The Riddler, The Penguin, Harley Quinn, Mister Freeze, Two-Face
Defining role: *Batman: The Animated Series* (1992–1995)
Traits: Heroic, brooding, mysterious, athletic, intelligent, vigilant

BatTrivia

- In *Batman: The Animated Series*, the role of the Joker is voiced by Mark Hamill, best known for his role as Luke Skywalker in the *Star Wars* film series.

- As the show progressed the Fox network wanted the show to market toward a younger audience. In the second season they began to put a larger focus on "The Boy Wonder" and even changed the show's title to *The Adventures of Batman and Robin*.

- Unlike many animated cartoons, voice actors for *Batman: The Animated Series* recorded their parts together in the same room sitting at a table—except for Mark Hamill who frequently stood to capture the manic energy of the Joker.

- In the *Batman: TAS* episode "Beware the Gray Ghost," Adam West, TV's original Batman, plays the part of the Gray Ghost.

- The look of Batman was strongly influenced by Alex Toth's designs for the 1960 Space Ghost.

- Batman refuses to use guns in his crime-fighting crusade. However this is a departure from early incarnations in which Batman was a gun-wielding detective. That version of Batman didn't last long. As Batman creator Bob Kane said, "Batman wearing a gun just didn't feel right."

- Of the dozens of actors who have portrayed the Dark Knight over the years, Kevin Conroy holds the record spanning seven series, six animated movies, six video games, and two decades!

- The show's theme song, by Danny Elfman, is borrowed from the 1989 *Batman* movie.

- The character Bruce Wayne is named after two historical figures: King Bruce I of Scotland and Revolutionary War hero General "Mad" Anthony Wayne.

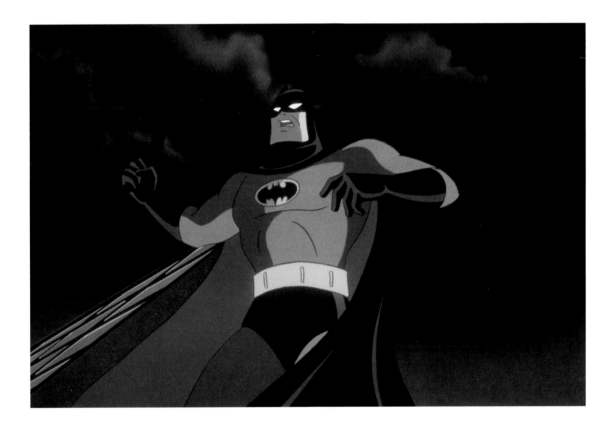

About Batman

Arguably, and people will argue, the greatest comic book superhero of all time, Batman leapt from the pages of the comics to the small screen for the first time in 1968. It was a supporting role on the *Superman* animated series, but from that point on Batman would be reinvented and reimagined dozens of times in animation.

Selecting a favorite Batman from his many incarnations can often be a generational marker, with those growing up in the 60s laying claim to Adam West and those in the 80s claiming Michael Keaton, but in the animated realm one actor crosses generations to stand above the rest: Kevin Conroy.

Kevin Conroy first served as Batman in the 1990s *Batman: The Animated Series*. The show was a departure from the bright feel-good animated superhero TV shows of the previous decades. Pulling its darker tone and palette from the Tim Burton Batman films, *The Animated Series* under the creative leadership of Bruce Timm took on a grittier film noir aesthetic. By establishing a darker more brooding Batman, the show could explore his motivation and complexities far beyond the campier Batman of yesteryear.

As voiced by Conroy, the dual roles of Batman and Bruce Wayne are given distinctive identities, allowing for storylines that explore the character's dual role in Gotham society. Ultimately Batman is defined and shines because of the stellar lineup of villains he faces, each bringing out a different aspect of his own personality in their interactions. Characters like Mark Hamill's Joker and Arleen Sorkin's Harley Quinn add a depth of personality seldom seen in animated television.

Why Batman Is No. 29

He's Batman! In the realm of cartoondom, Batman has become an almost Shakespearean character with each new actor bringing new breath and life in his own unique spin. His dark origins forged in vengeance make him one of the more complex superheroes. Batman as portrayed in *Batman: The Animated Series* drew in audiences young and old. The compelling storylines were worthy of a primetime series and garnered the show a primetime Emmy for the "Robin's Reckoning" episode, which dealt with Robin's own dark origin and his changing relationship with Batman.

—JW

30

PETER GRIFFIN

Creator: Seth MacFarlane
Studio: Fuzzy Door Productions
Voice: Seth MacFarlane
Debut: 1999 ("Death Has a Shadow")
Middle name: Lowenbrau
Parents: Mickey and Thelma
Wife: Lois
Daughter: Meg
Sons: Chris, Stewie
Dog: Brian
Vestigial twin: Chip Griffin
Hometown: Quahog, Rhode Island
Address: 31 Spooner Street
Best buddies: Cleveland Brown, Glenn Quagmire, Joe Swanson
Antagonists: Carter Pewterschmidt (Lois's father), Ernie the Giant Chicken
Employers: Happy-Go-Lucky Toy Factory, Pawtucket Patriot Brewery
Bosses: Mr. Weed (Happy-Go-Lucky Toy Factory); Angela (Pawtucket Patriot Brewery)
Favorite hangout: The Drunken Clam
Defining role: *Family Guy* (1999–2003, 2005–present)
Traits: Irresponsible, dumb, self-centered, unsympathetic, loutish, insensitive, careless

The Poop on Peter

- In one of many politically incorrect moments on the show, it is revealed that Peter is "retarded" after he takes an IQ test in *Petarded* (2005). A game of Trivial Pursuit in which he struggles to answer questions meant for preschool children confirms the lack of intelligence viewers had been aware of for years.

- MacFarlane has revealed that his voicing of Peter was inspired by sitcom characters such as Ralph Kramden (*The Honeymooners*) and Archie Bunker (*All in the Family*).

- The town of Quahog is stated to be close to Providence, the skyline of which can be seen frequently in episodes of *Family Guy*. MacFarlane is from nearby Connecticut.

- Peter's favorite song is the 1960s novelty hit "Surfin' Bird" by the Trashmen. The song is played on a jukebox at a restaurant, prompting Peter to break into an impromptu dance and embarrass his family in the episode "I Dream of Jesus" (2008).

- MacFarlane gained experience working with Hanna-Barbera on such Cartoon Network hits as *Dexter's Laboratory*, *Cow and Chicken*, and *Johnny Bravo* before earning his greatest notoriety by creating *Family Guy*.

- Peter is revealed to be Irish. He also speaks with a rather distinct Boston accent.

- The occasional mugging or eye-rolling at the camera and even a rare line uttered to the viewer proves that Peter is aware that he is a fictional character.

- Wife Lois is voiced by Alex Borstein, who previously toiled as a cast member of the sketch comedy show MADtv.

- Though the cutaways on *Family Guy* are often quite spontaneous and random, perhaps the most out-of-left-field moments are the epic and bloody battles between Peter and Ernie the Giant Chicken, who is his most frequently shown antagonist on the show.

- Peter's prodigious appetite is featured when he eats thirty hamburgers, then suffers a stroke that paralyzes the left side of his body in "McStroke" (2008). He is cured after a five-minute session in a stem cell research lab.

- Lacey Chabert voiced Meg in the first season of *Family Guy*, then fellow actress Mila Kunis assumed the role. Both have been considered sex symbols, which is ironic given that much of the humor directed at the hapless Meg revolves around her homeliness.

About Peter Griffin

Little could MacFarlane have imagined when he created *The Life of Larry* as a student at the Rhode Island School of Design that Larry would eventually morph into Peter Griffin and *Family Guy* would emerge as an animated megahit.

There are few physical similarities—Peter looked little like Larry aside from the round face. But his stupidity and sloth-like existence had been established. Peter is the ultimate dolt, which he does not compensate for with a giving heart. The man-child is too immature to deal with the responsibilities of husbandry or parenting. Furthermore, he is too uncaring and even cruel at times in his relationship with family members, particularly Meg, whom he torments unmercifully.

That treatment of Meg ties in with the political and social incorrectness that MacFarlane seems to embrace in his production of *Family Guy*. Whereas one understands the importance of building up the self-worth of teenagers in real life, Peter seeks to destroy that of his daughter with every sarcastic comment or humiliating joke. Viewers must understand that Peter is a boorish lout and a horrible father while not taking him or the show seriously to embrace the humor. He does develop more respect for Meg in later seasons, but prefers to hide his feelings.

Peter feels most comfortable in front of a television set and drinking beer in his favorite booth with his buddies at The Drunken Clam. He boasts the attention span and intelligence level of a small child. After all, among his favorite activities is farting.

It might be sad to those who take *Family Guy* with more than a grain of salt that he is raising his son as a clone. Chris too is a dolt with regrettable social skills. Peter seems to care more about Chris than he does Meg, but is too blind to understand that he is leading his son down a terrible path. In fact, Peter relishes the fact that Chris is just like him.

Family Guy has not been tied down to consistent characterization over the years. That has resulted in occasional moments of mental sharpness and even sympathy in Peter. But MacFarlane recognized first and foremost the importance of keeping the laughs coming in a fast-paced manner, particularly in the show's early years, and that the humor was greatly dependent on Peter being Peter—farts and all. Later forays into depth and seriousness of characterization targeted Brian and Stewie.

Allowing Peter to grow emotionally and intellectually might have been a death knell to *Family Guy*, which has rivaled *The Simpsons* as one of the most successful primetime cartoon shows in television history.

Why Peter Griffin Is No. 30

Granted, you must watch *Family Guy* with the same mindlessness and heartlessness as Peter displays just about every moment to embrace his character. You must remind yourself that he's merely a cartoon character and not a reflection of humanity to enjoy the laughs. If you can't divorce yourself from reality, don't bother watching because—bottom line—Peter Griffin is really funny.

Peter provides manic humor from beginning to end. His lack of sympathy, self-centered mindset, childish behavior, and sloth-like existence are the essence of his character. He has been compared in that respect to Homer Simpson on steroids. He brings physical humor to the screen as well, from his epic, bloody battles with Ernie the Giant Chicken to his spontaneous dancing. So, turn off your mind, close your heart, and laugh at Peter Griffin. From the standpoint of humor alone, few characters in the history of animation have brought more to the small screen.

—MG

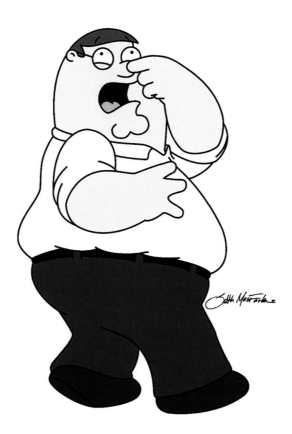

31
ASTRO BOY

TOON-UP FACTS

Creator: Osamu Tezuka
Studio: Mushi Productions
Voices: Billie Lou Watt (1963–1966), Patricia Kugler Whitely (1980–1991), Candi Milo (2003–2007)
Debut: January 1, 1963 (*Atom Boy,* Japan), September 7, 1963 (United States)
Manga debut: 1951, *Ambassador Atom*
Japanese name: Tetsuwan Atomu (Mighty Atom)
Powers: Rocket-powered flight, superhuman endurance, built-in machine gun, super hearing, headlight eyes, and innate ability to distinguish between good and evil
Antagonists: Mr. Cacciatore aka Ham Egg, Dr. I.Q. Plenty aka Dr. Fooler
Inventor: Dr. Astor Boynton II
Hometown: Niiza, Saitama
Defining role: *Astro Boy* (1963–1966)

Astro Trivia

- The first TV version of *Astro Boy* was a live-action series from 1959 to 1960.

- The original animated series aired in black and white.

- In 2007 Astro Boy was named Japan's envoy for overseas safety.

- Osamu Tezuka is regarded as one of the great animation masters. Besides Astro Boy he were also the creative force behind *Simba the White Lion*, which was the inspiration for *Disney's Lion King.*

- The distinctive large rounded eyes used in much anime were pioneered by Tezuka and were directly influenced by western cartoons such as Mickey Mouse.

- The city of Niiza, Saitama, Japan, added Astro Boy to its records as a registered citizen in April of 2003, the same year "in the distant future" that the animated series took place.

- Astro Boy was originally titled the *Mighty Atom*. The name was changed for American audiences because of similarities to the character Mighty Mouse, which had in fact been one of Tezuka's inspirations for the "Mighty" boy robot.

- The Astro Boy manga books have sold over one hundred million copies.
- Osamu Tezuka was a big fan of Walt Disney, and the two of them met at the 1964 World's Fair. As it turned out Walt Disney was a fan of Astro Boy!
- Voiceover artist Billie Lou Watt's final role was as the voice of Ma Bagge on the series *Courage the Cowardly Dog*.

About Astro Boy

Astro Boy first took flight in 1952 as a popular Japanese manga publication by the legendary Osamu Tezuka. Widely regarded as the "God of Manga" and father of Japanese anime, Tezuka brought his character to animated life as *Tetsuwan Atomu* on New Year's Day 1963. In September of that same year, NBC would bring the series across the ocean to American shores for syndication, making it the first anime series introduced to US markets. The US version culled the original 193 episodes down to 104. Those episodes would run in syndication through the 1970s and see resurgences in the 1990s and 2000s.

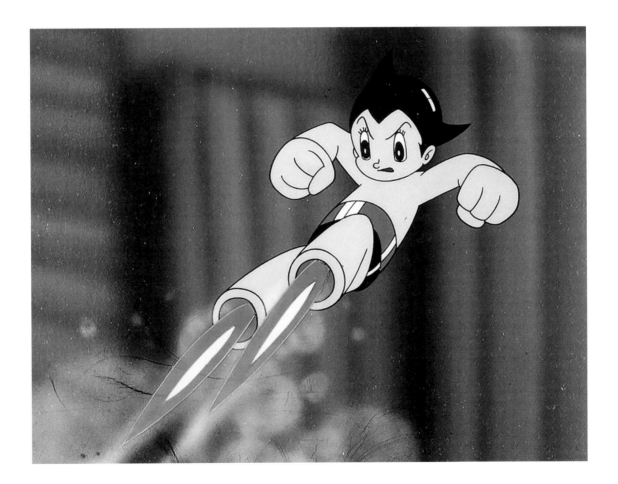

Astro Boy followed the adventures of a young robot with tremendous powers. The robotic lad was created by Dr. Astor Boynton, who while grieving over the loss of his own son built the robot in the child's image. Realizing the mechanical incarnation was no replacement for a human child, he sold Astro Boy to the sadistic circus showman, The Great Cacciatore (Ham Egg in the Japanese translation).

Eventually he was granted his freedom thanks in part to the passing of the "Law of Robot Rights" granting robots the ability to lead similar lives to humans.

Astro's ability to see the best in humanity leads him to act as a protector of the species, using his ability and gadgetry to fight crime and right injustice.

The formulaic "superhero" stories were a device for a more thoughtful allegory exploring racial prejudices, as robots and humans learned to interact with one another side by side in the far off future of the year 2003.

Astro Boy embodied the best qualities of both human and robot and served as a common hero, establishing peace and unity between the human and robotic races.

A technically superior color remake was produced in the 1980s. It maintained many of the original characters and pulled from the same source material, but had a noticeably darker tone that appealed to an older sci-fi fan base as the audience for animation matured.

Why Astro Boy Is No. 31

Astro Boy served as a positive role model who shared an optimistic worldview in a sci-fi genre often filled with dystopian futures. That a generation emerging from the recovery of a world war found enjoyment, laughter, and thoughtful content in a series produced by a man from a country only recently regarded as adversarial is a testament to the powerful charm of the character. The stylized hybrid of American and Japanese design made Astro Boy an informal ambassador of the two countries who embraced his positive message.

Astro Boy introduced anime to American audiences and in the process began a phenomenon that continues to this day. Its historical significance and impact alone warrants a place on this list and in our hearts.

—JW

32
MIGHTY MOUSE

TOON-UP FACTS

Creators: Izzy Klein, Paul Terry, Tom Morrison
Studio: Terrytoons
Voices: Roy Halee, Tom Morrison, Allen Swift, Alan Oppenheimer, Patrick Pinney
Debut: 1942 (*The Mouse of Tomorrow*)
Catchphrase: "Here I come to save the day!"
Antagonist: Oil Can Harry
Love interest: Pearl Pureheart
Defining role: Theatrical shorts
Top TV venue: *Mighty Mouse Playhouse* (1955–1967)
Traits: Heroic, pure, invincible, humble

Mouse Meanderings

- Bizarre comedian Andy Kaufman sought laughs by playing the Mighty Mouse theme on a record and singing only the "Here I come to save the day" part.

- Izzy Klein originally proposed a spoof of Superman using a super fly. It turned out the only Superfly in entertainment history would be a song sung by Curtis Mayfield and a movie starring Ron O'Neal in 1972. The Terrytoons art department opted for a mouse.

- Was originally named Super Mouse. Though many assumed the name change was motivated by the threat of legal action from the owners of Superman, it was due to a Terrytoons employee using Super Mouse in a new comic book in October 1942, the same month *The Mouse of Tomorrow* was released to theaters.

- Pearl Pureheart was not his only love interest. In earlier shorts he was sweet on Gypsy Princess, Sweet Susette, and Krakatoa Katy. The latter once set off a volcano through her sizzling dance routine.

- Several explanations for his superpowers emerged from various cartoons. The original from *The Mouse of Tomorrow* showed him charging up through a bath in Super Soup, a meal of Super Celery and Super Soup, and a plunge into Super Cheese. But later shorts showed him gaining his magic by swallowing Vitamins A through Z and drinking from a jug labeled "Atomic

Energy." Yet another claimed he had been raised as an orphan mouse and had his powers all along. That explanation was closer to the Superman storyline.

• First appeared in comic books in 1945. The Terrytoons comics were published by Timely, which later changed its name to the far-more-famous Marvel.

About Mighty Mouse

If not for Superman, Mighty Mouse likely never would have graced the silver and small screens. The wildly popular caped hero inspired former Disney story writer Izzy Klein to propose the Terrytoons response: a super fly. Paul Terry believed such a character would prove difficult to draw well or stand out against a larger villain, so he suggested to his crew that a mouse would work better. The result was the birth of Super Mouse, who was eventually renamed Mighty Mouse.

The initial problem with the new character was that his presence wasn't required until the end of the story. He was called upon only after the cat had terrorized the mice to the point at which their lives are endangered. Donning a red cape, he would emerge as a humanized, two-footed flying mouse with super speed and even mystical mental powers to destroy the ferocious feline.

Terrytoons attempted to remedy the problem by giving him a second persona in the form of a mysterious stranger that later changes into a hero—a takeoff on Clark Kent and Superman. That tactic placed Mighty Mouse in the role of battling famous historical natural disasters such as the Johnstown Flood and Krakatoa. But Paul Terry later admitted the audience's desire to see the hero destroy menacing cats and the like made those plot attempts unsuccessful.

Mighty Mouse was launched as a parody of Superman, red cape and all. He wore a gold leotard, red cape, boots, and pants. He was modest and humble, even bashful among female rodents to whom that shyness proved attractive. His morality and loyalty to his fellow mice were driving forces. He fought fairly against those who used trickery. He understood and embraced his role as a force of good against evil, often represented by such characters as Oil Can Harry.

The studio finally found a way to utilize Mighty Mouse for the full seven minutes of its shorts in the mid-to-late 1940s. Terrytoons placed him in the same role as Strongheart, a Nelson Eddy–type character it had used along with Silk Hat Harry and Fanny Zilch in musical spoofs known as "mellerdramas" in the 1930s. Mighty Mouse replaced Strongheart while Silk Hat Harry was transformed into Oil Can Harry. Pearl Pureheart was added to the mix as the damsel in distress and all the dialogue was spoken in operetta style rather than voiced. The first such undertaking was *Mighty Mouse & the Pirates* (1945). The formula worked and gave Mighty Mouse far more screen time.

Terrytoons was sold to CBS in 1955. Mighty Mouse was scrapped for a while, but returned in December of that year in *Mighty Mouse Playhouse*, a half-hour program that has been cited as the first building block for the Saturday morning cartoon fare that became popular among baby boomers for a generation. The show remained in place through 1967. Mighty Mouse returned in new shorts in *The New Adventures of Mighty Mouse and Heckle and Jeckle* (1979) through Filmation in 1979, but was animated cheaply and lasted just sixteen episodes. *Mighty Mouse, The New Adventures* (1987) proved far more appealing despite low TV budgets.

Why Mighty Mouse Is No. 32

No cartoon superhero was more dedicated to his moral duty than Mighty Mouse. His seriousness in fighting evil and rescuing the helpless from the clutches of villains gave him a beloved character that would be embraced by movie and television audiences for well over a half-century.

Mighty Mouse brought a sort of mysticism or God-like quality to the screen. He arrived like a bolt from the sky when all appeared doomed for the helpless mice. Paul Terry explained that in the same way someone at wit's end might exclaim, "It's in God's hands now," Mighty Mouse would fly down from the heavens to save the day. Though there was little variety in the formula, even after the shorts became operettas, the greatness of Mighty Mouse as an invincible and unflinching representative of righteousness places him among the best and most unlikely super-heroes ever.

—MG

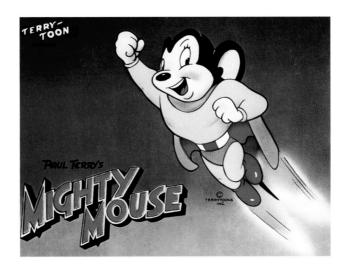

33
MR. MAGOO

TOON-UP FACTS

Creators: Millard Kaufman, John Hubley
Studio: United Productions of America (UPA)
Voice: Jim Backus
Debut: 1949 (*Ragtime Bear*)
Catchphrase: "Oh, Magoo, you've done it again!"
Handicap: Near-blindness
Defining role: Theatrical shorts
Top TV venue: *Mister Magoo* (1960–1962)
Traits: Oblivious, determined, honorable, reckless, self-confident

Magoo Minutiae

- Magoo's first name was Quincy.

- Jim Backus was not known for his cartoon voices. He was more famous as an actor, particularly for his roles as James Dean's father in the iconic *Rebel Without a Cause* and as eccentric millionaire Thurston Howell III in memorable TV comedy *Gilligan's Island*.

- Backus did not embrace his connection with Mr. Magoo in later years, believing he had been typecast and referring to the character as a "little jerk," and "pain in the posterior." Backus added that he wanted to "bury the old creep and get some good dramatic roles in movies." Despite it all, he at one point boasted a vanity license plate that trumpeted himself to be "Q MAGOO."

- Among the inspirations for the creation of Magoo was cranky comedian W. C. Fields, though the former proved—especially in his later years—to be far more upbeat. The two are physically comparable, especially their bulbous noses. Another inspiration was claimed to be Hubley's stubborn uncle Henry, who refused to change his mind once it was made up.

- Though Magoo was always the star of the show, several compatriots came and went, most notably nephew Waldo (who in his raccoon coat Magoo thought was a grizzly bear in *Ragtime Bear*). Girlfriend Millie and best friend Prezley arrived in the 1960s. Among his pets was a cat named Bowser, whom he mistook for a watchdog.

- The old-fashioned Magoo, whom Backus joked yearned to see William McKinley re-elected as president, drove a yellow 1913 Stutz Bearcat automobile.

- The opening theme showed Magoo driving on top of a train, barreling through a barn (displacing chickens, a pig, and a cow along the way), splashing through a mud hole, running over a fire hydrant, getting his car picked up by a crane, and hurtling into a high-electricity building.

- Magoo recognizes his nearsightedness in *Fuddy Duddy Buddy* (1951) when he is told he has been playing tennis with a walrus. UPA writer Bill Scott later admitted it was a mistake because any continued realization of his shortcoming would have "ruined his character."

- Dell Comics introduced Mr. Magoo in 1952. He appeared in more than a dozen of its productions over the next decade, sharing the spotlight with Gerald McBoing Boing, who had become a quite successful follow-up character for UPA less than two years after the launch of the nearsighted star.

About Mr. Magoo

Mr. Magoo was nurtured and harvested in the studios of United Productions of America, but the seeds for his creation were planted at Disney. Several animators who had become disenchanted with Walt Disney formed UPA in the 1940s, though they at first concentrated on producing animated films. A contract with Columbia Pictures signed in 1948 allowed them to produce animated theatrical shorts. A promising future attracted talent to the studio.

They decided that one way to separate themselves from others such as Disney and Warner Bros. would be to create human cartoon stars rather than animals. The result was Mr. Magoo (and later Gerald McBoing Boing). Columbia was reluctant in its acceptance of Magoo, whose success can be traced greatly to the unique characterization and distinctive voice provided by Backus.

The near-blindness of the crotchety old curmudgeon, who mumbles his way through short after short, provided an ideal outlet for sight gags. He mistakes wild animals for human friends, airports for movie theaters, stoplights for police officers, and construction sites for amusement parks. The result was constant peril for Magoo (who was somehow given a driver's license) and everyone unfortunate enough to get in his way. Yet he manages to emerge unscathed in the end while wreaking havoc upon others.

It did not take long for Magoo to become the most popular UPA character and a critical success. Director Pete Burness, who assumed control of the series from Hubley in the early 1950s, helped churn out premier shorts such as *When Magoo Flew* (1954) and *Mister Magoo's Puddle Jumper* (1956), both of which earned Oscars. In late 1953, the studio had fulfilled its strongest desire by producing two shorts based on literary classics. *Tell Tale Heart* was based on the Edgar Allan Poe suspense thriller, while *Unicorn in the Garden* was inspired by a short story written by James Thurber.

Financial reality eventually forced UPA to produce more Magoo cartoons at the expense of ultimate creative satisfaction. Magoo underwent a metamorphosis in time, changing from a bad-tempered old man into a rather good-natured, helpful soul, a change Burness later admitted proved regrettable. The shorts themselves were transformed from literally and figuratively dark to lighter and brighter in style and content.

His popularity remained intact, so much so that UPA produced *A Thousand and One Nights* (1959), the one and only Magoo full-length feature. The film, which revolved around Baghdad lamp dealer Azziz Magoo, was heavily promoted through advertising, publicity, and the sale of Magoo merchandise. It failed to attract large audiences, but Magoo remained popular enough to motivate UPA to feature him on television.

The requirements of TV production forced the studio to create 130 Magoo shorts from 1960 to 1962. Budget constraints resulted in animation shortcuts, but Magoo proved quite popular during that time and in later syndication. *The Famous Adventures of Mr. Magoo* followed in 1964, as did holiday and other specials.

DePatie-Freleng, known for their Pink Panther cartoons, bought the rights to Magoo and revived the character in a new television undertaking titled *What's New, Mister Magoo* in 1977 in which Backus also voiced a talking dog named McBarker. That program, however, lasted just one season. The death of Backus in 1989 destroyed hopes of further projects. Some cartoon characters such as Fred Flintstone could remain alive with another voice, but Backus *was* Mr. Magoo.

Why Mr. Magoo Is No. 33

Magoo is celebrated as among the most distinctive cartoon characters ever. His nearsightedness (putting it kindly) created a myriad of sight gags, his voice and original personality were a tribute to Backus, and the fact that he was a human star made him unique at the time. None of that would have mattered had the shorts not been funny, but they were downright hilarious. Despite the fact that every cartoon revolved around creating humor off Magoo's inability to see, the studio managed to consistently create fresh material. That was an accomplishment given its prolific output.

It's no wonder considering the creative effort that went into the making of Magoo that his shorts won two Academy Awards. Unlike hundreds of other cartoon characters who required sidekicks to maximize their comedic potential, Magoo needed only his own personality, a few objects to misidentify, and a few hapless victims to elicit laughter.

—MG

34
KORRA

TOON-UP FACTS

Creators: Michael Dante DiMartino, Bryan Konietzko
Studio: Nickelodeon Animation Studio
Voice: Janet Varney
Debut: April 14, 2012, *The Legend of Korra* (Episode: "Welcome to Republic City")
Parents: Tonraq and Senna
Powers: Waterbending, earthbending, firebending, energybending
Pet: Naga
Love interest: Asami Sato
Mentor: Katara
Weapon of choice: The elements, glider staff
Traits: Strong, stubborn, intelligent

Korra Trivia

- Air Temple Island is populated by strict vegetarians, and is a source of frustration for Korra who is a carnivore and craves meat.

- Though *The Legend of Korra* is an American show, the production responsibilities were split between studios in the United States, South Korea, and India.

- Korra is one of only three female avatars. The other two are Yangchen and Kyoshi.

- When confronted in locations where she shouldn't be, she will frequently respond, "I'm looking for the bathroom."

- Korra's physical appearance was inspired in part by Mixed Martial Arts fighter Gina Carano.

- *The Legend of Korra* was the first animated voiceover role for legendary actress Eva Marie Saint, who began her acting career in 1954 alongside Marlon Brando in *On the Waterfront*. In *Legend of Korra*, she plays the role of Katara.

- Eagle-eyed viewers may catch a subtle character quirk. Asami's eyes change from green to yellow when her emotions change.

- Several characters take their names from real spiritual leaders. Tenzin's name derives from the fourteenth Dalai Lama, Tenzin Gyatso, and Pema is named after famed Buddhist nun Pema Chodron.

- Korra is named after a dog the creators were introduced to at an eco-lodge while traveling.

- Korra is a sequel to the animated series *Avatar: The Last Airbender* and was originally titled *Avatar: The Legend of Korra*. However due to a copyright dispute with James Cameron, the "Avatar" was dropped from the title.

About Korra

The Legend of Korra is a rare animated television sequel. Korra is the immediate reincarnation of Avatar Aang (*Avatar: The Last Airbender*). As the newly reborn Avatar she is the mediator of balance, harmony, peace, order, and reconciliation. Korra was born in the Southern Water Tribe; by the age of four she presented herself to the Order of the White Lotus as the new Avatar. Already skilled at water-, earth-, and firebending, she honed her skills under the guidance of Katara.

As a young child she was drawn out into a snowstorm by a pack of polar bear dogs. Sneaking away from her parents, she discovered a lost pup that was separated from the pack. The two of them bonded almost immediately. Surviving the storm, she returned home with her newfound pet Naga, who would remain by her side from that point onward.

At age seventeen, as she entered young adulthood she fled in search of Air Temple Island. There she continued her training. It was during this time that she met her future love interest, Asami Sato. Eventually she returned to the Southern Water Tribe; it was there that she connected with her spiritual side, gained the power of energybending, and mastered the Avatar state.

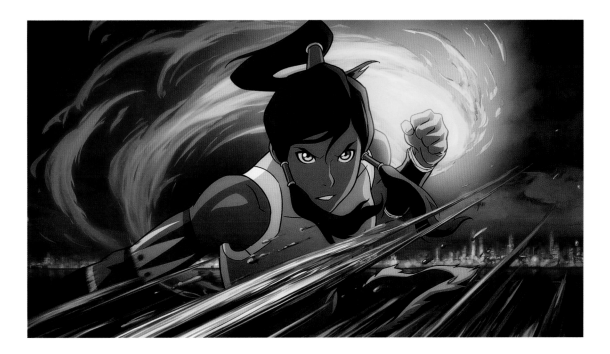

Korra is in many ways the opposite of her previous incarnation, Aang. Whereas Aang was a peaceful, calm Airbender, Korra is impatient, temperamental, and aggressive. Where Aang tried to escape his responsibilities as the Avatar, Korra was anxious to take her place from a young age.

Building a sequel around a female character was considered a risky venture. Initially the network was concerned that "only girls watch girls" and the show was put on hold. After screenings proved that Korra had a broad appeal to both girls and boys, the show was fast-tracked and proved very popular.

Korra is one of the strongest female leads in children's television and has proven her mettle again and again throughout her adventures.

Why Korra Is No. 34

Korra is a groundbreaking character on many levels. Without doubt she is one of the few and without a doubt strongest female leads in children's television history. Her strength provides an important message to young girls. When Korra was a child, she was very insecure about herself because her body appeared more masculine and she wanted to be leaner and "pretty" like other girls. Her self-perception changed after a conversation with Katara who told her that the world needs strong women like her.

Korra also holds the important distinction as being the first bisexual character portrayed in Western children's television. She is portrayed as being in a same sex relationship with her partner Asami. Their relationship evolved organically over the duration of the show. In the finale they were seen walking together hand in hand into the spiritual portal in what became an affirmation of their love for one another.

That final minute of screen time secured Korra's place in animation history and in many ways fulfilled the character's mission to open new doors and bring about balance, harmony, peace, order, and reconciliation.

—JW

35
CRUSADER RABBIT

TOON-UP FACTS

Creators: Alexander Anderson, Jay Ward
Studios: Television Arts Productions, Creston Studios, Jay Ward Productions
Voices: Lucille Bliss (1948–1951), Ge Ge Pearson (1956–1959)
Debut: 1948, *The Comic Strips of Television*
Sidekick: Ragland T. Tiger aka Rags The Tiger
Protagonists: Black Bilge, Gaston Glub, Whetstone Whiplash, Bilous Greene, Dudley Nightshade
Defining role: *Crusader Rabbit* (1949–1951)
Traits: Nearsighted, speedy, helpful, kind, brave, shy, curious

Trivia

- Jay Ward would go on to create Rocky and Bullwinkle and many other characters using the lessons he learned from his experiences producing Crusader Rabbit.

- Lucille Bliss, who had a long career in voiceover work, voiced Crusader Rabbit. She is best known for her work as the voice of Smurfette.

- The show's black and white animation was produced in Alex Anderson's garage studio in Berkeley, California. The camera he used is now on display at the Cartoon Art Museum of San Francisco.

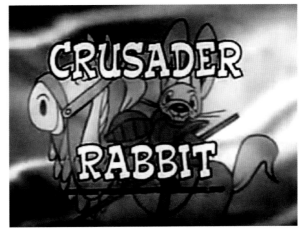

- Alex Anderson, co-creator of the show, was the nephew of famed animator Paul Terry of Terrytoons, the force behind Mighty Mouse and Heckle and Jeckle.

- The first concept for Crusader was called "Donkey Hote" and featured a donkey in the lead role.

- Traditional animation required roughly forty drawings per foot of film. *Crusader Rabbit*'s limited animation

style required only four cels, which reduced the cost to roughly twenty-five hundred dollars per episode.

- The studio where *Crusader Rabbit* was animated was just a few blocks away from the Clarence Bullwinkel Ford car dealership. That name stuck with them and would be used later for one of Ward's most famous characters, Bullwinkle J. Moose.

- The music for *Crusader Rabbit* was scored by Clarence Wheeler, who went on to score over one hundred cartoons for Walter Lantz Studios.

- The "T" in Rags T. Tiger stands for Larry. His father couldn't spell.

About Crusader Rabbit

In the era before *Crusader Rabbit*, cartoons were inexpensive filler material culled from preexisting animated movie shorts that had been cast aside in film cans collecting dust. They were produced with film audiences in mind, and while those cartoons were reasonably well done, they didn't take advantage of the benefits of the new television medium. *Crusader Rabbit* changed all that.

Initially part of a proposed series entitled *The Comic Strips of Television*, *Crusader Rabbit* was picked out of the proposal by NBC for syndication. Though it didn't air as a network telecast, it was made available to affiliates. This earned it a place as the first animated TV series.

The concept pulled from cliffhanger serials, encouraging the watchers to tune in to the ongoing "crusades" of Crusader Rabbit and his companion Rags.

The well-read Crusader Rabbit was a fan of Don Quixote, the Knights of the Round Table, and other heroic figures from which he drew his inspiration and values. The character's traits were designed to be contrary to his appearance of a small powerless bunny. His unmatched bravery took him on brave adventures battling injustice throughout America and beyond.

His first adventure, *Crusader Rabbit Vs. the State of Texas*, saw our hero head off to Texas to help free his multitude of rabbit cousins (all named Jack). The adorable little white rabbit fought for freedom and justice through 195 episodes before retiring, only to be called back into action (this time in color) in 1957 for another 260 escapades!

Why Crusader Rabbit Is No. 35

Crusader Rabbit holds a distinct place in history as the first animated character created specifically for television. He laid the groundwork for the type of humor, action, and heroics that would come to be expected from animated TV series for decades to come. The work Jay Ward did on Crusader Rabbit would directly influence other characters on our list such as Rocky and Bullwinkle, who in turn would influence countless other shows. But it all began with this little white rabbit. While he may not rank #1 on the list, he will forever rank #1 in the book of animated television history.

—JW

36
UNDERDOG

TOON-UP FACTS

Creators: Buck Biggers, Chet Stover
Studio: Total Television Productions
Voice: Wally Cox
Debut: 1964 ("Safe Waif")
Catchphrase: "There's no need to fear! Underdog is here!"
Superpowers: Flying, x-ray vision, super hearing, super strength
Love interest: Sweet Polly Purebred
Antagonists: Riff Raff, Simon Bar Sinister, Overcat
Power source: Super Energy Pill
Changing room: Phone booth
Defining role: *Underdog* (1964–1967)
Traits: Heroic, mild-mannered, humble, caring, brave, strong

Beagle Bites

- The bespectacled, scrawny Cox was an original regular on legendary television game show *Hollywood Squares*. He remained a panelist from 1965 to 1973.

- The *Underdog* theme brags of the hero boasting "speed of lightning, roar of thunder" and "fighting all who rob and plunder."

- Total Television bit the dust in 1969, but not before producing three notable cartoons in *King Leonardo and His Short Subjects*, *Tennessee Tuxedo and His Tales*, and *Underdog*.

- *Underdog* started on NBC, switched to CBS in 1966, then returned to the peacock network as a rerun entity in 1968.

- The voice of Polly was that of Norma McMillan, who also served as a voice actor for *Casper the Friendly Ghost* and *Gumby*.

- The overdramatic narration in *Underdog* was provided by Broadway actor George S. Irving, who also played the role of a rich man in a midlife crisis, unwanted guest, and Archie Bunker relative Russ DeKuyper in a memorable episode of *All in the Family*.

- Networks that showed reruns in the 1980s and early 1990s removed scenes in which Underdog popped his Super Energy Pill, fearing it would lead young viewers to take drugs.

- The phone booth in which Shoeshine Boy transformed into Underdog always exploded upon his conversion.

- Biggers and Stover were in the advertising business before helping launch Total Television Productions in 1959. They had toiled with General Mills in creating animated characters for its cereals.

- The name of super criminal Riff Raff originally began with "Raft" after Hollywood gangster character George Raft. The animated character was designed to look like Raft.

- Polly played a television reporter in *Underdog* episodes. Aside from her black doggie nose, it was hard to tell she was a canine. She dressed up like a woman-about-town, showed no tail, and covered her ears with shoulder-length whitish hair.

- Among the backup segments shown on *Underdog* was *Go Go Gophers*, which featured Native American characters Ruffled Feathers and Running Board battling for territorial rights against Colonel Kit Coyote and Sergeant Okey Homa. The episodes were popular enough to land the rodents their own series in 1968.

About Underdog

This heroic beagle was the most famous and successful character created during the short-lived, but fruitful era of Total Television Productions. Though Tennessee Tuxedo (voiced by *Get Smart* star Don Adams) and walrus buddy Chumley had their charms, they proved to be no match for Underdog's popularity and legacy.

Nondescript Shoeshine Boy, who was a canine rather than a boy, transformed himself Superman-style (cape, phone booth, and all) into Underdog when his x-ray vision or supersonic hearing detected trouble, often from a stable of wonderfully named earthly crooks such as Riff Raff or Simon Bar Sinister. He would also sometimes battle alien forces of evil that yearned to take over the planet. Underdog would fly into action to save the world or, at the very least, fellow canine Sweet Polly Purebred. Of course, he got some help from his "Super Energy Pill."

Underdog, a short, black-and-white beagle, spoke almost exclusively in rhymed couplets, which added to his noteworthiness. He was downright timid as Shoeshine Boy, but gathered up far more courage as the title character despite remaining humble. He took on foes far meaner and sometimes hundreds of times bigger. How he overcame said adversaries was never fully explained aside from the effects of his super drug hidden in his ring, but that mattered not to the citizenry that had come to depend on him for their very lives. Underdog always saved the day.

Underdog premiered in the fall of 1964 and continued to be aired until the late summer of 1973, though Total Television Productions had ceased to exist for four years by that time and had stopped making new episodes in 1967. A total of sixty-two half-hour episodes were created. Nickelodeon picked up reruns of the series for a few years in the early 1990s. A poorly received real-life movie titled *Underdog* was released in 2007.

Why Underdog Is No. 36

The contrast between the personality of Shoeshine Boy—and even that of Underdog himself—and his heroism made the character particularly intriguing and memorable. The meek voice of Wally Cox proved ideal for the perfectly named character. He was, after all, the ultimate underdog. Underdog was, after all, no Superman. He was small in stature, but big in heart and courage.

—MG

37
HARLEY QUINN

TOON-UP FACTS

Creators: Paul Dini and Bruce Timm
Studio: Warner Bros.
Voice: Arleen Sorkin
Debut: September 11, 1992, *Batman: The Animated Series,* "The Joker's Favor"
True identity: Harleen Frances Quinzel
Former profession: Psychologist
Love interest: Mr. J aka The Joker
Accent: Brooklyn
Best friend: Poison Ivy
Father: Nick Quinzel
Mother: Sharon Quinzel
Antagonist: Batman
Trademark weapon: Oversized mallet
Defining TV role: *Batman: The Animated Series* (1992–1995)
Former place of employment: Arkham Asylum
Traits: Loyal, devoted, intelligent, acrobatic

Harley Quiz:

- Her pet hyenas are named Bud and Lou, a reference to the comedy duo Bud Abbott and Lou Costello.

- Harley Quinn's creation was inspired in part by her voice-over artist, Arleen Sorkin. Sorkin had appeared in the television soap opera, *Days of Our Lives.* In one episode's dream sequence, she had briefly dressed as an actual harlequin. It was that moment that inspired the creation of the Batman foe.

- Film director and comic geek Kevin Smith named his daughter Harley Quinn Smith after the character.

- Harley is one of the few characters from the animated series to become part of the formal comic book canon. The character was given her origin story in the comic book, which was then produced as a part of the series as well.

- Harley is immune to all toxins, thanks to a potion from her companion Poison Ivy.
- Outside of the animated universe, Harley has had some interesting crossovers. She has appeared alongside the Teenage Mutant Ninja Turtles, The Spirit, and even Scooby Doo.
- Harley's sadomasochistic relationship with the Joker is summed up when she sings the song "Say That We're Sweethearts Again." Virginia O'Brien first popularized the song in the 1940s. The song includes such cheerful lyrics, as "I never knew that you and I were finished until that bottle hit my head, so I tried to be aloof when you pushed me off the roof . . ."
- Harleen first transformed into Harley Quinn and helped the Joker escape Arkham Asylum on April 1, April fools day!
- In the sixteenth episode of season three, Harley reveals one of her deepest secrets; she isn't a real blonde!
- The Joker first suggests to Harley that she call him "Mr. J." It's one of a few nicknames Harley has for her love interest. Her preferred moniker for him is "Puddin."

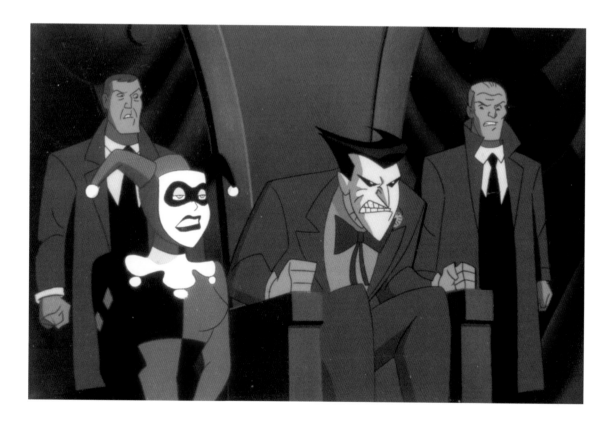

About Harley Quinn

Harley Quinn first appeared in what was meant to be a one-off episode as one of the Joker's henchman. In the episode "The Joker's Favor," the Joker was to jump out of a cake dressed as a woman. When writers questioned whether the Joker would dress as a woman, Paul Dini and Bruce Timm suggested a female henchman instead. The character was based on Dini's personal friend, soap opera star Arleen Sorkin, who was hired to voice the character as well. Harley Quinn proved so popular that she was soon given a backstory and became a recurring character.

Harleen Quinzel was a promising psychologist interning at Arkham Asylum when she first met the Joker. She began interviewing him in the hope of including his "interesting case" in a book. Through careful manipulation and a fictionalized story of abuse at the hands of his father, the Joker won her sympathy ,and soon she was deeply enamored with him.

Though Harley's love is frequently unrequited, the Joker has been known to show signs of jealousy. Their relationship is a complicated one, with not-so-subtle underpinnings of sadomasochism.

Harley is highly intelligent; however her "insanity" frequently causes her to make foolish and sometimes clumsy mistakes. Unlike the Joker, she is able at times to drop the Harley façade and take on the role as Dr. Quinn, for example, when needing a disguise for one of their various capers.

The on again/off again relationship between the Joker and Harley is sometimes considered an abusive one and has drawn its share of controversy. Harley gives up her own identity to be a part of the Joker's world. Despite her submissive role to the Joker's desires, she is viewed as a strong and powerful character in the DC universe and has a broad fan base among both males and females.

Why Harley Quinn is #37

It was love at first sight. Not just between Harley and the Joker, but between Harley and her legion of fans. What started out as a throwaway character rapidly became a fan favorite that has spanned incarnations across animated series, video games, and a live-action film.

Few villain "sidekicks" survive, let alone live to become iconic characters in their own right. She is the Joker's "Robin." Their relationship strikes a familiar if uncomfortable chord and embodies the spirit of unrequited love and a willingness to do anything for the object of one's affection, or perhaps affliction in this case.

Whatever the secret to her appeal, there is no denying that Harley Quinn has captured fans' hearts as surely as the Joker has captured hers.

—JW

38
WILE E. COYOTE AND ROAD RUNNER

TOON-UP FACTS

Creator: Chuck Jones Studio: Warner Bros.
Debut: 1949 (*Fast and Furry-ous*)
Road Runner's modus operandi: Running down the road all day
Wile E. Coyote's unfulfilled desire: To catch the Road Runner
Wile E. Coyote's favorite company: Acme
Road Runner's lone utterance: "Meep Meep"
Defining role: Theatrical shorts
Top TV venue: *The Road Runner Show* (1966–1973)
Road Runner traits: Speedy, unruffled, even-keeled
Wile E. Coyote traits: Reckless, persistent, hard-headed, hungry
Ten best Latin names for Wile E. Coyote and Road Runner:

Wile E. Coyote

Carnivorous Vulgaris Road-Runnerus
Digestus Eatibus Anythingus Famishius Fantasticus Famishius
Vulgaris Ingeniusi Hardheadipus Oedipus
Apetitius Giganticus Overconfidentii Vulgaris
Desertus-Operativus Imbecilius Poultrius Devourius

Road Runner

Accelleratti Incredibus
Hot-Roddicus Supersonicus
Velocitus Delectiblus Dig-Outius Tid-Bittius Birdibus Zippibus Batoutahelius Velocitus
 Incalculus Fastius Tasty-us
Disappearialis Quickius
Burn-em Upus Asphaltus

About Wile E. Coyote and The Road Runner

The seeds were planted by Chuck Jones and Warner Bros. writer Michael Maltese, who sought to create the ultimate chase cartoon. Jones had been fascinated by coyotes since reading Mark Twain's 1886 description of the creature from a semi-autobiographical travel book titled *Roughing It*.

The initial result of their work was *Fast and Furry-ous*, which established the premise of all the Wile E. Coyote and Road Runner shorts. Though some level of repetition was inevitable, the keys to maintaining originality were the facial expressions and body language of the hapless Coyote and the various methods he used in his efforts to catch his prey. The obsessed Coyote displays a look of evil optimism upon the launching of every attempt to catch or stop the Road Runner, then one of fear, resignation, and despair upon the discovery that not only had he failed, but that he is destined for a physical beating. His always-smiling target, meanwhile, simply stops on occasion to unintentionally mock the coyote with a "meep, meep" and disappear at the speed of light.

The site of every confrontation is the desert. The stage is set when the two characters are stopped in motion and shown individually with clever Latin captions underneath such as Desertus-Operativus Imbecilius (Coyote) and Hot-Roddicus Supersonicus (Road Runner). The action then gradually speeds up.

Silence is golden in every Wile E. Coyote–Road Runner cartoon—all attempts to provide a voice for the former failed. But the sound effects play an integral role in the entertainment, whether it's the Road Runner whizzing by or the Coyote getting crushed by a boulder.

It took Warner Bros. three years to produce a second Wile E. Coyote and Road Runner short. *Beep Beep* (1952) included a segment in which the Coyote chased the Road Runner through a mine shaft. Jones would revert thereafter and forever to chases in the light of day.

Warner Bros. continued production of the cartoons into 1964. The lone Academy Award nomination was achieved with *Beep Prepared* (1961). By that time Wile E. Coyote had branched out. He had been teamed with Bugs Bunny in *Operation Rabbit* (1952) and *To Hare is Human* (1956) with *Hare Breadth Hurry* arriving in 1963. He was also used in a series of clever shorts beginning in 1953 as Ralph Wolf (voiced by Mel Blanc), who seeks to steal sheep from sheep dog Sam. The humorous twist is that both check in on a time clock, then deviously (in the case of Ralph) and keenly (in the case of Sam) work as bitter enemies before checking out with a friendly "good night."

Why Wile E. Coyote and The Road Runner Are No. 38

Chuck Jones has been credited with creating and directing many of the premier Warner Bros. cartoon characters, but none are more beloved than this dynamic duo. His achievement is made greater by the fact that he did not depend on Blanc voices to add to their personalities. The brilliance of the Wile E. Coyote–Road Runner shorts was basically based on one premise, yet each remained thoroughly entertaining from beginning to end.

The theme is not good vs. evil. It's obsession vs. contentment. Wile E. Coyote is obsessed with catching the Road Runner. His all-encompassing desire motivates him to purchase a variety of mechanical devices provided by The Acme Corporation to better his chances, but they

all backfire with predictable results. The Road Runner seeks no revenge and has no notion of destroying the Coyote to ensure his own safety. He is content to run down the road all day. The theme is one with which we can all identify. The ability of Warner Bros. to take this simple concept and turn it into one of the most beloved and entertaining cartoons ever bespeaks of the genius of its creators.

—MG

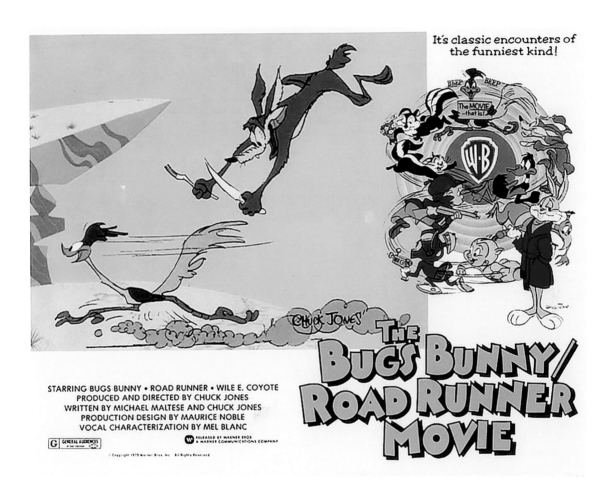

39
JOHNNY BRAVO

TOON-UP FACTS

Creator: Van Partible
Studio: Hanna-Barbera
Voice: Jeff Bennett
Debut: 1995 (*Johnny Bravo*)
Mother: Bunny Bravo (Mama)
Hometown: Aron City
Love interests: Himself, Little Suzy
Best friend/neighbor: Nerdy, annoying Carl Chryniszzswics
Namesake: Greg Brady alias
Catchphrase: "Oh, mama!"
Motivation: Attracting women
Failure: Attracting women
Defining role: *Johnny Bravo* (1997–2004)
Traits: Ego-driven, persistent, arrogant, overconfident, unintelligent, mama's boy

Bravo Bites

- Hanna-Barbera became aware of Partible through an animation project he created as a student at Loyola Marymount University in Los Angeles.

- The voice of Johnny Bravo as voiced by Jeff Bennett has a distinct Elvis Presley flavor to it. It is no coincidence that Johnny makes his home in Aron City. After all, The King's middle name was Aaron.

- Partible and the writers honored real-life television personalities of the past in a regular component titled "Johnny Bravo Meets. . . ." One particular short featured Farrah Fawcett (*Charlie's Angels*), Adam West (*Batman*), and pop singer Donny Osmond.

- Johnny has been compared to Warner Bros. female-chasing skunk Pepe LePew in his penchant for receiving and emotionally overcoming rejection from members of the opposite sex.

- Some cartoon kids are voiced by adults, but such was not the case with eight-year-old Little Suzy. Her voice was that of Mae Whitman, who was a mere nine when the animated series was launched.

- Among the writers of *Johnny Bravo* shorts was Seth MacFarlane, who later gained greater fame as the creator of such cartoon hits as *Family Guy* and *American Dad!* MacFarlane had also worked on Cartoon Network standouts such as *Cow and Chicken* and *Dexter's Laboratory*.

- The voice of Bunny Bravo (Mama) was supplied by veteran actress Brenda Vaccaro, who was up for an Oscar for her performance in *Once Is Not Enough* (1975), but might be better known for her Golden Globe–nominated effort as a socialite that paid for the sexual services of Joe Buck in *Midnight Cowboy* (1969).

- Annoying neighbor and nerdy best buddy Carl Chryniszzswics appeared regularly in Seasons 2 and 3, but only in cameos thereafter.

- Johnny Bravo first asks for universal peace and goodwill toward men when given one wish from a genie in "I Dream of Johnny" (2000). But he quickly changes his request to a talking monkey.

- Notable Season 1 episode "Cookie Crisis" (1997), which featured a persistent Suzy (Buttercup) seeking to sell Johnny Girl Scout cookies, was a clear parody of the legendary Dr. Seuss children's story *Green Eggs and Ham*. The entire episode was spoken in rhyme.

About Johnny Bravo

He is in his own mind God's gift to women. He is in the minds of every woman unfortunate enough to be approached by him a pain in the butt. It is no wonder Johnny Bravo was a boon to the pepper spray and stun gun businesses.

Those women are met by a square-headed, muscle-bound egomaniac with a towering blond pompadour and black shades. They are grabbing said pepper spray or clenching their fists for a punch to the jaw from the first word of the pickup line he utters. And after the women inevitably give him a physical rebuff, he is no less confident about his greatness as what he describes as a "one-man army." There is no such thing as discouraging Johnny Bravo.

Johnny throws his body language into his believed coolness. His array of poses that display his physique and scream ultra-confidence to the point of absurdity come early and often in his episodes. He is likely to pose while looking in a mirror, walking down the street, or after getting punched out yet again.

Yet somehow he is embraced by the viewer—after all, those watching cannot be victimized by Johnny Bravo, and he is basically harmless even to the animated women he approaches. And he's not all bad. He loves Bunny Bravo—his mother—and at least tolerates Little Suzy, who often arrives on the scene at just the wrong time while he is trying to make progress with a "hot mama."

The results of his outrageous personality, unending desire to garner the affections of females, and mind-boggling resilience are incredible plot twists. On one occasion, Johnny decides to take his "hobby" into the modern world and trolls for women on the Internet. He actually attracts a date, but learns to his shock when she arrives at the door that she is an antelope named Carol. Rather than tell her to go find a male antelope, he takes her to dinner. And even *she* rejects him. She informs Johnny that she is merely going out with him to make her boyfriend jealous. Making matters worse, that boyfriend is a lobster that happens to be his dinner and proceeds to attack

him, yanking on his nose with his claw. Johnny soon delivers the greatest line of the episode. "Where's Mrs. Paul when you need her?" he asks. Then he is pinched by the police and lands in jail for fighting in public.

The first segment of *Johnny Bravo* written and directed by Partible appeared in *What a Cartoon Show* on the Cartoon Network in 1995. Its distinction as Toon of the Year as voted by viewers provided momentum for the character that would continue for about a decade. The uniqueness of Johnny Bravo, nearly a one-man show whose place in the spotlight was never threatened by anyone else in his cartoons, resulted in an eight-year run on Cartoon Network and added to the rich legacy of Hanna-Barbera.

Why Johnny Bravo Is No. 39

Hey, the guy is hilarious. From the array of poses to the ridiculous come-ons to women that invited and resulted in rejection to his voice that made him sound like an Elvis impersonator, Johnny Bravo brought humor and personality to the small screen. It was no wonder that the initial effort of Van Partible earned Toon of the Year and launched Johnny into well-deserved stardom.

What is particularly humorous about this character is that, even after every one of his harmless flirtations with females is followed by a sock in the jaw or pepper spray attack, he remains undaunted and equally sure of his status as God's gift to women. There is never an ounce of deflation in his inflated view of himself. Johnny Bravo bounces right up, even announcing on occasion after taking yet another fall that the women who just landed the blow must really want him.

Sometimes it's simple. And, simply put, Johnny Bravo passes the eye and ear test. He's downright hysterical.

—MG

40

ALVIN

Creator: Ross Bagdasarian Sr.
Studio: Format Films
Voice: Ross Bagdasarian Sr.
Debut: 1958 ("The Chipmunk Song")
TV debut: 1961 (*The Alvin Show*)
Manager: David Seville
Brothers: Simon and Theodore
Love interest: Daisy Belle
The Seville scream: "AAAL-VINNNNN!!!"
Defining role: *The Alvin Show* (1961–1962)
Traits: Mischievous, confident, silly, outgoing, stubborn, irresponsible, lovable

Chipmunk Chatter

- In real time Alvin would be closing in on seventy years old if he had been in elementary school when created in 1958. But he and his siblings were in junior high in the 1980s and high school when their new show was launched in 2015.

- Bagdasarian adopted the stage name David Seville in 1956 and used it as the animated character that served as the manager of Alvin and his brothers.

- When contemplating which creatures would go best with the squeaky voices he created as a singing trio, Bagdasarian first considered butterflies rather than chipmunks.

- Among Alvin's funniest singing moments occurred when he and his chipmunks belted out a rendition of "Home on the Range." Alvin insisted on singing "where the deer and the cantaloupe play," raising the ire of David Seville. Alvin eventually leads his hungry brothers away from the studio to find a cantaloupe, further irritating their manager.

- Bagdasarian named Alvin after Liberty Records president Al Bennett. The other two Chipmunks were also named after executives from that company.

- Alvin and the boys did not hang around home. They traveled the world, took cruises, went camping, and even visited a haunted house. Parental groups liked the fact that such trips proved educational. Seville or Simon would provide accurate cultural information about countries they visited.

- The 1982 release of album *Chipmunks Go Hollywood* motivated Los Angeles mayor Tom Bradley to declare October 25 of that year Chipmunk Day. An official ceremony was held at the parking lot of Tower Records, complete with costumed characters.

- Alvin was quite interested in the opposite sex, but among those that could not attract him was Daisy Belle. Belle was voiced by the prolific June Foray (Rocky the Flying Squirrel). She (Daisy Belle, not June Foray!) had a crush on Alvin, who considered her only a friend.

- *The Alvin Show* featured a segment spotlighting crackpot inventor Clyde Crashcup, who "created" things through drawings that already existed, such as a baseball and a wife. Clyde was always accompanied by friend Leonardo, who communicated with him in whispers.

- Alvin became popular comic book fare between 1962 and 1973. Dell Publishing produced many Alvin comic books during that time, including a special Alvin for President issue during the 1964 election.

About Alvin

Bagdasarian was in dire financial straits in late 1957. His family, which (perhaps not so coincidentally) included three kids, was down to its last $190, which he spent on a tape recorder that he hoped would help him to write a desperately needed hit.

One day he sang into the machine while it was running at half-speed, then played it back at full speed. The result was a humorous, squeaky voice that proved inspiring. Bagdasarian used that voice in a novelty song titled "The Witch Doctor" that sold 1.5 million copies. So much for his financial destitution.

But with what animal to match the voices? According to legend that question was answered on a drive to Yosemite National Park when Bagdasarian noticed a spunky chipmunk playing in the road. But it is more likely the decision was made after he played the speeded-up voices to his children and they suggested they sounded like chipmunks.

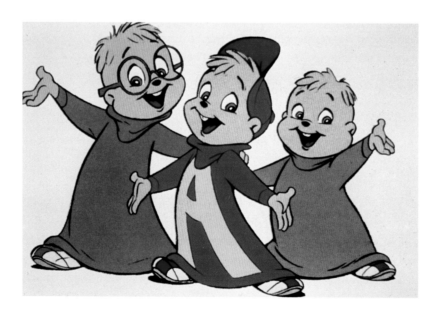

Soon the smash holiday hit "The Chipmunk Song" was selling 4.5 million copies in a matter of seven weeks, and Bagdasarian knew he needed to transform the chipmunks into animated reality. After all, the relationship between David Seville and Alvin had been established on vinyl. Bagdasarian created the legendary "AAAL-VINNNN" scream based on how he yelled at noisy son Adam.

Bagdasarian created Format Films and turned what had only been hand puppets used on variety shows into animated characters. *The Alvin Show* was launched in the early fall of 1961 with the title character assuming the starring role. It featured four segments with heavy emphasis on music that allowed Alvin to cement his reputation as a nonconformist. He interjected humorous changes in lyrics, much to the dismay of his manager. He went his own way, influencing in the process his brothers, who were often torn between obedience and following Alvin. Theodore was most easily swayed by the influential leader of the trio. Alvin, however, was not rebellious. He was merely determined.

Alvin also stood out visually. He wore a red baseball cap and red turtleneck sweater that extended to his shoes and featured a prominent letter "A" in front.

New segments for *The Alvin Show* were created for just two seasons, but it remained a rerun staple into the mid-60s. The death of Bagdasarian in 1972, however, did not kill off Alvin and the boys. Son Ross Jr. embarked on reviving the show, which then thrived in Saturday morning reruns beginning in 1979. New Chipmunk music followed, launching another generation of Alvin fans. A new series titled *Alvin and the Chipmunks* (1983) featured the Chipettes, female clones of the Chipmunks who brought sexual equality into the cartoons. Many Chipmunk television specials and movies followed. So did yet another series in 2015. Old-school fans still consider the original series the pinnacle of Chipmunk entertainment, while the younger generations appreciate what came after. But all agree that Alvin boasted easily the most distinctive personality and was the deserved star.

Why Alvin Is No. 40

Frankly, the Chipmunks were nothing without Alvin. He was the straw that stirred the drink. Both Theodore and Seville played off his personality, the former through his annoyance and frustration and the latter through how he was influenced by the magnetism of his brother. Even the intellectual Simon understood and respected the power of Alvin's personality.

That individuality made Alvin unique. While Simon and Theodore generally walked a straight line on the path set by Seville, he marched to the beat of his own drum. And he did it with humor, corrupting embraced classics with his variation on the lyrics and simply doing whatever he pleased, not to spite his manager, but for no other reason than because he wanted to.

Alvin did not unquestioningly accept authority or fall in line when challenged. And in the process, he made audiences laugh. They've been laughing at Alvin since the Kennedy Administration. And that's why he has landed a prominent position on the list of the greatest cartoon characters in television history.

—MG

41
TWILIGHT SPARKLE

TOON-UP FACTS

Creator: Lauren Faust
Studio: Hasbro Studios
Voice: Tara Strong
Debut: October 2, 2010, *My Little Pony: Friendship Is Magic* (Episode: "Elements of Harmony," pilot episode Part 2
Type of "pony": Unicorn/Alicorn
Cutie Mark: Star
Home: Castle of Friendship in Ponyville
Parents: Twilight Velvet and Nightlight
Best friends: Spike, Applejack, Pinkie Pie, Rainbow Dash, Fluttershy, Rarity
Pet: Owlowiscious
Powers: Magic
Interest: Books, magic, knowledge
Fears: Quesadillas and their "cheesiness"
Antagonists: Nightmare Moon, Discord, King Sombra
Starring TV roles: *My Little Pony*
Personality traits: Loyalty, intelligence, kindness, friendliness, sociability

Twilight Trivia

- "My Little Pony" was originally conceived and marketed as "My Pretty Pony," a large plastic toy pony whose hair you could brush.

- The smaller rubberized toy "My Little Ponies" debuted in 1982. There were six ponies: Snuzzle, Butterscotch, Blue Belle, Minty, Blossom, and Cotton Candy.

- Lauren Faust, the artist and creator of the reboot of *My Little Pony* (MLP), confessed she loved the toys but hated the animated shows that aired in the 80s.

- Twilight Sparkle is an Alicorn, which has the wings of Pegasus and the horn of a unicorn.

- *My Little Pony* "villain" Discord is based on the *Star Trek: Next Generation* villain "Q." Both characters are voiced by actor John De Lancie.

- Lauren Faust is married to animator Craig McCracken, creator of The Powerpuff Girls. He also designed the costumes for the MLP characters The Wonderbolts.

- The dragon Spike is the only character to have appeared in all the various animated incarnations.

- Male pony fans are known as Bronies.

- Twilight Sparkle is the only pony to have a "Cutie Mark" featuring a symbol surrounded by five stars.

- Tara Strong, the voice of Twilight Sparkle, has provided the voices of several "strong" female cartoon characters including Batgirl, Harley Quinn, and Bubbles (a Powerpuff Girl).

About Twilight Sparkle

My Little Pony is one of a handful of cartoons to have made the leap from being a toy to an animated property. The character of Twilight Sparkle can trace her origins to the "generation 1" unicorn toy called Twilight. Show creator Lauren Faust imbued the characters, including Twilight Sparkle, with elements of the personalities she had given the toys she had played with as a child.

Twilight Sparkle is the central character in *My Little Pony: Friendship Is Magic.* As the star pupil of Princess Celestia, Twilight Sparkle was sent from Canterlot to Ponyville to observe the residents and learn about the power and magic of friendship. She is a studious pony who is often engrossed in her books, sometimes at the expense of building friendships. However, once in Ponyville she overcomes her innate shyness to build a strong and close circle of friends including Applejack, Pinkie Pie, Rainbow Dash, Fluttershy, and Rarity. Collectively these characters are called "The Mane Six."

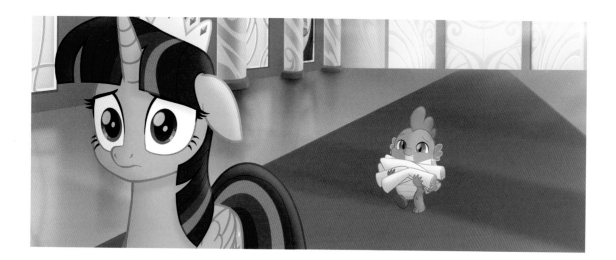

Despite gaining new friends, she retains some of her social awkwardness and relies heavily on the knowledge gained from her books. Over the course of the show's seasons, Twilight gains a deeper understanding of the power of friendship and in turn creates new magic based on her studies. With this newly garnered knowledge, she is transformed from a unicorn into an Alicorn, having traits of both a unicorn and flying Pegasus.

Twilight Sparkle is crowned a princess, and bearing the title as "Princess of Friendship" she takes on the role of teaching others throughout Equestria about the power and magic of friendship.

Why Twilight Sparkle Is No. 41

My Little Pony: Friendship Is Magic has transcended its TV show and toy roots and become a phenomenon. Annual conventions are held, children and adults dress up in costume, fan fiction is written, and even the tiniest of details can lead to epic debates.

The show's success lies in the creation of strong empowering female characters that still have real insecurities children can identify with. Twilight Sparkle addresses one of the most prevalent insecurities of any young child—making friends. In overcoming her antisocial tendencies, she learns that friendship truly is magic! The character resonated not just with young girls, but also with young boys and even adults. As a testament to the show's popularity across generations and genders, a new type of fandom known as "Bronies" was born. Rarely does a show with such a narrow audience target expand to encompass such a broad audience base.

Twilight Sparkle's journey to understand friendship and find acceptance is the core mission and message of the show. The strength of the show's popularity lies in its inclusiveness of not just the characters but the wide and varied spectrum of its audience.

Twilight Sparkle is a part of a greater community of friends and represents the broader external community of pony fans that share a passion for all things *My Little Pony*.

—JW

42
MISTER PEABODY

TOON-UP FACTS

Creator: Ted Key
Studio: Jay Ward Productions
Voice: Bill Scott
Debut: 1959 (*Show Opening*)
Breed: Beagle
Sidekick: Pet boy Sherman
Home: Penthouse apartment
Transportation: Way-Back Machine
Focused subject: History
Catchphrase: "Set the Way-Back Machine for . . ."
Defining role: *Peabody's Improbable History* (1959–1961)
Traits: Cultured, conceited, brainy, influential, scholarly

Dog Data

- Ted Key created the comic strip *Hazel* for the *Saturday Evening Post*. Her character was later featured in a long-running sitcom in the 1960s that starred Shirley Booth.

- The dog was originally named "Beware," but was renamed Peabody after Scott's pet pooch. Sherman was named after Sherman Glas, a technical director with whom Scott worked at United Productions of America.

- The Way-Back Machine was a takeoff on *The Time Machine*, a science fiction classic penned by H. G. Wells.

- In early meetings about the concept of the show, it was tentatively called *Danny Day-Dream*.

- Peabody takes credit for many historical events, but one can argue his greatest achievement was drawing up the blueprints for the Great Pyramids.

- Every segment of *Peabody's Improbable History* ended with a bad pun.

- Sherman was voiced by Walter Tetley, who had also provided the voice for Walter Lantz Studio standout Andy Panda.

- Peabody claims to boast extensive business experience, so much so that he is known as "The Woof of Wall Street."

- The writers of the 2014 movie tried to capture the spirit of the original show with their use of puns. Perhaps the best was uttered after Peabody explains to Sherman that Marie Antoinette should have issued an edict that provided a loaf of bread for every citizen. He added that the problem was she could not have her cake and edict too.

- Scott worked to make Peabody sound like sophisticated Hollywood and Broadway actor Clifton Webb.

- The female characters in *Peabody's Improbable History* were generally voiced by June Foray, who was best known for voicing Rocky the Flying Squirrel. The male voices were usually those of Paul Frees, who voiced Boris Badenov.

- The pun-master for *Peabody's Improbable History* was Chris Hayward, who wrote most of the segments and came up with most of the puns for which they became famous.

- Peabody and Sherman were always shown getting transported into history by the Way-Back Machine, but never seen returning.

- *Peabody's Improbable History* has been compared to *Through Time and Space with Ferdinand Feghoot*, a series of vignettes that appeared in the 1950s and 1960s in *The Magazine of Fantasy and Science Fiction* and were authored by Reginald Bretnor.

About Peabody

Rocky and His Friends (which morphed into *The Bullwinkle Show*) was not only a legendary cartoon because of Rocky and his friends. The innovation and creativity of the supplementary segments also played a role in creating a long-lasting legacy. One shining example is *Peabody's Improbable History*. And the star attraction received title billing.

Peabody was a short, bespectacled, talking beagle. Though such plaudits were unspoken, viewers were led to believe he was the most accomplished, learned canine to ever walk the face of the Earth. He also not only lived from practically the beginning of time, but was personally responsible for every great achievement in the history of mankind.

The erudite dog who talked so fast that Scott sometimes tripped over his words taught "pet boy" Sherman about history that one would never read in history books. It was Peabody, after all, that used his intelligence and influence to convince the great achievers through the ages (such as the Wright Brothers, Leonardo da Vinci, Alexander Graham Bell, William Shakespeare, and Beethoven) to make their historical contributions. His assistance was deemed necessary to make history turn out the way it did.

But Peabody did not use mere words to prove his points to Sherman. He utilized his own invention—the Way-Back Machine—to transport them both into history and into the lives of those who made history. The result was some weird retelling, such as Whistler painting only his mother's chair without his mother in it and Alexander Graham Bell asking "What's a telephone?" and planning at first only to invent the Graham cracker. Ward admitted that the historical figures featured in the segments were "complete boobs." Historical accuracy? Where's the humor in that? The humor came instead not only from the characterization of those featured in every

history book, but in the myriad of cringe-worthy puns uttered by Peabody, such as the one about William Tell having such bad eyesight that they named a visual malady after it—television.

The legacy of Peabody has lived on more than a half-century after he was introduced. A computer-animated film titled *Mr. Peabody and Sherman* was produced by DreamWorks Animation and released in 2014, and a Netflix cartoon based on the film followed a year later.

Why Mister Peabody Is No. 42

How can a haughty, bespectacled beagle that influenced or was responsible for every important moment in history and has his own pet boy not earn a prominent spot on the list? Peabody was among the most interesting animal characters in the history of animation—though it is the only history in which he really did play a role.

Peabody needed to be a memorable character to live up to the greatness of those with which he shared the half-hour, such as Bullwinkle, Dudley Do-Right, and Snidely Whiplash. *Rocky and His Friends* was arguably the greatest made-for-television animated show ever. Each segment was deservedly well received, including *Peabody's Improbable History*.

—M

43
BOBBY HILL

TOON-UP FACTS

Creators: Mike Judge, Greg Daniels
Studio: Fox Animation
Voice: Pamela Segall Adlon
Debut: January 12, 1997 (*King of the Hill*)
Parents: Peggy and Hank Hill
Birthday: September 29
Middle name: Jeffrey
Hometown: Arlen, Texas
School: Tom Landry Middle School
Favorite food: Fruit pies
Pet: Ladybird (dog)
Height: Four feet eleven inches
Skills: Comedy, marksmanship
Love interest: Connie Souphanousinphone
Best friend: Joseph Gribble
Best-known quote: "That's my purse! I don't know you!"
Defining role: *King of the Hill* (1997–2010)
Traits: Sensitive, kind, charming, witty, innocent, gentle, lovable

Bobby Trivia

- Bobby's little league jersey number is 3, the same number worn by Babe Ruth. In the episode "Bad News Bill," the coach refers to Bobby as "Great Bobino" in a nod to Ruth's nickname the "Great Bambino."

- Voice actress Pamela Adlon won a primetime Emmy for the Season 6 episode "Bobby Goes Nuts."

- A Bart Simpson doll sits on one of the shelves in Bobby's bedroom. Bobby and his family had a cameo on *The Simpsons* where Hank Hill delivered just one line: "We came two thousand miles for this?"

- Though Hank is frequently frustrated by his son's lack of "manly" skills, Bobby has earned his father's respect through his innate abilities at marksmanship and grilling meat.
- The inspiration for Hank Hill was the character Tom Anderson on Beavis and Butt-Head. The two characters share a similar voice and appearance.
- Over the course of the show's thirteen seasons Bobby aged only three years, from eleven to fourteen.
- Bobby's grandmother, Tilly Mae Hill, was first voiced by country music legend Tammy Wynette.
- Though Bobby has expressed interest in a variety of careers, from runway model to proctology, his true life's ambition is to become the first chubby comedian to live past age thirty-five.
- Show creator Mike Judge provides the voices for Hank Hill and Jeff Boomhauer.
- The catchy instrumental theme song that opens the show is called "Yahoo and Triangles" and is performed by The Refreshments. The band broke up less than a year after the show debuted.

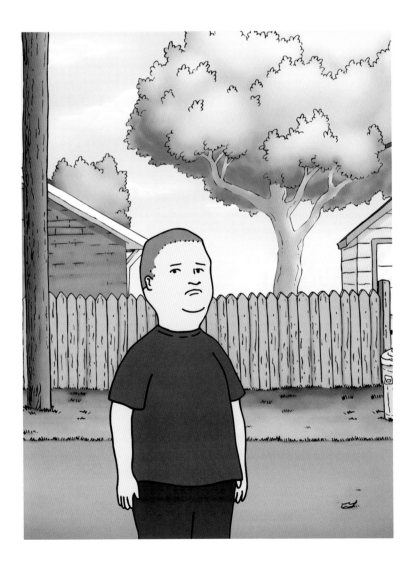

About Bobby Hill

"The boy ain't right," as Bobby's father Hank often says. But in truth there is something very right. Bobby Hill is a rarity in the animated world, a sincerely likeable good kid. Bobby is a portly young teen forever awaiting a growth spurt. He's a gentle and kind young man with an easy rapport with people.

Much of *King of the Hill* revolves around the relationship between Bobby and his father, Hank. He looks up to his father as his hero despite their many differences. Hank is a blue-collar Texan who values the perception of masculinity and American values. As a father Hank is often frustrated at Bobby's interest in less masculine activities such as dance. Though Bobby shows an affinity for marksmanship, his attempts at other sports and athletic activities for his father's approval tend to result in failure. Though at times insecure about his height, overall he is comfortable in his own skin and unencumbered by traditional gender roles.

Bobby's complex emotions and interactions with other characters make him arguably one of the most well-rounded child characters in animation history.

Why Bobby Hill Is No. 43

Bobby is easily one of the most realistically portrayed children on TV. His thoughtful portrayal avoids the caricatured clichés of most television kids. As a prepubescent child struggling with the ins and outs of both family and social life, he is a character grounded in our own childhood experiences.

—JW

44
ANGELICA PICKLES

Creators: Arlene Klasky, Gabor Csupo, Paul Germain
Studios: Nickelodeon Animation Studio, Wang Film Productions, Anivision, Klasky Csupo
Voice: Cheryl Chase
Debut: August 11, 1991, *Rugrats* (Episode: "Tommy's First Birthday")
Catchphrase: "Dumb babies!"
Parents: Drew and Charlotte Pickles
Cousins: Tommy and Dil Pickles
Best friends/victims: Tommy, Dil, Chuckie, Phil, and Lil
Rival: Susie Carmichael
Prized possession: Her doll, Cynthia
Pet: Fluffy
Favorite food: Cookies
Defining role: *Rugrats* (1991–2007)
Traits: Bossy, spoiled, manipulative, deceitful, charming, jealous, powerful, confident

Angelica Diva Disses

- "Only some of us stay beautiful, unless you go and get elastic perjury."
- "A cookie just tastes better when it's someone else's."
- "Sometimes I wish I could be you, so I could be friends with me!"
- "You babies are so dumb, I can't believe you lived to be one!"
- "You know, not all dogs go to heaven."
- "You babies are so dumb, I'm surprised you even know which end of the bottle to suck."
- "You'll never see your mom or your dad or your dumb old dog ever again! Hahahahahahaah!"
- "Dumb babies."
- "All I need is a 'thank you,' and . . . oh, yeah, for you to be my slave for the rest of your life!"

About Angelica Pickles

When *Rugrats* debuted on Nickelodeon in 1991, the network was at the start of an animation renaissance. The then fourteen-year-old network had built its identity on importing international shows. *Rugrats* was only the second "Nicktoon" produced especially for the network, but it helped solidify one of Nickelodeon's core tenets: "The kids are in charge." No character exemplified that attitude more than Angelica Pickles.

Angelica is an anti-heroine standing proudly against the cutesy innocent trope while at the same time embracing her outward innocent appearance as a means for manipulation.

As an only child whose parents frequently work, she is often forced to spend time with her Aunt Didi and Uncle Stu. She is rarely punished and is accustomed to getting her way at all times. As she once declared "You can't punish me; I'm Angelica! Your princess! Your cupcake! Your little tax shelter!"

At three years old she is only slightly older than the other toddlers she refers to as the "dumb babies." But that extra year comes with an extra ability, the ability to speak! In many ways, that is the source of much of her power to manipulate the babies. Her ability to both "understand" and communicate with adults has made her a dangerous liaison. She will often twist their words to create her own "true" stories to terrify Tommy and crew.

For an entire season Angelica wielded unquestioned power over the babies, loving them as a tyrant loves their oppressed people.

Arlene Klasky, the show's co-creator, would get in frequent arguments over her dislike for how nasty the character was. In the second season Angelica began to lose some of her power over the babies with the introduction of her rival Susie Carmichael. In Episode 75, "Meet the Carmichaels," Susie is introduced as a counter voice of reason frequently pointing out the flaws in Angelica's twisted tales to the babies.

The balance of power does little to squelch Angelica's delightful nastiness and only adds another foil for her barbs.

Angelica and Susie's rivalry transforms them into frenemies when they reemerge as young teens in *Rugrats, All Grown Up*. Age does little to mellow Angelica's attitude, but the frailty of teenage insecurities reveals a more sympathetic side to the character in the latter series. Angelica terrorizes the babies and then tweens through two TV series and three movies: *The Rugrats Movie*, *Rugrats in Paris*, and *Rugrats Go Wild*. Thankfully she remains wonderfully wicked through it all.

Why Angelica Pickles Is No. 44

Despite her "evil" streak, or more likely because of it, the diminutive diva has become an iconic role model of sorts for the empowerment of young girls. Outspoken, confident, driven, and witty, she knows what she wants and doesn't let anyone stand in the way of her obtaining her goals. She is one of the great characters we love to hate because she says things we wish we could. Her absolute lack of tolerance for babies and realistic assessment of the world around her makes her a refreshing break from cute and cuddly cookie-cutter TV toddlers.

The character ranked high at 7 in *TV Guide*'s 2002 "Top 50 Greatest Cartoon Characters of All Time." While we have ranked her lower, given time she will no doubt claw and insult her way higher doing whatever it takes until she gets to #1!

—JW

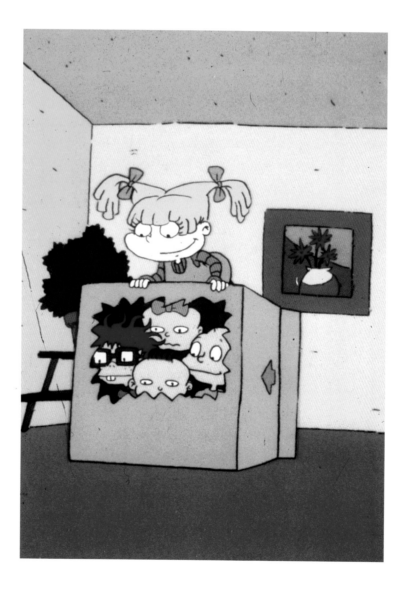

45
FINN AND JAKE

TOON-UP FACTS

Creator: Pendleton Ward
Studios: Frederator, Cartoon Network Studios
Finn voice: Jeremy Shada
Jake voice: John DiMaggio
Debut: 2006 (*Adventure Time*)
Series debut: 2010, *Adventure Time* (Episode: "Slumber Party Panic")
Finn catchphrases: "Mathematical!" . . . "Algebraic!"
Jake breed: Bulldog
Jake girlfriend: Lady Rainicorn
Home: Post-Apocalyptic Land of Oooo
Friends: Princess Bubblegum, Marceline (The Vampire Queen), Beemo
Antagonist: The Lich
Finn love interests: Princess Bubblegum, Flame Princess
Defining role: *Adventure Time* (2010–present)
Finn traits: Adventurous, eager, energetic, righteous, brave, stubborn, spacey
Jake traits: Lazy, easygoing, wise, tough, protective, romantic, magical

Oodles about Oooo

- *Adventure Time* found its audience on the Internet, leading Cartoon Network to pick it up for development. The pilot first aired as a *Random! Cartoons* segment on Nickelodeon.

- Pendleton Ward is one of many animators who has gained tremendous success in recent years after honing his craft at the California Institute of the Arts.

- Sweet names abound in *Adventure Time*. Among the characters that have appeared on the show whose names might motivate one to head to the bakery or candy store are Princess Bubblegum, Peppermint Butler, Prince Gumball, Cake, and The Candy People.

- Jake is a dog of many talents. Among them is his ability to play the viola, which he does with passion, most often for girlfriend Lady Rainicorn.

- One attraction of *Adventure Time* was the large number of intriguing characters that were considered friends or antagonists of Finn and Jake. Seventeen characters aside from those two are listed on the Cartoon Network website for the show.
- Jake voice John DiMaggio speaks humorously about how often he is called Joe DiMaggio, the name of one of the premier players in baseball history. The two are unrelated.
- *Adventure Time* was rejected by Nickelodeon before Frederator Studios owner Fred Seibert brought it successfully to Cartoon Network.
- Jake speaks Korean. It allows him to communicate with Lady Rainicorn.
- Among the strangest "characters" to appear on the show was The Fear Feaster, a gassy, greenish, talking manifestation of Finn's fears that emerged from his belly button to mock and deride him. The creature served, however, to embolden Finn to overcome his fears.
- The magical ability of Jake to change shape was explained in the Season 6 episode "Joshua and Margaret Investigations," which focuses on the dog's parents. His father (Joshua) had been bitten by a shape-shifting alien before birthing Jake from his head. The puppy was therefore born with the same capacity.
- Ward compared the animation style used to create *Adventure Time* to that of video games and the immensely popular role-playing game *Dungeons and Dragons*, which hit the market in 1974 and still boasts a strong following.

About Finn and Jake

Adventure Time was aptly named. What else would one call a cartoon in which the two central characters embark on both comic and dramatic adventures in a post-apocalyptic universe called the Land of Oooo?

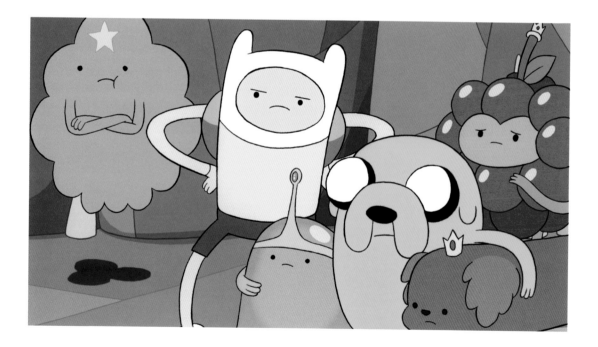

Finn the Human and Jake the Dog are certainly not cowardly, though the former had to often overcome his fears and the latter could not be considered particularly brave. The protagonists of the show accept challenges from any entity that seeks their services. Their adventures bring them in contact with a multitude of friends and in conflict with enemies such as The Lich.

Jake is a yellow bulldog with big, blank eyes and long, skinny arms. He walks on two legs and can stretch himself into various shapes. Finn can generally be seen wearing blue shorts and an aqua short-sleeve shirt. He has long blond hair that is covered by a white hat with short, upright ears. His only four teeth are slightly separated on top.

Finn can be silly, but he is devoted and enthusiastic about performing well in his duties. He gained a friendship with Jake as an adopted brother. It was revealed in the episode "Memories of Boom Boom Mountain" (2010) that he had been abandoned in the woods as an infant and subsequently laid on a large leaf until Jake's parents Joshua and Margaret rescued him and made him part of the family.

The twenty-eight-year-old Jake boasts what are known as Stretchy Powers, which allow him to change the shape and size of his body. This magical ability lets him survive and thrive during various adventures. He is far more relaxed in mind and body than his friend, but that attitude sometimes leaves Finn alone to extricate them from predicaments. Jake serves to brighten Finn's mood with a song or story when the latter feels discouraged.

The popularity of *Adventure Time* can be placed squarely on the shoulders of Finn and Jake and how they relate to the many side characters and embrace the adventures that lie before them. The strength of their friendship and the vagaries of their relationship based on the differences in their personalities prove to be the core of the success of *Adventure Time*.

Why Finn and Jake Are No. 45

One difference between Finn and Jake and other cartoon characters is that they were provided the opportunity to age and mature along with the show. That is one reason many viewers vastly prefer the later episodes to the earlier ones. Their personalities became more pronounced and their relationships deepened. The backstories about the two characters and their histories give viewers a perspective seldom achieved on other cartoon shows.

Adventure Time can be downright thought provoking. The relationships between Finn and Jake, as well as those between them and the side characters, give the storylines a level of depth that matches the pure entertainment value from the adventures themselves, which are wildly innovative. The two main characters are both comedic and dramatic. That is rare and impressive.

—MG

46
BEANY AND CECIL

TOON-UP FACTS

Creator: Bob Clampett
Studio: Snowball Productions
Beany voices: Daws Butler, Jim MacGeorge
Cecil voices: Stan Freberg, Irv Shoemaker
Debut: 1959 ("Beany and Cecil Meet Billy the Squid")
Beany nickname: Beany Boy
Cecil nickname: The Seasick Sea Serpent
Boat: Leakin' Lena
Friends: Crowy, Captain Horatio K. Huffenpuff
Antagonist: Dishonest John
Beany's plea: "Help, Cecil! Help!"
Cecil's reply: "I'm a-comin', Beany boy!"
Defining role: *Beany and Cecil* (1959–1962)
Beany traits: Cute, adventurous, cheerful
Cecil traits: Loyal, dimwitted, trusting

Nautical Files

- A Beany beanie copter cap with a propeller that allowed kids to fly it off their heads became a popular item in toy stores in the early 1960s. It was, of course, made by sponsor Mattel.

- The seeds for the series were planted by Clampett as a fifteen-minute puppet show in 1949 titled *Time for Beany* that aired on television and gained national attention before ceasing in 1955.

- In keeping with tradition, Dishonest John always wore black. He made his troubling presence known in a unique fashion by exclaiming, "Nya Ha Ha!"

- Among the settings on the show for which the writers used alliteration were The Ruined Ruins and the Jingle Jangle Jungle.

- The entire series was released on video in 1983. Clampett died of a heart attack a year later while promoting the videos in Detroit in 1984.

- *Time for Beany* was originally aired by Los Angeles television station KTLA in 1949 before gaining a national following.

- Cecil voice Stan Freberg was a giant in the world of satire. Beatles legend Paul McCartney credited Freberg as an influence in the satirical humor used in songs written by the Fab Four.

- The short-lived *New Adventures of Beany and Cecil* (1988) was created under the direction of John Kricfalusi, who later played a significant role in creating *Ren & Stimpy*.

- Among the cartoons shown on *Matty's Funday Funnies*, which was launched in 1959, was *Casper the Friendly Ghost*. Beany and Cecil did not debut on that show until 1962. The title of the show was changed to *Beany and Cecil* three months later.

- Clampett claimed to have produced the 104 Beany and Cecil cartoons planned for the series all in one weekend!

- The voice of Beany in the short-lived 1988 series was provided by ten-year-old Canadian Mark Hildreth.

About Beany and Cecil

Beany and Cecil contributed to the role television boasted in its infancy, as entertainers of children. But they also helped spark a movement later embraced by Jay Ward and shows such as *Rocky and His Friends* by humorously piquing the interests of adults as well.

The two buddies sailing on *Leakin' Lena* were given birth as puppets by Bob Clampett, who had been a mainstay at Warner Bros. before leaving in 1946. The main characters embarked on many journeys that included the cowardly, but friendly Captain Horatio Huffenpuff (Beany's uncle) and navigator Crowy and were hindered by the evil Dishonest John. The captain would give out the dangerous assignments, then hide himself below deck in a box labeled "Capt. Huffenpuff's Hiding Box" when the crew was in peril.

Beany was a well-adjusted kid with a sense of adventure that kids of the baby boomer generation could identify with. The blond-haired boy wore blue pants with suspenders and his signature red-and-white beanie with a propeller. He depended on Cecil the Seasick Sea Serpent to keep him safe, often calling upon him when endangered. Cecil's long neck and head hovered over the craft as it sailed along—his tail was generally obscured from the viewer. He was fiercely loyal to Beany. But his trusting nature and stupidity often resulted in physical abuse from the many enemies of the crew.

The show often used puns. In one episode, the captain warned of a sea monster that loved fish and ships, ships kabob, and a hull mess of spar ribs. Among the side characters was Tearalong the Dotted Lion. The show won two Emmy Awards during its run and attracted such admitted adult fans as Lionel Barrymore, Groucho Marx, Jimmy Stewart, Frank Zappa, and even Albert Einstein.

Beany and Cecil ran one season in primetime before moving in 1963 to Saturday mornings, where it remained for five years. It then went into syndication, but the characters remained dormant until 1988, when ABC ran an ill-fated new series titled *The New Adventures of Beany and Cecil* in which only five shows of the eight produced were aired. Old episodes were shown on Cartoon Network in 2003.

Why Beany and Cecil Are No. 46

As puppets, Beany and Cecil helped plant the seeds that grew into TV animation and Saturday morning fun for a generation of baby boomer children. As animated characters, they entertained both kids and adults, though with great help from witty writing and intriguing side characters.

Their friendship and caring for each other, as well as their adventurous spirits, were the glue that held the cartoon together. But they were also significant characters in the history of televised animation.

—MG

47
FOGHORN J. LEGHORN

TOON-UP FACTS

Creators: Robert McKimson and Warren Foster
Studio: Warner Bros.
Voice: Mel Blanc
Debut: 1946 (*Walky Talky Hawky*)
Catchphrases: "That's a joke, son." . . . "Go away, boy, you bother me."
Antagonist: George P. Dog (Barnyard Dawg)
Love interest: Miss Prissy (Widow Hen)
Student of life: Egghead Jr.
Rival: Rhode Island Red
Favorite song: "Camptown Races"
Defining role: Theatrical shorts
Top TV venue: *The Bugs Bunny Show* (1960–1975)
Traits: Domineering, vengeful, proud, clever, mischievous, spirited

Foghorn Facts

- Among the most humorous monikers ever heaped upon Foghorn was provided by Egghead, who called him a "loudmouthed schnook."

- *Walky Talky Hawky* starred Henery the Chicken Hawk, but Foghorn Leghorn stole the show and emerged as a series star. Henery appeared in only ten more shorts, eight of which were directed by McKimson.

- Foghorn received his first starring role in *Crowing Pains* (1947), which also featured Henery the Chicken Hawk and Sylvester the Cat.

- A 1947 movie that featured the fictional Senator Claghorn, portrayed by radio comedian Kenny Delmar, was titled *It's a Joke, Son*. Foghorn Leghorn often parroted those same words.

- Egghead Jr. was the intellectual, bespectacled son of Miss Prissy. His crowning athletic achievement was firing a baseball through "coach" Foghorn's bat and a line of trees after making some scientific calculations in *Little Boy Boo* (1954).

- Foster remained with Warner Bros. through 1958 before becoming a prominent writer with Hanna-Barbera. He played a significant role in writing storyboards for *The Flintstones*.
- The character of Miss Prissy, like that of Foghorn himself, was taken from a comic radio character. She was patterned after a dizzy rich woman played by Pert Kelton who seemingly answered every question posed to her on *The Milton Berle Show* with an arrogant "Yeeeesss."
- Foghorn was voiced in two Chuck Jones shorts of the 1990s by Frank Gorshin, better known as The Riddler on the campy *Batman* television series of the mid-1960s. Gorshin also gained fame for his spot-on and intense impersonation of Kirk Douglas.
- His middle name was never mentioned, but it started with a J.
- Foghorn was a white leghorn chicken. Thus, his white frame and "last name."
- *Walky Talky Hawky* landed a 1947 Academy Award nomination, but a *Tom and Jerry* short titled *The Cat Concerto* garnered the victory.

About Foghorn Leghorn

It was no coincidence that the first cartoon in which Foghorn Leghorn appeared earned an Oscar nomination. *Walky Talky Hawky* (1946) was intended to be a starring vehicle for Henery, but proved to be a coming-out party for what he described rather accurately and humorously as the "loudmouthed schnook."

Foghorn was aptly named—his foghorn voice and manner of speaking made him a unique character. His patterns of speech and southern accent were originally borrowed from a 1930s radio character known only as The Sheriff, who interrupted others obnoxiously and interjected "I say" before repeating his own remarks. The voice of Foghorn was later changed by Blanc to mimic that of the also-fictional Senator Beauregard Claghorn, who starred on the Fred Allen radio show and in a 1947 film appropriately titled (in regard to Foghorn) *It's a Joke, Son*.

The humor of Foghorn Leghorn was not merely based on how he talked. His personality was also distinctive. He was as much an instigator as a victim, particularly in his mindless battles against the barnyard dog. He felt a sense of personal freedom in his life and would not allow himself to be tied down. It was no wonder the confirmed bachelor painstakingly avoided making any commitments to the widow hen, who so desperately yearned to tie the knot. Only on occasions of his own desperation, such as when he realized her warm home could thaw out his freezing body, did he make overtures to Miss Prissy.

Foghorn was featured in only twenty-eight Looney Tunes and Merrie Melodies cartoons from 1946 to 1963. But like other secondary Warner Bros. characters, his voice and personality allowed him to create a legacy that far outlived the era in which he thrived. It was no wonder that he was provided a cameo appearance in *Who Framed Roger Rabbit?* (1988) and in the Michael Jordan movie *Space Jam* (1996), as well as two theatrical shorts created by Chuck Jones in the 1990s. But all his appearances beyond *Who Framed Roger Rabbit?* were voiced by actors not named Mel Blanc. They could therefore have never enjoyed the same impact.

Why Foghorn Leghorn Is No. 47

Foghorn Leghorn's manner of speaking, southern accent, "good old boy" nature, and overbearing personality make him unique and fun to watch despite his heavy-handed style.

His interaction with all those with whom he came into contact, whether by choice (such as the barnyard dog) or by chance (such as Henery and Egghead, Jr.) confirmed an unalterable outlook on life and confidence in himself. And, most important to the viewer, he was darn funny. Though that humor was based greatly on his voice—the brilliance of Blanc—his character boasted enough depth to become one of the biggest personalities to ever grace the small screen.

—MG

48

COURAGE THE COWARDLY DOG

TOON-UP FACTS

Creator: John Dilworth
Studio: Stretch Films
Voice: Marty Grabstein
Debut: 1996 (*The Chicken from Outer Space*)
Hometown: Nowhere, Kansas
Clueless owners: Eustace and Muriel Bagge
Antagonists: Dr. Le Quack, Katz the Cat, The Alien Chicken, Di Lung
Motivation: Surviving danger
Defining role: *Courage the Cowardly Dog* (1999–2002)
Traits: Frightened, heroic, protective, heady, loyal

Best Acts of Courage

- "A Night at the Katz Motel" (1999): Courage saves his owners from a red cat that seeks to feed them to humungous spiders.

- "The Clutching Foot" (2000): A fungus on Eustace's foot comes to life and consumes him, then transforms into a huge purple foot featuring five old-school, talking gangsters (one for each toe, including a dominant big toe) that seek to force Muriel and Courage to rob a bank for them. Courage eventually destroys the fungus by licking it.

- "Journey to the Center of Nowhere" (2000): Courage saves the day after a band of eggplants come alive in their anger over a drought and Muriel's use of them in her "eggplant surprise" and stage an attack on her.

- "Little Muriel" (2000): Courage finds a way to return Muriel to old age after she is sucked into a tornado and returns as a toddler.

- "1,000 Years of Courage" (2000): Muriel, Eustace, and their pup are hurtled a thousand years into a future Earth controlled by banana people after a meteor crashes into the planet.

- "Car Broke, Phone Yes" (2001): Courage seeks to recapture Muriel's kindness, which is stolen by an alien brain, thereby making her as crabby as her husband.

- "Curtain of Cruelty" (2002): Courage investigates after a bizarre pink curtain moves through Nowhere and makes its citizens angry and mean. He discovers the perpetrator is cruel and miserable Professor Mean, who seeks to depress everyone else.

- "Feast of the Bullfrogs" (2002): Courage and his owners are enslaved by bullfrogs whose pond has dried up. They force their captors to act like frogs.

- "Tulip's Worm" (2002): Two alien teddy bears invade and destroy Nowhere looking for a worm that belongs to a gigantic intergalactic human girl named Tulip and is attracted to Courage's tuba playing. Pied Piper Courage visits their planet to return the teddy bears and the worm, which has eaten Muriel. Mission accomplished.

- "Watch the Birdies" (2002): Courage must again save Muriel, who is abducted by a giant mother vulture, which threatens to eat her unless she looks after her baby vultures while she flies off to find a mate. Courage must help Muriel keep the baby vultures safe.

- "King of Flan" (2002): Courage prevents the King of Flan from addicting the citizens of Nowhere to flan through television hypnosis, thereby saving them from becoming obese.

- "House Calls" (2002): A lonely scientist named Dr. Gerhart with an envious, sentient house attracts the Bagge ranch house to move next door with music. The jealous Gerhart home seeks to destroy the Bagges in an attempt to keep the scientist all to itself, motivating Courage to find a way to make it happy.

- "Ball of Revenge" (2002): Eustace grows jealous of Courage, who is getting too much attention from Muriel, so he invites a group of adversaries such as the Weremole and Giant Foot to the house to kill the dog in a brutal game of dodgeball.

About Courage the Cowardly Dog

For an animator that had no desire to remain an animator, John Dilworth certainly created one captivating and lovable character in Courage the Cowardly Dog. Courage is actually misnamed—he is easily frightened, but he is no coward. He is downright heroic.

Dilworth emerged from the New York School of Visual Art to produce *The Chicken from Outer Space*, which featured Courage, hit the air on Cartoon Network, and earned an Academy Award nomination. Dilworth had no desire to pursue animation as a career, but the network persuaded him to transform the characters featured in *The Chicken from Outer Space* into a series. The result was *Courage the Cowardly Dog*.

Courage is a chubby, little pink pup with raised black ears, a black nose, and a black spot on his lower back. He and his family live in the middle of nowhere: Nowhere, Kansas.

The dog is confronted in every episode with an outrageous and terrifying threat from anything from a giant foot to an army of angry eggplants to a feline hotel owner, all of whom threaten him and his beloved, but clueless owners. Not that Eustace is appreciative—his typical verbal reaction to anything Courage does is "stupid dog!" But the resourceful Courage always finds a way in the end to rescue one and all.

Fifty-two episodes of *Courage the Cowardly Dog* were produced from 1999 to 2002. There have been no reboots, though the show has strengthened its legacy as standard fare on Boomerang, which has kept many characters and shows from the past alive.

Why Courage the Cowardly Dog Is No. 48

Viewers both young and old rooted for Courage. There was nothing not to like. And he was a bit like many of us. He was easily frightened, but had to gather up the emotional strength to overcome what life and fate throw his way. He was loyal, mostly to Muriel, but to some extent even the ungrateful Eustace, who always remained unaware that Courage was saving his life.

Courage was expressive without speaking. He displayed his terror with shrieks and yelps and hops up and down and tugs on Muriel's apron. But he played the role of hero in every episode, overcoming his natural inclination to fright—and who wouldn't be scared when confronted by a three-headed killer chicken?

He was the standout character on a fun show that was so absurd, the scary parts were never scary. Courage hit his stride around the turn of the twenty-first century. Cartoon aficionados might still be embracing the memorable mutt when the next century comes around.

—MG

49
PHINEAS AND FERB

TOON-UP FACTS

Creators: Dan Povenmire, Jeff "Swampy" Marsh
Studio: Disney Television Animation
Phineas voice: Vincent Martella
Ferb voice: Thomas Sangster
Debut: 2007 ("Rollercoaster")
Relationship: Stepbrothers
Full names: Phineas Flynn and Ferb Fletcher
Phineas catchphrases: "Hey, Ferb, I know what we're gonna do today!" . . . "Hey, where's Perry?"
Sister: Candace
Hometown: Danville
Friends: Baljeet, Butch
Pet: Perry the Platypus
Antagonist: Dr. Heinz Doofenshmirtz
Defining role: *Phineas and Ferb* (2007–2015)
Phineas traits: Unselfish, spirited, industrious, imaginative, creative
Ferb traits: Quiet, intelligent, musical, inventive, handy

Phineas and Ferb Fodder

- Ferb used to live in the United Kingdom. His infrequent speaking reveals a British accent.

- Povenmire was already a tremendously experienced television animator before embarking on this creation. He had previously worked on such hit shows as *SpongeBob SquarePants*, *The Simpsons*, and *Family Guy*.

- *Phineas and Ferb* was rejected by Fox and Cartoon Network before finding a home on The Disney Channel.

- The two boys are too busy in the summer to think about love, but one recurring character certainly has her eyes on Phineas. And that's Isabella Garcia-Shapiro, who often finds herself involved in his adventures.

- Music plays a major role in the show. Each episode features a song, sometimes sung by Ferb, who prefers belting out a tune to talking.

- Phineas voice Vince Martella, who was a mere fourteen years old when the cartoon was launched, is also well known for playing the role of Greg Wuliger in the sitcom *Everybody Hates Chris*.

- The name of every wildly complex invention created by Dr. Doofenshmirtz to take over the Tri-State area ends in "ator." Among them were the Bake Sale Obliterationator, Cute-Puppy-Call-Inator, Audience Control-inator, and the Erase-the-Special-Episode-Inator.

- Marsh, who is nicknamed "Swampy" for obvious reasons, worked with Povenmire on the successful cartoon show *Rocko's Modern Life*. That began a professional relationship that resulted in the creation of *Phineas and Ferb*.

- The only love interest targeted by the featured family is that of sister Candace, who has a mad crush on Mr. Slushy Burger employee Jeremy.

- Perry toils for the OWCA, which stands for the Organization Without a Cool Acronym. Dr. Doofenshmirtz runs an empire he named Doofenshmirtz Evil Incorporated.

- Phineas and Ferb do not discover that their pet platypus Perry is a secret agent in an episode of the show. They only learn the truth in *Phineas and Ferb the Movie: Across the 2nd Dimension* (2011).

About Phineas and Ferb

Few animated shows in the modern era have received stronger critical acclaim than *Phineas and Ferb*. There is nothing exceptional about the characters themselves aside from the workmanlike way they go about spending their time during their summer vacations. Never mind that they can create in minutes a myriad of wonderlands that would realistically take many years to build, as well as having construction abilities beyond anything two young boys could master. It's a cartoon, after all.

Phineas and Ferb established their motivations in Season 1, during which they built such creations as a flying car, monster truck track, backyard beach (complete with ocean), and a haunted house to scare the hiccups out of Isabella. They also forged relationships with friends Baljeet and Butch, though the latter was a bit of a bully. And little did they know that their pet platypus Perry was a secret agent determined to thwart the evil efforts of Dr. Doofenshmirtz, who was a bit less ambitious than other cartoon villains. He simply sought to rule the Tri-State area.

The stepbrothers certainly look dissimilar. Phineas has a triangular head that comes to a point on the top and features a patch of scruffy red hair. He typically wears blue shorts and an orange-and-white-striped T-shirt. Ferb boasts a long rectangular face topped with longer green hair.

But the pair works together well as a team with the willing help of Isabella, and despite the efforts of excitable sister Candace, who yearns to "bust" the boys and tattle to their mother before the efforts of the overdramatic, foolish Dr. Doofenshmirtz wipe out the construction du jour, thus destroying the evidence.

Phineas is the mastermind of the duo. He is not content to spend his summers lying under a tree or playing video games. His desire is to maximize every day through imagination and motivation. Their personalities are also different. Phineas is far more of a leader. Ferb, who delivers a line perhaps once an episode, is a construction whiz.

The popularity of *Phineas and Ferb* motivated the Disney Channel to keep it on the air for eight years and market it heavily through a full-length film, live tour, and talk show in which the main characters interviewed celebrities.

Why Phineas and Ferb Are No. 49

For those creating cartoon characters, often their highest aspiration is to simultaneously entertain and teach kids. Phineas and Ferb certainly achieved both. Their penchant for amusing young viewers is undeniable given the success of the show. But in this age of disturbing listlessness among children, even during summer vacations when in decades past the youngest generations spent time exercising their bodies and imaginations rather than just their thumbs on the latest video games, the lesson provided by the two stepbrothers can be considered invaluable.

They at least tried to accomplish a goal to better their lives on a daily basis. Never mind that their creations were invariably ruined by Dr. Doofenshmirtz.

That Phineas and Ferb were role models would have mattered little had few been watching. They proved to be intriguing enough characters to attract viewers, allowing their industriousness to filter through. One can only guess if it made a difference, but all those involved in producing *Phineas and Ferb* deserve praise for it. It's no wonder the show earned three Emmy nominations for Outstanding Animated Program.

—MG

50
BLOO

Creator: Craig McCracken
Studio: Cartoon Network Studios
Voice: Keith Ferguson
Debut: 2004, *Foster's Home for Imaginary Friends* (Episode: "House of Bloo's")
Full name: Blooregard Q. Kazoo
Home: Foster's Home for Imaginary Friends
Homeowner: Madame Foster
Friend: Mac
Antagonists: Mr. Herriman, Frankie
Defining role: *Foster's Home for Imaginary Friends* (2004–2008)
Traits: Selfish, attention-seeking, arrogant, snarky, candid, demented, competitive, manipulative

In Regard to Blooregard

- The impact Bloo had on Foster's Home has been compared to that of Randall P. McMurphy (played by Jack Nicholson) on the patients and staff at the asylum in the acclaimed film *One Flew Over the Cuckoo's Nest*. Both sought control of others and of their environments.

- McCracken first gained notoriety with his creation of *The Powerpuff Girls*. He considered that series more cartoonish than *Foster's Home for Imaginary Friends*, which he deemed as more story-driven.

- Bloo sometimes used mere pocket change in an attempt to buy off others.

- Imaginary friend Berry, who appeared in only two episodes, had a mad crush on Bloo, whose interest was nil. She sought to kill Mac by tying him to a gigantic rubber band ball and running him over with a train in her deranged belief that he was preventing love from blossoming in "Affair Weather Friends" (2007). Bloo, however, saved his creator's life by snagging him away with his beloved paddleball. Berry never reappeared on the show.

- Bloo greatly resembles one of the ghosts that chases and is chased by Pac-Man in the legendary video game.

- Various character and art designers won Emmy Awards for their work on *Foster's Home for Imaginary Friends* every year from 2005 to 2008. The show was nominated for Outstanding Animated Program in 2006 and 2007.

- Bloo is the lone imaginary friend who is not intimidated by Mr. Herriman, a humanized rabbit and product of Madame Foster's imagination.

- Mac voice Sean Marquette started young in the entertainment industry. He appeared in the soap opera *All My Children* at age seven in 1995.

- The title of the show is catchy, but misleading. The imaginary friends such as Bloo are not imaginary at all. They are quite real, complete with emotions and lives autonomous from those who first imagined them.

- Bloo is the lone character to appear in every episode of *Foster's Home for Imaginary Friends*. Mac had been in all of them until "Pranks for Nothing" (2008).

About Bloo

There was a lot of imagination put into the creation of the characters on *Foster's Home for Imaginary Friends*. And the most imaginative was the incredibly self-serving Bloo, who in the heart and mind of Mac's mother was on the way to destroying her son. The result was that Mac grudgingly dispatches Bloo to the home, but arranges secretly to visit him daily.

This seems like a bad arrangement at first, but Mr. Herriman threatens to put Bloo up for adoption if Mac does not keep a frequent eye on him. Bloo, however, continues to negatively impact Mac for quite some time. But they feel an emotional need for each other. And Mac eventually matures to the point to which he is able to stand up to Bloo, who gains respect for him because of it.

Bloo, after all, does not give his respect easily. He is far too self-centered for that. He proves to be easily the most rebellious housemate. The punishments meted out for his behavior only serve to strengthen his resolve to get what he wants at the expense of anyone who tries to get in his way. His desires, whether they be motivated by petty jealousies or the yearning to partake in activities to his liking, drive him to disregard practicality and the feelings of all others, including Mac.

The relationships between Bloo and characters such as Mac, Madame Foster, Mr. Herriman, Berry, and Frankie are more complex than the usual cartoon relationships. Each relationship is different, but Bloo's personality and motivation remain the same.

Why Bloo Is No. 50

Bloo is an intriguing character, not so much due to his selfishness, but rather because of how he manipulatively maneuvers each association to fulfill his desires. He knows how to push the buttons of the other characters to get what he wants. He softens and changes only for Mac, whom deep down he loves enough to finally give him the respect he has earned as a friend. The success of *Foster's Home for Imaginary Friends* can be attributed greatly to Bloo, around whom most of the storylines are based. The complexities of his relationships with the other characters make him one of the more captivating characters in the history of television animation.

—MG

51
ROCKO

Creator: Joe Murray
Studios: Joe Murray Productions, Nickelodeon Productions
Voice: Carlos Alazarqui
Debut: 1993, *Rocko's Modern Life* (Episode: "Trash-O-Madness")
Defining role*: Rocko's Modern Life* (1993–1996)
Species: Wallaby
Age: Eighteen
Workplace: Kind of a Lot o' Comics
Hometown: O-Town
Birthplace: Australia
Parents: Mr. and Mrs. Wallaby
Best friends: Heffer Wolfe, Filburt
Antagonists: Ed Bighead, Earl
Pet: Spunky (dog)
Catchphrase: "Day is a very dangerous day" (e.g., "Garbage Day is a very dangerous day").
Hobbies: Collecting comic books and rainbows
Traits: Loyal, cowardly, obsessive, polite, shy, paranoid, forgiving, sensible, moral, compassionate, neat, self-conscious

Rocko

- From the second season onward the theme song was sung by Kate Pierson and Fred Schneider of the B-52s.

- The show was known for its innuendo and included references to "spanking the monkey," "choking the chicken," and other sexual terms that slipped past the censors.

- In the original pitch for the show Rocko was described as "a young anthropomorphic Woody Allen who has just moved away from his home into a surrealistic adult world."

- Rocko is often mistaken for an animal other than a wallaby, such as a platypus, weasel, beaver, or dog.

- Rocko's best friend is voiced by Tom Kenny, who went on to voice SpongeBob SquarePants, who was created by one of the *Rocko's Modern Life* show's creative directors, Stephen Hillenberg.
- In the rich cartoon tradition of characters like Donald Duck, Rocko wears a shirt but no pants.
- Rocko worked briefly for a phone sex hotline. The guidelines posted on the wall behind him read: "REMEMBER. Be Hot. Be NAUGHTY. Be Courteous."
- The character of Dr. Hutchinson had a hook for a hand because the network encouraged the producers to "introduce a positive female character with a strong hook."
- Three episodes were banned from airing on Nickelodeon: "Leap Frogs," "Jet Scream," and "Heff in a Handbasket."
- The cast was encouraged to improvise and recorded their lines on a sound effects stage rather than in a traditional studio.

About Rocko

After graduating high school in Australia, Rocko, a wallaby, immigrated to the United States to begin his adulthood in the "surreal world." He soon realized the world was a dangerous place and every day was a "very dangerous day." Though obsessed with cleanliness, his own personal space tended to be a mess and was just one of the many responsibilities of adulthood he had to tackle. Simple daily tasks often resulted in trials and tribulations, and few things went as planned for the oft-abused and put-upon Rocko.

Rocko dealt with the issues of growing up and living on your own: getting your first credit card, taking out the trash, workplace drama, and navigating interpersonal relationships were all fodder for the newly independent wallaby. Rocko overcame his fear and trepidation with help from but often in spite of his friends Heffer Wolfe and Filburt. The humor of *Rocko's Modern Life* derived from the situations the character was put into that would rapidly degrade into herculean tasks.

While the show may have been produced for children, it found its strongest audience among college students who identified with the character's struggles. The theme of transitioning to adulthood was prevalent throughout the series and a part of its major appeal was the more "adult" humor and innuendo. It is that humor that has helped Rocko maintain a cult following.

Why Rocko Is No. 51

The 90s were a golden age of television animation and *Rocko's Modern Life* was one of the earliest shows produced for the newly launched Nickelodeon network. Nickelodeon had rapidly established itself as producing edgier but still kid-friendly animation with the introduction of shows like *Ren & Stimpy*. *Rocko's Modern Life* would fit perfectly into that mold.

Rocko's writers embraced the challenge of straddling the line between a show for children and adults just as the character straddled his own identity of a child recently grown into adulthood.

Inside jokes and innuendos were aimed above children's heads but hit the target of parents and older siblings. Sometimes they would push the envelope too far for the censors' liking, such as in the banned episode "Leap Frogs" in which Rocko's neighbor Bev seeks attention outside her marriage.

Overall Rocko managed to successfully navigate the difficult tasks of appealing to adults and kids equally without crossing the line too frequently. *Rocko's Modern Life* was a rare show that many loved as a child but gained new appreciation for as an adult.

—JW

52
MOJO JOJO

Creator: Craig McCracken
Studio: Hanna-Barbera
Voice: Roger Jackson
Species: Chimpanzee
Catchphrase: "Curses!"
Antagonists: The Powerpuff Girls
Debut: 1998, *The Powerpuff Girls* (Episode: "Monkey See, Doggie Do!")
Home: Townsville
Motivation: To rule the world
Defining role: *The Powerpuff Girls* (1998–2005)
Traits: Brilliant, evil, cunning, strategic, charismatic, verbose, creative

Major Mojo Material

- Mojo Jojo was patterned after Dr. Gori, an evil character from the 1971 Japanese live-action science fiction series *Spectreman*.

- Voice Roger Jackson is perhaps better known for voicing the killer Ghostface in the popular Scream films. He also voices Butch of The Rowdyruff Boys from *The Powerpuff Girls*.

- Mojo Jojo spoke with a distinct Japanese accent.

- The lead antagonists for The Powerpuff Girls in their debut as The Whoopass Girls, created by McCracken as part of an animation project as a student at the California Institute of the Arts, were the members of the Gangreen Gang. Mojo Jojo was not created until the series hit the small screen.

- The character is seen only on occasion in *The Powerpuff Girls* reboot, a series that was launched on Cartoon Network in 2016. He appeared in promotional videos for the show, but in just seven of the first twenty-seven episodes. Though each of the girls boasted a different voice actor than in the original series, Jackson continued to handle Mojo Jojo.

- Mojo Jojo was the leader of a band of supervillains called the Beat-Alls. His subordinates included Fuzzy Lumpkins and Princess Morbucks. But, in what can be construed as an allusion

to the Beatles (the episode in which the girls meet the Beat-Alls features dozens of references to the band and the lyrics of its songs), they quickly broke up.

- The nature of Mojo Jojo was changed extensively in a Japanese adaptation of the show titled *Demishita! Powerpuff Girls Z*. He is a zoo monkey rather than a lab chimp. He is more a comedic than serious villain. He is also inept and far less intelligent.

- Mojo Jojo is not the most feared villain in *The Powerpuff Girls*. That distinction belongs to HIM, who is so evil that even Mojo respects his malevolence, occasionally calling him "sir."

- The first episode of McCracken's highly successful follow-up series titled *Foster's Home for Imaginary Friends* (*House of Bloo's*) provided Mojo Jojo a cameo spot. He appears briefly in a hallway, resulting in shocked stares from the other characters.

- Though Mojo Jojo is the most prominent evil villain, a poll on The Powerpuff Girls Fan Club site listed The Rowdyruff Boys as by far the favorite. But Mojo Jojo certainly receives some credit. He created that gang in jail as the evil counterparts to The Powerpuff Girls. They were made by flushing armpit hair, cafeteria snails, and a puppy tail down a toilet that contained Chemical X. Their names were Brick, Boomer, and Butch.

About Mojo Jojo

In the tradition of good vs. evil, we bring you the story of Mojo Jojo and his antagonists. As the narrator once stated, he is "revengeful, resentful, spiteful, law-breaking, mad, swindling, thieving, malicious, extorting, assaulting, crooked, torturous, dishonest, complaining, wicked, indecent, menacing, touchy, swarthy, shadowy, and villainous." Mojo Jojo did not argue with that assessment.

The chimp known first only as Jojo toiled irresponsibly as a lab assistant under Professor Utonium, who had yet to produce The Powerpuff Girls. He caused the good professor to accidentally mix Chemical X in with the sugar, spice, and everything nice used to create the girls. The resulting explosion transformed Mojo Jojo into one megalomaniacal monkey.

Mojo, who lives atop Townsville Volcano Mountain, is unique in appearance and speech. His skin is green, his eyes are pink and white, his brain is exposed under his hat, and he wears white gloves and boots, a blue suit, and a purple cape. He speaks oddly in run-on sentences.

He is not always evil when he isn't actively seeking to destroy The Powerpuff Girls and take over the planet. He is sometimes even pleasantly thoughtful in his pursuits, such as building model ships. But he more often uses his genius toward evil ends, such as creating giant robots or destructive weaponry.

His life outside his dark, criminal activity gives his character depth. He can be seen purchasing food rather than stealing it. He can be downright generous, even allowing the girls to borrow items from him. His hostility toward his adversaries is not pronounced when he perceives them as no threat. But his evil intent and hatred for The Powerpuff Girls when they do seek to thwart him are unmistakable.

Mojo Jojo appeared in forty-four of the seventy-eight original *Powerpuff Girls* episodes, making him easily the most prominent villain in one of the most acclaimed cartoons in television history.

Why Mojo Jojo Is No. 52

There are simple villains and there are complex villains with intriguing personalities and motivations. Mojo Jojo falls squarely into the latter category. The depth of his character extends beyond the physical and emotional battles against The Powerpuff Girls. That he is thoughtful, intelligent, creative, and occasionally kind gives him an identity unlike most cartoon antagonists. Mojo Jojo is an ideal counterpart to The Powerpuff Girls. That they are able to overcome not only his evil intent, but his impressive brainpower, raises their achievements to a higher level. Perhaps the show could have thrived without him, given the wide array of villains created to do battle with the three flying kindergarteners. But Mojo Jojo boasts greater depth of character than any of the other evil-doers on a show that has earned tremendous critical acclaim. And that makes him one of the premier animated villains ever.

—MG

53
HONG KONG PHOOEY

TOON-UP FACTS

Creators: Bill Hanna and Joseph Barbera
Studio: Hanna-Barbera
Voice: Scatman Crothers
Debut: September 7, 1974, *Hong Kong Phooey* (Episode: "Car Thieves")
True identity: Penrod "Penry" Pooch
Antagonists: Dr. Disguiso, Mr. Tornado, The Gumdrop Kid, The Giggler, Grandma Goody
Starring TV roles: *Hong Kong Phooey* (1974), *Laff-a-lympics* (1977–1979)
Place of employment: Los Angeles Police Department
Boss: Sergeant "Sarge" Flint
Vehicle: The Phooeymobile
Pet/Sidekick: Spot
Changing area: File cabinet
Catchphrase: "Ho! Hee! Hi! Ho! Ha!"

Hong Kong Trivia

- In 2015 a ceramic mosaic of Hong Kong Phooey by the artist "Invader" sold for HK$2 million at a Sotheby's auction.

- Hong Kong Phooey is one of very few cartoons where the star, voiced by Scatman Crothers, also sings the theme song.

- The popular alternative rock group Sublime recorded their take on the Hong Kong Phooey Theme for the 1995 album *Saturday Morning Cartoons' Greatest Hits*.

- Children of the 70s are often surprised as adults to realize the lead characters name was "Penry" and not "Henry" as it is oft misremembered.

- Sarge Flint was played by Joe E. Ross. Ross had played the role of Officer Gunther Toody in the classic *Car 54, Where Are You?* He brought back his famous "ooh-ooh-ooh!" trademark phrase for his role in Hong Kong Phooey.

- Despite his name, Spot was a striped cat.

- In the 1990s a live-action CGI version of Hong Kong Phooey starring Eddie Murphy was in development. Test footage was produced but the idea was scrapped.

- Hong Kong Phooey is regarded by many as a positive black character in animation and is featured in the Museum of Uncut Funk collection.

- Among Hong Kong Phooey's Kung Fu moves are: The Rice Paddy Flying Dragon Kick, Wan Ton Wahoo, and the Fortune Cookie Flop.

- Hong Kong Phooey was a member of the Scooby Doobies team in the animated *Laff-A-Lympics*. His teammates included: Scooby-Doo, Shaggy Rogers, Scooby-Dum, Dynomutt, Blue Falcon, Captain Caveman, Brenda Chance, Taffy Dare, Dee Dee Sykes, Speed Buggy, Tinker, and Babu.

About Hong Kong Phooey

Hong Kong Phooey was the super identity of mild-mannered clumsy police precinct janitor Penry Pooch. As crimes were called into Rosemary, the telephone operator, our hero Penry would overhear and then spring into action! Via a convoluted conveyance of ricochets off of everyday objects such as ironing boards, Penry would transform into Hong Kong Phooey and make his way to the Phooeymobile (cleverly hidden in a Dumpster). However his transformation always seemed to bottleneck somewhere in the file cabinet at which time his trusty pet and companion Spot would come to the rescue to release him with a well-placed hit to the cabinet.

Hong Kong Phooey relied heavily (if unknowingly) on Spot, who was the real hero in capturing the criminals. However the world and Phooey himself held the canine crusader in high regard. No matter the amount of damage done by Hong Kong Phooey's clumsy negligence, the public regarded it as an honor to have suffered indignities at the hands of their hero.

In his trademark red robe with white trim, Phooey looked the part of a 70s-era Kung Fu hero. Though he had obtained only a yellow belt, he would frequently consult his correspondence course copy of *The Hong Kong Book of Kung Fu* before going into battle.

The hapless hero's cool factor was enhanced by the amazing Phooeymobile's ability to transform into a boat, plane, or even phone booth when triggered by the sound of Phooey's gong.

Despite Hong Kong Phooey's clumsy nature, his confidence and cool always seemed to carry him through along with a little help from his kitty sidekick Spot.

Why Hong Kong Phooey Is No. 53

Though the show ran only one season of a mere sixteen episodes, to many Hong Kong Phooey is their "number one super guy!" For just about any child of the 70s, Hong Kong Phooey brings back fond memories as Scatman Crothers's distinctive voice rings and struts through their head. Of the hundreds of voice actors working, few defined a decade the way Scatman did. As an actor in the 70s, he popped up in everything from *Silver Streak* to *The Love Boat*. As a cartoon voiceover artist he had worked for Disney, Don Bluth, Ralph Bakshi, and Hanna-Barbera. But of all his many roles over his four decades in film and television, Hong Kong Phooey was his most beloved. It can often be hard to define what allows such a short-lived character to take on iconic status, but for Hong Kong Phooey it's easy . . . it's that voice. Fan-riffic!

—JW

54
QUICK DRAW MCGRAW

TOON-UP FACTS

Creators: William Hanna, Joseph Barbera
Studio: Hanna-Barbera
Voice: Daws Butler
Debut: 1959 ("Scary Prairie")
Home: Wide open spaces of the Wild West
Alter ego: El Kabong
Catchphrase: "I'll do the thinnin' around here. And dooooon't you fergit it!"
Sidekick: Burro Baba Looey
Pet: Snuffles the Dog
Instrument and weapon of choice: Guitar
Defining role: *The Quick Draw McGraw Show* (1959–1962)
Traits: Heroic, brave, reckless, stupid, loyal, silly

Horse Cents

- Butler also voiced Baba Looey and Snuffles.

- Snuffles so loved the dog biscuits provided him that he would point to his mouth, gulp them down without chewing, hug himself, lie on his back, float into the air, and drop slowly back to Earth, all while moaning in ecstasy.

- Quick Draw appeared on box fronts of Kellogg's Sugar Smacks in the 1960s.

- The creation of sort-of superhero El Kabong as an alias was inspired by the TV show *Zorro* (1957), which was still on the air when Quick Draw debuted.

- All forty-five of his cartoons that aired from 1959 to 1962 were written by Michael Maltese, who made his name working with Warner Bros. and created many Bugs Bunny shorts. Maltese played a huge role in the writing of such classics as *The Flintstones* and *Wacky Races* after joining Hanna-Barbera.

- El Kabong debuted in the not-so-creatively titled "El Kabong" (1960), Episode 16 in the first season. He was introduced with the rhyme, "Of all the heroes of legend and song, there's

none so brave as El Kabong." And when the voiceover states that "he rights the wrong," he is shown changing the arithmetic problem "2 + 1 = 4" written by a young boy on a blackboard to "2 +1 = 6."

- Quick Draw McGraw was a horse that occasionally rode a horse.

- *The Quick Draw McGraw Show* also featured two other series. Included were the cat- and-mouse detective team of Snooper and Blabber and father-and-son hounds Augie Doggie and Doggie Daddy.

- Extreme Championship Wrestling standout New Jack used an acoustic guitar as a weapon in the ring, prompting announcer Joey Styles to refer to him as "El Kabong."

- Quick Draw made a brief appearance in a Met Life commercial in 2012.

- The voice of Baba Looey has been compared to that of Cuban-born bandleader and television actor Desi Arnaz, who had starred alongside Lucille Ball in *I Love Lucy* from 1951 to 1957.

About Quick Draw McGraw

Quick Draw McGraw followed Ruff and Reddy, Huckleberry Hound, and Yogi Bear to the small screen as the last Hanna-Barbera main character to debut in the 1950s. Fifteen episodes hit the air in 1959. The first to be shown in the new decade was the debut of El Kabong.

Unlike real horses, Quick Draw walked like a human. His hooves featured thumbs that allowed him to carry things, such as the guitar he strummed as he wandered around the West seeking out and subduing bad guys. His distinctive look included a red cowboy hat and holster, blue bandana tied around his neck, and short black mane and tail.

Quick Draw made it clear who was the boss to buddy Baba Looey, who was far more intelligent than him and whose generally wise ideas were answered with the insistence of his horse friend that, "I'll do the thinnin' around here." Baba Looey was always agreeable and Quick Draw good-natured. Though careless in his quest to rid the West of its many bandits, his bravery and persistence always resulted in him getting his man.

The somewhat surprising, out-of-nowhere creation of an alter ego sets him apart from other notable cartoon characters. El Kabong boasted many of the same characteristics as Quick Draw, but looked quite different. He shed the red cowboy hat and gun for a small black hat and guitar, which he slammed over the heads of outlaws with the cry, "KABONG!" and the sound of a strum on a badly out-of-tune instrument.

But both Quick Draw and El Kabong are certainly not immune from being victims of violence. They are shot in the face perhaps more often than any cartoon character in history. That victimization has resulted in comparisons with Daffy Duck.

Quick Draw and El Kabong took advantage of the fascination of baby boomer children for western movies and television shows. The clichéd dialogue resonated with kids and provided a bit of knowing humor for adults watching along. It was no wonder *The Quick Draw McGraw Show* was nominated for an Emmy Award in 1960 for Outstanding Achievement in the Field of Children's Programming (it lost out to *The Huckleberry Hound Show*).

The Quick Draw McGraw Show lasted three seasons, but his popularity was brought to new generations. He appeared in animated programs featuring Yogi Bear, Fred Flintstone, and Casper the Friendly Ghost in the late 1970s. His legacy lived on past the turn of the twenty-first century with an appearance in the highly popular *South Park* and references to El Kabong in *The Critic*.

Why Quick Draw McGraw Is No. 54

Quick Draw McGraw has been described as the last of the cartoon characters that could have thrived in theatrical shorts. That he was a western character fit in with both the movies and television fare lapped up by kids of that era.

The Michael Maltese influence on Quick Draw was evident from the start. The character has been equated to Daffy Duck in his silly stupidity and desire to play the role of hero. His voice has been compared to that of comic genius Red Skelton. Those are lofty comparisons.

The sameness of the Quick Draw McGraw character as a do-gooder in the Old West catching bad guys was transformed into versatility when he became El Kabong. Memories of that character flying through the air, yelling "Ole!" and slamming the outlaw over the head with his guitar have created a legacy that Quick Draw alone could never have enjoyed.

—MG

55
PORKY PIG

TOON-UP FACTS

Creator: Friz Freleng
Studio: Warner Bros.
Voice: Mel Blanc
Debut: 1935 (*I Haven't Got a Hat*)
Catchphrase: "Th-th-th-that's all folks!"
Antagonist: Daffy Duck
Father: Phineas Pig
Love interest: Petunia Pig
Defining role: Theatrical shorts
Top TV venue: *The Porky Pig Show* (1964–1967)
Traits: Calm, unaggressive, intelligent, victimized, unflamboyant

Pig Slop

- The legendary stutter as produced by original voice Joe Daugherty was far more severe than that of Porky as voiced by Mel Blanc. Daugherty was actually inflicted with a stuttering issue that he could not control when he voiced Porky. It took him too long to deliver his lines, thus leading Warner Bros. to replace him with Blanc.

- The first Porky short voiced by Blanc (*Porky's Duck Hunt* in 1937) also marked the debut of Daffy Duck. Daugherty had voiced the first twenty Porky Pig shorts.

- In his 1935 debut, a young student Porky stutters his way through a recitation in front of his class, but somehow *The Midnight Ride of Paul Revere* morphs into *The Charge of the Light Brigade*. The short has been compared to the real-life *Our Gang* comedies of that period. But it was not until 1936 that *Our Gang* star Alfalfa recited *The Charge of the Light Brigade* in front of his class. That recitation ended when his friend—who also debuted in 1935 and was named Porky—used a magnifying glass to set off fireworks in Alfalfa's back pocket.

- In 1991, the National Stuttering Project of San Francisco picketed Warner Bros. to protest the continued use of the Porky stutter, claiming it was disparaging to real-life stutterers. The

studio did not stop utilizing the voice, but it did give the organization a twelve thousand dollar grant and produce public service announcements railing against those who demeaned and belittled stutterers.

- The emergence of Porky as its first star motivated Warner Bros. to place him in eighty-one shorts from 1936 to 1940 alone. The studio created at least thirteen Porky cartoons every year from 1936 to 1942 before slowing down as Porky became more of a sidekick than a star character. He never again appeared in more than eight in a single year (1949).

- Stuttering ran in his family. His father Phineas stuttered about one-third of the words he uttered in three shorts in which he appeared in the late 1930s, including more than half in *Porky the Rain-maker* (1936).

- Porky grew so angry over his stuttering in *Porky's Poppa* (1938) after listening to a recording he made to the tune of "Old MacDonald Had a Farm" that he violently smashed the record and the record player. It was a rare physical display of anger for Porky.

- Blanc gained inspiration for his legendary voicing of Porky by visiting a pig farm. He stated that he "wallowed around with them" and decided that his new character should talk with a grunt.

- Among the animals that shared a classroom with Porky in his debut short *I Haven't Got a Hat* were twin dogs named Ham and Ex and a cat named Beans.

- Actor Bob Bergen was a mere twenty-six years old when he took over as voice of Porky in 1990, following the death of Blanc a year earlier.

About Porky Pig

Bosko was not a chocolate syrup misspelled. He was an animated sort-of human and the first Looney Tunes standout. But when creators Hugh Harman and Rudolph Ising took their character from Warner Bros. and later revived him at MGM, he needed to be replaced. The first attempt was Buddy, a more humanlike character whose animator was an up-and-coming Chuck Jones. But Buddy proved so bland that even Jones couldn't save him.

The studio needed a replacement as its signature character. Little did they know that they'd find one in a nervous, stuttering pig that stole the show in *I Haven't Got a Hat*. New Warner Bros. director Tex Avery and his animators embraced Porky to the point that they sought permission from Leon Schlesinger to feature him in *Gold Diggers of '49* (1935). That short cast Porky as an enormous adult rather than large child. It took a while for the character to be established as his familiar chubby self, but he quickly became a stuttering standout, particularly after Blanc took over the voicing duties.

Porky's personality and versatility as a character, however, made him a better sidekick than lead. In cartoons, as in real life, there are schlemiels and schlimazels. The former are incompetent, clumsy, and foolish. The latter are their victims. Porky falls solidly in the schlimazel camp, most notably and humorously in shorts featuring the madcap lunacy of Daffy Duck.

The stuttering pig featured more human emotional characteristics. He was an everyman who yearned for nothing but peace and serenity, but was caught up in the craziness around him. He boasted no standout personality traits, but proved to be an ideal victim. Warner Bros. played Porky perfectly off the loony Looney Tunes characters that followed him to the silver screen.

Among the funniest examples was *A Pest in the House* (1947), in which Porky plays a hotel manager that works desperately to maintain peace and quiet for a tired, cranky, and threatening guest in Room 666, but both are having a devil of a time. The problem is that bellboy Daffy time and again carelessly prevents the guest from getting any of his badly needed shut-eye by partaking in a series of noisy endeavors such as doing a duet with a drunk in the next room and scraping his fingernail against a window to remove a speck. After each incident, the guest marches downstairs and punches Porky in the nose.

Bob Clampett assumed the directorial duties for Porky in the late 1930s as the familiar look of the pig was established. His creativity became evident from the start, particularly in the classic, inventive short *Porky in Wackyland* (1938) in which he hunts for a believed-to-be-extinct Do-Do bird claimed in a newspaper headline to be worth "$4000,000,000,000 P.S. 000,000,000." He enters a strange world with silly creatures, including one that is nothing but two legs and a head, a duck that walks sideways and repeats the word "Mammy," and a half-dog, half-cat that fights with itself. In the end, Porky joyously outwits and catches the Do-Do, proclaiming he has captured the last of the species, only to be surrounded in the end by hundreds more.

It became obvious even in that short that Porky was outshone by the zany characters around him. Chuck Jones recognized that Porky was best suited as a straight man schlimazel victimized by the likes of sillier and more physically active characters such as Daffy and Sylvester the Cat. Porky became the ultimate co-star in shorts in the 1940s and 1950s.

He also maintained his star quality on television in the 1960s—and not simply because his "Th-th-th-that's all, folks" signoff of Warner Bros. cartoons had been embraced by new generations of fans—so much so that he landed his own starring vehicle in *The Porky Pig Show* after having been featured in *The Bugs Bunny Show* earlier in the decade. A series of his theatrical shorts were used for two decades, in *Porky Pig and Friends* (1971). Steven Spielberg even insisted that Porky's signature signoff end the 1988 animated film *Who Framed Roger Rabbit?*

Why Porky Pig Is No. 55

Porky is among the most versatile and beloved characters ever created by Warner Bros., though his role as more of a hapless victim than frenetic aggressor places him a bit lower in terms of overall greatness than flashier studio standouts such as Bugs Bunny and Daffy Duck. The fact that he became the first Warner Bros. star, adapted perfectly to whatever role changes he underwent and uttered arguably the second-most famous line in the history of animation ("Th-th-th-that's all, folks!") to "What's up, Doc?" gives him a legacy that places him solidly among the all-time greats.

—MG

56
CHARLIE BROWN

Creator: Charles M. Schulz

Studio: Lee Mendelson/Bill Melendez Productions

Voices: Peter Robbins (1963–1969), Chris Inglis (1971), Chad Webber (1972–1973), Todd Barbee (1973–1974), Duncan Watson (1975–1977), Dylan Beach (1976), Arrin Skelley (1977–1980), Liam Martin (1978), Michael Mandy (1980–1981), Grant Wehr (1981), Brad Kesten (1983–1985), Michael Catalano (1983), Brett Johnson (1984–1986), Chad Allen (1986), Sean Collins (1988), Erin Chase (1988–1989), Jason Riffle (1988), Kaleb Henley (1990–1991), Justin Shenkarow (1992), Jamie E. Smith (1992), Jimmy Guardino (1993), Steven Hartman (1995–1997), Christopher Ryan Johnson (2000), Quinn Beswick (2000), Wesley Singerman (2002–2003), Adam Taylor Gordon (2003), Spencer Robert Scott (2006), Alex Ferris (2008–2010), Trenton Rogers (2011), Noah Schnapp (2015), Aiden Lewandowski (2016)

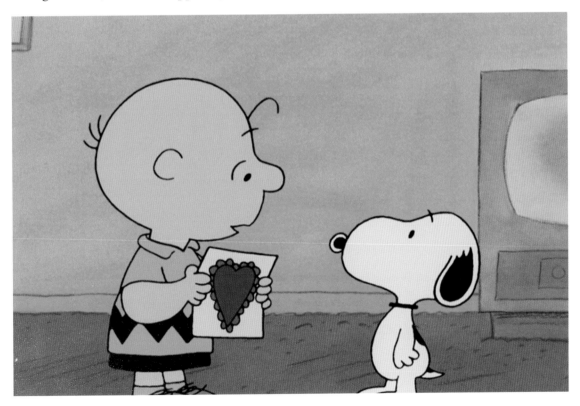

Debut: 1959, *The Tennessee Ernie Ford Show*
Print debut: October 2, 1950, *Peanuts*
Catchphrase: "Good Grief!"
Antagonists: The kite-eating tree, Lucy Van Pelt, Life
Pet: Snoopy
Sister: Sally Brown
Best friend: Linus Van Pelt
Baseball positions: Pitcher and coach
Defining role: *A Charlie Brown Christmas* (1965)
Love interest: The Little Red-Haired Girl
Traits: Wishy-washy, loyal, determined, optimistic

Good Ol' Charlie Trivia

- Much of Charlie Brown's angst was pulled from *Peanuts* creator Charles M. Schulz's own life, including the painful rejection of the "Little Red-Haired Girl."

- All the *Peanuts* TV specials and series feature Charlie Brown's name in the title, whether he is the star of that particular show or not. The exception is *Snoopy: The Musical!*

- Charlie Brown's name was taken from one of Schulz's fellow instructors at Art Instructions Inc.

- Charlie Brown and his friends have become a media empire conquering television, film, stage, video games, and comic books.

- *Peanuts* creator Charles M. Schulz published his final strip on February 13, 2000, with a heartfelt letter. Ironically he died the evening before on February 12 at the age of seventy-seven.

- Charlie Brown's father is a barber, just as Schulz's father was.

- According to his "therapist," Lucy Van Pelt, Charlie Brown suffers from pantophobia, the fear of everything.

- The animated specials broke a lot of the rules of traditional television animation: They used no laugh track and real children's voices were used instead of adults impersonating kids.

- Children throughout the United States felt so bad about Charlie Brown not getting candy on Halloween that some sent sacks of candy via the mail!

- There have been over fifty "Charlie Brown" television specials, spanning six decades.

About Charlie Brown

It would be unfair to call "good ol' Charlie Brown" a hopeless loser. Though no doubt a loser in the classic definition, he is ever and always hopeful. His persistence when faced with the insurmountable odds against him is his most laudable trait.

His failures are many. In both love and flying kites, all is lost for Charlie Brown. For seven decades we have followed Charlie in print and on screen.

We've watched him fail again and again at kicking that darn football, we've witnessed year after year of rocks in his trick-or-treat bag, decades of empty mailboxes and broken hearts on Valentine's Day, and a record-setting baseball loss streak as the world's worst pitcher and coach.

Yet he still holds out hope. His ability to see the best in the worst of situations is summed up in his selection of the fledgling pathetic Christmas tree in the perennial favorite *A Charlie Brown Christmas*. Despite Linus's protest that Lucy won't approve, Charlie Brown says, "I don't care. We'll decorate it and it'll be just right for our play. Besides, I think it needs me."

Charlie Brown manages to see himself in the pathetic little tree, just as we see ourselves in the ever hopeful, yet hopeless, "nice round-headed kid."

His multitude of failings and flaws make him all the more admirable to us.

Lucy put it best: "of all the Charlie Browns in the world, he's the Charlie Browniest."

Why Charlie Brown Is No. 56

Charlie Brown has been celebrating our holidays with us since 1965. Christmas and Thanksgiving just wouldn't be the same without him. Few holiday specials or animated series have had the enormous staying power of the "Charlie Brown" specials. Charlie Brown is an annual tradition for many families throughout the United States and even around the world. He will always have a chair waiting at our holiday dinner table and a place on our list of top animated TV characters! "You're a good man, Charlie Brown!"

—JW

57
DOUG

TOON-UP FACTS

Creator: Jim Jinkins

Studios: Jumbo Pictures, Nickelodeon Animation, Walt Disney Animation, and Plus One Animation

Voices: Billy West (1991–1994), Tom McHugh (1996–2000)

Debut: August 11, 1991, "Doug Bags a Neematoad"

Middle name: Yancey

Last name: Funnie

Imaginary superhero identity: Quailman

Protagonist: Roger M. Klotz

Pet/Sidekick: Porkchop

Best friend: Mosquito "Skeeter" Valentine

Love interest: Patti Mayonnaise

Hometown: Bloatsburg

Current residence: Bluffington

Quailman's hometown: The Planet Bob

Age: Eleven and a half

Defining role: *Doug* (1991–1994)

Funnie Facts:

- Creator Jim Jinkins credited the unique color palette of the characters in Doug to being in a margarita-induced stupor.

- Doug was first pitched as a children's book titled *Doug Got a New Pair of Shoes*. It was rejected by most major publishing houses.

- Doug is left-handed.

- The characters of Doug and Porkchop first appeared in a short animated commercial teaser for the USA Network, though the characters were not yet named at that point.

- Doug's favorite band, The Beets, are based on The Beatles. The Beets's followers are known as *Beetniks.*

- The theme song and most of the soundtrack was produced using vocal effects from voice actor Fred Newman.
- When Doug moved from Nickelodeon to the Disney network, he aged from eleven and a half to twelve and a half.
- Doug was originally going to be named Brian, but creator Jim Jinkins thought the name sounded "too fancy."
- Doug's dog Porkchop has a doghouse shaped like an igloo, but the character is usually seen sleeping indoors with Doug.
- Jim Jinkins revealed in an interview that Doug and Patti do not end up together because "people don't end up with their first love."

About Doug

Though not directly autobiographical, series creator Jim Jinkins pulled from the emotional experiences of his childhood growing up in Virginia for the show *Doug*.

The animated series follows the sixth grade adventures of Doug Funnie as told via the writing in his journal. Like most eleven-and-a-half-year-olds, Doug has a fear of failure and being made to look foolish. In many ways he is just an average kid leading an average life.

His life and adventures become extraordinary through his own imaginings. Creating worst-case scenarios in his own mind, he has also created numerous alter egos as a form of sometimes productive escapism.

He acts out vicariously through his portrayal of characters such as adventurous explorer Race Canyon, cowboy Durango Doug, and The Chameleon, master of disguise. His best-known "role" is that of the superhero Quailman, whose amazing quail-like powers include flight, patience, speed, intelligence, and the "Quail-eye!" In his first adventure Quailman, along with his trusty sidekick Quail-Dog, face off against the evil scientist Doctor Klotzenstein (an incarnation of school bully Roger Klotz). It was the first of several fabulous misadventures of the popular quail duo!

Why Doug Is No. 57

Doug gives us an insight into the inner workings of the mind of a young cartoonist. The parallels between his own life and that of his creator Jim Jinkins are many, and one can almost imagine a future where Doug grows up to create an animated series about his own life. As a modern-day animated Walter Mitty, Doug is able to explore far beyond the limitations of his neighborhood and let his imagination run wild. It is in his imagined adventures as Quailman that Doug soars above traditional pre-adolescent characters and flies to #57.

—JW

58
HUEY FREEMAN

TOON-UP FACTS

Creator: Aaron McGruder
Studios: Rebel Base Productions, Adelaide Productions
Voice: Regina King
Debut: November 6, 2005, *The Boondocks* (Episode: "The Garden Party")
Comic strip debut: February 8, 1996, *The Boondocks*
Antagonists: Ed Wunclear Sr., Uncle Ruckus
Grandfather: Robert Jebediah "Granddad" Freeman
Brother: Riley Freeman
Heroes: Martin Luther King Jr., Muhammad Ali, Che Guevara, Malcolm X, Hugo Chavez
Home address: 327 Timid Deer Lane, Woodcrest
School: Hoover Elementary
Age: Ten
Starring TV role: *The Boondocks* (2005–2014)
Traits: Cynical, radical, misanthropic, intelligent, pessimistic

Huey Freeman's Top "Villains"

- Ed Wunclear I, II, and III
- Uncle Ruckus
- Siri
- The Devil
- Bill O'Reilly
- The Hateocracy
- Colonel H. Stinkmeaner
- Kardashia Kardashian
- A Pimp Named Slickback
- Gin Rummy

About Huey Freeman

Huey Freeman is a ten-year-old boy wise, experienced, opinionated and cynical far beyond his years.

He is a self-described revolutionary left-wing radical whose sometimes controversial viewpoints have led him to being mislabeled a "domestic terrorist."

Huey has a firm and thorough grasp of history, philosophy, and politics and is a skilled orator like many of his African-American activist heroes. Huey is also skilled at hand-to-hand combat and will defend himself with violence when necessary. Pulling inspiration from such diverse sources as the civil rights movement, Japanese Samurai, and "street smarts," Huey is an amalgamation of diverse philosophies.

At the age of ten he claims to have founded twenty-three different radical leftist organizations including Africans Fighting Racism and Oppression (A.F.R.O.) and the Black Revolutionary Underground Heroes (B.R.U.H.).

He is devoutly cynical and rarely shows emotion, and yet holds strong moral values based on his personal beliefs grounded in his desire for greater African-American unity.

Why Huey Freeman Is No. 58

Huey and *The Boondocks* have drawn the ire of political pundits and celebrities from Reverend Al Sharpton to Tyler Perry. It was a show mired in frequent controversy, much of the controversy dealing with the topic of race. It is Huey's bold stances and willingness to take a stand that makes him such a compelling character. His outspoken outrage is delivered unflinchingly but with humor and satire. In a medium that often relegates African-American characters to passive secondary roles as neighbors and coworkers, ten-year-old Huey commands a starring role and soapbox. He has earned a vocal spot on our list.

—JW

59
RACER X

Creator: Tatsuo Yoshida
Studio: Tatsunoko Production
Voice: Peter Fernandez
Debut: April 1967, *Speed Racer* (Episode: "Challenge of the Masked Racer")
Print debut*:* 1966, *Mach GoGoGo*
True identity: Rex Racer
Secret "secret" identity: Secret Agent 9
Vehicle: The Shooting Star
Brothers: Speed Racer, Spritle
Parents: Pops and Mom Racer
Rivals: Speed Racer
Mentor: Prince Kabala
Starring TV roles: *Speed Racer* (1967–1968), *Speed Racer X* (1997)
Traits: Calm, selfless, mysterious, secretive

Racer X Trivia

- Speed Racer is based on the popular manga comic *Mach GoGoGo* by Tatsou Yoshida.

- The cars and look of several characters were inspired by combining elements of Elvis Presley's *Viva Las Vegas* and the James Bond film *Goldfinger.*

- Besides being the voice of Racer X, Peter Fernandez was the show's producer, music arranger, writer, and editor, and voiced Speed Racer as well.

- In the Japanese anime version of Speed Racer, Racer X is known as Kenichi Mifune.

- The animated series *Dexter's Laboratory* paid a satirical tribute to Speed Racer. In the episode titled "Mock 5," Dexter's sister Dee Dee played the role of Racer X.

- Throughout the entire run of the series, Racer X is seen without his mask only four times.

- The 80s speed metal band Racer X is named in the character's honor.

- Speed Racer would frequently translate complicated plots using the preexisting animated lip movement from the Japanese version. This resulted in the show's trademark quick dialogue delivery.
- *TV Guide* ranked the moment Racer X revealed his identity to Speed Racer as one of the most memorable moments in TV history.
- A 2008 live-action Speed Racer film was directed by the Wachowskis (best known for their work on the Matrix film series). Actor Matthew Fox played the role of Racer X.

About Racer X

Racer X is the mysterious Formula 1 racing competitor of Speed Racer, and in animation's worst kept secret, his long lost brother! Though unknown to Speed and his family, the revelation of Racer X's true identity to the audience occurred in almost every episode. His face was finally revealed to audiences in Episode 50, "The Trick Race," the same episode in which Speed Racer's suspicions are finally confirmed and he learns Racer X is his brother.

Rex Racer had been a promising driver but after a major race he lost control of the Mach 1, destroying it in the process. After Pops flew into a rage, Rex abandoned the family, leaving forever and vowing to become the world's greatest driver.

Rex travels the world eventually ending up in Kapetapek, where he is taken under the wing of Prince Kabala as his ninth student. It is from Kabala that Racer X learns to navigate dangerous roads. After his training Racer X returns to the Formula 1 circuit and rapidly advances to become one of the world's best racers.

Using a mask to conceal his true identity, Racer X remains protective of his younger brother, frequently coming to his defense and selflessly aiding in his victories. Besides being a driver, Racer X is also a secret agent whose assignments often intersect with his travels on the circuit.

Why Racer X Is No. 59

Racer X was a complex hero who portrayed the very real emotions of sibling rivalry.

As a mask-wearing, sportscar-driving secret agent, he was the embodiment of cartoon cool. Speed Racer was prone to emotional outburst and tears, but Racer X was cool and collected, assessing the situation and taking whatever risk necessary to protect his younger brother. Their complicated family dynamic was the core driving force of the show.

Though we were in on the secret of Racer X's identity, the character remained mysterious and aloof. In a two-dimensional cartoon using very limited animation, he was a character with great depth. Coming in at #59 on the list, he will no doubt leave the scene unnoticed, leaving us wondering, "who is that masked man?"

—JW

60
MR. BURNS

TOON-UP FACTS

Creator: Matt Groening
Studios: Gracie Films (1987–1989); Klasky Csupo (1989–1992); Film Roman (1992–present)
Voice: Harry Shearer
Debut: 1989 ("Simpsons Roasting on an Open Fire")
Catchphrases: "Excellent!" . . . "Simpson, eh?"
Hometown: Springfield
Ownership: Springfield Nuclear Plant
Lackey and secret crush: Waylon Smithers
Whipping boy employee: Homer Simpson
Defining role: *The Simpsons* (1989–present)
Traits: Evil, egotistical, greedy, inhumane, vengeful, scheming, nasty, supercilious

Bastard Burns Bluster: His Most Malevolent Lines

- To the Junior Achievers Club: "Family, religion, friendship. These are the three demons you must slay if you wish to succeed in business."

- "You know, Smithers, I think I'll donate a million dollars to the local orphanage . . . when pigs fly."

- To his employees: "Now, a few more details about this year's company picnic. It's at the plant, no food will be served, the activity will be work . . . and the picnic is cancelled."

- To a candy machine that is unresponsive to his verbal command for toffee: "You've made a powerful enemy today, my friend."

- About people researched who view him as an ogre: "I ought to club them and eat their bones."

- To Homer: "You're actually pleased with your appearance? My boy, you're the fattest thing I've ever seen, and I've been on a safari."

- Comparing himself to Oskar Schindler: "Schindler and I are like peas in a pod. We're both factory owners. We both made shells for the Nazis, but mine worked, damn it!"

- Giving a pep talk to football players: "Men, there's a little crippled boy sitting in the hospital who wants you to win this game. I know because I crippled him myself to inspire you."

- About lawyers who urged against Smithers poisoning Homer's doughnut: "Damn their oily hides!"

- After watching the violent *Itchy and Scratchy* cartoon for the first time: "That was delightful. Did you see that? That mouse butchered that cat like a hog! Is all TV this wonderful?"

- To a post office worker: "I'd like to send this letter to the Prussian consulate in Siam. Am I too late for the 4:30 autogyro?"

- After his lawyer, per Mr. Burns's instructions, reminds the court how rich and important he is during his trial for running over Bart Simpson with a car: "I should be able to run over as many kids as I want!"

- To Homer, who has called him the richest man he knows: "Yes, but I'd trade it all for a little more."

About Mr. Burns

Though he is known as Monty to those greedy or desperate enough to be his friend, his full name is Charles Montgomery Plantagenet Schicklgruber Burns. The most appropriate of those names is Schicklgruber, the given last name of Adolf Hitler's father and one that dictator shed before terrorizing the world. After all, Mr. Burns is the Hitler of Springfield.

His wicked intent could never be matched by anything physical, but Mr. Burns certainly looks evil. This is particularly true of his beady eyes and menacing hand gestures, which always give away his malicious plans.

Mr. Burns is the owner of the Springfield Nuclear Plant. He understands and embraces the breadth of his power. He is arguably the most miserly, villainous, black-hearted animated human in the history of animation. He feeds off the misery of others, particularly if he has heaped it upon them. His one-hundred-plus years on the planet (his exact age has not been nailed down), appalling greed, and heartlessness make it unsurprising that he still owns significant stock in Confederated Slave Holdings. He is the richest, oldest, and most powerful man in town.

How old is Mr. Burns? Only he apparently knows, but he has expressed firsthand knowledge of a boxing match featuring "Gentleman" Jim Corbett, who fought in the 1890s, and riding in the first horseless carriage manufactured by Henry Ford during that same decade.

The character stops at nothing to satisfy his greed. He grows richer for the sake of growing richer and will destroy anyone who gets in his way. Never mind that his power plant has been hit with hundreds of violations. He will spend pennies to "fix" them—and the endangered people of Springfield be damned.

Why Mr. Burns Is No. 60

Mr. Burns is deliciously, unapologetically evil. If awards were given out for animated bastards, the trophy would be handed to him permanently. He symbolizes the corporate stereotype, but one can only shudder to think any real-life CEO can be *that* horrible. His character is certainly an exaggeration and it comes off perfectly.

The Simpsons boasted dozens of memorable characters, particularly the featured family members themselves. But it can be argued that Mr. Burns was among the funniest, particularly to viewers who turned off their senses of righteousness. His greatness as a character is also cemented by the corporate greed and uncaring for humanity that he represents. Though one invariably laughs at Mr. Burns because he's downright hilarious, his humor is based on his utter lack of feeling for others. That gives his character greater depth and meaning.

—MG

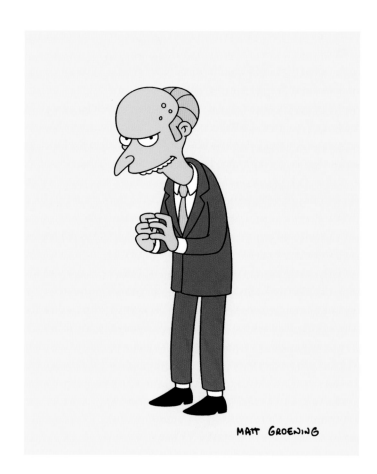

61
SPACE GHOST

Creators: Alex Toth, Joseph Barbera, William Hanna
Studio: Hanna-Barbera
Voices: Gary Owens (1966–1982, 2011), George Lowe (1994–present)
Debut: September 10, 1966, *Space Ghost*
True identity: Tad Ghostal
Powers: Invisibility, flight, freeze ray, shock ray, hyperspeed, stun ray
Sidekicks: Jan, Jace, and Blip the Monkey; Zorak
Vehicle: The Phantom Cruiser
Home: Ghost Planet
Protagonists: Moltar, Zorak, Brak
Defining role: *Space Ghost Coast to Coast* (1994–2004)
House band: The Original Way-Outs
Catchphrase: "Tell me about your superpowers?"

Space Guests! Top 10 Guests Featured on *Space Ghost Coast to Coast*

- The Bee Gees
- Cast of *Gilligan's Island*: Bob Denver, Dawn Wells, and Russell Johnson
- Weird Al Yankovic
- Carrot Top
- Mike Judge
- Charlton Heston
- Gary Owens (original voice of Space Ghost)
- Steven Wright
- Willie Nelson
- William Shatner

About Space Ghost

Few characters have gone through as massive a career change as Space Ghost, going from a classic Saturday morning staple to late night adult talk show host.

Space Ghost began his career as an outer space superhero ushering in a new era of animated TV caped do-gooders who followed in his boot prints. The animated series of the 60s and 80s followed Space Ghost and his sidekicks Jan, Jace, and Blip the Monkey in their battle against nefarious supervillains such as Brak and Moltar. Occasional crossover appearances were arranged where Space Ghost would assist Herculoids, Teen Force, and other characters. This tactic allowed Hanna-Barbera to introduce their audiences to other series superheroes and grow their respective audiences.

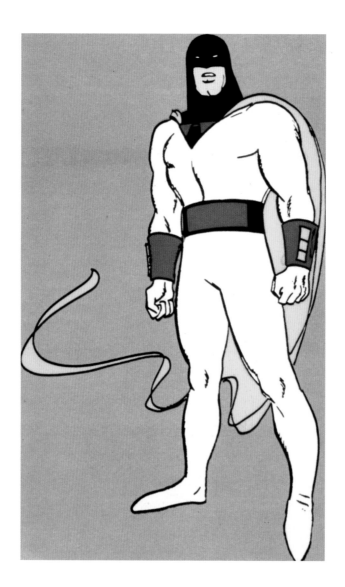

Space Ghost was the first cartoon superhero created specifically for television, and he helped establish the new genre. Space Ghost's original run was for only two seasons but remained in syndication into the 1970s. Space Ghost was brought back in 1981 as part of the new Space Stars series block of cartoons. It lasted only one year.

It would be yet another decade before Space Ghost would reemerge from retirement, and once again he would usher in a new genre, this time in *Space Ghost Coast to Coast*.

He returned to television in a "traditional" late night talk show format. With Space Ghost as host he was joined by his former foe Zorak, now his bandleader, and nemesis Moltar now acting as director/producer in punishment for their many crimes.

Re-editing old clips with new voiceovers, the characters took on new life and personalities. This combined with the inclusion of the character's backstories from the original series created a constant and comical tension. The crew's disdain for Space Ghost would lead them to constantly insult the host and try to derail the show. Space Ghost revealed himself to be temperamental, egocentric, fragile, and clueless, and his new role as a TV show host served to satiate his constant desire for attention. Along with plots involving the characters' interpersonal relationships, the show served a real purpose as a talk show with actual guests. Space Ghost's awkward interactions with real celebrity guests would often leave both host and guests confused at the show's anarchist methodology and surrealist style.

Space Ghost was a dual caricature of superheroes and talk show hosts, and the merger of those two identities resulted in a unique animated character.

Why Space Ghost Is No. 61

Space Ghost deserves a place in the Top 100 for his groundbreaking role as televison's first medium-specific superhero. He set the standards and tropes for an entire genre. Yet it is through his reinvention as a talk show host that his true character really took shape. The character is a bold self-satire. We are given a rare insight into the mind of a superhero in all its bizarre frailty. In the end we come to feel that his greatest heroic act is just doing his job in spite of his peers' constant plotting against him. In exposing his own foolish humanity, Space Ghost lets us know that superheroes are a lot like us, and earns a spot on our list.

—JW

62
PATRICK

Creator: Stephen Hillenburg
Studio: United Plankton Pictures
Voice: Bill Fagerbakke
Debut: 1999, *SpongeBob SquarePants* (Episode: "Help Wanted")
Hometown: Bikini Bottom
Address: 120 Conch Street
Father: Herb
Mother: Margie
Sister: Sam
Best buddy: SpongeBob SquarePants
Employer: The Krusty Krab (briefly)
Passion: Junk food
Love interest: Mermaids
Hobby: Watching TV, jellyfishing
Defining role: *SpongeBob SquarePants* (1999–present)
Traits: Stupid, lazy, annoying, loyal, hungry, nonsensical, friendly

Starfish Stuff

- People who lack intelligence or common sense are sometimes asked if they live under a rock. The same could be asked about Patrick and the answer would be figurative and literal. He is indeed dumb as a rock and he indeed lives under one.

- Patrick voice Bill Fagerbakke has football in his blood. He played defensive lineman at the University of Idaho before playing the role of assistant coach Michael "Dauber" Dybinski in the popular television sitcom *Coach*.

- Little positive can be claimed about Patrick in terms of skill. But one thing he does far better than SpongeBob is drive.

- Patrick claims to have invented two items in the episode "Chimps Ahoy" (2006). Unfortunately, they are a pencil and a lightbulb, both of which SpongeBob tells him have already been invented.

- Fagerbakke has revealed that he voices Patrick by slowing down and pretending his mouth is in his chest.

- A lack of power is not a problem for Patrick. He has been known to lift the heavy rock under which he lives and has displayed other feats of strength.

- Patrick has often shown his prodigious appetite, but never more so than when he downed a double Krabby Patty in one gulp in the episode "Just One Bite" (2001).

- The character seemed to acknowledge the surprising moments in which he displays a comparatively high level of intelligence when he was asked by Squidward, "How dumb are you?" His reply? "It varies."

- Patrick plays the drums in several episodes.

- Memory is not Patrick's long suit. He is so forgetful that he cannot remember what he studied in community college. And while working at the Krusty Krab, he replied to a caller asking, "Is this the Krusty Krab?" by answering, "No, this is Patrick."

- The animators cannot seem to decide how many teeth Patrick should have. He has been shown with one, with several on top and bottom, and with his mouth full.

- A foul, steamy odor is emitted from Patrick's brain when he thinks.

- Patrick weighs a mere two ounces despite his appetite-generated girth.

About Patrick

The starfish character first conceived by Hillenburg and creative director Derek Drymon was the owner of a roadside bar and angry that he was pink. He was also a bully. Obviously, the character changed dramatically after the conception.

Patrick Star is anything but a bully and he certainly has no issues with his color. He doesn't have many issues with anything in life, partly because he is a friendly sort and partly because he—at least most of the time—is virtually brainless. He does show a slow-burn type of temper on occasion, however, though it disappears quickly, and his devotion to his friendship with SpongeBob sometimes results in more than a twinge of jealousy when he perceives it to be threatened.

The character looks as dumb as he acts—and that's saying something. He is pink from head to toe with an elongated bald head, big eyes and mouth, and no sense of smell due to being minus a nose, though he once grew one out of sheer will. Patrick wears green and purple swim trunks that fail to cover his bulging belly.

Patrick does not generally work, though he has toiled a bit at the Krusty Krab. He owes Mr. Krabs money for previous food bills. He is quite lazy and satisfied to hang around his house watching a dancing barnacle on television or just doing nothing. His lack of intelligence is matched by his lack of common sense, though he has been known on occasion (especially in early episodes) to show a surprising amount of both. He has one good friend—SpongeBob—and no real enemies. There are those such as Squidward that do not like Patrick, but he is considered too inconsequential to act out against.

Why Patrick Is No. 62

Patrick once asked if mayonnaise was a musical instrument. He mistook a fire hydrant for Squidward. He proclaimed that he could not see his forehead.

When Patrick was on his clueless game, there was nobody better.

Sometimes a character is just darn funny. The writers for *SpongeBob SquarePants* utilized his mind-numbing stupidity to create humor. A simpleton should be a simple character. There is nothing complex about Patrick. He's just arguably the funniest character on one of the funniest cartoon shows ever produced.

—MG

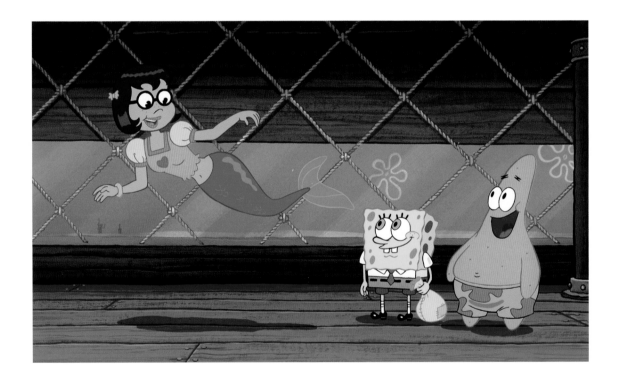

63
JONNY QUEST

TOON-UP FACTS

Creator: Doug Wildey
Studio: Hanna-Barbera Productions
Voices: Tim Matheson (1964–1965), Scott Menville (1986), J. D. Roth (1996–1997)
Debut: September 18, 1964, "The Mystery of the Lizard Men"
Age: Eleven
Antagonist: Dr. Zin
Defining role: *Jonny Quest* (1964–1965)
Father: Dr. Benton C. Quest
Best friend: Jadji
Pet: Bandit
Tutor/Bodyguard: Race Bannon
Home: Palm Key
Traits: Intelligent, adventurous, curious, athletic

Jonny Quest Gadgets and Gear

- Portable Video Communicator—handheld person-to-person video communication device.
- Video Tape Camera—VHS camera
- Unitized Neutronic Information Center (UNIC)—Voice-activated artificial intelligence computer
- VERTOL Aircraft—VERtical Take Off and Landing aircraft
- Portable wearable jet packs
- Hovercraft
- Snow Skimmer—airboat adapted for snow travel
- Portable Sonic Projector—produced ultra-high frequency sound waves
- Robot Delivery Craft—Designed to deliver robot spies to their destination
- Erikon anti-gravity device

About Johnny Quest

When Jonny Quest debuted at 7:30 p.m. on September 18, 1964, it took its place in history as the first animated primetime television show.

The show follows the adventures of eleven-year-old Jonny and his scientist/secret agent father Dr. Benton C. Quest. They are joined by: Haji, the adopted Kolkata-born son of Dr. Quest, Roger T. "Race" Bannon, special agent and tutor to Jonny, and Bandit, Jonny's pet dog.

The character of Jonny's initial inspiration was from a radio show: *Jack Armstrong, The All-American Boy*. Unable to obtain the rights to the character, Hanna-Barbera had writer/animator Doug Wildey develop a new character. He drew on inspiration from child actor Jackie Cooper, and adventure comic strips, as well as the James Bond film *Dr. No*.

Jonny was created with a greater realism than most cartoons of the time. The actual drawings portrayed characters with a less cartoonist style, using bold shadows and lines, influenced by the comic realism of artists like Milton Caniff. Details such as the exotic locations were richly drawn despite Hanna-Barbera's traditionally limited animation.

Beyond its stylistic choices *Jonny Quest* was a hybrid adventure tale combining elements of science fiction, spy genre, and even old movie serials.

Why Jonny Quest Is No. 63

As the central protagonist of one of the first primetime animated cartoons, Jonny Quest earns a place on the list for his historical significance alone. Jonny acted as the binding central character of an ensemble team, offering the audience, especially young boys, a role model and hero. As a young boy growing into manhood, the character maintained the responsibilities of his youth such as homework, and balanced them with his growing independence. Jonny was a new kind of kid in an era when traditional roles were beginning to transform for the nation. Jonny Quest was a modern Tom Sawyer and remains one of television's most iconic kids.

—JW

64
DEXTER

TOON-UP FACTS

Creator: Genndy Tartakovsky
Studio: Hanna-Barbera
Voice: Christine Cavanaugh
Debut: 1995 (*Changes*)
Hometown: Genius Grove
Antagonist: Sister Dee Dee
Mom: Mom
Dad: Dad
Lab supermonkey: Monkey
School: Huber Elementary
Rival: Mandark
Aliases: Boy Genius, Dorkster, Dex-Bot, The Great and Powerful Dexter
Idols: Albert Einstein, Major Glory
Defining role: *Dexter's Laboratory* (1996–1998, 2001–2003)
Traits: Egotistical, brilliant, inventive, arrogant, irascible, plotting, unsociable

Dexter's Greatest Hits

- Dee Dee grows into a giant after eating one of her brother's experimental cookies and transforms Genius Grove into her personal dollhouse. Her destruction of the city forces Dexter to don his Robo-Dexo suit and come to the rescue.

- Trying to study for his French test while asleep, Dexter creates a device that fails and teaches him only the phrase "omelette du fromage," the incorrect translation of "cheese omelette." That supposed French phrase is all he can say upon awakening, but this somehow makes him a star. Unfortunately, he can no longer utter the password that allows him to enter his secret lab, causing it to self-destruct as a security measure.

- The thought of listening to a long and boring story spewed out by Dee Dee motivates Dexter to give her a silencing formula, which turns her into a huge monster still determined to tell her tale. He then transforms himself into a giant Godzilla-like creature.

- Dexter tries to teach his sister a lesson after seeing her about to kill some ants, so he shrinks them both to ant size and places them into his ant farm for a lesson in empathy. He discovers to his horror that the ants act quite horribly.

- An illness plaguing Dee Dee prompts Dexter to inject himself inside of her to find a cure, but he accidentally winds up inside his dog. A veterinarian discovers Dexter, concludes that he is a new dog virus, and shows him to the medical community.

- Dexter transforms his brain into that of a mouse, then must prevent extermination by his mother.

- In an attempt to reach vital things in his laboratory, Dexter gives himself greater flexibility by turning himself into half-boy, half-bubble gum.

- Mandark and Dexter bring the faces of Abraham Lincoln and George Washington on Mount Rushmore to life and force them to battle for supremacy.

- Dexter releases a giant monster with the head of an ax from a volcano during a student exchange visit to Japan. He enlists his family, as well as the casts of *The Justice Friends* and *Dial M for Monkey*, to help subdue the beast. He is also forced to reveal his lab to his parents, but later erases the knowledge from their memories.

- In fusing himself to his sister, Dexter accidentally becomes her foot.

About Dexter

Dexter was not the first cartoon genius. Brainiacs such as Mr. Peabody the dog, Donatello the turtle, and Lisa Simpson the girl all preceded him. He is not even the first animated boy genius. Baby Weems of Disney fame deserves that distinction.

But Dexter boasts idiosyncrasies that make him unique. Like, for instance, a Russian accent that seemingly comes out of nowhere given that he was born into an all-American family. And the fact that he is a rather evil, arrogant genius with the social skills of a hermit. He is ill-tempered, jealous, and overly competitive.

The Eastern European accent voiced by Cavanaugh might have been in recognition of the Russian-born Tartakovsky, whose family fled his native country for Italy, then the United States due to concerns about anti-Semitism. He was a mere twenty-four years old when he completed his first Dexter cartoon, which was an expansion of an earlier work titled *Changes*, a class project at the California Institute of the Arts.

He created Dexter to be unique in his appearance as well as in his personality. Dexter is exceptionally short, dons a long white coat that covers all from his neck to his feet, and wears light blue-tinted glasses.

Tartakovsky was toiling as a storyboard artist on *2 Stupid Dogs* when *What a Cartoon!* began its development. He had originally conceived of a show featuring a dancing Dee Dee, a character he created before Dexter, who debuted in February 1995 and began starring in his own series fourteen months later.

Dexter developed unique relationships with various characters, particularly Dee Dee, Mandark, and Monkey, as well as his parents, from whom he scrambled to keep his lab secret. That was some mean feat given the fact that it by all accounts was larger than the house itself.

The first run of *Dexter's Laboratory* concluded in 1998, but an hour-long television movie titled *Dexter's Laboratory Ego Trip*, which aired on New Year's Eve in 1999, helped spur a comeback of the series that was produced by Cartoon Network. That show lasted two years and spawned seventy-eight episodes.

Why Dexter Is No. 64

Dexter is among the more complex characters in cartoon history. His negative personality traits, such as jealousy and competitiveness, prevented him from utilizing his brilliance and his lab to benefit mankind. He was an immature genius, which made him particularly interesting.

His relationships brought out his uniqueness. He was annoyed by sister Dee Dee. He was blindly envious of and competitive with Mandark. He was fearful of Monkey. He was dismissive of Mom and Dad in every way and never revealed the existence of his lab.

What made Dexter a fun character in an albeit disturbing way were his fear and imagination and how they led to outrageous experiments. Those that featured Dee Dee were particularly fascinating and funny. One can claim that the success of Dexter inspired Nickelodeon character and fellow boy genius Jimmy Neutron. That alone is a tribute.

—MG

65

THE TICK

TOON-UP FACTS

Creator: Ben Edlund
Studio: Sunbow Entertainment
Voice: Townsend Coleman
Television debut: September 10, 1994, "The Tick vs. The Idea Men"
Print debut: July 1986, *The Tick, New England Comics Newsletter 14*
True identity: Nick (Last name unknown)
Sidekick: Arthur
Powers: Superhuman strength, nigh-invulnerability, drama power
Weaknesses: Shiny objects, sensitive antennae, the common cold
Starring TV role: *The Tick* (1994–1996)
Hometown: The City
Catchphrase: "Spoon!"

Top 10 Tick Lame Villains

1. Chairface Chippendale
2. The Breadmaster
3. The Deadly Bulb
4. The Eastern Bloc Cowboy Robot
5. The Human Ton and Handy
6. The Sewer Czar
7. The Man-Eating Cow
8. Multiple Santa
9. Pineapple Pokopo
10. Uncle Creamy

About The Tick

The Tick is a satirical superhero that began his life as a mascot for a comic book chain in the Boston area. He made the leap to animation as a Saturday morning cartoon for Fox in 1994. His origin and background are shrouded in mystery or perhaps amnesia.

However, his super career began at the Superhero Institute Convention in Reno, Nevada. Unannounced he crashed the convention, bringing with him a steel "death" box to demonstrate his super prowess. Though the demonstration didn't go quite as planned, an explosion destroying much of the convention left the Tick unscathed, proving his nigh-invulnerability. Impressed, the judges awarded him The City to protect.

On his first outing patrolling the city he meets Arthur, a mild-mannered accountant, albeit one in a moth suit (though it looks suspiciously more like a bunny costume). The two of them form an immediate bond and unite to fight crime.

The Tick is an exaggerated caricature of superhero tropes. He features a square jaw, overly muscular physique, and brightly colored tight-fitting costume. He is never seen without his costume and can't recall much about his past other than he thinks perhaps he has always been a superhero.

The Tick was a deft satire of all things superhero—exaggerated battles, ludicrous lairs, evil plans, costumed villains, and of course a catchphrase battle cry: "Sppooooooooon!"

Further satirizing the cartoons of the era, The Tick is prone to nonsensical non-sequitur moral pronouncements at the end of the day. For example: "There are many mysteries in this universe big and small, why do clowns make us laugh, why do we love puppy dogs, and why, why do little blue midgets hit me with fish? See what I mean, mysteries abound!"

Though the animated series ended after only three seasons, it developed a cult following. The Tick remains a popular character primarily among adults, and nostalgia for the character has led to two separate live-action series.

"Wherever villainy rears its great big head, wherever evil set its giant ill-smelling foot, you will find the Tick!"

Why The Tick Is No. 65

The 90s were an era in which the comic book superhero genre began to take itself seriously. No longer regarded as kiddie fare, the medium began to take a darker tone and rebrand itself as "graphic novels." This was true of animated heroes too. The animated Batman series was the darkest of the era in both its theme and lack of lighting!

The Tick punctured the genre's newfound pretentiousness with sadistic glee! The Tick lovingly and mercilessly mocked the characters, storylines, and every aspect of the superhero genre.

The Tick made us laugh at our love for a bunch of grown men running around in tights dressing up like cartoon animals while fighting villainous cartoon clowns. He was a big bright blue beacon of laughter standing out in an increasingly morose medium. He was the antidote to the Dark Knight! By poking fun at the characters we loved, he reminded us why we loved them in the first place. He made both being and watching superheroes fun again.

—JW

66
WANDA AND COSMO

TOON-UP FACTS

Creator: Butch Hartman
Studio: Frederator Studios
Wanda voice: Susan Blakeslee
Cosmo voice: Daran Norris
Debut: 1998 (The Fairly OddParents!)
Series debut: 2001, *The Fairly OddParents!* (Episode: "The Big Problem!")
Godchild: Timmy Turner
Home: Fairy World
Relationship: Married
Son: Poof
Antagonists: Anti-Fairies, Pixies, Vicky, Denzel Crocker, Norm the Genie
Boss: Jorgen Von Strangle
Defining role: *The Fairly OddParents!* (2001–present)
Wanda traits: Intelligent, wise, responsible, devoted, sympathetic, compassionate
Cosmo traits: Stupid, foolish, well-intentioned, unreliable, loving, powerful

Fairy Dust

- Among the many well-known magical characters with whom Wanda and Cosmo came into contact in various episodes were Santa Claus, Easter Bunny, Cupid, Tooth Fairy, and New Year's Baby.

- When Timmy asked for Wanda and Cosmo to have a baby, little could he have imagined that it was the latter who would get pregnant. But such is the way of the fairy world.

- Cosmo voice Daran Norris also serves as the voice actor for Mr. Turner and Jorgen Von Strangle.

- Butch Hartman joined Hanna-Barbera in the mid-1990s and worked his way up to animation director. Among his other achievements was his voicing of *Family Guy* character Mr. Weed after he had developed a friendship with series creator Seth MacFarlane. Hartman also worked on the highly successful *Johnny Bravo* cartoon.

- Cosmo shares a first name with one of the most famous sitcom characters in television history. The *Seinfeld* wacko generally known only as Kramer became briefly proud of his first name when it was revealed by his mother to be Cosmo.

- *The Fairly OddParents!* cast managed three crossover specials with Jimmy Neutron. The first was *The Jimmy Timmy Power Hour* in 2004, during which Wanda and Cosmo granted Timmy's wish to switch places with Jimmy. The former visited the latter's 3-D model environment while Jimmy experienced Timmy's existence in a flat, cel-style animation.

- Bart Simpson is not the only young boy character voiced by a woman. Timmy Turner is voiced by prolific voice actor Tara Strong, who has also worked such animated shows as *The Powerpuff Girls*, *Rugrats*, and *Teen Titans*.

- The voice of Wanda has been compared to that of legendary Broadway actress and singer Ethel Merman.

- The streets in the Fairy World home of Wanda and Cosmo were named after real-life magicians such as Penn and Teller, as well as Siegfried and Roy.

- The *Fairly OddParents!* was ticketed for cancellation in 2006, but its popularity caused its absence to be short-lived.

- The show earned Daytime Emmy Award nominations for Outstanding Children's Animation Program in both 2014 and 2015.

- Understated, dry-witted writer and actor Ben Stein lent his distinctive voice to *The Fairly OddParents!* as the head of the bureaucratic Pixies.

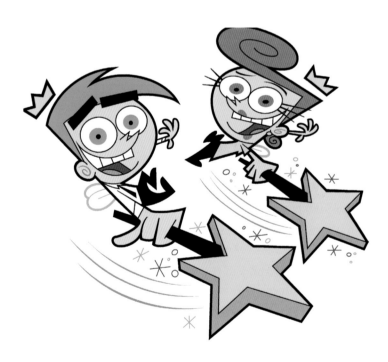

About Wanda and Cosmo

The brainchild of Hartman was given birth in 1998 as part of the *Oh Yeah! Cartoon* series on Nickelodeon, which rivaled the *What a Cartoon!* offering by Cartoon Network in finding successful full-time animated fare for their networks. *The Fairly OddParents!* proved to be easily the best of the bunch for Nickelodeon.

Though the show revolved around the married fairies and their relationship with a misunderstood and often miserable young boy named Timmy Turner, other intriguing and funny characters helped make the show a success. Among them were downright evil babysitter Vicky and Timmy's clueless parents (known only as Mr. and Mrs. Turner), all of whom join forces (Vicky knowingly and his parents unwittingly) to make Timmy unhappy, thereby requiring the need for Wanda and Cosmo. They serve to fulfill his desires, some of which revolve around thwarting the efforts of Vicky and overcoming the stupidity and lack of attention coming from his parents.

Among the attractions of Wanda (can one assume that's her name because she carries a wand?) and Cosmo are their colorful appearances. The former has pink hair and pink eyes, a yellow shirt, black pants, and a yellow crown that floats inches above her head. The latter has bright green hair and green eyes.

Their looks are where their similarities end. Wanda is intelligent and keen. She seeks to provide Timmy the self-respect she feels every boy deserves. Though he too is a caring character, Cosmo boasts the brainpower of a doorknob and gives Timmy terrible advice. The other side of their existences is centered in Fairy World, which gives the show much of its personality and humor.

That humor harkens back to the theatrical cartoons of more than a half-century earlier, when punchline jokes reigned supreme. But *The Fairly OddParents!*, which thrived in a half-hour format, also succeeds due to its storylines and character development.

One result of that success was a full-length film written by Hartman titled *A Fairly Odd Movie: Grow Up, Timmy Turner!* (2010) in which the title character is real-life (played by Drake Bell of *Drake and Josh* fame), but Wanda and Cosmo are animated.

Why Wanda and Cosmo Are No. 66

The depth of the Wanda and Cosmo characters in terms of backstory and personality has helped make their show one of the longest-running in the history of television animation. Their humor comes from many different angles: their relationships with Timmy and Vicky, their antagonists in Fairy World, and each other all result in laughs.

Though the show boasts many featured and funny characters, the two fairies provide the magic both literally and figuratively. Wanda and Cosmo are the straws that stir the drink. That "drink" has lasted nearly two decades on Nickelodeon. Their place as the central characters on one of the finest animated shows ever to appear on the network is undeniable.

—MG

67
THE WONDER TWINS

TOON-UP FACTS

Creator: Norman Maurer
Studio: Hanna-Barbera
Zan voice: Michael Bell
Jayna voice: Louise Williams
Debut: September 10, 1977, *The All-New Super Friends Hour* (Episode: "Joy Ride")
Powers: Shape shifting, telepathy
Starring TV role: *The All-New Super Friends Hour* (1977)
Pet: Gleek, the space monkey
Home Planet: Exxor
Catchphrase: "Wonder Twins Power, activate!"
Signature move: The fist bump

Wonder Twins' Top 10 Transformations

- Form of a brontosaurus. Shape of a giant water hand.

- Form of an octopus. Shape of an ice unicycle.

- Form of a seagull. Shape of an ice gondola.

- Form of a spider. Shape of an ice door.

- Shape of steam. Form of a mosquito.

- Form of a gorilla. Shape of an ice crowbar.

- Shape of an igloo. Form of a reindeer.

- Form of a space insect. Shape of a vial of water.

- Form of a polar bear. Shape of a ski slope.

- Shape of an ice dam. Form of a kangaroo.

About The Wonder Twins

The Wonder Twins, Zan and Jayna, are shape-shifting siblings from the planet Exxor. They joined the Justice League after the exit of kid heroes Wendy Harris and Marvin White. Real-life sibling entertainers Donny and Marie Osmond inspired the duo's personalities.

The characters were introduced concurrently in both the *Super Friends* animated series and issue #7 of the tie-in comic book. Much of their backstory is derived from the comic.

According to the comic book, Zan and Jayna were aliens from the planet Exxor. Having lost their parents, they were adopted by the owners of a circus who put them on display as sideshow freaks. A kindly circus clown who also introduced them to their loyal pet Gleek, the space chimp, raised them. Eventually they escaped and made their way to Earth where they became junior members of the Justice League after warning Superman of the villainous Grax plan to destroy Earth.

The twins' main superpower is their ability to shape shift. When near each other they have the power to transform by touching hands and uttering the words "Wonder Twin Powers Activate." Zan is able to transform into various forms of shapes and forms of water, ice, and vapor, while Jayna can transform into a limitless variety of animals both real and mythical. The seemingly random nature of their choices often provided comic relief. They also share a telepathic link to one another.

While lacking the power to transform, their space chimp, Gleek, seemed to be able to materialize buckets out of thin air, as he often has to transport Zan in his watery form.

Why The Wonder Twins Are No. 67

The Wonder Twins may not have played an important role on the Justice League and are often regarded as secondary characters, but they did play an important role for the audience by acting as the child's surrogate in the cast. They shared the curiosity, inexperience, and eagerness of the young audience, allowing kids to imagine themselves as members of the Justice League.

One of their primary roles was to assist children in danger via "The Teen Trouble Alert." It was in this role that they would provide the "educational" public service content for the show.

The Wonder Twins were beloved by young audiences. As adults those former children embraced the nostalgic campiness of the characters and the duo became a formal part of the DC Comics canon, appearing in comics and on TV series such as the young Superman series *Smallville*. Their catchphrase, "Wonder Twin Powers Activate," along with the fist bump, have entered the American lexicon.

Zan, Jayna, and Gleek provided much more than mere comic relief on the show; they also provided a respite of random surrealness in an otherwise predictable show. While other heroes fell into their roles within their existing power constraints, the Wonder Twins' often nonsensical and frequently bizarre moments of transformation were something to look forward to. Until the Wonder Twins joined the Justice League, we had no idea just how many ways random animals and forms of water could work together to defeat evil and injustice!

—JW

68
GEORGE OF THE JUNGLE

TOON-UP FACTS

Creators: Allan Burns, Jay Ward, Bill Scott
Studio: Jay Ward Productions
Voice: Bill Scott
Debut: 1967 ("The Sultan's Pearl")
Parodied character: Tarzan
Home: Jungle treehouse
Friends: Shep the Elephant, Ape
Love interest: Ursula ("Fella")
Transportation: Vine
Favorite toy: Rhinestone yo-yo
Theme warning: "Watch out for that tree!"
Defining roles: *George of the Jungle* (1967)
Traits: Stupid, loyal, careless, scatterbrained

Jungle Junk

- The role of Ursula was voiced by June Foray, who was better known as the voice of Rocky the Flying Squirrel.

- The theme song for the 1967 show was a minute long. The version in the 2007 remake lasted 140 seconds and did not show George until early in the second minute. But both featured the iconic "Watch out for that tree!" line.

- The live-action *George of the Jungle* film starred Brendan Fraser.

- George was featured in one of three segments in each episode. The others spotlighted Super Chicken and race car driver Tom Slick, neither of whom gained much notoriety.

- Allan Burns worked for the Jay Ward Studios and is credited for creating Cap'n Crunch, one of the most legendary animated spokescharacters ever.

- One of the few incidental characters that appeared more than once was Dr. Chicago, who in successive episodes created a formula that caused all insects and plants to wreak havoc. One plant stole Ursula's purse, then kidnapped Ursula.

- The George jungle call was nearly identical to that of Tarzan.

- The original George was larger and more muscular than the one featured in the 2007 cartoon.

- Burns helped create several sitcoms, including socially groundbreaking programs such as *Room 222* and *The Mary Tyler Moore Show*.

- Only seventeen episodes were produced of the original *George of the Jungle* series.

- George appeared in 1967 in *America's Best TV Comics*, which was produced by Marvel Comics to promote the Saturday morning cartoon lineup on ABC.

- The most famous voice actor to lend his talents to *George of the Jungle* was Daws Butler, who played some of its incidental characters. Butler was far better known for his voicing of Yogi Bear and Huckleberry Hound for Hanna-Barbera.

About George of the Jungle

George debuted eight years after Jay Ward Productions first gained fame by launching *Rocky and His Friends* in 1959. And though his series was quite short-lived, the creativity of the new cartoon show and the personality of the title star created a legacy that resulted in a full-length film and television remakes.

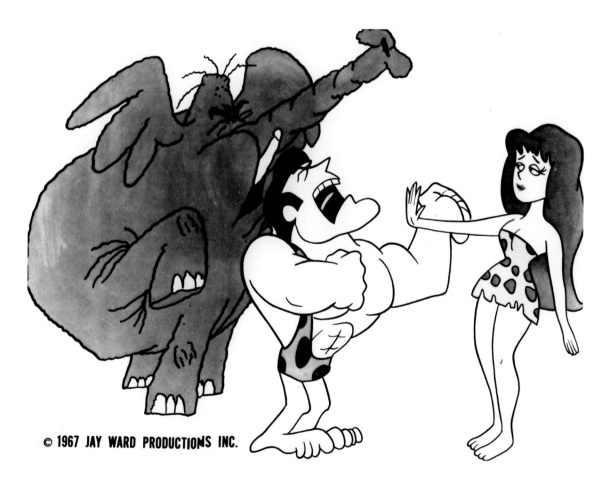

© 1967 JAY WARD PRODUCTIONS INC.

The animated Tarzan clone was about as dumb as the trees from which he swung. He spoke in broken English, believed Shep the Elephant to be his pet dog, and called the beautiful Ursula "fella" in the mistaken notion that she was male. His intelligence level paled in comparison to that of Ape, who spoke as if in a Shakespeare play. It seemed appropriate that George loved his yo-yo. He *was* a yo-yo.

The Jay Ward influence on George was clear—one could have imagined him as a side segment character on *Rocky and His Friends* or *The Bullwinkle Show*. But he was also a departure in his utter stupidity, which made Bullwinkle and Dudley Do-Right look like geniuses in comparison.

The popularity of George—who was the clear star of the show despite the humor of such side characters as Ursula and Ape—resulted in frequent airings in syndication. And in 2007, five years after Jay Ward Productions went out of business, new episodes hit the air for another short run. The full-length *George of the Jungle* real-life film followed, as did yet another television cartoon of the same name in 2016.

Why George of the Jungle Is No. 68

One might argue that such a simpleton was only worthy of the seventeen original episodes that aired late in 1967. His character indeed lacked the depth that warranted a much longer run. But within the restrictions provided by his rather one-dimensional personality, George of the Jungle was a scream. He took idiocy to an extreme—how else can one believe an elephant is a pet pup or call a beautiful woman "fella?"

The proof is in the pudding. In this case, the pudding is a memorable legacy, a thirst for more George that had to be quenched through extensive syndication, a full-length feature film, and two remakes. Even the theme song line ("Watch out for that tree!") has become among the most iconic in the history of American animation.

—MG

69
GOLIATH

TOON-UP FACTS

Creators: Greg Weisman, Michael Reaves, and Brynne Chandler Reaves
Studios: Walt Disney Television Animation, Buena Vista Television
Voice: Keith David
Debut: October 24, 1994, *Gargoyles*
Love interest: Elisa Maza
Powers: Strength, intelligence, combat skills
Antagonists: David Xanatos
Defining role: *Gargoyles* (1994–1996)
Traits: Strong, intelligent, loyal, moral, philosophical

Gargoyle Trivia

- The series pulled heavily from the cast of *Star Trek: The Next Generation*. Series regulars included Marina Sirtis and Jonathan Frakes, and other voice guests included fellow *Next Generation* alumni Brent Spiner, Michael Dorn, LeVar Burton, and Colm Meaney.

- Goliath is named after the biblical giant. He is the only member of the New York Clan whose name does not reference New York. The other team members are: Brooklyn, Hudson, Broadway, and Lexington.

- Despite only running for a few seasons, *Gargoyles* inspired an intense fan base including an annual "Gathering of the Gargoyles" conference.

- Goliath was the only gargoyle to have a name prior to their reawakening.

- According to the show mythos, Gargoyles are members of the biological class called Gargates. Their origin is unknown.

- Keith David's first ongoing TV series role was as "Keith the Southwood Carpenter" on *Mister Rogers Neighborhood* from 1983 to 1985.

- Several fan "radio plays" were written by Greg Weisman for fan conventions. These include a crossover storyline between *The Spectacular Spider-Man*, *Young Justice*, and *Gargoyles*.

- Despite their mammal-like qualities, Gargoyles are an egg-laying species.

- According to the show's canon, at first Gargoyles' clothes did not turn to stone and when they awakened the clothing would be torn in the process, leaving them naked. Augustus, a character who had strong "family values" asked a wizard to cast a "spell of humility" over the Gargoyles that would turn their clothing to stone as well.

- The concept of gargoyles as protectors can be found throughout world cultures including Mayan, Chinese, Egyptian, Indian, Greek, Japanese, and Roman.

About Goliath

Pulling from such diverse inspirations as Celtic folklore, King Arthur, Scottish history, Shakespeare, the supernatural, and sci-fi, *Gargoyles* possessed a dark gothic tone unlike anything else on the Disney Afternoon animation block.

The show originated with an idea by Greg Weisman, a former English teacher who was working at Disney when early versions of the show were being pitched. As the idea evolved the show became much darker and more serious. Ultimately it became Disney's first animated TV drama.

In the year AD 994, a clan of warrior gargoyles led by Goliath guarded Castle Wyvern and its residents until misfortune befell them, casting the guardians under a spell forcing them to sleep as stone gargoyles for a thousand years. When a billionaire named David Xanatos buys the castle and relocates it atop his New York skyscraper home, he breaks the spell and awakens the Gargoyles, who take on a new role protecting the denizens of New York City under the leadership of Goliath.

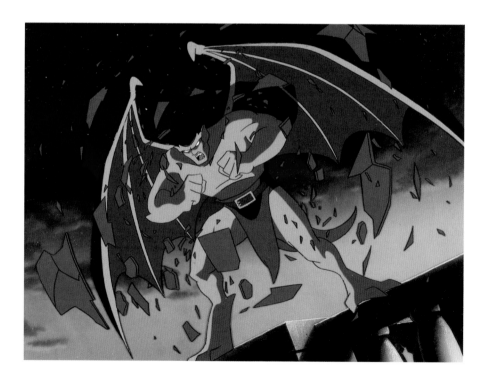

Goliath is an impressive almost monolithic figure with a huge stature, and literally chiseled features. Though a deeply emotional and thoughtful character, his fury can be tremendous and intimidating. He has a strong sense of justice and loyalty that makes him take his position as protector of New York with grave seriousness.

Why Goliath Is No. 69

As a hero, Goliath represents more than mere brute strength; he is a deeply thoughtful and educated character. His interest in classical literature (which is also an inspiration for many of the stories) adds a layer of intellectual depth not often found in "superhero" characters. When he debuted in 1994 he was part of a growing trend in animation toward darker characters and storylines. What set Goliath apart was despite the darker tone his attitude was not one of despair but of hope and understanding. He demonstrated that brawn requires brains and heroics requires heart.

—JW

70
GARFIELD

TOON-UP FACTS

Creator: Jim Davis
Studio: Film Roman Productions
Voice: Lorenzo Music
Origin: 1978 (*Garfield* comic strip)
TV debut: 1980 (*The Fantastic Funnies*)
First special: 1982 (*Here Comes Garfield*)
Series debut: 1988, *Garfield and Friends* (Episode: "Garfield's Moving Experience")
Owner: Jon Arbuckle
Housemate: Nitwitted dog Odie
Rival: Nermal
Favorite food: Lasagna
Defining role: *Garfield and Friends* (1988–1995)
Traits: Lazy, selfish, arrogant, witty, cynical, conceited, hungry

Garfield Gab

- Lorenzo Music was an unseen, but often heard star as Carlton the Doorman in the popular 1970s sitcom *Rhoda*. His dry humor and arrogance eventually matched the traits in Garfield.

- Garfield was named after creator Jim Davis's grandfather, who was named after the assassinated US president.

- *Garfield and Friends* was the only series produced by Film Roman Productions in the 1980s.

- The immensely popular *Garfield* comic strip inspired twenty-five paperback collections and thirteen television specials, all of which were at least nominated for Emmy Awards.

- Another Davis comic strip—*U.S. Acres*—was brought to life in a separate segment on *Garfield and Friends*. The title character appeared on occasion.

- Legendary television and movie comedian Bill Murray lent his talents to voice Garfield in the 2004 computer-animated film.

- The popularity of *Garfield and Friends* motivated a doubling in time from a half-hour to an hour in 1989. A total of 121 episodes were produced, but just seventy-three became available in syndication in 1993.

- Davis had little to do with the production of *Garfield and Friends*. Veteran television and comic book writer Mark Evanier did much of the writing for the show along with Sharman DiVono. Evanier wrote for such 1970s sitcoms as *The McLean Stevenson Show* and *Welcome Back, Kotter*.
- Howard Morris voiced the duck named Wade in *U.S. Acres*. Morris was best known for his role nearly two decades earlier as the hillbilly crackpot Ernest T. Bass in *The Andy Griffith Show*.
- Garfield did not speak, but his thoughts as voiced by Music were audible.

About Garfield

Jim Davis created a figurative monster—in more ways than one—when he conceived of this orange and black tabby cat that debuted in his comic strip in 1978. Garfield was a monster in regard to popularity. He was also a bit of a monster in his thoughts, as understated as those were. Garfield certainly had more negative traits than positive ones, but those negative traits were so easily identifiable with the reader and viewer that he emerged as one of the most beloved comic

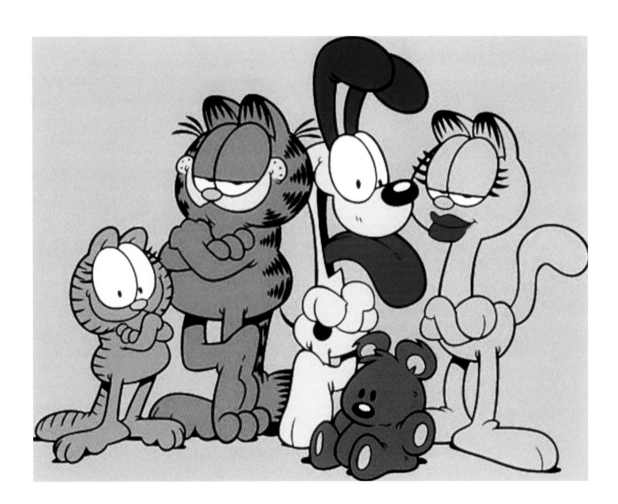

strip and television characters of all time. He was certainly among the most embraced of the pre-cable and post–baby boom cartoon era of the late 1970s and 1980s, which some consider a relative barren wasteland in animation. *Garfield and Friends*, which launched in 1988, allowed him to maintain and grow that popularity.

He was embraced for the same reasons real people would be shunned, because he represented finicky felines everywhere. Garfield was lazy—his favorite activity was sleeping. He was arrogant, like one might imagine most cats to be. He was self-centered . . . check. He was a loner—and don't most of us embrace our privacy? And he also loved to eat, but was too proud to chase mice. In fact, he vastly preferred human food such as lasagna. It's no wonder he was so fat.

Garfield would be hard-pressed to admit it, but he felt a soft spot in his heart for principled and neurotic master Jon and dumb dog Odie, whom he looked down upon. His relationship with those with whom he shared a home tied in to the humor, which revolved greatly around his anti-social behavior in a social world and myriad of identifiable and negative personality traits.

This character had more outlets than a modern kitchen. His comic strip has been published for nearly four decades. His television specials were spectacularly successful. His television show, which was rebooted in 2009, was so popular that it was quickly extended from a half-hour to an hour. And his character starred in two full-length movies.

Why Garfield Is No. 70

Critical acclaim and versatility have both played roles in earning Garfield a place among the animated greats. After all, he starred in comic strips, comic books, television, and film. And four of the television specials in which he was featured, including *Garfield on the Town* (1983), *Garfield in the Rough* (1984), *Garfield's Halloween Adventure* (1985) and *Garfield's Babes & Bullets* (1989) won Emmy Awards.

Garfield is a cat fancier's dream. He embodies the traits those who own cats embrace about their pets and those who don't like cats dislike about them, including laziness, selfishness, and arrogance. No other animated feline character—certainly not Sylvester or Heathcliff—ever captured (or was created to capture) those qualities so completely. But he was also quite witty in his thoughts and remarks to others, which greatly added to the humor of all of his outlets.

—MG

71
ROGER RAMJET

TOON-UP FACTS

Creator: Fred Crippen
Studio: Pantomime Pictures
Voice: Gary Owens
Debut: 1965, *Roger Ramjet* (Episode: "Dr. Ivan Evilkisser")
Organization: American Eagle Squadron
Underlings: Yank, Doodle, Dan, Dee
Power source: Proton Energy Pill
Love interest: Lotta Love
Rival: Lance Crossfire
Antagonists: The No Goods from The National Association of Spies, Traitors and Yahoos
 (N.A.S.T.Y); Solenoid Robots, Red Dog the Pirate, Noodles Romanoff
Defining role: *Roger Ramjet* (1965–1969)
Traits: Heroic, patriotic, upstanding, mindless, foolish, sleepy

Ramjet Realities

- The jet piloted by Roger Ramjet was red. Those piloted by his young Eagle Squadron mates were blue.

- The Proton Energy Pill popped by Roger gave him the strength of twenty atom bombs for twenty seconds.

- Writer Jim Thurman later wrote episodes of *The Bob Newhart Show* and *The Muppet Show*.

- The *Roger Ramjet* theme song is merely *Yankee Doodle* with different words.

- The frequent mention of the town of Lompoc in *Roger Ramjet* cartoons reflects the California hometown of many of the staff members working on the show.

- Several comic strip characters were referred to in episodes of *Roger Ramjet*, including Little Orphan Annie, Nancy, and Winnie the Pooh.

- The early 1990s PBS series titled *Square One TV* featured an animated character named Dirk Niblick that looked quite a bit like Roger Ramjet. Dirk's animation director (Crippen), writer (Jim Thurman), and voice actor (Owens) were the same as those responsible for *Roger Ramjet* cartoons.

- A running gag featured a chicken nesting in the engine when Roger Ramjet blasted off.

- The narrator of *Roger Ramjet* cartoons was Dave Ketchum, a sitcom character actor of the era whose most famous work was arguably as the put-upon Agent 13 in the wildly popular series *Get Smart*.

- Pantomime Pictures also produced another aviation-related cartoon titled *Skyhawks* in 1969. It did not fall into the comedy realm and lasted about two years.

About Roger Ramjet

Adults thirsting for the surreal, ridiculous humor they could embrace along with their kids after the cancellation of *Rocky and Bullwinkle* had their thirsts quenched when *Roger Ramjet* hit the air in 1965. One might have mistaken it for a Jay Ward production.

The absurdity of this parody of superheroes was established in the first episode ("Dr. Ivan Evilkisser") when the evil scientist title character wreaks havoc upon the United States by destroying all of its tiny refrigerator lightbulbs. That prevented people from eating, making them weak from hunger and allowing the No Goods to take over.

Square-jawed Roger looked and spoke like an upstanding, patriotic hero. But he often slept on the job, popped pep pills to gain his power, and was not the sharpest tool in the shed. His incompetence brought great suffering to his boss, General G.I. Brassbottom, who invariably was enveloped by fumes as he stood behind Roger's plane when it took off. There was something at least mildly subversive about the main character and his show.

Little time was spent on his heroism as he subdued the nasty no-goodniks of N.A.S.T.Y. Roger would often simply take his proton pill and bash one and all to smithereens. Good thing, too. Any additional moments showing the destruction would have resulted in less time for the pun-heavy humor. What would one expect from a show featuring characters such as Lotta Love and Jacqueline Hyde, as well as the Eagle Squadron foursome of Yank, Doodle, Dan, and Dee? One wonders why a character named "Ima" had not been created to place in front.

References to political figures of the day even popped up on occasion. Roger accidentally drills a hole through the Earth in "The Shaft" (1965), creating a whistling sound as the planet rotates. Among those who complain about it is a Lyndon Johnson look-alike and sound-alike wearing a cowboy hat and shouting "Yahoo! Heck of a noise, ain't it, Hubert?" Hubert Humphrey, of course, was his vice president at the time. The American Dental Association claims it can plug the hole with a giant porcelain filling, but the plan is scrapped because it would take six weeks to make an appointment.

Rapidity played a role in the popularity of *Roger Ramjet*. Movements were swift, scenes were short, and so were segments— four in each half-hour program. The result was strong viewership that led to a run from 1965 to 1969 and the production of 156 episodes.

The show was syndicated from the beginning, allowing networks to air them at any time. *Roger Ramjet* remained on the air in some markets for two decades. The Family Channel even showed it in the late 1980s and early 1990s, followed by the Cartoon Network late that decade.

Why Roger Ramjet Is No. 71

Roger Ramjet was the ideal character for the style of humor created for the cartoon. His vapid personality and deadpan delivery proved to be a perfect counterpoint to the plethora of bad guys that sought to destroy him. His goody-goody image was overemphasized to the point of ridiculousness, which resulted in laughs for kids who did not quite understand and a knowing smile for adults who certainly did.

Animation allows for exaggeration and absurdity that simply cannot be captured in real-life sitcoms. Those responsible for this series took full advantage of that ability. And they utilized Roger as both a centerpiece and a counter to other characters to create one of the downright funniest cartoons of all time. The more famous Jay Ward Studios would have been proud to create an equally amusing follow-up to *Rocky and Bullwinkle*.

Oh, and come on . . . apologies to Dick Dastardly and Snidely Whiplash, but Noodles Romanoff has *got* to be the greatest villain name in cartoon history.

—MG

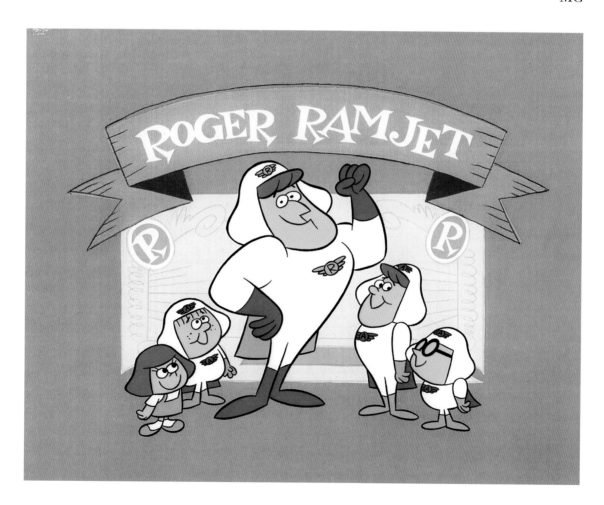

72
JOKEY SMURF

TOON-UP FACTS

Creators: Peyo Culliford
Studio: Hanna-Barbera
Voice: June Foray
American debut: September 12, 1981, *The Smurfs*
European animated debut: 1965, *Les Aventures des Schtroumpfs*
Comic book debut: *Spirou*, October 23, 1958
Antagonists: Gargamel, Azrael
Most frequent prank victim: Brainy Smurf
Starring TV role: *The Smurfs* (1981–1989)
Home: Smurf Village
Height: Three apples tall
Preferred prank: Exploding gift box
Traits: Funny, mischevious, patient, curious

Smurfy Facts

- Smurfs are naturally male and are delivered into the world by a stork.

- The voice of Brainy was provided by legendary voice artist June Foray, who voiced Rocky of Rocky and Bullwinkle fame.

- In 2005 a commercial for Unicef was produced in which the Smurf village was bombed. The graphic commercial featured the Smurf village in flames and dead Smurfs strewn across the ground. The anti-war commercial caused international backlash.

- The type of hats worn by the Smurfs are called Phygian. They were worn as symbols of liberty. A red Phygian, much like Papa Smurf's, can be seen on the seal of the US Senate.

- The original Belgian name of "Smurfs" is Les Schtroumpfs; Smurfs is the Dutch translation.

- All male Smurfs are naturally bald but they can grow facial hair.

- Voice actor and comedian Jonathan Winters voiced Grandpa Smurf in the television cartoon and Papa Smurf in the film adaptations, *Smurfs* and *Smurfs 2*. Frank Welker is the only actor to portray the same character in both the cartoon and movies. He played Azrael, Gargamel's cat.

- The Moof museum in Brussels features a "smurf-size" re-creation of the Smurf village. The Museum is the largest of its kind dedicated to Smurfs and other comic figures.

About Jokey Smurf

Based on the Belgian comic books by Peyo, the Smurfs are a race of peaceful, loving, kind, gentle, little blue creatures. They all live peacefully alongside each other and nature with each character having a distinct role in their society based on their personal traits. It is a Smurfy blue utopian society—and then there is Jokey Smurf. Jokey is the prankster whose sole role is to prey upon the trusting nature of Smurfs with sometimes violent pranks. His prank of choice is a large yellow gift box with a red ribbon. He will present this "gift" to unsuspecting victims. Upon opening the box his victims are treated to a small explosion, leaving them in a cloud of smoke covered in soot.

His pranks are at their best when they serve to puncture the pompous ego of Brainy Smurf. It is in those moments when Jokey becomes more than just an anarchist run amok but instead elevates his pranks to a level of social justice, providing a well-deserved comeuppance.

He is delightfully malicious and follows in a rich folklore tradition of the Norse god Loki, and Native American coyote tricksters. In the Smurf world he is quickly forgiven for his hijinks, because it is ultimately his role in their society.

Jokey Smurf was voiced by the legendary first lady of cartoons, June Foray. Her distinct and slightly disturbing laughter added just the right amount of malice to the lovable character.

Why Jokey Is No. 72

In the 1980s children's television was under a continued pressure to provide positive and educational messages to its young viewers. The "bad guys" suffered clear consequences and an often heavy-handed moral lesson was delivered. Jokey Smurf was a welcome relief: a negative role model! As the era of dropping anvils on friends and foes came to an end, Jokey was a rare purveyor of pranks. He let us know that good characters can be bad sometimes too, and that was just Smurfy!

—JW

73

MS. FRIZZLE

Creators: Joanna Cole, Bruce Degen
Studio: Scholastic Entertainment
Voice: Lily Tomlin
Full name: Valerie Felicity Frizzle
Nickname: The Friz
Catchphrase: "Bus, do your stuff!"
Debut: 1994, *The Magic School Bus* (Episode: "Gets Lost in Space")
Occupation: Teacher
School: Walkerville Elementary
Defining role: *The Magic School Bus* (1994–1997)
Traits: Adventurous, supportive, happy, unconventional, caring, colorful

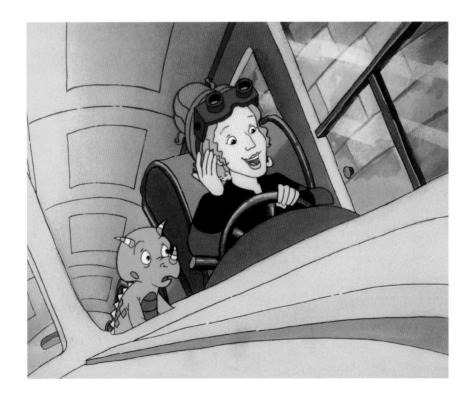

Wildest Frizzle Journeys

- Ms. Frizzle takes her students into Ralphie's sore throat via a vein through a cut to see what is making him sick. But his white blood cells sense the bus as a threat and seek to consume it.

- A lesson on what makes a log rot is provided as Ms. Frizzle shrinks the kids to examine one up close.

- The class finds itself trapped in a closed book after shrinking down to learn about the importance of friction.

- Ms. Frizzle leads an expedition to an ant colony as the class seeks to make a movie about the little buggers.

- The bus travels back in time to the Triassic, Jurassic, and Cretaceous prehistoric periods to learn about dinosaurs. Ms. Frizzle and her gang run into trouble when an Ornithomimid steals a fossilized dinosaur egg from Arnold, who later battles a *Tyrannosaurus rex*.

- The class embarks on a journey to Mercury, Venus, and Mars, but while Janet attempts to snag an asteroid as proof of the excursion, the group loses Ms. Frizzle and gets lost in space.

- Ms. Frizzle accompanies the class to the zoo, then transforms her students into various animals, such as foxes, possums, and falcons. She turns herself into a raccoon. The bus then believes itself to be a bear and leaves the group as city officials give chase in the belief it is a lost animal that must return to the zoo.

- The class learns a lesson about gravity as Phoebe seeks to find a way to slam dunk a basketball despite a distinct lack of height. Ms. Frizzle takes her kids into outer space and transforms the bus into a planet with adjustable gravity.

- Ms. Frizzle gets her class stuck in a pickle jar that she explains is not empty because it is filled with air. The students do not understand how air keeps the jar from being empty, but their leader uses that very air to get them out and teach them a lesson.

- The class shrinks down to the size of molecules to find a bit of tar on the hood ornament of a famous singer.

- Ms. Frizzle provides her students a lesson in the importance of recycling by transforming the bus into an anti-recycling machine and turning the city into one that does not recycle. They learn to their horror that the forest has been cut down, their swing set in the park has been replaced by aluminum cans, and the school itself is a garbage dump.

About Ms. Frizzle

If not for the vivid imagination and creativity of an elementary school teacher and librarian named Joanna Cole, there would be no Ms. Frizzle. Cole brought the character to life through her passion for science and the *Magic School Bus* book series for Scholastic, which hit the shelves in the 1980s and 1990s and were illustrated by Bruce Degen.

Ms. Frizzle boasted the same role in the books as she did in the animated series for PBS, which was produced by Scholastic Entertainment and first aired in 1994. She escorts her students

onto the magic school bus, which allows her to shrink them down and have them gain knowledge with closeness and clarity about the wonders of science.

The rather peculiar but keenly aware redhead uses her eccentric and gregarious personality, as well as her love for science, to help her students expand their minds. She engages the kids with humor and resourcefulness to fuel their imaginations and desire to learn about everything from outer space to the inner workings of an engine. The troubles they experience are not only necessary to create tension in the plot, but reveal the bravery of Ms. Frizzle and the love and trust her students feel for her.

The show gained popularity beyond the kids that watched it. Celebrities yearned to play voice acting roles. Included were Tyne Daly, Dom DeLuise, Rita Moreno, Tony Randall, Sherman Hemsley, Ed Asner, Dolly Parton, Paul Winfield, and Bebe Neuwirth.

The Magic School Bus remained on PBS for four years, but its cancellation did not stop its influence. It has since been shown on various networks such as Fox, NBC, The Learning Channel, and Discovery Kids. The full series became available on Netflix in 2013.

Why Ms. Frizzle Is No. 73

Ms. Frizzle is a character with strong enough appeal to kids to both teach and entertain them. That is no easy feat. Children often accept learning in their cartoons with the same enthusiasm they would have for swallowing a dose of castor oil. But Ms. Frizzle combined humor and an engaging personality to help pique interest in science among the viewers. Her journeys with her students captured the imagination and thirst for knowledge for kids watching at home.

Her program was indeed more than a learning tool. It was more than an adventure. It was more than humorous entertainment. And that was because of Ms. Frizzle, who *was* the show. Frankly, *The Magic School Bus* would have been nothing without her.

—MG

74
SCROOGE MCDUCK

TOON-UP FACTS

Creators: Carl Barks
Studio: Walt Disney Studios
Voice: Alan Young
Comic debut: December 1947, *Dell's Four Color Comics #187*
Animated screen debut: 1967, *Scrooge McDuck and Money*
Defining role: 1987–1990, *DuckTales*
Family: Donald Duck (Nephew), Huey, Dewey, and Louie (Great Nephews)
Love interest: Glittering Goldie
Antagonists: Magica De Spell, Flintheart Glomgold, The Beagle Boys
Net worth (according to *Forbes* magazine): $44.1 billion
Net worth (according to Carl Barks, creator of Scrooge McDuck): One multiplujillion, nine obsquatumatillion, six hundred twenty-three dollars and sixty-two cents
Prized possession: Lucky number one dime
Traits: Adventurous, loyal, industrious, wealthy, shrewd, honest

Duck Data

- Scrooge McDuck is Donald's uncle. Scrooge's sister Hortense is Donald's mother.

- Alan Young is perhaps best known for his role of Wilbur Post on the television classic *Mister Ed*.

- According to a map shown on the animated series, DuckBurg is in approximately the same location as Pittsburgh, Pennsylvania.

- In Hungary those born between 1985 and 1990 are considered part of the "DuckTales Generation."

- *DuckTales* was the first American cartoon to be shown in the former Soviet Union.

- Scrooge McDuck is one of only three fictional characters to appear on the city of Glasgow, Scotland's list of famous Glaswegians.

- McDuck played his namesake character, Ebenezer Scrooge, in the theatrical animated film *Mickey's Christmas Carol*.

- The first image ever displayed on an Apple Macintosh computer was of Scrooge McDuck.

- In the Netherlands a tax on the extremely wealthy is named the Dagobertducktaks in Scrooge's honor.

About Scrooge McDuck

From the moment of his comic debut in 1947, Scrooge McDuck was launched into a lifetime of adventure that rivals Indiana Jones—which seems only appropriate, as Steven Spielberg and George Lucas cite his comic book capers as one of the inspirations for the iconic archaeological adventurer.

Scrooge McDuck began his life in Scotland where he earned his beloved first dime shining shoes. As it turned out it was an American dime, worthless in his hometown of Glasgow. It was a lesson learned that stayed with him his entire life as he vowed never to "get taken" again and to forever be "sharper than the sharpies and smarter than the smarties." That dime would become the foundation of one of the largest fortunes of any fictional character in history.

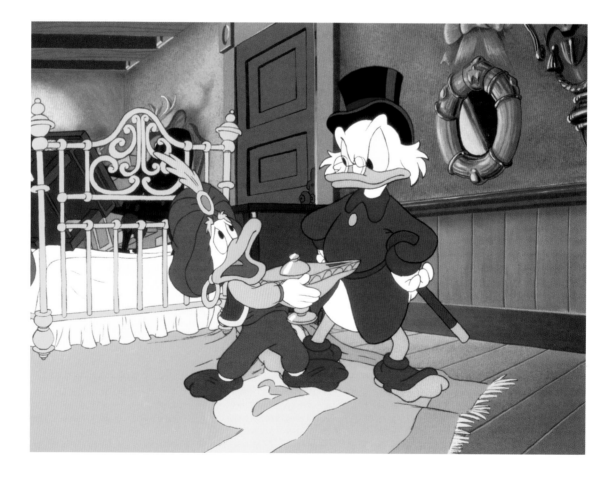

At the young age of thirteen, he heard the call of gold and headed to the Klondike as a prospector during the Alaskan gold rush, where he built his fortune and fame. He traveled around the world increasing his wealth. His life story played out in flashbacks through the comic books that have remained popular and in continuous production for over seven decades!

Pulling from the storylines in those comics, Disney launched the animated series *DuckTales* in 1987. Scrooge became a kinder and softer duck thanks to the introduction of his family. His adventures continued but now with his three nephews, Huey, Dewey and Louie, in tow they took on new meaning as not just mere acquisition of wealth but as an opportunity to broaden and educate his young wards.

Along with his personal pilot and sidekick, Launchpad McQuack, the family traversed the world, outsmarted villains, and protected Scrooge's sacred Money Bin.

Why Scrooge McDuck Is No. 74

As an elderly duck with no superpowers, he certainly doesn't fit the profile of your average comic book or animated hero, but Scrooge McDuck has proven his mettle through countless trials and tribulations. What easily could have been dismissed as kiddie animal comics quickly became an adventure story for all ages. The key to both the comics and animated cartoon was the storytelling largely written and drawn by Carl Barks. Scrooge McDuck was a character with a well-honed backstory. His adventures were well researched and plotted out with meticulous detail. Whether it was tales of his youth or his contemporary exploits, Scrooge's unflappable courage and driven ambition always paid off.

When Disney Studios decided to invest in a high-quality animated series, they pulled from that source material to create a vibrant adventure tale centered on Scrooge McDuck. It was a return to the values instilled by Walt Disney himself, that storytelling above all else comes first. It was a bold move that paved the way for a golden age of television animation, blazing a path for the Disney Afternoon and raising the bar for animation across the board.

—JW

75
DUDLEY DO-RIGHT

TOON-UP FACTS

Creators: Alex Anderson, Jay Ward, Bill Scott
Studios: Television Arts Productions, Jay Ward Productions
Voice: Bill Scott
Debut: 1961, *Dudley Do-Right of the Mounties* ("The Disloyal Canadians")
Employer: Royal Canadian Mounted Police
Boss: Inspector Fenwick
Love interest: Nell Fenwick
Antagonist: Snidely Whiplash
Horse: Horse
Defining role: *Dudley Do-Right of the Mounties* (1961–1964)
Dudley traits: Stupid, vain, obsessive, heroic, foolish

Dudley Drippings

- Scott was a Jay Ward mainstay who also voiced Bullwinkle and Mr. Peabody in *Rocky and His Friends* and *The Bullwinkle Show* episodes.

- The *Dudley Do-Right* episodes were set in the latter part of the nineteenth century.

- Ward opened the Dudley Do-Right Emporium in 1971 to sell memorabilia associated with the famous animated Mountie and other related characters. The store closed in 2005.

- Nell loved Horse far more than she did Dudley. It became a running gag on the show.

- Voice actor Paul Frees patterned his voicing of Inspector Fenwick after 1930s and 1940s British character actor Eric Blore.

- Dudley was featured on box fronts of Frosty O's cereal in the 1960s.

- Only one of the thirty-nine episodes produced was left out when rerun as part of *The Dudley Do-Right Show*. It featured Stokey the Bear, who had been hypnotized to start fires rather than put them out. The US Forestry Service objected to what it perceived as a lack of respect for revered mascot Smokey Bear and the episode was pulled.

- The live-action *Dudley Do-Right* movie (1999) starred Brendan Fraser, who also captured the lead role in the *George of the Jungle* film.

- There are no lyrics to the theme music in the opening of *Dudley Do-Right* segments, during which he is seen riding backwards on Horse before saving Nell from Snidely Whiplash, who has (of course) tied her to a railroad track.
- Dudley tried to be rotten in "The Disloyal Canadians" so he could be welcomed into the gang of fur smugglers led by Snidely Whiplash. But every attempt backfired until he ate his peas with a knife and was kicked out of the Mounties.
- The voice acting for Nell was provided by June Foray, who also voiced Rocky the Flying Squirrel, as well as Tweety and Granny in Warner Bros. cartoons.

About Dudley Do-Right

The Canadian cop was created more than a decade before first appearing on television. Ward and aspiring animator Alex Anderson produced pilot films in 1948 that featured *Dudley Do-Right of the Mounties* as well as *Crusader Rabbit*, which received the only significant interest. But Dudley was not dead. He would be revived when *Rocky and His Friends* was transformed into *The Bullwinkle Show* in 1961.

Dudley Do-Right and his cohorts were parodies of characters from the sappy Canadian melodramas that had spewed forth from Hollywood over the previous decades. Included were several that starred Nelson Eddy and Jeanette McDonald and were set in the Canadian wilderness. Eddy, in fact, played a Mountie in *Rose Marie* (1936).

The farcical Dudley helped bring humor by satirizing the roles of the heroes in such films. He yearns to live up to his expectations as a hero, but his stupidity, bumbling, and sometimes even cowardice prevent it. He emerges as the victor only by luck and the writer's understanding that the embodiment of evil in Snidely Whiplash cannot triumph in the end. Dudley's last name was Do-Right for a reason.

Dudley is tall and rather dashing in his red Mountie uniform and wide-brimmed red hat. He features a chin that sticks out well beyond his long nose and a cleft in which one could lose a finger.

He speaks with courage and confidence, but that dissipates on occasion when confronted with a dangerous assignment from the blustery, demanding Inspector Fenwick. He has been known to shake and stammer while begging to get out of it, even asking if the Mounties can use Nell instead. But more often he accepts his work with enthusiasm and bungles his way through it. Indeed, Nell is infinitely smarter than Dudley, but what can she do when she is tied to the railroad track yet again by Snidely?

His popularity resulted in no new episodes, but a program of reruns titled *The Dudley Do-Right Show* (1969) arrived several years later but lasted only a brief period. Dudley and his friends were seen frequently in syndication thereafter, bringing his goofiness to new generations of fans. In fact, the character even motivated a real-life film titled *Dudley Do-Right* in 1999.

Why Dudley Do-Right Is No. 75

Dudley is the ideal character to mock the heroes from the overly sentimental Hollywood melodramas of yesteryear set north of the border. He seeks to embrace the stereotype. He is destined to be its embodiment despite his ineptitude because, well, there can only be one hero and one villain, and Snidely Whiplash has assumed the other role.

In one scene, Snidely sadly admits his fate, stating that he's wasting his time because the outcome is a foregone conclusion even if Dudley does not realize it. Indeed, Snidely is far more intuitive and intelligent than Dudley, but then so is everyone—one suspects even Horse. It's Dudley's mindless stupidity and pride over the heroic deeds he achieves despite himself (after all, he's incompetent and doesn't even know it) that make him such a likeable and fun character.

—MG

76
DONATELLO

Creators: Kevin Eastman, Peter Laird
Studio: Murakami-Wolf-Swenson
Voices: Barry Gordon, Greg Berg, Sam Riegel
Debut: December 28, 1987, *Teenage Mutant Ninja Turtles*
Comic book debut: May 1984, *Teenage Mutant Ninja Turtles*
Brothers: Leonardo, Raphael, Michelangelo
Age: Fifteen
Sensei: Master Splinter
Best friend: April O'Neil
Antagonist: Shredder
Transportation: The Turtle Van
Favorite food: Pizza
Weapon: Bo staff
Bandana color: Red
Starring TV roles: *Teenage Mutant Ninja Turtles* (1987–1996), *Teenage Mutant Ninja Turtles* (2003–2009), *Teenage Mutant Ninja Turtles* (2012–present)
Traits: Creative, inventive, intelligent, peaceful, loyal, leadership, calm, tech savvy

Turtle Trivia:

- Donatello is the tallest of the turtles and the "brains of the group."

- When the show was exported to the UK, the title was forced to drop the word "Ninja" because of its violent connotations. The characters were redubbed as Teenage Mutant *Hero* Turtles.

- Donatello was almost named after Italian artist and architect Gian Lorenzo Bernini, but the creators decided another name ending in "o" would fit in better with the other names.

- Famed children's television host Buffalo Bob from *The Howdy Doody Show* filed a five million dollar lawsuit over the turtles' use of the phrase "Cowabunga!" The case was settled for fifty thousand dollars.

- Donatello's voice actor, Barry Gordon, got his start as a child actor appearing in such shows as *Leave It to Beaver* and *Make Room for Daddy.*

- B-movie director Roger Korman had approached Eastman and Laird about making a live-action film version of TMNT. It would have starred comedians Gallagher, Sam Kinison, Bobcat Goldthwait, and Billy Crystal. The idea was rejected.

- The original comics were much darker in tone than the animated series. The show was lightened up in an effort to appeal to a younger audience at the urging of Playmate Toys, who owned the licensing rights.

- The first sketch of the Teenage Mutant Ninja Turtles sold at an auction for seventy-one thousand dollars.

- The character of Shredder was inspired when Kevin Eastman was fooling around and put a cheese grater on the end of his arm. Thankfully his partner Peter Laird suggested the name Shredder instead of "The Grater."

- Much of the TMNT origin story is a direct tribute to the comic *Daredevil.*

- Rob Paulsen voiced Raphael from 1987 to 1995, and he returned to the TMNT franchise in 2012, as the voice of Donatello.

About Donatello

The Teenage Mutant Ninja Turtles started their unlikely rise to fame as a self-published parody of vigilante comics of the 1980s. Created by Kevin Eastman and Peter Laird, the four anthropomorphic turtles drew their names from renaissance artists: Raphael, Michelangelo, Leonardo, and Donatello. The popularity of the comic book led to a toy licensing deal on the condition that a wider audience could be found via an animated series. A short five-episode series, with a lighter tone than the comic, was produced in 1987 and developed an immediate following. By fall of 1988 Playmates Toys released their first line of TMNT action figures and a cultural phenomenon was born.

The turtles each have very distinct traits and personalities, but the uninitiated know them best by the color of their masks and choice of weapons: Michelangelo wears orange and uses nun-chucks, Leonardo wears blue and prefers katanas, Raphael wears red and uses sais, and Donatello dons purple and uses a bo staff.

Of the four turtles Donatello is by far the most intelligent, inventing many of the practical contraptions and weapons systems for the team. He's not as outgoing as his brothers and prefers to spend his time tinkering rather than training in the ninja arts. Though he is a skilled fighter, he is more likely to rely on reason to work his way out of a tough spot.

Why Donatello Is No. 76

While it is tempting to think of the TMNT quartet as interchangeable, their differences go well beyond the colors of their masks. Donatello is the most well rounded of the heroes in a half shell, and his shyness and mechanical inclinations make him a bit of a teenage enigma. He is more contemplative of the world around him and thus more sympathetic. The balance between action hero and thoughtful teenager makes him the most compelling of the turtles and a character worthy of our Top 100.

—JW

77
SYLVESTER AND TWEETY

TOON-UP FACTS

Creators: Friz Freleng, Bob Clampett
Studio: Warner Bros.
Voice (both): Mel Blanc
Sylvester debut: 1945 (*Life with Feathers*)
Tweety debut: 1942 (*A Tale of Two Kitties*)
Team debut: 1947 (*Tweetie Pie*)
Tweety owner: Granny
Sylvester motivation: Catch and eat Tweety
Tweety motivation: Thwart Sylvester
Sylvester antagonists: Hector the Dog, Hippety Hopper, Speedy Gonzales
Sylvester catchphrase: "Thufferin' thuccotash!"
Tweety antagonist: Sylvester
Tweety catchphrase: "I tawt I taw a puddy cat."
Defining role: Theatrical shorts
Top TV venue: *The Bugs Bunny Show* (1960–1975)
Sylvester traits: Persistent, scheming, foolish, befuddled, hungry
Tweety traits: Cute, innocent, fearful, childlike, carefree

The Cat-Bird Seat

- Among the voice actors who worked both characters was impressionist Joe Alaskey, who was famous for not only doing a spot-on impression of legendary comic actor Jackie Gleason, but looking like him as well. Alaskey voiced Tweety and Sylvester in *The Sylvester and Tweety Mysteries*, a Warner Bros. Animation series that ran on the Kids' WB channel from 1995 to 2001.

- Tweety worked his way up to top billing along with Bugs Bunny in 1990s broadcasts titled *The Bugs Bunny and Tweety Show*.

- In his pairings with Hippety Hopper, the feline also known as Sylvester Pussycat continually mistook the kangaroo for a giant mouse.

- Tweety Bird was forced to defend himself against Hollywood caricature felines Babbit and Catstello in his debut, which landed in theaters five years before he was matched up with Sylvester.

- Noted actress Bea Benaderet, who voiced Betty Rubble in *The Flintstones* for one season before landing a starring role in the sitcom *Petticoat Junction*, was the voice of Granny from 1950 to 1955. It was then taken over by June Foray, who would eventually become better known as the voice of Rocky the Flying Squirrel in the *Rocky and His Friends* and *The Bullwinkle Show* series.

- Tweety sported a sailor hat in early cartoons.

- While Tweety eventually appeared alongside Sylvester exclusively, the cat continued to be featured with Speedy Gonzales and others on occasion. His last appearance in a theatrical short was with Speedy in *Cats & Bruises* (1965).

- The legacy of Sylvester and Tweety motivated the US Postal Service to place the duo on a stamp in 1998.

- Warner Bros. legend Chuck Jones used Sylvester alongside Porky Pig in shorts. He played the role of Porky's pet who could not talk and therefore could not warn him of danger.

- Tweety did not save his signature line for Sylvester. He first uttered "I tawt I taw a puddy cat" in his debut short after catching a glimpse of Catstello, a feline that looked and sounded like Lou Costello.

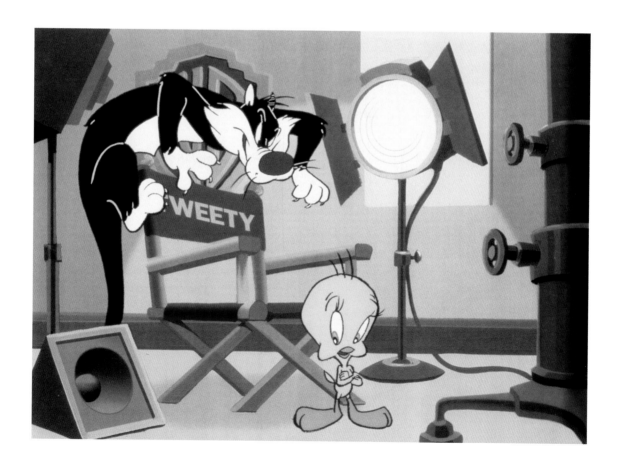

About Sylvester and Tweety

Sylvester and Tweety were like the peanut butter and jelly of animation. They were OK characters separately when first created, but they were an ideal combination when placed together. The vast talents of Freleng, Clampett, and Blanc made it work.

Tweety was a tiny yellow bird with small tan beak and feet and three vertical hairs emanating from his head. Sylvester was a black-and-white, two-legged cat and certainly no relation just because he too had three vertical hairs coming out of his scalp. Also hanging around, much to Sylvester's dismay, were elderly Granny and her tough dog Buster, both of whom conspired to keep him from his prey.

Tweety is seemingly innocence personified, but he does have a bit of shrewdness to him in staving off his adversary time and again. He yearns to spend his life swinging on his swing and singing in the bathtub, but Sylvester is more than a nuisance—he's a threat. Sylvester simply does not know when to give up. He is never rewarded, but he comes so close to succeeding, sometimes clutching Tweety in his hand, that he gains encouragement in his efforts. In the end—just like Wile E. Coyote—he emerges with nothing but frustration.

The chemistry between the two was evident from the start, so much so that their initial pairing in *Tweetie Pie* (1947) became the first Warner Bros. cartoon to win an Oscar. It would not be their only one—they snagged another Academy Award for *Birds Anonymous* a decade later.

The Sylvester and Tweety cartoons have grown in popularity after their last theatrical short (*Hawaiian Aye Aye*) was produced in 1964. Their original popularity had already landed them in their own comic book in 1952 and eventually motivated *The Sylvester and Tweety Mysteries*, which debuted on the Warner Bros. television channel for kids in 1995.

Why Sylvester and Tweety Are No. 77

Neither Sylvester nor Tweety boast the allure and depth enjoyed by Warner Bros. brethren such as Bugs Bunny and Daffy Duck. But together, they are cartoon dynamite. Their personalities and motivations combined ideally to create one of the most entertaining shows in the history of animation.

Some viewers enjoyed their shorts more so than they did the Wile E. Coyote and Road Runner cartoons because of the addition of the verbal sparring and characters such as Granny and Buster. Indeed, the Sylvester and Tweety combination boasted a higher level of complexity than did the other pair, though it could be argued that the coyote and road runner gained greater notoriety.

—MG

78
PENNY

Creators: Bruno Bianchi, Andy Heyward, Jean Chalopin
Studio: DIC Entertainment
Voices: Mona Marshall (pilot), Cree Summer Francks (1983–1984), Holly Berger (1985), Tara Strong (2015–present)
Debut: December 4, 1982, *Inspector Gadget*
Protagonists: Doctor Claw
Uncle: Inspector Gadget
Pet: Brain
Grandparents: Jules and Anne Brown
Hometown: Metro city
Age: Ten
Fears: Ghosts, snakes
Gadgets: Computer book, utility/monitor wristwatch
Starring TV roles: *Inspector Gadget* (1983–1986), *Inspector Gadget* (2015)
Traits: Intelligent, brave, curious, precocious

Penny Trivia

- In 1983 Penny's eyes were green; they were changed to blue the following season.

- Penny is Dr. Claw's daughter! Well, not exactly. The original voice actor for Penny, Cree Summer, is the daughter of Dr. Claw voiceover artist Don Francks. It was her first role; she has since gone on to a productive career in animation voiceovers.

- One of Penny's favorite TV shows to watch was *Heathcliff*. Both Heathcliff and Inspector Gadget were produced by DIC Entertainment.

- Penny's voice changed when the show's production moved from Toronto to Los Angeles between seasons. The role went to American voiceover artist Holly Berger.

- It took over 350 drawings to get the look of Inspector Gadget just right. After the pilot was filmed they still had one more alteration—they removed his moustache.

- Cree Summer reprised her role in the satirical *Robot Chicken* episode "Adoption's an Option."

- *Inspector Gadget* was the first animated television show to be presented in stereo.

- Andy Heyward created Inspector Gadget after being inspired by Hanna-Barbera's Dynomutt.
- Before *Inspector Gadget*'s debut Don Adams, Gadget's voice actor, was best known as secret agent Maxwell Smart of the TV show *Get Smart*. The two characters share many similarities including their bumbling nature.
- Inspector Gadget has more than 13,000 crime-fighting gadgets attached to his body.

About Penny

Pigtailed junior detective Penny is the niece of super cybercop Inspector Gadget. Unlike her cybertronic uncle, Penny's gadgetry is limited to her "computer book" and video watch. Using these tools and her own natural curiosity and investigative skills, Penny is the real brains behind cracking criminal cases.

She looks up to her uncle and in an effort to both emulate and adulate him takes a very active role in investigations. Often it is Penny's snooping around MAD's hideout that uncovers their latest devious plans. However, this generally leads to her being captured by the nefarious evil agency. On occasions when she cannot rely on her own resourcefulness to escape she is aided by her faithful dog Brain or her Uncle Gadget. Overall Penny is an independent and skilled junior agent able to use her wits and skills to solve even the toughest cases, unbeknownst to her uncle who gets to bask in the glory as the hero. Unlike other characters that are put in thankless situations as the "real" heroes, Penny is grateful to serve out of an unselfish devotion to her loving uncle.

The character of Penny would go on to appear in the 2015 animated reboot as well as a successful live-action film in 1999 and a 2003 direct to video sequel.

Why Penny Is No. 78

Penny is one of the strongest female characters in television animation. Intelligent, curious, skillful, and self-reliant, she served as a role model to young girls and boys alike. In the animated world young girls are often penalized for curiosity that leads them wandering down a pointless path of ruin to await rescue. Penny's curiosity serves a functional purpose as the protagonist and true hero resolving the case. On the occasions where she is captured and cannot escape on her own, she is never used as a prop or end goal as in most cartoons. She is not a damsel to be rescued. Her role as a young action hero is what earns her a spot on the list.

—JW

79
BENDER

TOON-UP FACTS

Creators: Matt Groening and David X. Cohen
Studios: The Curiosity Company, 20th Century Fox Television, Rough Draft Studios
Voice: John DiMaggio
Debut: March 28, 1999, *Futurama* (Episode: "Space Pilot 3000")
Built in: Mom's Robot Company, Tijuana, Mexico, Earth
Alma mater: Bending State University
Best friend: Fry
Ex-wife: The head of Lucy Liu
Fears: Electric can openers, magnets
Power source: Alcohol-based fuels
Defining role: *Futurama* (1999–2013)
Catchphrase: "Bite my shiny metal ass!"
Traits: Pathological liar, alcoholic, loyal, physical strength, narcissistic, generally immoral

Bender's Most Frequently Used Words (according to the episode "War Is the H-Word")

* Ass
* Daffodil
* Shiny
* My
* Bite
* Pimpmobile
* Up
* Yours
* Chumpette
* Chump

About Bender

Bender Bending Rodriguez is a robotic denizen of the future. The beer-swilling, chain-smoking, gambling, womanizing, mechanized degenerate is one of the breakout characters of Matt Groening's *Futurama*.

In the pilot episode "Space Pilot 3000," twentieth-century human Fry is thawed one thousand years into the future. While on a quest to track down his one remaining living relative, he encounters the suicidal, human-hating, robot Bender at a bar. They strike up an unlikely friendship that forms the core of the show and carried through seven seasons.

Unlike most other robots Bender is mortal due to a manufacturing error that has left him unable to upgrade. Perhaps that is what gives him a small piece of the humanity he despises.

If Bender has a moral compass, it is clearly malfunctioning as well. He is a sociopathic compulsive liar and thief who once kidnapped Jay Leno's head (Episode 16, "A Head in the Polls"). Of all his criminal, malicious, and oft dangerous behavior, perhaps his most disturbing trait is his "true calling" to be a folk singer, which manifests itself whenever his head is near a magnet.

Why Bender Is No. 79

We love a malcontent! Bender embraces his flaws as if they are gifts. He's the kind of friend you wish you had when you need to hide a body. Despite his hatred of humans, he's a lovable tin can Archie Bunker, spewing angry insults and smoke in our direction, and we love him for it.

—JW

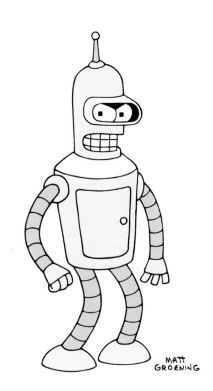

80
BABY GONZO

Creator: Jim Henson
Studios: Henson Associates, Marvel Productions
Voice: Russi Taylor
Debut: September 15, 1984, *Jim Henson's Muppet Babies*
Love interest: Miss Piggy
Defining role: *Jim Henson's Muppet Babies* (1984–1991)

Gonzo Trivia

- Baby Gonzo was voiced by female voiceover artist Russi Taylor, while the female character of Skeeter was voiced by male voiceover artist and comedian Howie Mandel.

- In the series it is never made clear what sort of animal or creature Gonzo is. It was not revealed until the film *Muppets from Space* that Gonzo is in fact an alien.

- Baby Gonzo appeared alongside Baby Kermit and Baby Piggy in the anti-drug program *Cartoon All-Stars to the Rescue*. The bizarre show featured characters from Disney, Hanna-Barbera, Warner Bros., and more.

- *Muppet Babies* was a collaborative effort between Jim Henson Associates, Marvel Productions, and Disney. This predates Disney's purchase of the other two companies.

- Nanny, the caretaker of the Muppet Babies, was voiced by America's mom, Barbara Billingsley, best known as Mrs. Cleaver of *Leave It to Beaver* fame.

- Baby Gonzo, who as an adult Muppet has what can only be described as a chicken fetish, carries a stuffed toy chicken named Camilla with him. Camilla is the name of his "love interest" in many of the Muppets film and TV ventures.

- Statler and Waldorf are the only adult humans whose faces you see in the show.

- The show was known for its quirky pop culture cameos. One of the most notable is in the "Comic Capers" episode where Spider-Man creator and cameo king Stan Lee appeared!

- Gonzo first appeared as a Muppet puppet as Snarl the Cigar Box Frackle in the CBS holiday special *The Great Santa Claus Switch*.

• The Muppet Babies appeared in a 2015 sequence of the comic strip *Nancy* drawn by Guy Gilchrist. Guy had been the artist and originator of much of the early Muppet Babies licensed art.

About Baby Gonzo

Jim Henson's Muppet Babies was inspired by the popularity of the infantized Muppets in a dream sequence of the film *The Muppets Take Manhattan*. The show followed the imagined adventures of the young muppets: Piggy, Kermit, Gonzo, Fozzie, Scooter, Rowlf, Animal, Bunsen, Beaker, and the newly introduced Skeeter.

While the actual show took place in the Muppet nursery, it was their escapist imagined sequences that supplied most of the plots' adventures. The show was at its best when it acted as a platform for parody. Pop culture references and reenactments of films such as *Star Wars* or television shows like *Saturday Night Live* were frequent, with occasional real-life celebrities making appearances.

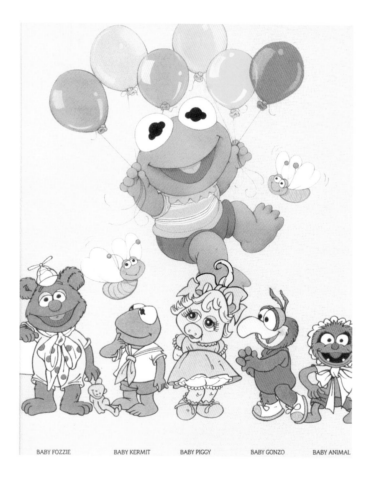

BABY FOZZIE BABY KERMIT BABY PIGGY BABY GONZO BABY ANIMAL

In the world of wild imaginings, Gonzo oddly stands out. He possesses an almost surrealistic creativity, typified by the manifestation of strange objects, such as speeding trains, upon his opening a door.

Much of his personality is derived from the character's "adult" incarnation in film and television. He celebrates his bizarre uniqueness. "Weird is my middle name," he once said with great pride. Like his adult self, he is a stuntman of sorts as in the episode "Faster Than a Speeding Weirdo" in which he attempts to break the sound barrier while riding a vacuum cleaner.

Gonzo's ability to dream without the restrictions imposed by being normal make for the most exciting Muppet Babies adventures.

Why Baby Gonzo Is No. 80

Baby Gonzo is a day care Dali! His imagination knows no bounds or limits. It is in his willingness to embrace the strange and unusual that the show takes its most interesting twists and turns. As a character Gonzo has always been the ultimate embodiment of geek pride. He speaks to the strange, different, unusual, and outcast of society. Knowing that even as a child he was a weirdo was a great comfort to countless weird kids of the 1990s, this author included.

—JW

81
BORIS AND NATASHA

Creators: Jay Ward and Bill Scott
Studio: Jay Ward Productions
Boris voice: Paul Frees
Natasha voice: June Foray
Boris's last name: Badenov
Natasha's last name: Fatale
Debut: 1959, *Rocky and His Friends* (Episode: "Jet Fuel Formula")
Home: Pottsylvania
Nationalities: Russians
Professions: Spies
Bosses: Fearless Leader, Mr. Big
Boris catchphrases: "Sharrup you mouth!" . . . "Must catch moose and squirrel"
Natasha catchphrase: "Hello, dollink"
Antagonists: Rocky the Flying Squirrel, Bullwinkle J. Moose
Defining roles: *Rocky and His Friends* (1959–1961); *The Bullwinkle Show* (1961–1964)
Boris traits: Scheming, fiendish, intimidated, jealous, foolish, stupid
Natasha traits: Wicked, cautious, nervous, faithful

Good Enough Badenov and Fatale Facts

- Paul Frees was particularly strong with foreign dialects, which made him the ideal choice to voice Boris Badenov with his Russian accent.

- A rush job to hit deadline imposed by ABC in 1959 resulted in animation errors, including Boris sans moustache in one scene after having it in the previous one.

- Boris appeared frequently as a foil in side segments featuring Bullwinkle, including *Bullwinkle's Corner* and *Mr. Know It All.*

- Pottsylvania was a clear takeoff on Soviet Russia.

- Though Boris and Natasha were Russian spies, Fearless Leader dressed and spoke like a caricaturized Nazi officer.

- Boris sometimes interrupted the narration to express his opinions or explain his fiendish plot. His jealousy in regard to his limited exposure in comparison to Rocky and Bullwinkle added to the abstract humor of the show.

- *Rocky and His Friends* enjoyed a daily run on ABC from 1959 to 1961, but became a weekly program as *The Bullwinkle Show* on NBC from 1962 to 1964.

- The *Boris and Natasha* animated film of 1992 was directed by Charles Martin Smith, who is best known for his role as the nerdy Terry "The Toad" Fields in the highly acclaimed 1973 movie *American Graffiti*.

- The name of the villain was a takeoff on that of sixteenth-century Russian tsar Boris Godunov.

- It was revealed in an advertisement that Boris was a member of Local 12 of the Villains, Thieves and Scoundrels Union. That must have been in the United States—unions had long been banned in Soviet Russia.

- General Mills cereals were not only promoted by good guys: Boris and Natasha were featured in ads for Lucky Charms in the 1960s.

- Sally Kellerman voiced Ms. Fatale in *Boris and Natasha: The Movie* (1992). She is far better recognized, however, as Margaret "Hot Lips" Houlihan in the film *M*A*S*H* (1970), a role that earned her an Academy Award nomination.

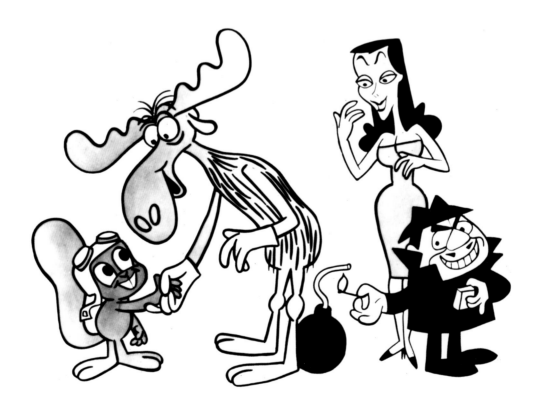

About Boris and Natasha

Ward and Scott could not have created a more ideal pair of no-goodniks to counterbalance Rocky and Bullwinkle while capturing the spirit of the show than Boris Badenov and Natasha Fatale. The moose and squirrel parodied traditional media portrayals of heroes, while the Russian scoundrels satirized similar notions of villains.

The conflict was a reflection of the Cold War, which was at its height during the run of *Rocky and His Friends* and *The Bullwinkle Show*. In fact, the Cuban Missile Crisis occurred while the latter was in its heyday.

The two could not have looked more different, though both featured a rather macabre appearance. Boris was a short man with wisps of moustache on both sides of his lip, big, expressive eyes, and a wide-brimmed black hat, though he was taller with red eyes in earlier episodes. Natasha was a tall woman with long black hair and a purple dress. Though their personalities were more similar, it should be noted that Natasha boasted greater intelligence and awareness of danger than did her partner. She was fiercely loyal, however, as she continued to go along with his ultimately and inevitably disastrous schemes.

Boris was evil from birth. He received his education in Pottsylvania, center of espionage and deceitfulness where the highest honor was to receive the Double Cross and where its most prestigious newspaper (*The Pottsylvania Eavesdropper*) was written in invisible ink. It was in the Pottsylvania schools that Boris learned his ABCs (Arson, Bomb-Throwing, and Conspiracy) before gaining a "scoundrelship" at USC (University of Safe-Cracking). He graduated from there magna cum louse. He was justifiably fearful of Fearless Leader, who constantly threatened him with death, motivating Boris to butter him up to stay on his good side.

Less was revealed about Natasha, who was a former Miss Transylvania and failed apprentice witch. She first befriended Boris when they were both arrested for throwing rocks at Girl Scouts selling cookies.

The mission of the rotten pair was simple: prevent the moose and squirrel from doing good. Each segment in which they were featured was part of a long story arc. The results were predictable—they were thwarted every step of the way despite Bullwinkle's ineptitude and Rocky's trusting nature. Among the examples is the story arc *Upsidasium* (1960–1961), in which Boris and Natasha seek to steal from Bullwinkle a mine in a mountain that floats skyward because of the title-name anti-gravity metal. Another that same season is *Buried Treasure*, which features Boris in a more traditional gangster role as he seeks to rob banks in Frostbite Falls, Minnesota, home of the heroes. But perhaps the most entertaining is *Topsy Turvy World* (1961–1962), in which Boris causes the world to tilt, thereby moving the South Pole to the Pacific. During the telling of that story by the narrator, Boris orders the narrator to halt the proceedings, thereby freezing all the characters in place, to outline his fiendish plan.

Boris and Natasha maintained their standing as the super scoundrels of the show throughout its run and onto the big screen in *Boris and Natasha* (1992), *The Adventures of Rocky and Bullwinkle* (2000) and *Rocky and Bullwinkle* (2014). But they were real-life characters in the first two films and had lost their evil energy as 3-D animated characters in the third. There is little doubt that they were at their best in the original.

Why Boris and Natasha Are No. 81

Boris and Natasha were far more than simply funny villains in a cartoon show. They boasted infinitely more complex personalities and purposeful motivations than other animated anti-heroes. They were driven not just by their evilness, but by the fear placed into them by Fearless Leader and Mr. Big. Their humor was based not just on their deeds, but their dread (particularly that of Boris) at the possibility of being killed if they failed to stop the moose and squirrel.

They also created humor through conceit in their rottenness. Boris boasted about his achievements in the field of nastiness. Natasha showed an unspoken pride in her wickedness and a loyalty to her partner despite his penchant for getting blown up and otherwise physically maimed. They embraced their work and believed unquestioningly that they were the ideal scoundrels to carry out their missions in the name of all that is rotten. It is no wonder they are considered by some the greatest villains in the history of animation.

—MG

82
BEAST BOY

Creators: Arnold Drake and Bob Brown
Studios: DC Animation, Warner Bros. Animation
Voices: Greg Cipes (2003–2006), Logan Grove (2010–spresent)
Debut: July 19, 2003, *Teen Titans*
True identity: Garfield Logan
Home country: Qurac
Mother: Marie Logan
Team: Teen Titans
Love interest: Terra
Best friend: Cyborg
Nickname: BB
Powers: Animal-based shape shifting, animalistic powers, combat skills
Antagonists: Slade, The Brotherhood of Evil
Defining role: *Teen Titans* (2003–2006)
Traits: Outgoing, energetic, mischievous, kind, immature

Top 10 Beast Boy Favorite Transformations and Primary Abilities

- *Tyrannosaurus rex*—Combat
- Hawk—Flight
- Kangaroo—Boxing skills
- Cheetah—Speed
- Sasquatch—Strength
- Blue Whale—Underwater travel
- Hummingbird—Evasive skills
- Turtle—Protection
- Dog—Tracking
- Kitten—Irresistible cuteness

About Beast Boy

Raised in the jungles by his geneticist parents, as a young child, Garfield Logan was bitten by a rare species of green monkey. When he contracted a rare disease known as Sakutia, his parents developed a lifesaving serum, which possessed "super-powered" side effects giving him animal shape shifting abilities.

After his parents passed, the young beast boy joined the Doom Patrol. After a short-lived stint with the super group, he set out on his own eventually ending up in Jump City. It was there he met Robin, Starfire, Raven, and Cyborg, eventually forming a new group of their own known as The Teen Titans!

Despite a hard life and the loss of his parents at a young age, Beast Boy maintains a positive and carefree outlook on life. He is a frequent prankster and tends to lack the responsibility possessed by others on the team. Beast Boy best summed up his philosophy this way: "I'm not smart enough to do everything, but I'm dumb enough to try anything!"

Why Beast Boy Is No. 82

DC Comics superheroes have taken a darker tone over the past three decades. Despite being a teenage character, Beast Boy breaks away from that stereotype of the brooding moping hero filled with teen angst. Though he may occasionally experience emotions of sadness, he is overall an upbeat and fun character. He doesn't spend his time lamenting the hopelessness of society or his own lot in life; he truly loves being a superhero. He is a fanboy who looks up to other heroes, and even saves souvenirs of his own super adventures; in short . . . he's one of us, a geek who just loves the superhero and cartoon genre and we are just wild about him!

—JW

83
STERLING ARCHER

Creator: Adam Reed

Studios: Floyd County Productions, Radical Axis, FX Productions (2009–2015), FXP (2016—present)

Voice: H. Jon Benjamin

Debut: September 17, 2009, *Archer* (Episode: "Mole Hunt")

Full Name: Sterling Malory Archer

Occupation: Secret agent

Place of employment: International Secret Intelligence Service (ISIS)

Codename: Duchess

Skills: Hand-to-hand combat, firearms, scuba, archery, drink mixology

Weapon of choice: Walther PPK

Birthplace: Reggie's Bar, Tangiers, Northern Morocco, Africa

Mother: Malory Archer

Possible fathers: Nikolai Jakov, Len Trexler, Buddy Rich, unnamed Italian man

Childhood hero: Burt Reynolds

Favorite film: *Gator*

Antagonists: Crenshaw, Barry Dylan, Mister Moto, Tony Drake, Nikolai Jakov, Conway Stern, Katya Kazanova

Fears: Alligators, brain aneurysms

Catchphrase: "Phrasing."

Character traits: Arrogant, misogynistic, suave, promiscuous, narcissistic, sarcastic, vain, incompetent, bumbling

Archer's Top 10 Aliases

1. Rando
2. Bob Belcher
3. Randy Magnum
4. Cyril Figgis
5. Father Guido Sardouchebag

6. Topper Bottoms
7. Rander Randerson
8. Col. Lando Calrissiano
9. Chet Manley
10. Pirate King

About Sterling Archer

Sterling Archer is a somewhat lovable cad and superspy cast in the mold of Ian Fleming's James Bond. Born in Reggie's Bar in Northern Morocco, he was named after a sterling silver baby rattle left behind by an Arab prostitute. Quickly abandoned by his mother, he was raised by the former bar owner William Richard Woodhouse. As Archer aged Woodhouse took on the role of his personal valet. Sterling's abandonment and mommy issues are made worse by his mother's lying about the identity of Archer's father. The few occasions when he did see his mother during childhood were often marred by her mistreatment of him. Among her more nefarious deeds was the theft of his bicycle, and her leaving him stranded at boarding school.

His hatred of his mother is further complicated in his adulthood when he begins working as a spy at the agency founded by his mother, the unfortunately named ISIS (International Secret Intelligence Service). His "mommy issues" are a recurring theme throughout the show.

Despite the relationship with his mother, or perhaps because of it, he excels at being a secret agent and quickly rises through the ranks to take his place as the "world's deadliest spy!"

The inspiration for Archer was hit upon by Adam Reed while watching the James Bond film *GoldenEye*. In watching Judi Dench's portrayal of M, he thought to himself, what if M were James Bond's mother, "and what if they were horrible people." That dynamic became the show's core motivation.

Archer is a narcissist whose main focus is his own immediate gratification. Promiscuous and sex-crazed, he uses his station in life as a secret agent to seduce women at every opportunity.

Despite being an arrogant, sexist, racist, self-absorbed, immature, alcoholic, "giant gaping asshole" with a complete lack of empathy, he does have his own unique brand of charm and can

be a sympathetic character. Revelations into his sad upbringing and childhood bullying provide an insight into the man he has become.

Archer makes us shudder at his behavior while letting out a laugh at the unimaginable inappropriateness of his words and actions. He is both the mirror image and magnification of the classic "super spies" such as James Bond and Matt Helm, characters who in reality would spend more time in sensitivity classes for sexual harassment than they would in the field.

Why Sterling Archer Is No. 83

In creating the character Reed set out to make him "as dickish as possible but still sympathetic." It's a perhaps ignoble cause, but one that he achieves in perfect balance. Archer has the worst qualities that we all wish we could have. He says what's on his mind without a filter; he's sarcastic, sexual, and completely self-centered. There is an undeniable appeal to a character so extreme in an era of political correctness. We can't imagine a character like him could survive or exist in the twenty-first century, and yet here he is, drinking, swaggering, and sexing it up.

There is a visceral reaction of laughter when we witness his actions. They are so over the top, so extreme that we can't help but think, "I can't believe they went there." And yet they go there again and again, to that point just beyond common decency where society is satirized for its own misbehavior. Sterling Archer is not just a spot-on satire of the sexism of the spy genre; he is the embodiment of all our own worst qualities that we hope never see the light of day.

We know we could never, or should never do or say the things he does and says . . . but we secretly delight in watching him do it.

For being a likeable low-life, we rank Archer at #83 on our list.

—JW

84
ROADBLOCK

Creator: Donald Levine
Studios: Hasbro, Sunbow Productions, Marvel Productions, Toei Animation
Voice: Kene Holliday
Debut: September 10, 1984, *G.I. Joe a Real American Hero* (Episode: "In the Cobra's Pit")
Real name: Marvin F. Hinton
Birthplace: Biloxi, Mississippi
Specialty: Heavy machine gunner, cook
Rank: E-4 corporal
Weapon of choice: M2 Browning heavy machine gun
Antagonists: Cobra Commander, Snake Eyes
Starring TV role: *G.I. Joe*
Traits: Strong, friendly, intelligent, brave, frequently speaks in rhyme

Top 10 Things We Learned from the G.I. Joe Public Service Announcements:

- Don't go near downed power lines.
- Don't give strangers your address.
- Don't pull the fire alarm unless there is a fire.
- Don't swim during a thunderstorm.
- Wear proper protection out in the sun.
- Have proper ventilation when painting.
- Be careful around frozen ponds and lakes.
- Taking something that isn't yours just isn't right.
- Don't get in anything that could close and trap you.
- Don't pet strange animals.

Now you know . . . "And knowing is half the battle!"

About Roadblock

G.I. Joes first went into service for Hasbro as a line of toys in 1964. Taking inspiration from the popularity of Barbie, Hasbro introduced a series of male-centric dolls redubbing them "action figures." Its popularity lasted for ten years, but by 1974 the social climate and its view of war had changed and the toy was discontinued.

By 1982 war-oriented toys were once again in vogue and G.I. Joe was reintroduced as a line of smaller action figures. This time Hasbro paired up with the comic book company Marvel to produce a backstory for a line of comic books. The companies took the bold step of producing an animated television commercial for the comic book, a gamble that paid off. The popularity of the commercials led to a G.I. Joe miniseries and eventually a full-fledged series of its own in 1985. By the time the series launched, they had already developed over 125 different figures and characters including Roadblock, who became a part of the core team for the new animated show.

The character's backstory included a large extended family growing up in Biloxi and a lifelong ambition to be a chef. He had a dream to attend Escoffier School in France, but when an army recruiter informed him he could learn to be a chef in the army, he quickly enlisted.

Roadblock joined the infantry and was noted for his ability to use the M2 Browning machine gun as his weapon of choice. The heavy weapon usually required a small squad to operate it.

Roadblock was noted for inexplicably speaking in rhyme, most likely a character quirk that was influenced by the patter of Muhammad Ali.

Throughout his time with the Joes, he maintained his interest in cooking and during his brief hiatus from the team became a gourmet chef, wrote several cookbooks, and even hosted his own cooking show. He returned to the squad when they were reactivated and remained a part of the series throughout the remainder of its animated run. The character remained one of the most popular and was portrayed by Dwayne Johnson in the 2013 live-action film *G.I. Joe: Retaliation*.

Why Roadblock Is No. 84

G.I. Joe became known for its almost comical use of public service announcements within the show. This was a direct response to criticism that the show was indiscernible from its toy commercials. In an effort to add educational content, they produced the PSA tags. However *G.I. Joe*'s most important lesson taught was one that was within the show itself—diversity.

When Hasbro introduced the G.I. Joe line of toys in the 1960s, they made the then bold move of including an African-American figure. When the animated series began, the cast was fully integrated and diverse. This was done without the heavy-handedness of other children's shows that seem to force the message of a "diversity rainbow." The characters on *G.I. Joe* were all part of a team and worked together flawlessly. Roadblock was one of the most visible and developed minority characters of the show. His backstory added a real depth and personality to the character rarely seen in action-adventure cartoons. As a tough yet sensitive guy who loved to cook, he served as a powerful role model with passion and conviction.

—JW

85
MAGILLA GORILLA

TOON-UP FACTS

Creators: William Hanna, Joseph Barbera
Studio: Hanna-Barbera
Voice: Allen Melvin
Debut: 1964, *Big Game*
Catchphrase: "We'll try again next week."
Home: Peebles Pet Shop
Owner: Mr. Peebles
Adoring temporary owner: Ogee the little girl
Defining role: *The Magilla Gorilla Show* (1964–1967)
Traits: Trusting, friendly, lonely, reckless

Primate Points

- Voice Allen Melvin is better known for his live roles, particularly as various characters in *The Andy Griffith Show* and as Sam (Alice's boyfriend) the butcher in *The Brady Bunch* and Barney Hefner (Archie Bunker's buddy) in *All in the Family*.

- Mr. Peebles was voiced until the last four shorts by wacky comedian Howard Morris, who played together with Melvin on occasion in *The Andy Griffith Show*. Morris played the role of nutty, rock-throwing hillbilly Ernest T. Bass.

- When Morris was replaced by Don Messick as the voice of Mr. Peebles, the pet shop owner lost his signature whistle when he pronounced words with the letter "s."

- The opening theme song showed Mr. Peebles marking the price of Magilla down from one hundred dollars to two cents.

- *The Magilla Gorilla Show* also included shorts featuring hillbilly cat-and-mouse combatants Punkin' Puss and Mushmouse, as well as Old West sheriff Ricochet Rabbit, whose sidekick Droop-a-Long was voiced by legend Mel Blanc. Punkin' Puss was the rarest of cartoon cats, because he often won his battles against a mouse. The Ricochet Rabbit shorts were eventually replaced by Breezly Bruin and Sneezly Seal in a trade-off with *The Peter Potamus Show*.

- Ogee was voiced by Jean Vander Pyl, who had gained far greater fame for voicing Wilma Flintstone.

- Magilla ran against Yogi Bear as a candidate for the 1964 presidency in a Hanna-Barbera promotion to sell merchandise. Among the campaign claims was that Magilla would stay at work through the winter rather than hibernate. A campaign song urged voters to "go ape and rejoice" at his candidacy.

- *The Magilla Gorilla Show* boasted a strong licensed tie-in with the Ideal Toy Company. The company was even alluded to in the opening theme music.

- Author Christopher P. Lehman claimed in his 2007 book about animated cartoons of the Vietnam era that the inability of Magilla to remain sold reflected the outlook of racist Americans about integration during the civil rights movement. The claim was that Magilla represented a perception of sub-humanity when white customers inevitably returned him at the end of each episode. Many believe, however, that Magilla was no more than a cartoon gorilla and that such a claim was a vain attempt to make a significant social statement about a character and show whose creators and writers had no such point in mind, even subconsciously.

- "Megillah" is a Yiddish term that means a detailed account and has been popularized as meaning a story or adventure that has been unduly drawn-out or complicated.

- Singer Little Eva, who had earlier gained fame with her hit "The Loco-Motion," sang "Making With the Magilla" to go along with the 1964 short of the same name in which the animated primate becomes a surfing star.

About Magilla Gorilla

Hanna-Barbera had been established for nearly a decade in animation for television with such popular standouts as Yogi Bear and the Flintstones when it created Magilla Gorilla, who emerged as one of its biggest stars.

Magilla occupied the storefront window in Peebles Pet Shop with plenty of bananas to eat and a television to watch. He seemed at times to have the run of the place, skating or driving around the premises and generally wreaking havoc, motivating Mr. Peebles to feel a sense of desperation to sell him off permanently once and for all. Magilla indeed is either sold or departs in every short, but always comes back or is returned by unsatisfied customers.

Magilla is a colorful brown beast sporting red shorts, green suspenders, purple bow tie, oversized brown shoes, and undersized green derby hat. He yearns for little more (aside from bananas) than to love and to be loved. His friendly and contented nature is often tested by loneliness, and the foolhardy acts that get him into trouble and prompt buyers to return him quickly to the pet shop.

The one exception among the many displeased all-too-temporary pet owners is a little girl named Ogee (pronounced like "oh, gee"), whose love for Magilla is evident in the opening credits when she asks, "How much is that gorilla in the window?" and appears in several shorts. Her parents force her to return Magilla when he makes a mess of their lives.

Certainly, his character would not have thrived had he remained in the pet shop. Hanna-Barbera writers placed Magilla in a variety of roles and settings. He played fullback for the Pennsyltucky Lions in "Gridiron Gorilla" (1964). He floats skyward after drinking an anti-gravity formula in "Airlift" (1964). And he joins the French Foreign Legion in "Beau Jest" (1965).

The Magilla Gorilla Show began in syndication in early 1964. Episodes continued to be produced for two years, but the show remained a Saturday morning staple into 1967. Its legacy motivated Boomerang to pick it up and air it well after the turn of the twenty-first century.

Why Magilla Gorilla Is No. 85

Magilla was arguably the most endearing of the second wave of Hanna-Barbera cartoon characters. He was provided a more powerful motivation in life than many of his animated counterparts of the era as a gorilla desirous of finding a loving and caring home, while his self-destructive and reckless nature prevented him from earning that security and happiness.

Unlike many other Hanna-Barbera cartoon characters of that time, Magilla didn't need a sidekick to play off of. He shared the spotlight with no one—not even Mr. Peebles—as the star of the show. It is noteworthy that of the six cartoon series in *The Magilla Gorilla Show* and *The Peter Potamus Show* families, Magilla was the only main character that required no sidekick.

—MG

86
COUNT DUCKULA

Creator: Cosgrove Hall Films
Studio: Cosgrove Hall Films
Voice: David Jason
Debut: *Danger Mouse* (September 28, 1981)
Full Name: Count Duckula the 17th
Favorite food: Broccoli sandwiches
Antagonists: Dr. Von Goosewing, The Crow Brothers, Gaston and Pierre
Servants: Igor (Butler), Nanny (Housekeeper)
Home: Castle Duckula, Transylvania
Starring TV role: *Count Duckula* (1988–1993)
Place of employment: *The Daily Bugle*
Traits: Vegetarian, selfish, egotistical, helpful, ambitious, cowardly

Duckula Data

- Count Duckula speaks with an American accent, despite being voiced by British actor David Jason.

- He occasionally wears Danger Mouse pajamas as a tribute to his former nemesis in "another lifetime."

- Barry Clayton, who also did the voice introduction for the Iron Maiden song "The Number of the Beast," provides the voiceover introduction for each episode.

- The Duckula family motto is *Per Ardua ad Sanguina*, which means "Work hard for blood."

- The character was changed substantially from the one that appeared on *Danger Mouse*.

- Duckula is often confused with the Filmation-produced *Quackula* (1979). Other than being about vampire ducks, the two shows are unrelated.

- Duckula appeared in four episodes of *Danger Mouse* before getting his own show. The character was reworked as a vegetarian and they dropped his lisp.

- The villainous characters of Gaston and Pierre were humanized, renamed, and featured in the spinoff, *Victor and Hugo: Bunglers in Crime*, making that show a rare spinoff of a spinoff!

- The entire show was produced using only six voice actors.
- In 1993 Duckula voiceover actor David Jason was knighted by the Queen of England for his services to acting and comedy.

About Count Duckula

Count Duckula is the seventeenth in a long line of duck vampires, each one reborn and regenerated from the last via a ritual blood transfusion. However due to a slight mixup involving ketchup being used in the resurrection ceremony, Duckula was born without the bloodlust (or fangs) of his predecessors and instead reborn a vegetarian!

His break with vampirical blood thirst tradition is a frequent point of frustration to his servants, Nanny and Igor. Many episodes are spent trying to correct this situation to no avail.

Duckula's thirst for carrot juice is matched only by his desire for fame. Many of his adventures revolved around his efforts to break into show business as an entertainer. Using his castle's teleportation abilities, he is able to take his quest throughout the world. He once notably attempted to become a blues musician in New Orleans with predictable results.

Danger Mouse had been successfully airing on the American network Nickelodeon and became a hit. The network approached Cosgrove Hall about producing a second show but passed on the ideas shown. While meeting with Brian Cosgrove, the head of Nickelodeon spotted a picture of Count Duckula in the office and said "That's the one I want!" The character of Duckula was originally a villain on *Danger Mouse*, but for the new show they reworked him as a vegetarian and from that point on it just got sillier and much more fun.

Why Count Duckula Is No. 86

Along with Danger Mouse and Banana Man, Duckula was part of a British animation invasion of Nickelodeon in the late 1980s. The shows introduced children to British humor, wordplay, and satire. Count Duckula was notable for its darker tone featuring themes of the occult, and can loosely be classified as a horror fantasy cartoon. Count Duckula is also notable for its subtle innuendo such as the first episode's title "No Sax Please, We're British," a satirical nod to the British play "No Sex Please, We're British."

Duckula blazed a path on Nick for shows like SpongeBob SquarePants by helping build an audience that was a cross section of ages with humor for everyone, young and not so young.

—JW

87
ARTHUR

Creator: Marc Brown Studio: CINAR
Initial voice: Michael Yarmush
Book debut: 1976 (*Arthur's Nose*)
Series debut: 1996 (Episode: "Arthur's Eyes")
Species: Aardvark
Full name: Arthur Timothy Read
Hometown: Elwood City
School: Lakewood Elementary
Grade: Third
Father: David
Mother: Jane
Sisters: DW and Kate
Dog: Pal
Best friends: Buster Baxter, Francine Frensky
Defining role: *Arthur* (1996–present)
Traits: Smart, friendly, moralistic, thoughtful, loyal

All About the Aardvark

- PBS rejected opportunities to use animation in its children's programming until it successfully aired *Arthur*.

- The show is based on a series of books written by Marc Brown that extend two decades before the cartoon was launched.

- *Arthur* eventually became the second-longest-running program in the history of PBS behind *Sesame Street*.

- The friends and associates of Arthur represent many species of the animal kingdom. Buster is a rabbit, Francine and Muffy are orangutans, Alan "The Brain" is a bear, Binky is a bulldog, and George is a moose.

- *Arthur* is among the most honored cartoon shows ever. It won Daytime Emmy Awards for Outstanding Children's Animated Program in 1998, 1999, 2001, and 2007. It was nominated on eight other occasions.

- The character was created in book titles as an actual aardvark before eventually evolving into the human form later adopted for the animated series.

- Arthur is generally honest, but can be caught in a lie on occasion. Viewers could figure out when he was being untruthful because that is when he played with his glasses.

- Despite owning the title role, Arthur has not appeared in every episode. He has been left out of some of the 242 episodes that aired from 1996 to 2016.

- Among the dozens of celebrities who have lent their voices and characters to *Arthur* are singer Art Garfunkel, actor Matt Damon, cyclist Lance Armstrong, journalist Larry King, skater Michelle Kwan, and cellist Yo-Yo Ma.

- No aardvark has ever married an orangutan (it can be presumed), but scenes from the future show Arthur wed to Francine.

- Eight different voice actors have played Arthur since 1996. Only original voice Michael Yarmush voiced him for more than four seasons.

About Arthur

Aside, of course, from being an aardvark, Arthur is much like a typical eight-year-old kid, which makes him identifiable to young viewers. He is intelligent, but often displays little common sense. He loves his sister, DW, but she torments him, which results in a lack of patience. He plays the piano, but sometimes fails to practice. He is generally trustworthy, but not always honest.

Kids can also relate to Arthur because of his appearance. He most often looks like a bit of a nerd, complete with bow tie (on occasion) and glasses, yellow sweater, and blue pants.

Why Arthur Is No. 87

The simplicity of *Arthur* the show and Arthur himself provide an ideal format for kids seeking entertainment and parents yearning for them to learn lessons in life along the way. Children cannot learn if they don't watch—and both the show and the character are easy to watch. Though times had changed from his creation in book form in 1976 to his first series appearance two decades later, the basis of the character's appeal remained unchanged. Just as the Arthur books were assigned reading by teachers, the cartoon was shown in classrooms to educate and provide a moral compass for young students.

—MG

88
DR. KATZ

Creators: Jonathan Katz, Tom Snyder
Studios: HBO Downtown Productions, Popular Arts Entertainment, Tom Snyder Productions, Warner Bros. Television
Voice: Jonathan Katz
Debut: May 28, 1995
Starring TV role: *Dr. Katz* (1995–1999)
Son: Ben Katz
Secretary: Laura
Best friend: Stanley
Ex-wife: Roz
Profession: Psychotherapist

Dr. Katz's Top 10 Patients

1. Winona Ryder
2. Ray Romano
3. Louis C. K.
4. Dom Irrera
5. Patton Oswalt
6. Jon Stewart
7. Rodney Dangerfield
8. David Duchovny
9. Jeff Goldblum
10. Dave Chappelle

About Dr. Katz

One of the great secrets to a successful sitcom is to surround yourself with funny people. It was a style forged by the legendary Jack Benny and perfected by Jerry Seinfeld. Dr. Katz took that premise and put those funny people on a therapist's couch. Not just any funny people, the funniest people. Comedians like Joan Rivers, Dave Chappelle, Bobcat Goldthwait, and many more all took a turn sharing their secrets and comedic material with the animated Dr. Katz.

Dr. Katz had an unusual production method. Using rough script outlines, much of the dialogue and material was improvised. From that point it was animated in computer-generated "squiggle vision." The simple animation method used lines that were in a constant state of motion while the background was often in grayscale or monotone. The style of animation fit the show and its characters well.

Dr. Katz would begin most days at breakfast with his adult son Ben, who was perpetually unemployed due to an unfortunate lack of jobs in his chosen dream profession as a stuntman, something he had neither training nor aptitude for. Their relationship formed the basis for many episodes' plots. The plot segments were intercut with Dr. Katz's professional role as a psychotherapist to the stars, primarily comedians.

Katz's dry methodical delivery made him a perfect sparring partner to some of the world's great comics. The wild off the rails conversations and confessions would often take Dr. Katz off guard as he did his best to maintain composure. From David Chappelle discussing why Hulk was a bad role model to David Duchovny musing on the nature of reality, Dr. Katz provided a platform for great comic material and a look inside the comically warped minds of comedians and actors.

Why Dr. Katz Is No. 88

While an asset in sitcoms, the "straight man" isn't a popular role in animation, but Dr. Katz is the perfect straight man. He feeds his improvised lines perfectly and responds to the outrageousness around him with dry, impeccably timed humor. The slow pace, quiet delivery, and crude animation seem counter to everything that makes a great cartoon, and yet *Dr. Katz* makes our list because it embraces the core tenet of great cartoons: It's all about the relationships. Dr. Katz's relationship with his son and interactions with his patients make him one of the all time great characters.

—JW

89
DICK DASTARDLY AND MUTTLEY

TOON-UP FACTS

Creators: William Hanna and Joe Barbera
Studio: Hanna-Barbera
Dick Dastardly voice: Paul Winchell
Debut: 1968, *Wacky Races* (Episode; "See-Saw to Arkansas")
Race car: Mean Machine
Car number: oo
Targets: Penelope Pitstop, Peter Perfect, Yankee Doodle Pigeon
Catchphrases: "Drat and double drat!" . . . "Muttley, do something!"
Defining roles: *Wacky Races* (1968–1970); *Dastardly and Muttley in Their Flying Machines* (1969–1970)
Dick Dastardly traits: Evil, devious, foolish, angry, cowardly
Muttley traits: Apathetic, easily amused, careless

Dastardly and Dog Dealings

- Muttley spoke nary a word, but his famous snickers and mumbles were provided by noted voice actor Don Messick, who also worked such characters as Scooby-Doo, Papa Smurf, Boo-Boo Bear, and Bamm-Bamm Rubble.

- Every car driven in *Wacky Races* won at least one race except that of Dick Dastardly and Muttley. Young viewers would never have been allowed to believe that their cheating paid off.

- Dick Dastardly voice Paul Winchell was a famous ventriloquist who had his own children's TV show in the early 1950s in which he displayed his talents alongside dummies Jerry Mahoney and Knucklehead Smiff.

- *Wacky Races* narrator Dave Willock boasted a familiar voice to fans of loopy, surreal 1960s sitcom *Green Acres*. He played bit roles in nine of its episodes.

- Dick Dastardly and Muttley were described as "double-dealing do-badders" in the *Wacky Races* theme.

- The skullduggery of the duo often occurred despite the fact they were leading the other racers. They could have won often had they not stopped to wreak havoc on their competitors.

- Both shows in which Dick Dastardly and Muttley starred were inspired by movies of the era. *Wacky Races* was motivated by *The Great Race* and *Dastardly and Muttley in Their Flying Machines* by *Those Magnificent Men in Their Flying Machines*. Both films hit the theaters in 1965.

- The rhyming complaint of Dick Dastardly about his ineffective dog in the theme song for *Dastardly and Muttley in Their Flying Machines* was uttered as follows: "Muttley, you snickering, floppy-eared hound, when courage is needed, you're never around. Those medals you wear on your moth-eaten chest should be there for bungling, at which you are best."

- *Dastardly and Muttley in Their Flying Machines* is also known as *Stop That Pigeon!* That was, after all, their primary task.

- The use of the fiendish duo in *Dastardly and Muttley in Their Flying Machines* precluded their appearing in *The Perils of Penelope Pitstop*, as had been originally planned. Members of the Ant-Hill Mob, a gangster clan from *Wacky Races*, were prominent in the latter show.

About Dick Dastardly and Muttley

A sneaking, conniving villain was needed to spice up the cast of characters for the launching of *Wacky Races* in 1968. So Hanna-Barbera created Dick Dastardly and, for a bonus, gave him a canine partner in Muttley. The result was two of the rottenest meanies in the history of animation.

Dick Dastardly perfectly fit the part of an old-school scoundrel as one might have seen tying a woman to the railroad tracks in a silent film, complete with handlebar moustache, cheesy grin, and shifty eyes. He was evil from head to toe. One suspects he was born evil.

That was not the case with Muttley. Viewers get the impression that he was corrupted by his possessor. After all, he was ordered to perform all the terrible deeds to his fellow racers, as well as to the heroic pigeon in a World War I setting in *Dastardly and Muttley in Their Flying Machines*. Muttley, who viewers learned in "Dash to Delaware" (1968) was a combination bloodhound, pointer, and hunting dog, snickered when Dick Dastardly took a physical beating, even when it was his own fault. The dog seemed indifferent to the failures of his owner and even seemed to revel in his misery.

What was not a failure were the characters themselves. Their popularity landed them the new cartoon in which the dog also received a featured segment titled *Magnificent Muttley*. *Dastardly and Muttley in Their Flying Machines* featured the scheming twosome leading a squadron of nitwits, including jumpy Zilly and silly Klunk, whose mission it was to stop the courageous courier named Yankee Doodle Pigeon. Unfortunately for Dastardly and Muttley, they boasted no more success in those attempts than they did trying to cheat their way to victory in *Wacky Races*.

Muttley proved a bit more positively endearing in the *Magnificent Muttley* segments, as he dreamed of heroism in a wide array of endeavors that often took him back in history. He even imagined himself saving those tormented by Dastardly.

Only seventeen episodes of the show also known as *Stop That Pigeon!* were created over a two-year period. *Wacky Races* emerged with a stronger legacy. Dastardly and Muttley experienced a bit of a revival in 1978 as part of the ensemble cast in *Yogi's Treasure Hunt*.

Why Dick Dastardly and Muttley Are No. 89

The struggle between good and evil is often the heart of all entertainment. It is certainly true in animation. If not for Dastardly and Muttley, cartoon shows such as *Wacky Races* would have been without that conflict. And they had to be *good at evil*. Young viewers especially believed Dick Dastardly to be, well, dastardly.

The number of thoroughly and deliciously evil rogues in animated comedy geared for children is limited. But Dastardly and Muttley play it with great success while providing distinctly different personalities and motivations. It is no wonder that Hanna-Barbera sought to maximize their characters, albeit for a short time, by giving them their own cartoon following the success of *Wacky Races*.

—MG

90
SKELETOR

TOON-UP FACTS

Creator: Mattel
Studio: Filmation Associates
Voice: Alan Oppenheimer
Debut: September 5, 1983, *He-Man and the Masters of the Universe* (Episode: "The Diamond Ray of Disappearance")
Antagonist: He-Man
True identity: Keldor, of the House of Miro
Weapon of choice: Havoc Staff
Powers: Sorcery, telepathy, teleportation, hypnotism
Home: Snake Mountain
Pet: Panthor
Henchmen: Beastman, Blade, Clawful, Fangman, Merman, Whiplash

Skeletor Trivia

- In all 130 episodes He-Man never once uses his sword as a weapon against another character.

- According to Skeletor's backstory, his true identity is Keldor, brother to King Randor and uncle of Prince Adam/He-Man.

- In the comic book *DC Comics Presents #47*, Skeletor magically takes control of Superman in an effort to defeat He-Man.

- During the course of He-Man's initial run through the late 1980s, the franchise brought in over two billion dollars.

- The character of Orko was originally named Gorpo and initially had a letter "G" instead of an "O" on his chest. The name was changed because the letter O was easier to draw over and over in animation.

- An action figure named Stinkor was produced with special oil added to the plastic to give it a putrid smell. He-Man producer Lou Scheimer considered the concept of the character "too stupid" to add to the animated cast. He also insisted they change the name of one of the vehicles that was initially known as "The Ball Buster."

- He-Man is half human. His mother, Marlena, was a NASA astronaut who accidentally landed on the planet Eternia where she met Prince Adam's father, King Randor.

- *He-Man and the Masters of the Universe* was one of the first animated cartoons created specifically for weekday afternoons and not Saturday mornings.

- After the series ended in 1985, Skeletor continued to make appearances in the spinoff series, *She-Ra, Princess of Power*, which ran until 1987.

- The voice of Skeletor is very similar to the voice Alan Oppenheimer used for another classic villain, Ming the Merciless, in the animated *Buck Rogers* series.

About Skeletor

The evil nemesis of He-Man and scourge of Eternia, Skeletor is driven to obtain the secrets of Castle Grayskull and become the one and only "master of the universe."

Skeletor is a demon from the Infinita dimension. He lords over the dark side from his lair, Snake Mountain. His menacing skeleton face is enshrouded in a purple hood, and he holds his Havoc Staff in his evil clutches.

Once a student of black magic, he mentored under the warlord Hordak before betraying him and trapping him in an alternate dimension. Skeletor's backstory is pieced together through the animation, toy line, comics, and subsequent animated incarnations. Initially his origins were not regarded as important to his role as the primary nemesis to He-Man. He was designed with only one purpose—to represent evil.

Because *He-Man and the Masters of the Universe* was regarded as a show devised to market toys, the show had to appeal to young audiences. As a result, Skeletor's more threatening villainous aspects were toned down considerably as the series progressed.

Skeletor's sinister appearance and malicious intentions are in direct contrast to the often comical and slapstick situations he is forced into. It is this slightly bumbling quality that contributes to his unintentional charm, making him a comically sympathetic character.

Why Skeletor Is No. 90

In the Parthenon of animated infamy, few villains possess the menacing appearance of Skeletor. His bright yellow skull covered by a purple hood, his muscular blue physique, the ram skull staff, and the crossbones chest plate should be the stuff of nightmares. Despite his appearance, Skeletor is often laughable, even slightly likeable as he endures the incompetence of his minions. His constant berating of them as a bunch of blundering witless fools is the angry ranting of a capable boss in a workplace lording over an ineffectual staff.

As we look back through the lens of nostalgia, Skeletor becomes a more sympathetic and tragic character. In the context of our adult life experiences, his angry frustrations become not only understandable, but also, comical. Skeletor makes our list because we kind of feel sorry for the cranky blue beast and think it's about time he got a break!

—JW

91
SECRET SQUIRREL

TOON-UP FACTS

Creators: William Hanna, Joseph Barbera
Studio: Hanna-Barbera
Voice: Mel Blanc
Debut: 1965 (*The World of Atom Ant and Secret Squirrel*)
Profession: Spy
Employer: International Sneaky Service
Boss: Double-Q
Sidekick: Morocco Mole
Alias: Secret Agent 000
Antagonists: Yellow Pinkie, Hy-Spy
Love interest: Penny
Defining role: *The Secret Squirrel Show* (1965–1966)
Traits: Courageous, trustworthy, cool, careless, persistent, ingenious

Triple Zero Trivia

- The look of Morocco Mole has been compared to that of Signor Ferrari, a character played by Sydney Greenstreet in the movie classic *Casablanca*. Ferrari too wore a fez cap.

- Morocco Mole was voiced by giant-of-the-industry Paul Frees, whose most famous voice in classic cartoons was that of *Rocky and Bullwinkle* do-badder Boris Badenov. Frees gave Morocco a distinctive Peter Lorre flavor.

- Secret Squirrel was referred to as "SS" by his spy partner.

- The tan car driven by assistant/chauffeur Morocco Mole folded up neatly into an attache case after it reached its destination. But it accidentally unfolded and drove itself out of an elevator in "Yellow Pinkie" (1965).

- The most notable cartoon character to supplement *The Secret Squirrel Show* was Squiddly Diddly, a six-armed squid who made his home in a water tank at Bubbleland marine park and dreamed of bigger things.

- One might think that the creation of Secret Squirrel was inspired by hit TV sitcom *Get Smart*. But the loopy comedy starring Don Adams made its debut six days after a primetime special featured Secret Squirrel in the late summer of 1965.

- The first Secret Squirrel episode after the primetime launch was "Sub Swiper," which featured the rodent seeking to locate an atomic submarine that had disappeared.

- Unlike many popular Hanna-Barbera characters of the era, Secret Squirrel appeared just once in comic book form during that time. Gold Key placed him on the cover in October 1966 along with the headline, "The Secret Agent Who Out-Secrets Them All!"

- The theme music before Secret Squirrel episodes cites only some of the many secret weapons used by the main character. Among the weapons glorified in song are a bulletproof trench coat, cannon hat, and machine-gun cane.

- The array of tricky devices hidden behind the trench coat have been compared to those used two decades later in the cartoon world by Inspector Gadget.

- Yellow Pinkie was a clear takeoff on James Bond antagonist Auric Goldfinger.

About Secret Squirrel

The fascination with spies and international intrigue fueled by James Bond in the mid-1960s resulted in the creation of Secret Squirrel. The cool and daring rodent completed dangerous missions around the world.

Adorned in a white trench coat and purple hat pulled down so low that it required cutouts for his eyes, the buck-toothed, bushy-tailed squirrel utilized an array of secret devices hidden in his coat and hat to subdue antagonists such as Yellow Pinkie. Though his occasional carelessness was necessary to add a comedic touch, his general sharpness and intelligence differentiated him from most other Hanna-Barbera star characters, who often triumphed despite themselves.

Hanna-Barbera sought to make a splash when it debuted Secret Squirrel and Atom Ant in a one-hour primetime special in 1965. The one-hour format continued when the pair teamed up in *The Atom Ant/Secret Squirrel Show*, which was launched two weeks later. The show ran for three seasons. The two continued to share the same program until Secret Squirrel briefly owned his own top billing before reuniting with the powerhouse insect.

The popularity of Secret Squirrel landed him on merchandised items for kids such as lunchboxes. And that same popularity resulted in his inclusion as part of *Yogi's Gang* and several other Hanna-Barbera shows that sought to keep their characters alive in the 1970s. His revival continued when he returned to star in back segments of *2 Stupid Dogs* in 1993 in *Super Secret Secret Squirrel*. His signature look remained virtually unaltered, though added was a love interest in an adoring female squirrel named Penny.

Why Secret Squirrel Is No. 91

A squirrel super spy? That alone makes him unique. But it was his calm demeanor and the hidden gadgets in his hat and coat that he coolly used to escape danger that made Secret Squirrel particularly notable. So did the voice of Mel Blanc, which added to his distinctive personality.

His cartoons were simply fun for kids of that era who had become greatly fascinated by spies such as James Bond and, in a much lighter way, Maxwell Smart. Secret Squirrel had a bit of both in his character. It is for those reasons that Secret Squirrel emerged with a more memorable legacy than his teammate, Atom Ant.

—MG

92
TOP CAT

Creators: William Hanna and Joe Barbera
Studio: Hanna-Barbera
Voice: Arnold Stang
Debut: 1961, *Top Cat* (Episode: "Hawaii Here We Come")
Nickname: T.C.
Best buddy: Benny the Ball
Other gang members: Choo-Choo, Brain, Fancy-Fancy, Spook
Antagonist: Officer Charlie Dibble
Hometown: New York City
Hangout: Hoagy's Alley
Defining role: *Top Cat* (1961–1962)
Traits: Scheming, droll, influential, proud, charismatic, gregarious

Feline Facts

- Bill Hanna co-wrote the theme music for *Top Cat*.

- Arnold Stang was known more for his live comedic acting roles in radio and television than his voice work. He worked with legendary Milton Berle on his variety program in the 1950s.

- Despite the title of the first episode, the gang did not reach the shores of Hawaii until the end. They spent the beginning of the show in the alley and the rest aboard ship en route to the land that had just become a state.

- The success of *The Flintstones* motivated Hanna-Barbera to create *Top Cat* as the studio's second primetime cartoon show.

- Top Cat lived in a luxurious trash can—at least as luxurious as a trash can might be.

- The show was a parody of *You'll Never Get Rich*, a late-1950s sitcom that also became known as *Sergeant Bilko* and *The Phil Silvers Show*. *Top Cat* hit the air two years after its cancellation. The main character sounded quite a bit like the legendary Silvers.

- The alley in which T.C. and his buddies make their home is adjacent to Madison Avenue in Manhattan.

- Hanna-Barbera had displayed a penchant for creating cartoon shows based on live programs of the 1950s. *The Flintstones* was based greatly on *The Honeymooners*.

- Hoagy's Alley was a not-very-subtle reference to Hogan's Alley, a prominent early-twentieth-century cartoon shown in newspapers owned by Joseph Pulitzer and William Randolph Hearst.

- The name of the cartoon was changed to *Boss Cat* in Britain because Top Cat was the brand of a cat food there.

- Benny the Ball provided another Phil Silvers connection. He was voiced by Maurice Gosfield, who played Doberman in *You'll Never Get Rich*.

About Top Cat

The idea of creating another animated lead character and show that could appeal to both kids and adults in primetime motivated Joe Barbera to draw Top Cat. That and a short description he worked on with Bill Hanna were all they needed to convince the network that they had their feline. Unlike *The Flintstones*, the new show would need no change in time period to gain popularity.

Top Cat is the leader of a scheming, but friendly New York gang. He is distinctive among his motley group of friends with his yellow fur, purple vest, and matching hat with holes on the sides that allow his ears to poke through. His best buddy is chubby and bluish-violet Benny the Ball, but he is friends with the other members of the gang, all of whom provide him great respect.

Officer Dibble is not only an adversary, though his name is purposely and often mispronounced by Top Cat as "Dribble" or "Dabble" or "Drubble." Though the no-frills Dibble becomes angry when Top Cat uses the alley phone, which is connected to a telephone pole next to the feline's trash can home, and must stay on his toes when the gang sets in motion one of its many half-baked money-making ventures, he also utilizes their streetwise skills to catch crooks.

Top Cat is sharp, instinctive, and quick-witted. He is a natural-born leader. He utilizes his ability to socialize and influence others to thrive. He knows all the small-time crooks in the neighborhood. Top Cat too is a petty thief, but one with a conscience. He is willing to work not only against, but also with Dibble, who appreciates the cooperation. It is no wonder that the generally joyless cop has a soft spot in his heart for his favorite feline.

Only thirty episodes of *Top Cat* were produced in its one-season run, but the show became a staple in syndication throughout the 1960s. A lack of sequels prevented him from gaining a strong following in future generations.

Why Top Cat Is No. 92

Top Cat boasts one of the strongest and most distinctive personalities animated or otherwise on the small screen. His natural leadership ability made him the undisputed top cat of his gang. It is that personality that results in a long-lasting legacy despite the relatively small number of episodes in which he starred.

—MG

93
TINA BELCHER

TOON-UP FACTS

Creator: Loren Bouchard
Studio: 20th Century Fox Television
Voice: Dan Mintz
Debut: January 9, 2011, *Bob's Burgers* (Episode: "Human Flesh")
Full name: Tina Ruth Belcher
Age: 12–13
Parents: Bob and Linda Belcher
Siblings: Gene Belcher, Louise Belcher
Love interest: Jimmy Pesto Jr.
Place of employment: Bob's Burgers
Interests/Hobbies: Horses, rainbows, zombies, movies, writing erotic fiction, butts
School: Wagstaff School
Catchphrase: "Ughhhhhhh."
Personality traits: Socially awkward, overtly sexual, confident, intelligent, reasonable

Tina Trivia

- She didn't become the eldest child until the first episode; in the pilot Daniel was oldest.

- In the early days of production Tina was a boy named Daniel. They decided to change the gender of the character and name but kept the same voice.

- Tina's shoe size is 8.5.

- Several of the cast members of *Bob's Burgers* also voice characters on the animated series *Archer*. Several of the *Bob's Burgers* characters appeared in the *Archer* episode "Fugue and Riffs."

- Initially the series was pitched as a story about a family of cannibals who owned a burger restaurant. While that concept was dropped, in the pilot episode Louise spreads a rumor that the family's burgers were made of human flesh.

- Kristen Schall, who voices Louise Belcher, is the only female cast member to voice a female member of the family. The rest of the main female family members are voiced by men.

- While most animated series record each of the actor's lines separately, the cast of *Bob's Burgers* acts out their scenes as an ensemble cast.
- In 2015 The Vandal, a restaurant in Pittsburgh, Pennsylvania, "dressed up" as Bob's Burgers for Halloween complete with a "re-re-re-opening" sign.
- Bob's two daughters, Tina and Louise, are named for the actress Tina Louise, who played Ginger Grant on *Gilligan's Island.*
- Tina is left-handed, a trait she shares with popular cartoon characters such as Bart Simpson (*The Simpsons*), Chuckie (*Rugrats*), and Chris Griffin (*Family Guy*)

About Tina Belcher

As the oldest of the Belcher children, Tina is perennially in the hyper-sexualized limbo between childhood and adolescence. Trapped in this perpetual state, she harbors a love of rainbows and ponies while teenage fantasies of zombies making out beckon her. Her most defining trait is her burgeoning sexuality.

While she seems comfortable within her own skin, her lack of social skills leads her to say and do things that create awkward moments, such as the Episode 17 incident in which she suggest a polyamorous relationship to her two prospective suitors, losing both of them in the process.

She is a wildly creative young woman who writes freaky erotic "friend fiction," and her diary is filled with confessions of touching other's butts, the height of her sexual experience thus far.

Tina's main love interest is Jimmy Pesto Jr. According to her estimate she has logged over 125 fantasy days with him and "You don't just throw that away!" As a hopeless romantic she has been attracted to many boys and men, including an entire baseball team, prompting her to wonder if it was possible to be in love with twenty-five people at once.

Why Tina Belcher Is No. 93

It seems odd that a character voiced by a male actor would become a strong female role model. However Tina has become just that. Media is saturated with oversexed boys and men, while girls are often portrayed as mere objects of affection with little sexual desire of their own. Tina's embracing of her sexuality struck a chord with audiences. Her filterless expressions of her desires and confidence stand as a testament to her strength and empowerment.

She proudly tells the world she is "a smart, strong, sensual woman." She brings out that same confidence in others as when she tells her father, "If you believe you're beautiful, you will be. I did." Despite her obsession with boys, she has made clear she doesn't need anyone to boost her confidence—"I don't need a boy to pay attention to me, I'll pay attention to myself." Even with all that confidence, she manages to remain grounded, reminding her little sister: "I'm no hero. I put my bra on one boob at a time, just like everyone else."

—JW

94

JAZZ

TOON-UP FACTS

Creators: Hasbro, Takara Tomy, Bob Budiansky
Studio: Sunbow Productions, Marvel Productions, Toei Animation, Akom Productions
Voice: Scatman Crothers (1984–1987), Phil Lamarr (2007–2009)
Debut: September 1984, *Transformers* (Episode: "More Than Meets the Eye")
Antagonists: Decepticons
Group: Autobots
Earth vehicle mode: Porsche 935 Turbo
Accessories: Grapple hand, 180 DB speakers, missile launcher, flamethrower
Superior: Optimus Prime
Position: First lieutenant, head of Special Operations
Motto: "Do it with style, or don't bother doing it."
Defining Role: *Transformers* (1984–1987)
Traits: Calm, cool, courageous, hip, musically inclined

Jazz Facts

- Because the recording studio was so small, the cast would wait turns to record their dialogue. Scatman Crothers would always arrive with guitar in hand to keep his fellow cast entertained in the lobby.

- Autobot Doctor Ratchet is named after Nurse Ratchet from the film *One Flew Over the Cuckoo's Nest*, in which Scatman Crothers played Mr. Turkle the night orderly.

- *The Transformers* movie was Scatman Crothers's final role.

- Jazz made a cameo appearance in Season 7, Episode 4 of the show *30 Rock* as part of a Mitt Romney propaganda video aimed toward black voters.

- The series was designed to promote Hasbro's line of toys. *The Transformers* feature film took it a step further by killing off characters whose toys had been discontinued!

- Jazz was inducted to the Transformers Hall of Fame in 2012. The induction took place at BotCon in Dallas, Texas.

- In the original tech notes and early scripts, Jazz had an extra Z in his name and was listed as Jazzz.

- The Transformers originated as two different toy lines: Diaclone and Microman. When Hasbro acquired the production rights, they merged them into opposing sides of the same robot race.
- Original in box Jazz action figures have sold at auctions for up to eight hundred dollars.
- The voice director Wally Burr would often fill in for actors that were unavailable. He filled in for Scatman on the "Kreemzeek" episode of *Transformers*.

About Jazz

Jazz is one of the primary members of the Autobots and is the second in command to Optimus Prime. The wisecracking, slang-talking Autobot's earth automotive form is a Martini Porsche 935 Turbo with impressive 180-decibel speakers, which he uses to play a wide selection of Earth music. He easily assimilates into Earth culture and has a great appreciation for the music and arts.

Like the other characters his humor and dialogue can be prone to bad puns and attempts at contemporary "hip phrases." However, thanks to the smooth delivery of voiceover artist Scatman Crothers, he manages to pull off much of the slang without it seeming forced.

The character would continue to be voiced by Scatman in the 1986 feature film *Transformers: The Movie.* It would be his final role before his passing later that year. The series ran for another year after his death. Rather than attempting to find a replacement for Crothers, the producers decided Jazz would no longer have a speaking role. Recent live-action film and animation have reintroduced the character using African-American voiceover artists who have attempted to keep the tone established by Crothers. But there is only one Scatman.

Why Jazz Is No. 94

Jazz just makes it all look so easy. He takes the toughest missions on for himself because he knows he can remain cool in even the tensest situations.

Much like the music that is his namesake, Jazz is cool, easy, and does everything with style and class. It is his effortless cool that makes him the most human and likeable of all Transformers.

Ultimately much of the credit belongs to his voice. Scatman Crothers's unmistakable raspy yet smooth stylings come through in every single syllable he says. Whatever he does . . . he does with style.

—JW

95
JOSIE AND THE PUSSYCATS

Creators: Dan DeCarlo and Richard Goldwater
Studio: Hanna-Barbera
Josie voice: Janet Waldo
Valerie voice: Barbara Pariot
Melody voice: Jackie Joseph
Full names: Josie McCoy, Valerie Brown, Melody Valentine
Josie instrument: Guitar
Valerie instrument: Tambourine
Melody instrument: Drums
Manager: Alexander Cabot III
Antagonist: Alexandra Cabot
Comic book debut: 1963 (*She's Josie*)
Series debut: 1970 ("The Nemo's a No-No Affair")
Defining role: *Josie and the Pussycats* (1970–1971)
Josie traits: Calm, pleasant, steady
Valerie traits: Intelligent, mechanical, impulsive
Melody traits: Stupid, immature, ditzy, hopeful

Pussycat Points

- Valerie was an important figure in the history of animation as a leading African-American cartoon character. She was the first African-American female character to appear on a Saturday morning series.

- The singing voice of Melody belonged to none other than future star model and actor Cheryl Ladd, who was billed at the time under the name of Cherie Moot.

- Co-creator Dan DeCarlo named Josie after his wife. She has stated that the idea for the theme of the band popped up after she had worn a cat costume during a Caribbean cruise.

- The Pussycats and their entourage experienced a myriad of adventures, which gave the series a similar feel to that of *Scooby-Doo, Where Are You!* The dog and his gang, however, encountered ghosts, monsters, and other alien horrors, whereas the mysteries met by the Pussycats were not so otherworldly in their first series.

- There were actually four pussycats on the show. An animated feline named Sebastian was a pet of the scheming Alexandra.

- The popularity of previous live-action and fast-moving movies and shows in the 1960s featuring superstar acts such as The Beatles and The Monkees gave Hanna-Barbera a bit of a blueprint for the series.

- Legendary disc jockey Casey Kasem voiced manager Alexander Cabot III. Kasem was a prolific voice actor well into the 2000s. Among his characters was Batman sidekick Robin and Shaggy of Scooby-Doo fame.

- Though the Archie Comics franchise gave birth to both *The Archies* and *Josie and the Pussycats*, the former was animated by Filmation and the latter picked up as competition by Hanna-Barbera. The Archies voiced smash bubblegum hit "Sugar, Sugar" in 1969.

- Josie voice Janet Waldo also provided the voice for *Wacky Races* standout Penelope Pitstop, whose popularity landed her a follow-up series titled *The Perils of Penelope Pitstop*.

- Among those who played a role in the development of *Josie and the Pussycats* was Fred Silverman, who toiled as head of children's programming for CBS at the time. Silverman went on to help bring television into a new generation by placing on the air socially and politically groundbreaking sitcoms such as *All in the Family*, *M*A*S*H*, and *The Mary Tyler Moore Show*.

- An attempt to duplicate the success of *Scooby-Doo, Where Are You!* motivated Hanna-Barbera to use some of the same voice actors on *Josie and the Pussycats*. Among them was the quite accomplished Don Messick, who voiced both Scooby on the former and Sebastian the Cat on the latter.

About Josie and the Pussycats

What began as an attempt to lure girls into the comic book market resulted in a rock-and-roll generation cartoon show that attracted a heavy female television audience. *Josie and the Pussycats* combined the unquenchable thirst for rock band themes and a growing pride in the potential of young women into a short-lived series that created a long-lasting impression.

The seeds were planted by Archie Comics, but it was Hanna-Barbera that brought *Josie and the Pussycats* to animated life. The three members of the band boasted distinct and unique looks and personalities. Josie was its red-headed lead guitarist and vocalist. She kept her cool head when bedlam reigned. Valerie was its African-American tambourine player, main songwriter, and backup vocalist. She was the smartest of the bunch and a scientific whiz. Melody was a drummer and stereotypical dumb blonde whose sexiness was used in episode plots. The Pussycats all wore leopard print leotards, long tails, and ears for hats.

The plot twists were certainly not varied. Each show featured them in a foreign location such as the Amazon rain forest, Holland, London, Paris, or Peru, where they were to perform or record. Thanks most often to Alexandra, they would wind up involved in a dangerous adventure battling a spy or mad scientist or high-tech madman seeking to rule the world. Their brainpower (OK, not Melody's) and courage would allow them to extricate themselves from the jam and bring the villain to justice, but not before a comic chase scene underscored by one of their songs.

The original series ran just from September to January, but reruns of *Josie and the Pussycats* remained on Saturday mornings into 1972. The girls then went out of this world in *Josie and the Pussycats in Outer Space* (1972–1974). Their legacy led to a children's book published in 1976 and brought them to younger generations on USA Network, Cartoon Network, and Boomerang. A *Josie and the Pussycats* live-action film hit the big screen in 2001.

Why Josie and the Pussycats Are No. 95

Individually, the three band members were nothing special. But together they were dynamite. Their disparate personalities meshed to create a trio whose legacy far outlasted the original run of either cartoon series that ran on Saturday mornings in the early 1970s.

As with *The Archies*, never mind the music—neither group will ever be considered for induction into the Rock and Roll Hall of Fame. *Josie and the Pussycats* was not about the songs. It was about expanding the efforts in the world of animation to include young women and African Americans. It was about showing young viewers the value of friendship and teamwork. It's no wonder that nearly sixty years after their creation, many teenagers still know all about *Josie and the Pussycats*.

—MG

96
SNIDELY WHIPLASH

TOON-UP FACTS

Creators: Alex Anderson, Jay Ward, Bill Scott
Studios: Television Arts Productions, Jay Ward Productions
Voice: Hans Conried
Debut: 1961, *Dudley Do-Right of the Mounties* (Episode: "The Disloyal Canadians")
Catchphrase: "Curses, foiled again!"
Love interest: Nell Fenwick
Antagonist: Dudley Do-Right
Pastime: Tying women to railroad tracks
Defining role: *Dudley Do-Right of the Mounties* (1961–1964)
Snidely traits: Melodramatic, villainous, careless, weak-willed, obsessive

Stuff about Snidely

- Among the many live roles handled by Snidely voice Hans Conried was the uncle of Danny Williams (played by Danny Thomas) in long-running 1950s and 1960s sitcom *Make Room for Daddy*.

- Snidely was so addicted to tying women to railroad tracks that he was seen doing just that in the wordless *Dudley Do-Right of the Mounties* theme.

- Though unrelated in the animation family tree, Hanna-Barbera creation Dick Dastardly has much in common physically with Snidely. They both boast a rather thin handlebar moustache, long black sideburns, and protruding chin.

- In a segment titled "The Locket," it was revealed that Dudley Do-Right had been trying in vain to bring Snidely to justice for twenty-three years.

- The look and personality of Snidely have had a long reach in the entertainment world. Among those referred to as Snidely by fellow characters has been ruthless Victor Newman, a veteran character in *The Young and the Restless*.

- The action stopped briefly in *Dudley Do-Right of the Mounties* segments to provide the viewer the name of a fictional actor supposedly playing the role of the fictional character. Arguably the cleverest given to Snidely were Hickey Pimpleton, Madison A. Swill, and Cranston Belch the Third.

- Snidely employed an occasional henchman named Homer, who lacked the villainous traits of his boss.
- British actor Alfred Molina played many serious roles in his career, but departed from that pursuit to play a real-life Snidely Whiplash in the film *Dudley Do-Right* (1999).
- Snidely cannot always follow through with his dastardly deeds. In the segment titled "Niagara Falls," he ties Dudley Do-Right to a railroad track, but diverts the train as it speeds toward him, thereby saving the life of the Mountie. Snidely then sulks off to lament what he perceives as his depressing goodness.

About Snidely Whiplash

Snidely Whiplash was the ultimate hackneyed scoundrel. And that was a good thing. He was formulaic to the point of absurdity—and the *Dudley Do-Right of the Mounties* cartoons that appeared on Rocky and Bullwinkle shows were indeed intended to be an absurd, farcical poke at the melodramatic films of yesteryear, old western saloon piano music and all.

The pigeon-holing of Snidely was evident in his appearance—the black coat and top hat, the long handlebar moustache, the ever-present leering grin, and the upturned eyebrows. It was evident in his mannerisms and voice—the threatening poses, the villainous chuckle. It was evident in his actions—particularly the laughably stereotypical pastime of tying women to railroad tracks or on a collision course for a circular saw at the sawmill.

But Snidely boasted a bit more depth to his character than the banal Dudley Do-Right. Snidely was sometimes torn by his inner demons, though generally lacking any idea what to do about it. He on occasion would break down and claim that he did not want to tie women to railroad tracks anymore, but admitted that he was incapable of change, as if controlled by the writers themselves and their desire to keep him in his place. He even confessed in one episode that he was wasting his time battling Dudley because he understood how the story would ultimately end. The same could not be said about his clueless adversary.

The character and his antagonists are parodies of those featured in hackneyed Canadian melodramas produced in Hollywood decades earlier. The cartoon itself satirizes films like *Rose Marie*, which was set in the Canadian wilderness and featured Nelson Eddy as a Mountie. Snidely Whiplash was certainly an exaggerated character in comparison to the antagonists of those melodramas, but that is exactly what the creators of the cartoon had in mind.

Why Snidely Whiplash Is No. 96

First things first. His name is Snidely Whiplash. If that's not the greatest villain name in cartoon history, it's certainly in the discussion.

Most evil characters whose look and personality are exaggerated are created absurd with no purpose beyond the need for an anti-hero. The look and personality of Snidely are exaggerated in an effort to satirize stereotypical villains. And he carries it off perfectly in every way, from his appearance to his voice to his actions. That he is somewhat one-dimensional aside from occasional decency is not a negative in regard to his legacy. He is *supposed* to be a simplistic evil character just as Dudley is supposed to be a simplistic hero.

Snidely is not a character viewers love to hate, especially the adults who ate up the more sophisticated humor of all Jay Ward creations. He is so ridiculous and unthreatening even to young viewers that he cannot be taken seriously as a villain. And that's great, because he's not supposed to be.

—MG

97
DANGER MOUSE

TOON-UP FACTS

Creators: Brian Cosgrove, Mark Hall
Studio: Cosgrove Hall Films
Voice: David Jason
Debut: September 28, 1981, *Danger Mouse* (Episode: "Rouge Robots")
Profession: Secret agent
Assistant: Penfold
Catchphrase: "Shush"
Antagonists: Baron Silas Greenback, Count Duckula
Vehicle: The Mark III (car), Space Hopper (rocket)
Defining role: *Danger Mouse* (1981–1992)
Traits: Brave, agile, intelligent, courageous

Dangerous Trivia

- Danger Mouse was based on Patrick McGoohan's character in the British TV show *Danger Man* that was syndicated in the United States as *Secret Agent*.

- In 1984 *Danger Mouse* became the first British cartoon to air on Nickelodeon in the United States.

- Danger Mouse's secret codename was so secret even his codename had a codename.

- Musician, songwriter, and producer Brian Joseph Burton, who produced the album *Demon Days* for the fictional cartoon group Gorillaz, later adopted the name Danger Mouse.

- When *Danger Mouse* aired in the United States, the accents of the Italian villains were changed to British cockney so as not to offend Italian Americans.

- Danger Mouse knows thirty-four different languages.

- Danger Mouse wears a patch over his left eye, though it is never revealed why.

- Danger Mouse's secret hideout was located just outside 221B Baker Street in London, the same address that was home to Sherlock Holmes.

- The villainous Baron Silas Greenback is modeled after James Bond nemesis Ernst Stavro Blofeld.
- Speeding up the voice of David Jason speaking gibberish created the voice of Greenback's pet caterpillar.

About Danger Mouse

Danger Mouse is a rodent James Bond. His quick Brit wit, novel gadgetry, and comical combat skills made him popular with over twenty million viewers in Great Britain at his height. In 1984 *Danger Mouse* became one of the first British cartoons to syndicate to America when it began appearing on Nickelodeon.

From his secret lair in a London post box, Danger Mouse and his trusty sidekick Penfold answer the call of his superior Colonel K. to keep the world safe from a menagerie of Bondesque villains.

Danger Mouse's often pun-filled rapid-fire dialogue was strongly written, especially for a children's show, and was underlined with British comic sensibilities.

Danger Mouse's adventures would send him around the world to exotic locales in an informed and satirical spoof of live-action spy films and television shows. As his theme song says, "He's the greatest, he's fantastic, wherever there is danger he'll be there."

Why Danger Mouse Is No. 97

Danger Mouse led the way for the animated British invasion. He introduced British highbrow humor to American audiences via his syndicated debut on Nickelodeon. In an era when children's shows tended to talk down to their young audience, Danger Mouse let the gags fly, often going over the children's heads but elevating their taste enough to land a few. *Danger Mouse* ran for over a decade in dozens of countries, a testament to the character's enduring legacy and Britain's contribution to our cartoon Parthenon.

—JW

98
SNAGGLEPUSS

TOON-UP FACTS

Creators: William Hanna, Joseph Barbera
Studio: Hanna-Barbera
Voice: Daws Butler
Debut: 1959, *The Quick Draw McGraw Show* (Episode: "Lamb Chopped")
Home: Cavern
Antagonist: Big game hunter Major Minor
Catchphrases: "Heavens to Murgatroyd!" . . . "Exit, stage left" (or right)
Defining role: *The Quick Draw McGraw Show* (1959–1962)
Traits: Friendly, resourceful, self-centered, peaceful, intelligent, alert

All Facts—No Lyin'

- Butler created his voice to be similar to that of Bert Lahr as the Cowardly Lion in *The Wizard of Oz* (1939). The "Heavens to Murgatroyd" line often emphasized by Snagglepuss was also uttered by Lahr in the film *Meet the People* (1944).

- Major Minor belonged to The Adventure Club, which threatened to throw him out if he did not bag Snagglepuss.

- The Butler voice sounded so much like Lahr that when he voiced a commercial for Kellogg's as Snagglepuss, the actor sued. Butler was given a credit during the ad so nobody was given the impression that Lahr was speaking.

- Like other Hanna-Barbera characters, the image of Snagglepuss was placed on a Kellogg's cereal box in the 1960s. He graced the front of a Cocoa Krispies box.

- Snagglepuss was featured in Gold Key comics four times in 1962 and 1963, but never became one of its most popular Hanna-Barbera characters.

- Was an orange mountain lion referred to as Snagglepuss in his earliest appearance in the *Quick Draw McGraw* cartoons, but a brown zoo feline named Ol' Snaggletooth in the *Augie Doggie and Doggie Daddy* episode titled "The Party Lion" (1962)? His familiar voice was far more evident in the latter. Snaggletooth was in later cartoons referred to as Snagglepuss's brother.

- Snagglepuss was a rare Hanna-Barbera character with no sidekick and no consistent friendships.

- Plays the judge, prosecuting attorney, and every witness against bank robber Fowler Means in a unique episode titled "Legal Eagle Lion" (1961). Among his characters was Wild Bill Hickory Stick.

- Snagglepuss was "outed" in a Weekend Update segment of *Saturday Night Live* that focused on gay marriage in 2008. The segment features Bobby Moynihan in a Snagglepuss costume. Snagglepuss admits that his domestic partner is outer space alien The Great Gazoo of *Flintstones* fame.

- Major Minor was voiced by Don Messick, who also served as the voice of Ricochet Rabbit, Boo-Boo Bear, Scooby-Doo, and Atom Ant.

- Two references to Snagglepuss in episodes of *The Simpsons* occurred two weeks apart in 1994.

About Snagglepuss

The loopy lion experienced a couple of slight alterations before establishing himself as the colorful and iconic character with whom we became familiar. He was orange sans clothing of any kind in *Quick Draw McGraw* episodes. He was brown and still unadorned in shorts featuring Augie Doggie and Doggie Daddy.

It was not until he starred in his own segments of *The Yogi Bear Show* that Snagglepuss boasted his signature pink look with a black string tie, as well as white flipped-up collar and cuffs. Both his appearance and speech gave him a civilized, even sophisticated, air.

His personality was unlike that of many Hanna-Barbera stars that stupidly bumbled their way to victorious conclusions. Snagglepuss was victimized as often as they were, but through little fault of his own. His awareness of impending danger and quick thinking allowed him to escape jams with a cursory "Exit, stage right" and survive perilous situations. His survival instincts were certainly more keen than those of most of his animated contemporaries.

Snagglepuss was sometimes mistaken for the fierce feline he could never be, especially by hunter Major Minor, the only significant recurring character in the thirty-two episodes that graced *The Yogi Bear Show* in which the lion starred. The overtly theatrical Snagglepuss was simply too unaggressive (pacifistic, *even* . . .) to pose a threat, though he was certainly more antagonistic in his first appearances as side characters.

Snagglepuss was shown only in reruns after *The Yogi Bear Show* left the air. But he continued to be featured for new generations to enjoy in such outlets as *Yogi's Gang* (1973), *Scooby's All-Star Laff-A-Lympics* (1978), and *Yogi's Treasure Hunt* (1985).

Why Snagglepuss Is No. 98

While most Hanna-Barbera main characters were slow-witted, Snagglepuss was intelligent. While most Hanna-Barbera main characters were unrefined, Snagglepuss was rather cultivated. While most Hanna-Barbera characters claimed bravery, Snagglepuss embraced his cowardice with quick exits, stage right or left.

The inimitability of his personality, mannerisms, and speech allowed Snagglepuss to emerge as one of the most popular characters ever created by Hanna-Barbera. Most influential to his legacy was his oft-spoken expression, "Heavens to Murgatroyd," which simply sounded funny.

All the world was a stage for Snagglepuss, even when he was not referring to the stage before his hasty departures. His theatrical air permeated every performance. It is his uniqueness of character, as well as the humor he provided millions, that earns him this spot.

—MG

99
DARKWING DUCK

Creators: Tad Stones
Studio: Walt Disney Television Animation
Voices: James Jonah, Jim Cummings
Debut: March 31, 1991, *Darkwing Duck* Sneak Preview
Secret identity: Drake Mallard
Sidekick: Launchpad McQuack
Daughter: Gosalyn Waddlemeyer
Hometown: St. Canard
Weapon of choice: Gas gun
Transportation: Thunderquack (plane), Ratcatcher (motorcycle)
Antagonists: Megavolt, Bushroot, Quakerjack, Negaduck
Love interest: Morgana MacCawber
Defining Role: *Darkwing Duck* (1991–1992)
Catchphrase: "Let's get dangerous"
Traits: Egotistical, helpful, brave, daring

Darkwing's 10 Best Entrances

"I am the terror that flaps in the night! I am—
- the batteries that are not included."
- a special news bulletin that interrupts your favorite show."
- the fingernail that scrapes the blackboard of your soul."
- the surprise in your cereal box."
- the hairball that clogs your sink."
- the low ratings that cancel your program."
- the auditor that wants to look at your books."
- obviously out of my trademark blue smoke!"

- the bubblegum that sticks in your hair."
- the ten dollar service charge on all returned checks."

—I am Darkwing Duck!"

About Darkwing Duck

He is the terror that flaps in the night! Darkwing Duck is a superhero/spy/adventure satire that pays tongue-in-beak tribute to the golden age of heroes. He's a duck with dash of Batman, a pinch of The Shadow, and a dose of Double "o" 7. Originally intended as a spinoff of *DuckTales*, the show took on a life of its own.

Generally spinoffs give supporting characters a chance to take on a lead role. *Darkwing Duck* was unusual in that it spun off the character Launchpad McQuack from *DuckTales* to act as the sidekick to the titular superhero. Where *DuckTales* focused on adventure, *Darkwing Duck* was all action!

By day Drake Mallard (a satirical nod to The Shadow's alter ego Kent Allard) is an ordinary everyday resident of St. Canard, but by night he dons his mask, cape, and fedora to become the "Masked Mallard" known as Darkwing Duck.

In the first episode "Darkly Dawns the Duck," Drake Mallard is established as a character in conflict. His arrogance and egocentric desire for fame are a direct contrast to his natural courageous generosity and altruism.

It is through the admiration of his sidekick (and number one fan) Launchpad McQuack and adopted daughter Gosalyn that he is slowly grounded in doing good for its own sake, though he never quite shakes his pursuit of fame.

Darkwing has multiple origin stories, and it is unclear which one is the "true origin." In *The Secret Origins of Darkwing Duck*, his origin has several satirical parallels to Superman, having been sent by rocket to Earth upon the destruction of his home planet "Ziptor." That origin tale however seems to be the result of Drake's own ego-laden fabrication. Other more earthly bound origin tales occur in the episodes "Paraducks" and "Crash Reunion."

Why Darkwing Duck Is No. 99

Long before the house of mouse purchased the Marvel universe, *Darkwing Duck* was Disney's first true animated foray into the full-time superhero genre. He pulled the best elements from multiple hero genres to become a unique kind of superhero with a nod to noir.

Darkwing was a duck that wasn't afraid to get his feathers dirty with a little rough stuff when needed. The darker tone, while still light and humorous, led the way for Disney's *Gargoyles* as Disney transitioned into older afterschool audiences. Darkwing Duck stands out in the Disney Duckaverse as its greatest superhero.

—JW

100
HECKLE AND JECKLE

TOON-UP FACTS

Creator: Paul Terry
Studio: Terrytoons
Voices: Sid Raymond, Ned Sparks, Roy Halee, Dayton Allen, Frank Welker
Debut: 1946 (*The Talking Magpies*)
Catchphrase: "I say ol' chum!"
Targets for abuse: Dogs Dimwit and Clancy, Farmer Alfalfa
Defining role: Theatrical shorts
Top TV venue: *The Heckle and Jeckle Cartoon Show* (1956–1971)
Traits: Unflappable, mischievous, antagonistic, fun-loving, droll

Magpie Minutiae

- Though twins, it can be presumed that Heckle and Jeckle are not brothers. One boasts a British accent while the other speaks like he's from the New York borough of Brooklyn.

- Though they are physically indistinguishable, Jeckle is believed to be the British magpie and Heckle the one from New York. That, however, has never been confirmed by either one.

- The creation of the pair by Terrytoons came on the heels of its success with Mighty Mouse. But Heckle and Jeckle proved far more edgy than their predecessor, as well as other more pleasant and bland studio standouts such as Gandy Goose.

- The most creative voice of *Heckle and Jeckle* came from Dayton Allen, who injected impressions of such stars of the time as Groucho Marx and Humphrey Bogart into their shorts.

- Their debut in *The Talking Magpies* featured them as husband and wife. The magpie with the New York accent is the former. He wears a hat and carries a suitcase. The other is referred to as "Maggie" and she carries a purse. That arrangement, however, was quickly discarded. A makeover for the second short *The Uninvited Pests* featured the pair as male twins.

- It was not until the fifth short, titled *Cat Trouble* (1947), that one of the magpies was voiced with a British accent.

- Magpies are not fictional birds. They are part of the Crow and Jay family. Heckle and Jeckle are specifically yellow-billed magpies, which according to ornithologists are limited to areas

of California. That makes the choice of British and Brooklyn accents rather interesting—theirs must have been quite long migrations.

- A slang definition of a magpie is someone who yacks ceaselessly. Heckle and Jeckle are indeed quite talkative, which indicates that Terrytoons made the connection in creating the duo.

- Dog Dimwit was aptly named. He began many of his utterings with a drawn-out "duhhh" before generally saying something quite stupid and getting outwitted by Heckle and Jeckle.

- Identical twin characters had appeared in the comics before Terrytoons created Heckle and Jeckle, but Mike and Ike, as well as Dover and Clover, were humans. Mike and Ike (They Look Alike) first appeared in 1907.

About Heckle and Jeckle

Paul Terry had a vision for his studio following the success of Mighty Mouse. He sought a series featuring twin animal characters. He had in the early 1940s come up with human twins (who happened to stumble upon each other and were not brothers) named Ickle and Pickle. Terry yearned to make his characters a team rather than adversaries, such as Tom and Jerry, as well as Wile E. Coyote and the Road Runner.

The result of his dream and the work of writer Tom Morrison and director Minnie Davis was Heckle and Jeckle, who debuted as a married couple in *The Talking Magpies*, but really began hitting their stride with the release of *The Uninvited Pests*. Both shorts hit the screen in 1946, but the latter arrived much later in the year.

Among the differences between Heckle and Jeckle and other cartoon characters of their era and beyond was that they were aggressive and antagonistic. They boasted similar characteristics to Bugs Bunny in that they were unflappable in the face of danger and confident in a favorable outcome, but the famous rabbit reacted to provocation while the twin magpies were provocateurs. One result was that while Bugs always emerged victorious, Heckle and Jeckle quite often tasted defeat in the end.

Heckle and Jeckle were among the most violent cartoon characters of all time. Yet despite the fact that they generally instigated the violence rather than using it as retribution, they were embraced by fans to the point that they emerged as a highly successful and embraced duo. Their success was largely due to their personalities, which were far more distinctive than the others dreamed up by the studio. They looked identical, but did not sound alike. Heckle spoke with a New York accent and called his twin familial names such as "old pal" and chum." Jeckle's voice was British and sophisticated. He often referred to his friend as "old chap" or "old boy."

Heckle and Jeckle cartoons generally consisted of back-and-forth pursuits against those they chose to antagonize for a purpose, such as the procurement of food. Certainly, it proved to be repetitive as formula cartooning, but the attraction of Heckle and Jeckle, as well as the side characters, allowed their cartoons to maintain popularity as theatrical shorts and television fare for generations, arguably more so than any other Terrytoons stars, even Mighty Mouse. It's no wonder the magpies attracted a large audience upon the debut of the *Heckle and Jeckle Cartoon Show* in 1956, so much so that it generally remained on the air through 1971. It is no surprise that it was

cancelled for good right around the time in which violence on television had become an issue. *The New Adventures of Mighty Mouse and Heckle and Jeckle* debuted in 1979 and lasted two seasons. And unlike some of the most prominent cartoon characters in television history, the twin pair never made it back into the spotlight.

Why Heckle and Jeckle Are No. 100

The uniqueness of Heckle and Jeckle alone earn them a place among the greatest cartoon characters ever. They are unique in that they are magpies with distinctive and different accents, twins (yet apparently not brothers), antagonistic rather than reactionary, and an animated comedy team that works together rather than apart as adversaries. They are simply two of the most memorable characters to ever grace the large and small screen.

It is that legacy that earns them the last spot in this ranking.

—MG

TOP 10s

TOP 10 CARTOON VILLAINS

1. Joker
2. Mojo Jojo
3. Mr. Burns
4. Boris and Natasha
5. Dick Dastardly
6. Snidely Whiplash
7. Cobra Commander
8. Skeletor
9. Gargamel
10. Shredder

TOP 10 CARTOON DOGS

1. Snoopy
2. Scooby-Doo
3. Ren
4. Peabody
5. Underdog
6. Courage the Cowardly Dog
7. Brian (*Family Guy*)
8. Pluto (*Mickey Mouse Club*)
9. 2 Stupid Dogs (*2 Stupid Dogs*)
10. Jake

TOP 10 CARTOON CATS

1. The Pink Panther
2. Garfield
3. Stimpy
4. Tom
5. Sylvester
6. Top Cat
7. Snagglepuss
8. Meowth (*Pokémon*)
9. Mr. Jinks (*The Huckleberry Hound Show*)
10. Felix (*Felix the Cat*)

TOP 10 SCREEN-TO-TV CHARACTERS

1. Bugs Bunny
2. Daffy Duck
3. Donald Duck
4. Popeye
5. Tom and Jerry
6. Woody Woodpecker
7. Yosemite Sam
8. Mickey Mouse
9. Mighty Mouse
10. Mr. Magoo

TOP 10 WARNER BROS. CHARACTERS

1. Bugs Bunny
2. Daffy Duck
3. Yosemite Sam
4. Wile E. Coyote and Road Runner
5. Foghorn Leghorn
6. Porky Pig
7. Sylvester and Tweety
8. Pepe LePew
9. Elmer Fudd
10. Tasmanian Devil

TOP 10 HANNA-BARBERA CHARACTERS

1. Yogi Bear
2. Scooby Doo
3. Fred Flintstone
4. Johnny Bravo
5. The Powerpuff Girls
6. Mojo Jojo
7. Hong Kong Phooey
8. Quick Draw McGraw
9. Jonny Quest
10. Dexter

TOP 10 CARTOON KIDS

1. Stewie Griffin
2. Eric Cartman
3. Daria Morgendorffer
4. Bart Simpson
5. Astro Boy
6. Alvin
7. Finn
8. The Powerpuff Girls
9. Bobby Hill
10. Angelica Pickles

TOP 10 CAT-AND-MOUSE CARTOONS

1. Tom and Jerry
2. Itchy and Scratchy (*The Simpsons*)
3. Mighty Mouse and Oil Can Harry
4. Pixie and Dixie and Mr. Jinks (*The Huckleberry Hound Show*)
5. Punkin' Puss and Mushmouse (*The Magilla Gorilla Show*)
6. Sylvester and Speedy Gonzalez
7. Courageous Cat and Minute Mouse (*Courageous Cat and Minute Mouse*)
8. Worker and Parasite (*The Simpsons*)
9. Herman and Katnip (*The New Casper Cartoon Show*)
10. Waffle and Squeakus (*Catscratch*)

TOP 10 CARTOON THEME SONGS

1. Flintstones
2. Spider-Man
3. Scooby-Doo, Where Are You!
4. The Jetsons
5. DuckTales
6. The Pink Panther
7. Inspector Gadget
8. The Simpsons
9. SpongeBob SquarePants
10. Jonny Quest

TOP 10 COMMERCIAL SPOKESCHARACTERS

1. Charlie the Tuna
2. Tony the Tiger
3. Speedy Alka-Seltzer
4. Toucan Sam
5. Cap'n Crunch
6. Count Chocula
7. Snap, Crackle, and Pop
8. Mister Clean
9. Quisp
10. Trix Rabbit

TOP 10 HOLIDAY SPECIALS

1. *Charlie Brown Christmas*
2. *How the Grinch Stole Christmas*
3. *A Charlie Brown Thanksgiving*
4. *A Year Without a Santa Claus*
5. *Rudolph the Red-Nosed Reindeer*
6. *It's the Great Pumpkin, Charlie Brown*
7. *Mr. Magoo's Christmas Carol*
8. *Santa Claus Is Coming to Town*
9. *Frosty the Snowman*
10. *A Rugrats Chanukah*

TOP 10 VOICE ARTISTS

1. Mel Blanc
2. June Foray
3. Don Messick
4. Daws Butler
5. Frank Welker
6. Tom Kenny
7. Scatman Crothers
8. Rob Paulsen
9. Billy West
10. Hank Azaria

TOP 10 ANIMATED SUPERHEROES

1. Batman
2. Teenage Mutant Ninja Turtles
3. Spider-Man
4. X-Men
5. Superman
6. The Super Friends
7. Astro Boy
8. Teen Titans
9. The Tick
10. Darkwing Duck

TOP 10 DISNEY TV CHARACTERS

1. Donald Duck
2. Mickey Mouse
3. Scrooge McDuck
4. Winnie the Pooh
5. Chip 'n' Dale
6. Darkwing Duck
7. Goofy
8. Goliath (*Gargoyles*)
9. Kim Possible
10. Don Carnage (*Tailspin*)

TOP 10 FILMATION CHARACTERS

1. Skeletor
2. Fat Albert
3. She-Ra
4. Jughead (*The Archies*)
5. James T. Kirk (*Star Trek, The Animated Series*)
6. Superman
7. Sabrina (*Sabrina the Teenage Witch*)
8. Tarzan
9. Microwoman
10. The Brown Hornet

About the Authors

Marty Gitlin is a freelance author based in Cleveland. He has had about 120 books published since 2006, including many in the pop culture realm. Included were the *Great American Cereal Book*, which remained No. 1 in the Breakfast Book and Americana categories on Amazon.com for several months and was featured in *Time Magazine, Reader's Digest, Wall Street Journal*, and *New York Times*. Gitlin also authored *The Greatest Sitcoms of All-Time*. During his eleven years as a newspaper journalist, he won forty-five writing awards, including first place for general excellence from The Associated Press. That organization selected him as one of the top four feature writers in Ohio.

Joe Wos has had a long and varied career in the cartoon arts. As a cartoonist he has performed nationwide with his unique blend of storytelling and cartoon arts. He has served as the visiting resident cartoonist of the Charles M. Schulz Museum for the past fifteen years. He has illustrated live symphonies with orchestras throughout the United States. His feature MazeToons, a hybrid of cartoon illustration and mazes, is distributed to newspapers worldwide by Creators Syndicate.

As a cartoon historian, Joe Wos served as both founder and director of the ToonSeum, a cartoon art museum in Pittsburgh. During his seven-year tenure he curated over seventy exhibitions and presented over one hundred programs.

Joe also serves as the historian and brand character integrity consultant for Charlie the Tuna of StarKist fame.